Indian Sculpture

BOWDOIN COLLEGE
MUSEUM OF ART
WALKER ART BUILDING
BRUNSWICK, MAINE 04011

Volume 1

circa 500 B.C.–A.D. 700

Indian Sculpture

by Pratapaditya Pal

A Catalogue of the Los Angeles County Museum of Art Collection

Los Angeles County Museum of Art
in association with
University of California Press
Berkeley, Los Angeles, and London

Copublished by the
Los Angeles County Museum of Art
5905 Wilshire Boulevard
Los Angeles, California 90036
and
University of California Press
Berkeley, Los Angeles, and London

Edited by Kathleen Preciado
Designed by Renée Cossutta and Judith Lausten
Photography by Jeffrey Conley
and Department of Photographic Services,
Los Angeles County Museum of Art
Typeset in Garamond typefaces
by Continental Typographics, Inc.,
Chatsworth, California
Printed in an edition of
4,000 softcover and 750 hardcover
by Nissha Printing Co., Ltd., Japan

This project is supported in part by a grant
from the National Endowment for the Arts.

Catalogue entries are keyed to a letter-number
system, with the letters *C* and *S* representing,
respectively, Coins and Sculptures.

In the transliteration of names and terms,
diacritical marks have been omitted, except in
the Bibliography and Index; they also have been
retained in selected words used only once.

Dimensions are in inches (in) and centimeters
(cm), height preceding width, unless otherwise
indicated. For most sculptures, height is the
only dimension provided.

Cover: *Railing Pillar with Figures*,
Mathura, first century, S55.

Library of Congress Cataloging
in Publication Data

Pal, Pratapaditya.
Indian sculpture.

Bibliography: v. 1, p.
Includes index.
Contents: v. 1. Circa 500 B.C.—A.D. 700.
1. Sculpture, Indic—Catalogs. 2. Sculpture—
California—Los Angeles—Catalogs.
3. Los Angeles County Museum of Art—Catalogs.
I. Los Angeles County Museum of Art. II. Title.
ISBN 0-87587-129-1 (v. 1 : pbk.)
ISBN 0-520-05991-3 (v. 1 : Univ. of Calif. Press)
ISBN 0-520-05992-1 (v. 1 : Univ. of Calif. Press : pbk.)

Contents

Foreword

This volume is the third in a projected eight-volume series of catalogue raisonnés intended to present to the general public and scholarly community the museum's preeminent Indian and Southeast Asian collections and introduce readers to the geographical, historical, and cultural milieu in which that art flourished. The outstanding quality of the collection, breadth and comprehensiveness of the text— written by Pratapaditya Pal, senior curator of Indian and Southeast Asian art—and clarity and organization of the material will combine to make the series not only an important contribution to art-historical scholarship but also a major resource for the general public. Not since Ananda K. Coomaraswamy's seminal studies on the Indian collections in the Museum of Fine Arts, Boston, jointly published with Harvard University Press in the 1920s, has a similar corpus of Indian works received such critical attention.

 Indian Sculpture is unique in that it includes a detailed discussion of numismatic art. The chapter is of significance for anyone with an interest in the history of the Indian subcontinent as well as for coin enthusiasts. Moreover, in the introductory essay and individual catalogue entries Dr. Pal examines the influence of the West, particularly Greece and West Asia, on Indian history, religion, and aesthetics. In his close observation of individual coins he traces the development of certain iconographic elements found in later monumental sculpture, thereby contributing to our knowledge of early Indian art. His discussion of the history and iconography of coins constitutes a departure from most general books on Indian art, which have not focused on this very important evidence.

 The sculpture collection is not only rich in representing various schools, materials, and techniques as well as geographic areas but also in displaying a wealth of iconographic detail. The extent and significance of this collection— which covers an enormous span of time, from 500 B.C. to A.D. 700—are here well documented. Many objects never before published are presented as well as the results of new research on specific works and their art-historical background. *Indian Sculpture* concentrates with welcome detail on the collection while providing a very useful commentary on various aspects of the early Indian sculptural tradition.

Earl A. Powell III
Director
Los Angeles County Museum of Art

The Indian Subcontinent and Afghanistan

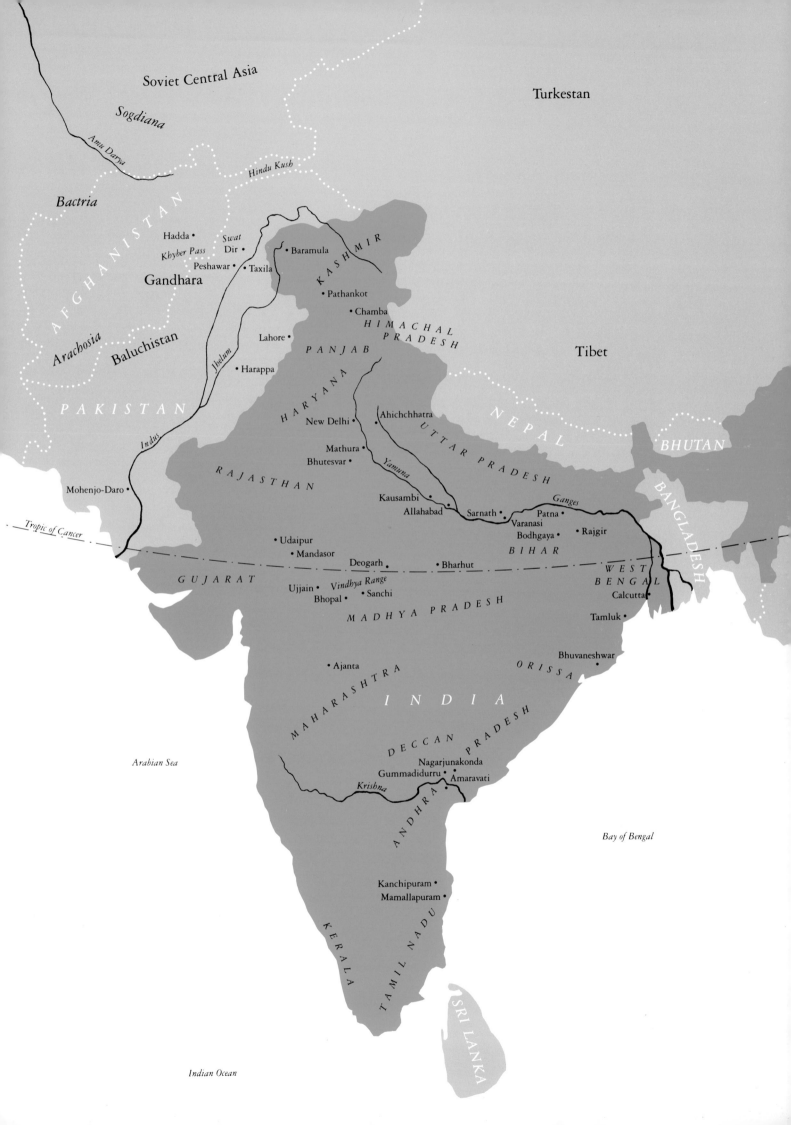

Preface and Acknowledgments

Indian Sculpture is the first of two volumes devoted to the Los Angeles County Museum's extensive holdings of Indian sculpture and is the third catalogue raisonné in a series documenting the museum's collections from South and Southeast Asia, following two earlier volumes on the arts of Tibet and Nepal.

The term *Indian* is used here in its broadest application as the volume includes sculpture from Afghanistan and Pakistan as well as India. Thus it would perhaps be more appropriate to consider this a catalogue of the museum's holdings of sculpture from South Asia excluding Nepal and Sri Lanka. The sculpture entries have been arranged chronologically by country and modern Indian state, moving across the subcontinent west to east, from Afghanistan to West Bengal, followed by the states of the midregion and southern peninsula.

Although the book is largely about sculpture, a substantial section is devoted to numismatic art. While books about Indian sculpture generally do not include coins, I feel strongly that coins, which involve the art of engraving, are essential to a better understanding of the history of Indian sculpture. Throughout the catalogue it has been my constant endeavor to relate the coins to sculpture as far as possible. Numismatists, however, should keep in mind that I claim to have no expertise in the specialized study of coins and have relied on many colleagues who have generously shared their knowledge with me. They include A.D.H. Bivar of the School of Oriental and African Studies, University of London; Martha L. Carter of the University of Wisconsin, Madison; coin dealer Joel Malter of Los Angeles; and B. N. Mukherjee of Calcutta University. Without their help the chapter on coins could not have been written, and I am deeply grateful to them all.

To better illustrate the catalogue additional photographs were kindly supplied by the British Museum, Cincinnati Art Museum, Cleveland Museum of Art, and Mrs. J. LeRoy Davidson. I particularly appreciate the cooperation of Mrs. Davidson, whose husband was one of several individuals responsible for bringing the Heeramaneck collection to Los Angeles in 1969. Thanks are also due to my friends and colleagues Wladimir Zwalf and Eva Ray.

While the Nasli and Alice Heeramaneck Collection, acquired through the enthusiasm of former museum director Kenneth Donahue and Senior Curator of Far Eastern Art George Kuwayama among others, forms the basis of the museum's South Asian collection, since 1969 the core collection has more than doubled. This expansion has been possible due not only to the vigorous acquisition policy supported by the trustees but also to the generosity of many donors who are identified in the catalogue entries. It is a great pleasure for me to thank all of them. A curator is always conscious of the fact that no great museum collection can be formed without the munificence of donors and cooperation of dealers who often work closely with a curator to fill the many lacunae in a comprehensive collection. They, too, deserve my thanks.

A catalogue of this size and scope cannot be prepared in isolation, and I am indebted to many museum colleagues, foremost among them the staff of the Art Research Library, particularly Eleanor Hartman and Anne Diederick. Many objects in the collection, including all the terra-cottas, were carefully examined and treated by the Conservation Center headed by Pieter Meyers. Much preparatory work was accomplished by Registrar Renee Montgomery and her able staff as well as by members of the Department of Indian and Southeast Asian Art and Department of Ancient and Islamic Art: Robert Brown, Thomas Lentz, Nancy Thomas, and Janet Zieschang. Mention should also be made of the department's diligent volunteers, especially Ethel Heyer. For their support and encouragement of this project, thanks are also due to Director Earl A. Powell III, Assistant Director for Museum Programs Myrna Smoot, and Managing Editor Mitch Tuchman.

Finally, a special word of appreciation to the photographers, designer, and editor, all of whom contributed directly to the successful production of the book. Head Photographer Larry Reynolds and his colleague Jeffrey Conley have risen to the occasion splendidly, while Renée Cossutta, who designed *Art of Nepal*, has achieved an elegant presentation of text and illustrations. Working with Kathleen Preciado, who also edited the Nepal volume, once again proved to be both rewarding and pleasurable.

Pratapaditya Pal
Senior Curator of Indian and Southeast Asian Art

General Introduction

Art is an affirmation not of reality, but of man's ability to create something beyond reality.

Herbert Read, *The Grass Roots of Art*, 1955

To forms hewn from solid stone there has been given the unearthly intangibility and lightness of sheer vision, the matter of the rock being transmuted into shapes of foam and mist comporting perfectly with the subtle mind-substance of supersensuous experience. Indeed, I wonder whether in the whole artistic tradition of mankind there exists another sculptural style in which this effect has been aspired to with such fervor and realized with such consummate ease.

Heinrich Zimmer, *The Art of Indian Asia*, 1955

History

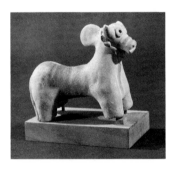

Bull, Pakistan, c. 300 B.C., S1.

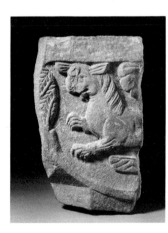

Fragment of a Pillar, Bharhut, c. 100 B.C., S28.

The earliest sculpture in the collection is a terra-cotta bull produced about the time when the Macedonian emperor Alexander the Great reached the river Indus in 327 B.C. Soon after Alexander's death in 323 B.C., according to the historian Justin, India "had shaken off the yoke of servitude and put his governors to death. The author of the liberation was Sandrocottus."[1] Sandrocottus is the Hellenized name for the ruler Chandragupta, who founded the Maurya dynasty. Under his grandson Asoka, the empire stretched from Afghanistan in the north to Karnataka in the south and from Gujarat in the west to Bengal in the east.

By the year 187 B.C. the Maurya Empire had collapsed, and while the center of the country was ruled by the Sunga dynasty (187–75 B.C.) the Indo-Greeks controlled the northwest. During the rule of the Sungas the stone railings and gateways around the great Buddhist stupa at Bharhut in Madhya Pradesh were constructed (S27–28). The Indo-Greeks were the successors of the Greek rulers of Bactria in northwestern Afghanistan, where an independent kingdom was founded about 256–255 B.C. by Diodotus I, local governor of the Seleucid emperor Antiochus (II) Theos.[2] About 150 B.C. Heliocles, last Greek ruler of Bactria, was pushed south by the Parthians and probably by the Scythians, nomadic tribes from Central Asia. Since parts of their territories comprised northwestern India, these later rulers of Greek origin are generally referred to as Indo-Greeks. The rule of the Indo-Greeks was of fundamental significance for the history of Indian coinage (see C2–5). Hellenistic concepts also played important roles in the evolution of Indian art, particularly in Gandhara, and in the development of astronomy and religion.

The Bactrian Greeks were not the only foreign presence in the northwestern region of the subcontinent during this period. Following in their trail in the first century before Christ several Central Asian nomadic peoples successively took control of the region. These included the Scythians, Parthians, and Kushans. Known as Sakas in India, the Scythians must have come in fairly large numbers, and one of their rulers, Azes I, is said to have originated the Vikrama era in 58–57 B.C., which has remained one of the two most important reckonings used in India. A second era, begun in A.D. 78, is also associated with the Scythians and is known as

the Saka era, the official reckoning of the Indian government today. Pushed south by the Parthians, some of the Scythians settled in present-day Gujarat, Madhya Pradesh, and Rajasthan provinces, where they became known as the Western Kshatrapas. Ruling an extensive kingdom, they were a powerful political presence until they were defeated around A.D. 400 by the Gupta emperor Chandragupta II.

By far the most powerful among these Central Asian tribes were the Kushans, who first conquered Bactria and then moved south into India, probably sometime during the first century. At its height under Kanishka I, the Kushan Empire stretched from Soviet Central Asia in the north to the Deccan in the south and as far east as Bihar. The Kushans introduced gold coinage (see C9–10, C12–14, C16–18), and Kanishka may have been the founder of the Saka era of A.D. 78. The political power of the Kushans began to decline shortly after the reign of Vasudeva I in 176, but they appear to have retained control over their Indian provinces until the midthird century. Even as late as the midfourth century, they were a notable power in the northwest, as is known from contemporary inscriptions and the continued use of Kushan coin types in the region.

While the Kushans were the acknowledged political power in much of northern India, the Deccan was ruled by a native dynasty known as the Satavahanas. The Satavahanas probably belonged to the Andhra tribe, some of whom may have originally lived in the trans-Vindhya region in central India between Uttar and Madhya Pradesh, although only the eastern coastal area is today known as Andhra Pradesh. In any event, sometime during the second half of the first century, the Satavahanas established a kingdom in present-day Maharashtra, which they later expanded east to include parts of Andhra Pradesh. An officer of the Satavahanas commissioned parts of a gateway at the Great Stupa at Sanchi (see S29–30) sometime about the time of the birth of Christ. The coins of the Satavahanas (see C21–24) certainly indicate that by the midsecond century parts of Andhra Pradesh were brought under the sway of the Satavahanas. By 225, however, Satavahana power had declined, and when the stupa at Gummadidurru in Andhra Pradesh was built (see S82–85), probably in the second half of the third century, the dominant political dynasty in the region were the Ikshvakus, who were once feudatories of the Satavahanas. Although the Ikshvakus were not a major political force, the female members of the royal family were munificent patrons of Buddhism and responsible for the building of many magnificent monuments in Andhra Pradesh.

Not until the second half of the fourth century was much of northern India united once again politically, by a dynasty known as the Guptas. The dynasty originated in eastern India in the beginning of the century. By the close of the fourth century two powerful Gupta rulers, Samudragupta and Chandragupta II, had succeeded in bringing much of northern India from Panjab in the north to Bengal in the east as well as the Deccan under their political hegemony. Between these lands, and to their north, territories they did not directly conquer fell within their sphere of influence. Thus, although the Gupta Empire was not as extensive as that of the Mauryas, which had flourished almost half a millennium before, it marked the second period in Indian history when the political and cultural influence of a single dynasty encompassed almost the whole of northern India and was also felt in the south. Not until the Mughals came to power in the sixteenth century was this again the case.

By 450 the Gupta Empire had begun to shrink, although the imperial Guptas were a political presence in some parts of northern India until the middle of the sixth century. The years between 320 and 600 are generally regarded as the age of the Guptas, but, culturally, the period is sometimes extended to 700. Most historians characterize it as the classical period or "golden age" of Indian civilization.[3] Whether or not one agrees with such a designation, it must be admitted that the period was one of remarkable intellectual and cultural achievement.

Clay and wood remained the principal media for Indian art and architecture almost until the time of the Maurya emperor Asoka in the third century B.C. Archaeological excavations of the first urban civilization on the subcontinent, known as the Indus Valley civilization or Harappan civilization, which flourished in the third millennium B.C., have discovered that brick was the major building material for architecture, while terra-cotta and pottery commonly were used for manufacturing both secular and religious objects. Although stone and bronze were also employed, no monumental sculpture in either medium has been found.[4] This remained true as well of the second phase of urbanization that probably began just before the birth of the Buddha, around 563 B.C. Most archaeological sites along the Ganges Valley confirm that brick remained the popular building material, and even the great palace of the Mauryas, according to an eyewitness account left us by the Greek ambassador Megasthenes (active third century B.C.), was largely constructed of brick and timber.[5]

With few exceptions, most objects of the pre-Christian period in the collection are terra-cottas. Most are also from urban sites, such as Taxila in the northwest; Ahichchhatra, Kausambi, and Mathura in the Ganges-Yamuna valleys; and Chandraketugarh, an ancient river port in West Bengal. Through the Gupta period terra-cotta remained an important artistic medium at urban centers catering to the secular and religious needs of city dwellers. While objects of terra-cotta and clay are principally made today in rural areas and brought to the cities during festivals and fairs, during the period discussed the industry probably flourished in both cities and villages. Certainly the sophistication of some figures, particularly the realistic representation of the urban upper class and foreigners, was unlikely achieved by villagers.

Monumental stone sculptures were not created on the subcontinent until the Maurya period. These consist of monolithic, freestanding columns more than forty feet tall with impressive animal sculptures serving as capitals. While some were erected by the Maurya emperor Asoka, others may well be older.[6] Indeed, the aesthetic and technical sophistication of these Maurya-period sculptures seems unaccountable, unless one assumes that they were produced by highly skilled stone sculptors from Bactria or even Iran. In any event, Asoka was the first Indian monarch known to support an imperial workshop and patronize the arts.

While the major media of Indian sculpture continued to be clay, wood, and ivory, by the second century B.C., no doubt inspired by Asoka's efforts, Buddhists began to use stone for their religious art. Less than a dozen religious sculptures in the round have been discovered from various sites dated to the second–first century B.C., and not until the birth of Christ did stone become a popular medium with Hindus for representations of their gods. Literary evidence indicates, however, that Hindu images and temples were erected at least from the

time of the Sanskrit grammarian Panini (active fourth century B.C.).[7] Although no temple remains of the Maurya period have yet been discovered, the reliefs preserved on the late-second-century B.C. Buddhist sites at Bharhut and Amaravati clearly demonstrate that houses of worship, consisting of either hypaethral shrines or multistoried structures, were constructed of wood, brick, and other perishable material. Even when the Indians became comfortable in designing, constructing, and excavating temples in stone, they steadfastly continued to model their lithic architecture on earlier wood prototypes. The earliest examples of relief sculpture, as at Bharhut, also are clearly based on the traditions of the painter and woodcarver.

While the principal reason stone became popular from about the second century B.C. was the realization of the material's durability, other factors must also have contributed to the sudden surge in its use for architecture and sculpture. Certainly by Panini's time, the earlier Vedic religious system of the Aryans (a branch of Indo-Europeans who came into India, probably in several waves, during the second millennium B.C.), with its emphasis on sacrifice, was being considerably modified by the concept of devotion known as bhakti, which included worship of images. Not only did the subcontinent witness the evolution of theistic religion, involving personal devotion to specific deities, which later came to be known by the blanket term *Hinduism*, but even such heterodox religions as Buddhism and Jainism adopted elaborate rituals requiring cult images. Another contributory factor was the growth of a capitalistic economy, at least since the time of the Buddha, and expansion of international trade, first with West Asia and then with the Roman Empire. Trade with Southeast Asia had originated during the fifth–fourth centuries B.C. at the latest and increased enormously during the Gupta period. Wealthy merchants and traders were, in fact, among the most munificent patrons of the arts and generously contributed to the religious establishments. With the expansion of capitalism, the practice of building temples in stone became a matter of status for affluent members of society.

The influence of the Greeks on the growth of temple building in India is particularly significant. Stone temples and cult images have been discovered in the cities founded by Alexander and the Greek settlers following his conquests. Alexander himself is known to have built several monuments in the Panjab. Ancient coins provide prima facie evidence of images of Hellenistic gods introduced in the region (see C2–3, C5–7, C12b), and archaeologists have unearthed remains of Greek temples in Taxila and other places. Yet, no traces of Indian temples can be found earlier than the surviving Greek examples. If temples were built earlier on the subcontinent, they were very likely made with perishable materials such as brick and wood. Thus, one must consider the possibility that if not the practice of erecting temples itself, certainly the building of houses of worship in the more durable stone material was due partly to Greek inspiration.

Pertinent to this discussion is a passage from the *Vishnudharmottara-purana*, an encyclopedic religious text compiled during the Kushan and Gupta periods. The Indian tradition divides the history of civilization into four ages: Kṛīta, Tretā, Dvāpara, and Kali. The Kali is the age in which we now live and is said to have begun in 3102 B.C. The relevant passage informs us that in the Kṛīta age the gods had visible forms but no images, in the Tretā age images were worshiped in homes, and in the Dvāpara age, in forests.[8] Only in the Kali age was it customary to build temples of the gods in towns. The dominant characteristic of the Kali age—the presence of mlechchhas (non-Aryans, believers in heterodox religions, and foreigners)—would indicate a much later date for the beginning of the cycle, about

400 B.C., when parts of the northwest were under Iranian domination and after the arrival of the Greeks in 327 B.C. Moreover, the second urbanization began almost two hundred years earlier, and Panini mentions that temples were built in towns. The heterodox Jains may well have built their shrines in villages and forests away from orthodox Aryan settlements. Houses of worship belonging to tribes and non-Aryans would also have been found in forests and villages. By the fourth century B.C. Buddhist stupas appear to have been built at crossroads and in rather remote places, although their monasteries must have sprung up in towns associated with the Buddha, an incentive to other communities to build shrines. An added impetus may have been provided by the Greeks, whose temples were an important part of their urban planning. Although some features and iconographic attributes of early Indian gods on coins are of indigenous origin, these images clearly incorporate classical influences, as convincingly argued by the great scholar of Indian iconography J. N. Banerjea.[9] Thus, without entering into the controversial issue of whether or not the first Buddha image was created in the Indian or Greek tradition, there seems no doubt that although images of village gods and tutelary divinities were familiar in ancient India, the impetus to portray and worship the Vedic and cosmic deities was partly due to the presence of the Greeks and other foreigners in northwestern India.[10] More specifically, Banerjea has thoroughly discussed the influence exerted by the forms of such Greek deities as Apollo, Hercules, Hermes, Tyche, Zeus, and others on various Indian images of the Indo-Parthian and Kushan periods.

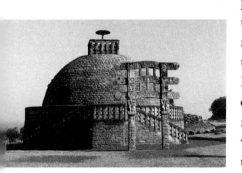

Stupa III, Sanchi, early first century. Photograph courtesy Mrs. J. LeRoy Davidson.

Buddhists were among the first to use stone extensively for their religious monuments, known as stupas, as is clear from Bharhut, Sanchi, and other sites built during the two centuries preceding the birth of Christ. While only one object in the collection bears an inscription (S53), which identifies the donor as a confidant of King Suryamitra of the ancient Panchala kingdom in present-day Uttar Pradesh, a plethora of material exists from this period that tells us who the donors were and why they commissioned works of art.

The donors of the stupa at Bharhut included members of royal families, merchants, pilgrims from various places on the subcontinent, and Buddhist monks and nuns as well as artists. Interestingly, donors came from as far off as Patna in Bihar, Kausambi near Allahabad, and the state of Maharashtra. Some sculptors working at Bharhut were from the northwest. The stupa at Bharhut undoubtedly was an important Buddhist pilgrimage shrine since it attracted devotees from such distances. Donors to the Buddhist site at Sanchi also came from various parts of the country and included both individuals and guilds. One dignitary, who paid for the building of an architrave on the southern gateway, was the overseer of the artisans of the Satavahana king Satakarni from the Deccan. Equally interesting is another inscription on the same gateway, which informs us that some sculptures were made by ivory carvers from Vidisa (present-day Besnagar not far from the monuments).

Until the beginning of the Gupta period in 320, Buddhists appear to have been far more enterprising than Hindus and Jains in recording their acts of piety. During the earlier Kushan period most donative inscriptions in Gandhara were carved on Buddhist objects. Donor names include a number of foreigners,

either administrators or merchants, and monks and nuns. The latter also feature strongly among the donors at Kushan Mathura, although names of both Jains and Hindus have survived as well. Some Buddhist monasteries in Gandhara and Mathura were built by Kushan monarchs, the most well known being that built by Kanishka I in Peshawar. By and large, however, few inscriptions of either the Kushan or Gupta period directly record royal commissions. This does not mean that members of the Kushan and Gupta royal families did not build temples or were not generous patrons of the arts. Surviving records, as in the dominions of the Satavahanas and Ikshvakus, document that royal largesse was frequently responsible for much of the art and architecture that remains today.[11] In any event, the ruler indirectly accrued merit whenever a piece of land was given to a religious establishment as a tax-free endowment. It was, after all, his royal prerogative to exempt religious establishments from paying taxes.

While the inscriptions at Bharhut and Sanchi simply bear the names of donors, by the Kushan period it became customary to state why a temple was built or an image installed. Generally, devotees of all three religious systems believed that they were gaining merit by such donations. Buddhists appear to have been more altruistic, usually their benefaction was meant "for the welfare and happiness of all sentient beings." An elaborate dedicatory inscription on the pedestal of an image commissioned in the year fifty-one (= A.D. 129?), when Huvishka was king, includes the following: "By the donation of this sacrifice and pious gift let it be for the acquisition of knowledge of teacher Sanghadāsa . . . mother and father . . . for the lessening of all griefs of Buddhavarman (and) for the welfare and happiness of all sentient beings."[12]

Many surviving Satavahana inscriptions are interesting for religious and art-historical studies. The Satavahanas continued to perform Vedic sacrifices, and detailed accounts of their largesse to the brahmins are available.[13] Nevertheless they were also generous patrons of Buddhist communities. The Nasik cave inscription of Vasishthiputra Pulumavi informs us that the cave temple "resembling a heavenly palace" was caused to be excavated by the queen Gautami Balasri. Furthermore, "for the embellishment of this Cave, her grandson, . . . who is desirous of serving his grandmother and pleasing her, adds to the religious endowments [of this cave], for the bridge of the religious merit of his father," a village was given by the king.[14] Not only do we learn about the personal lives of the rulers in Pulumavi's attempt to please his grandmother, but we are also told that a religious gift by the son could benefit the father. It is interesting that a Hindu could acquire merit by making a donation to a Buddhist establishment, which in fact remained true throughout the period here discussed.

In 408, while Chandragupta II was emperor, a lady, who describes herself as a mere householder's wife, went all the way from Patna in Bihar to a village near Allahabad in Uttar Pradesh and donated ten dinars for the maintenance of an almshouse for the local brahmin community "[for the purpose] of adding to [her] own religious merit."[15] While acquiring merit for oneself and others remained the primary purpose of a donation, Gupta-period inscriptions provide other and more specific reasons as well. Several inscriptions state that the donor hoped to ascend to heaven by his pious deed. A Buddha image from Mankuwar in Uttar

Pradesh was dedicated in 459 by the monk Buddhamitra "with the object of averting all unhappiness."[16] In an unspecified year the emperor Skandagupta dedicated a Vishnu image at Bhitari in Uttar Pradesh "in order to increase the religious merit of [his] father."[17] During the same monarch's reign in the year 460–61 a man named Madra, who was "especially full of affection for Brahmans and religious preceptors and ascetics," dedicated "five excellent [images], made of stone [of those] who led the way in the path of the Arhats, who practice religious observances" as he had become "alarmed when he observed the whole of this world [to be ever] passing through a succession of changes" and thereby "acquired for himself a large mass of religious merit."[18] The inscription does not identify Madra as a Hindu or Buddhist; it is interesting that he asserted his affection for brahmins even while dedicating images of the five Buddhas, presumably the pentad of Vajrayana Buddhism.

One of the most fascinating inscriptions of the Gupta period is that found in Mandasor in Madhya Pradesh.[19] The inscription was engraved on a slab in 473–74 during the renovation of a sun temple in the city, then known as Dasapura. Apparently a community of silk weavers had immigrated to Mandasor from Gujarat in the west. After their arrival in Mandasor some gave up their hereditary profession and prospered, but others constituted themselves into a guild. In the year 437–38 this guild built a sun temple, which fell into disrepair in the short span of thirty-six years and was renovated by order of the same guild. Thus, it is clear that trade guilds continued to patronize the arts at least through the Gupta period.

Certainly by the Kushan period the building of a temple or installation of a divine image was considered the highest act of piety, an act that would not only bring happiness in this world but would also assure final release from the chain of rebirth. Thus, in the *Vishnudharmottarapurana* the royal interlocutor asks the sage Markandeya what would bring him happiness in this world and the next. Markandeya unhesitatingly replies that the worship of the gods is the best method of achieving happiness in both worlds. He then elaborates on two kinds of worship, one involving sacrifice and the other consisting of abstinence, fasting, and charitable deeds. Better than either he says is to build temples and worship images because the deity resides in an image. "To build a temple is meritorious," says the sage, and "so is the making of an image of a deity. Meritorious is the worship of a divine image and so is its adoration."[20]

This emphasis on devotional worship with images and temples profoundly influenced Buddhists and Jains. Whatever their early practices and rituals, by the first century B.C. Buddhists had resorted to venerating the images of the Buddha with rituals similar to those used by Hindus. In an early Buddhist text the Buddha himself predicts that in course of time the custom of honoring the relics, the principal cultic practice among members of the early Buddhist community, will be replaced by the worship of the image.[21] In another text the future Buddha, Maitreya, unambiguously states that his audience is privileged to hear his teachings as a direct result of their having worshiped Sakyamuni "with parasols, banners, flags, perfumes, garlands and unguents."[22] In a Hindu text compiled in Kashmir during the seventh–eighth centuries, we are specifically told that at celebrations of the Buddha's birthday during the month of April "the image of the Buddha should be bathed [with water rendered holy] with all medicinal herbs, jewels and perfumes, in accordance with the saying of the Sakyas."[23]

The Jain community appears to have venerated images of the saintly Jinas at least from before the Maurya period. An inscription of the first-century B.C. king Kharavela of Kalinga (comprising parts of present-day Orissa) records how the monarch raided Magadha (Bihar) and brought back images of Jinas, which the Nandas of Magadha, a dynasty overthrown by the Mauryas, had looted in the fourth century B.C.[24] Evidence for the worship of Jinas during the Maurya period is provided by a statue discovered at Lohanipur near Patna in Bihar. Apparently, therefore, as early as the fourth century B.C. Jains in the eastern region were building temples and installing statues of their idealized teachers; by the Kushan period they had moved west at least as far as Mathura.

The early sculptures of the pre-Christian period discussed here are mostly small terra-cotta human and animal figures meant for secular and religious purposes. During the next six centuries terra-cotta certainly remained popular, but stone increasingly became the favorite material for building temples and sculpting religious figures. These sculptures served two primary functions: as icons meant for worship inside the temple and didactic elements embellishing exterior temple walls. In the representation of myths and stories, as in the early Buddhist stupas, these didactic elements assumed the form of reliefs. Hindus and Jains of this period did not employ narrative themes as much as did Buddhists, and the surviving exterior walls of their stone temples from the Gupta period are generally embellished with either single figures or compositions encapsulating myths in abbreviated forms. Brick temples of the period are richly adorned with reliefs from the epics and mythological texts (see S122–23). Rarely are the compositions as elaborate as those in early Buddhist reliefs. Buddhists, too, moved away from their early dependence on mythological themes and narrative reliefs and became more oriented in using single figures for architectural adornment.

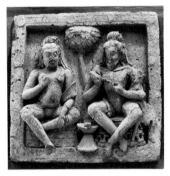

The Sages Nara and Narayana, Uttar Pradesh, fifth century, S122.

Most religious sculptures in India were created for an architectural context. Essentially, therefore, most stone sculptures are in the form of deeply carved reliefs and were not meant to be seen on a pedestal or from the back. In fact, the tradition of freestanding sculpture, conceived in isolation from an architectonic context, seems never to have been popular in India. The forms of the sculptures, whether stone or terra-cotta, were thus determined to a large measure not only by their religious function but also by their architectural position in a given temple. For instance, the exact placement of a figure may well have necessitated certain distortions of form that appear peculiar when the object is viewed in isolation. The height at which the sculpture was placed and angle of placement would certainly have influenced its shape, form, and detail. Thus, the breasts from Sanchi (S30) would have been part of a bracket figure, placed some ten or fifteen feet above the viewer at a forty-five-degree angle. The viewer would have had a totally different perspective of the tree dryad as he or she admired the subject while craning up to look at the figure rather than viewing her at eye level.

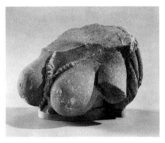

Bust of a Tree Dryad, Sanchi, 50 B.C.–A.D. 25, S30.

Sculptures in other materials, such as metal, wood, and ivory, were probably made as early as the Indus Valley civilization, but only examples in metal have survived. Bronze as well as gold and silver continued to be used for sculpture until the beginning of the Christian era, but the total available corpus is very small. Certainly the classical writers were impressed by the sumptuous metalwork, including gold, silver, gilded copper, and brass, of the Indians.[25] The collection contains several metal sculptures from the Kushan and Gupta periods. Although

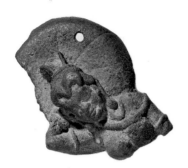

Mayadevi, Mathura, c. 100, S57.

most are of modest size, they are remarkably varied in style and subject matter. A small bronze of a reclining female (S57) is probably the finest example of a surviving Kushan-period metal sculpture. Interestingly, as early as the Gupta period it was customary to associate certain materials with certain results. For instance, the astronomer Varahamihira (active sixth century) tells us:

Images made of wood or clay bring {to their worshipers} long life, fortune, strength, and victory; those made of jewels are for the good of the people, and the golden ones bring prosperity. Images made of silver bring fame, while those made of copper cause increase of population.[26]

Curiously, nothing is said of dedicating images in stone. In fact, the early books discussing art give much greater emphasis to clay and wood, clearly the two most popular materials. In the *Vishnudharmottarapurana*, however, an entire chapter is devoted to the suitability of stone as a sculptural material just as a similar chapter in Varahamihira's work concentrates on wood. Apart from enumerating the elaborate rites and techniques to be observed by artists in the selection of stone or wood, the texts also describe what kind of material is suitable for whom. For instance, with regard to stone, we are told that brahmins should make images with white stone, kshatriyas (warriors) with red, vaisyas (traders) with yellow, and sudras (laborers) with black. Such injunctions, however, were not strictly followed.

Religion

Most sculptures in the collection were inspired by the religions known today as Hinduism, Buddhism, and Jainism. Both Buddhism and Jainism trace their origins to historical personages, but Hinduism has no such precise historical beginning. Buddhism originated with Buddha Sakyamuni (563–483 B.C.). Jainism is an older religion, and Mahavira (active sixth century B.C.) is its best-known teacher. Although the three religions differ from one another in philosophy and mythology, all use art to further their aims. Jains may have begun to use images of their saviors and teachers fairly early, while Buddhists certainly were enterprising in spreading their message through narrative art as early as the second century B.C. With its emphasis on theistic cults, Hinduism as it is known today began to assume its distinct character not much before the birth of Christ, although many of its major components are of far earlier origin.

Hinduism is a blanket term describing three major religious systems and countless sects and cults. Its multitude of gods and goddesses and endless mythological cycles provide the artist with an inexhaustible repertoire of themes and motifs. The three major Hindu religious systems are Vishnuism (Vaishnava), Sivaism (Saiva), and Saktism (Sakta) after the principal deities: Vishnu, Siva, and Sakti, or the Goddess. Although each has earlier origins, all three came into prominence during the Kushan period (first–midthird centuries). Scriptural texts pertaining to each system also began to be redacted and compiled at this time. By the beginning of the Gupta period in the fourth century most such texts known as the puranas (ancient lore) and the *Mahabharata* and *Ramayana*, two well-known epics, took their present shape. Alterations, modifications, and even major recastings of the puranas continued, however, for many more centuries. The core texts of other sacred Hindu books, known as agama, generally in the south, and tantra, mostly in the north, can be traced to the Gupta period. Unlike the puranas, these were not accessible to the general public. Much of this literature contains descriptions of deities in the form of precepts for meditation and complex mythologies, which served as verbal models for artists. Some puranas, such as the *Vishnudharmottarapurana* and *Matsyapurana*, include specific sections on art and iconography and are of considerable help to the art historian. The exact dates of these texts are often disputed, and a greater diversity is reflected in the surviving art of the period than that described in the contemporary literature.

Each Hindu deity is a complex, composite personality with numerous aspects and facets. Their personalities and iconographic attributes were fluid in the pre-Christian era, and only during the Kushan period did they begin to assume their distinctive forms. Siva is a clearly recognizable figure on Kushan coins, but Vishnu and the principal forms of the Goddess are conspicuously absent. Even in Mathura, which has remained the most important center of Vishnuism on the subcontinent, artistic evidence does not allow us to push back the history of the faith much before the first century B.C., although various cults, which later by the Gupta period coalesced into what came to be known as Vishnuism, were flourishing as early as the fourth century B.C.

Basically three originally distinct concepts and cults form the principal components of Vishnuism. Vishnu is the name of an important sun and sky god of the Vedic religion practiced by the Aryans. Whether or not the Aryans worshiped images, they did believe in gods and goddesses, the former predominating. A second concept, also of later Vedic origin, is that of Narayana, who may originally have been "the founder of a religion of devotion," as suggested by the eminent historian of religion Jan Gonda, and who was apotheosized "as the exalted Being, the Universal Spirit, the ultimate source of the world and all its inhabitants."[27] The third component is Vasudeva-Krishna, a tribal god-hero, probably of non-Aryan derivation. By the Kushan period, certainly in the Mathura region, the cult of Vasudeva-Krishna and his half brother, Balarama, seems to have predominated. As a matter of fact, the most impressive Vaishnava images discovered in Mathura represent Balarama (S59) rather than Vasudeva.

How complex the concept of each major Hindu deity is can best be demonstrated by briefly recounting the principal components that contributed to the total personality of Balarama. The review will also explain how the iconographic forms and attributes of each deity were devised.

Although Balarama is presented in mythology as one of the five deified heroes of the Vrishni tribe, by the Kushan period, when he loomed large as a major deity, he may have assimilated other concepts into his personality. His principal attribute is the plowshare, which clearly announces his connection with agriculture. Another important feature of his early images is the snake-hood canopy above his head. Of great antiquity, serpent worship was important in Kushan Mathura as it was in many other parts of the country. The association of Balarama with the serpent may, therefore, have been a conscious effort by Vaishnavas to broaden their base by assimilating the snake cult. Indeed, the worship of the serpent was so important and pervasive in ancient India that it was incorporated in one form or another by all three major religions. Thus, in a third-century relief (S81), the Buddha is protected by a multihooded serpent as is Balarama, while the head of Jina Parsvanatha (S134) is similarly surmounted by a snake-hood canopy. The serpent is also a frequent adornment of Siva and other Hindu deities.

Thus, so far, Balarama has appeared to us in at least three guises, as a deified hero of the Vrishni clan, agrarian deity, and serpent-god. He has also assimilated some aspects of the ancient yaksha cult, especially in his weakness for alcohol. Before the rise of theistic Hinduism and triumphant emergence of the cosmic deities Vishnu, Siva, Durga, and others, yakshas (ones worthy of worship) were widely patronized all across the subcontinent and are still venerated in villages. Not only do most monumental images surviving from the pre-Christian era depict yakshas and their female counterparts, yakshis, but they are addressed by the term *bhagavata*, which also means "one worthy of homage." Significantly, in early

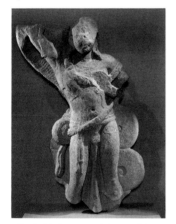

The God Balarama or A Serpent-King, Mathura, 100–125, S59.

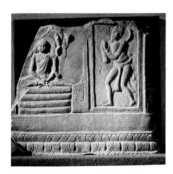

The Buddha Sakyamuni Sheltered by Muchalinda, Nagarjunakonda, third century, S81.

literature this expression consistently was applied to the Buddha and Hindu gods, such as Vishnu and Siva, while the Goddess came to be known universally as *bhagavatī*. Indeed, like the serpent-gods, the yakshas and yakshis were revered by all. Incorporated directly and en masse into the Jain pantheon, they remained subservient to the Jinas, and contributed significantly to both Hindu and Buddhist pantheons. Some were included directly, the most prominent being Kubera, god of wealth venerated in all three religions; others were absorbed by the cosmic gods of Hinduism in a more subtle fashion.

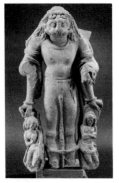

The Man-Lion Avatar of Vishnu, Mathura area, midsixth century, S129.

To return to the concept of Balarama, a fifth dimension was added to this deity in his role as avatar, or incarnation, of Vishnu. In Hindu mythology all cosmic gods are capable of assuming different forms to destroy the forces of evil and save the pious. From time to time, Siva, Durga, and Kumara (the divine general and son of Siva) assume such savior roles to punish the wicked and reward the good. The concept had particular relevance for Vaishnavas, for Vishnu is the savior par excellence and preserver of the cosmic order. When the world is especially overpowered by evil, Vishnu is believed to assume forms that vary depending on the task to be performed. Ten such avatars, including animal and human forms, are generally represented in art collectively, although some individual incarnations, such as Balarama, Varaha, Narasimha, and Rama, have enjoyed individual cults. The concept of the avatar was a convenient means of absorbing various other cults as well. For instance, the first three avatars—in the forms of fish, tortoise, and boar—may have been tribal totems or gods, while Rama and Balarama were tribal heroes, who may have been deified even before their absorption into Vishnuism. The ninth avatar, the Buddha, certainly had nothing to do with Vishnu, but his teachings formed the basis of one of the most important world religions, and by the Gupta period he was included in the list of Vaishnava avatars.

Although the avatar concept is specifically Vaishnava, that of the savior is fundamental to both Jainism and Buddhism. Jainism reveres a group of twenty-four Jinas, also known as Tirthankaras. "A Tirthankara is he," says a typical Jain text, "by whom was shown the broad-fording place of virtue, the best of all reaching [by] which men overcome sorrow."[28] The aim of the Jain religion is to seek salvation (moksha) by liberating the soul (jiva) from the nonsoul (ajiva) and impurities of karma; the path was shown by the Jinas, successive teachers believed by the Jains to be historical personages.

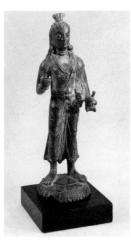

A Bodhisattva, Kashmir, c. 400, S99.

Buddhism, too, is a religion of salvation, and Sakyamuni is one of many Buddhas who have from time to time appeared on earth to show the way. The suffix *yana* in such expressions as Hinayana, Mahayana, Tantrayana, and others, designating various forms or schools of Buddhism, means "path," "way," or "vehicle." Buddhists continue to believe that Sakyamuni is not the last Buddha and still await the arrival of the future Buddha, Maitreya. Mahayana Buddhism specifically developed the concept of a bodhisattva, a perfected being who has postponed his own nirvana to enlighten and, therefore, save others. Avalokitesvara and Tara are savior-deities revered universally by all followers of later forms of Buddhism. Each not only saves sentient beings spiritually but also protects them from mundane fears and threats.

The evolution of Balarama is typical of the conceptual development of the divinities in India. Assimilation and inclusiveness have been the principal modes of enriching the personalities of the gods and expanding the pantheons. Each religion absorbed the gods and spirits of the new locales and communities with

which it came into contact. They also borrowed and adapted ideas from one another. The component *īśvara* in Avalokitesvara's name means "lord," and Mahesvara (great lord) is a common epithet of Siva. Avalokitesvara's function, however, is akin to that of Vishnu's. The Buddhist goddess Tara serves the same function as Durga of the Hindu pantheon and has the same form and attribute of the much earlier Sri-Lakshmi. In addition to adopting the earlier yakshas, Jains absorbed entire groups of Hindu deities into their pantheons.

Hindus believe that the Ultimate Being known as Brahma cannot be perceived by the senses and is formless. This abstraction, however, can assume many forms, the three principal being known as Brahma, the creator, Vishnu, the preserver, and Siva, the destroyer, who periodically create, preserve, and destroy the universe in endless cycles. Brahma has remained more or less a figurehead in Hindu mythology, while Vishnu and Siva are the two dominant personalities. Siva is worshiped principally in his aniconic symbol known as the linga (sign), which combines two ancient cults of fertility embodied in worship of the phallus and the cosmic pillar linking heaven and earth. He also assumes anthropomorphic forms, several of which were conceived and represented in art during the Kushan period.

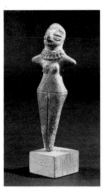

A Goddess, Peshawar division, second century B.C., S6.

Images of the Goddess constitute, perhaps, the earliest examples of Indian art, dating to the third millennium B.C. Although the museum does not have any objects dating from the Indus Valley civilization, the collection does represent the thematic multiplicity of figures whose primary function is related to fecundity and abundance, irrespective of whether they represent yakshis or goddesses. The cult of the Goddess was pervasive in ancient India and still remains the focus of popular religion in the country. One of the earliest Mother Goddesses to be distinguished and elevated as a major deity in the Hindu pantheon is Sri-Lakshmi, venerated ubiquitously by Hindus, Buddhists, and Jains as the goddess of wealth and good fortune. She continues to enjoy the most adored status virtually in every Hindu household. The cosmic goddess Durga, slayer of the buffalo demon and embodiment of sakti, the power and energy basic to all creation, is rather a latecomer to Hinduism. Her earliest images are from the Kushan period, and all are remarkably small, indicating the somewhat modest nature of her cult at the time. She may well have been a composite of various concepts, both native and foreign, which coalesced into a cosmic magna mater. As with other deities, she absorbed diverse village and tribal cults and divinities and became a supreme goddess to her devotees by the Gupta period.

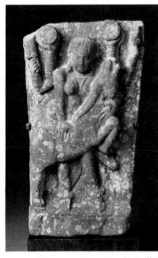

The Goddess Durga Destroying the Buffalo Demon, Mathura, c. 200, S72.

Although the important divinities of Hinduism, such as Vishnu, Siva, Surya (the sun god), Kumara (the divine general), and Ganesa (the universally worshiped elephant-headed god of success), are all male, by the Gupta period goddesses came to play an important role. Not only does each god have a wife, but the goddess is considered to be the inherent power or energy residing in each male member of the pantheon. Vaishnavas thus came to regard Sri-Lakshmi as both the wife and power of Vishnu. Siva similarly is regarded as powerless without Parvati or Uma, the two common names of his spouse. Significantly influencing the development of this concept is Samkhya, a philosophical system advocating a kind of dualism by asserting that the universe was created by Prakriti (nature) for the sake of Purusha (spirit). Purusha is regarded as the passive spectator, while Prakriti is the active first principle.

Buddhism was profoundly influenced by similar ideas. In Mahayana Buddhism a bodhisattva may be of either sex, and innumerable gods and goddesses were created to help the adept along the path toward enlightenment. The principal text of Mahayana philosophy, the *Prajnaparamita*, was deified as a Mother Goddess. As the word *prajñā*, meaning "wisdom" or "knowledge," is of the feminine gender, all Buddhist goddesses came to be regarded as embodiments of prajñā. Jains, too, accepted yakshis and goddesses into their pantheons, and, although generally they do not enjoy the importance accorded their counterparts in the Hindu and Buddhist pantheons, some, such as Sarasvati, goddess of learning and wisdom, and Ambika, a benevolent Mother Goddess, are no less popular than some Jinas.

Early Buddhism was a simple, humanistic faith that had no use for rituals or images. The focus of devotion was the stupa, a hemispherical mound made of brick and rubble that symbolized the faith, the Buddha, and the cosmic mountain, which was piously circumambulated by the devotees, both lay and monk. Although the Buddha had been represented by symbols much earlier, it was not until the first century B.C. that images of him began to appear simultaneously in Mathura and the northwest. Not only had the Buddha become a transcendental being, but the introduction of the bodhisattva was also a major concession to the concept of personal devotion. Thus, from an austere, monastic belief emphasizing introspection, meditation, and charity, Buddhism became an emotional religion with rituals and esoteric practices.

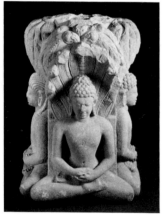

Shrine with Four Jinas, Uttar Pradesh, c. 600, S134.

Although the history of Jainism is traced a century or two before the teacher Mahavira (active sixth century B.C.), he is regarded as the true founder of the faith. Like early Buddhism, Jainism also consists of two principal groups, a smaller one of monks (*yati*) and a larger group of lay disciples (*śrāvaka*). Extreme pacifism is common to both. Whereas Jain monks dispense with all acts of worship and lead a life of complete abstinence and continence, lay followers must visit a temple and worship images of their teachers. Indeed, while a temple visit is obligatory for Jains, it is voluntary for both Hindus and Buddhists. This insistence on public worship may be one reason for the greater antiquity of temple building among Jains. The primary objects of worship in the Jain religion are representations of the twenty-four Jinas. A host of gods and goddesses subservient to the Jinas are also included in the pantheon. Images of these subsidiary divinities are used profusely to adorn Jain temples. Like Buddhists, Jains underwent a schism in the first century and were divided into Svetambaras, "those who put on white clothes," and Digambaras, "sky-robed," or naked. The principal difference between the two that is pertinent for us is the fact that Digambaras portray their Jinas as naked, while Svetambaras not only clothe, but occasionally adorn their images with ornaments and crowns.

Just as there were many conceptual similarities and adaptations among the three major religions, so also in their ritual practices. Most stone images and reliefs in the collection once embellished temple walls and served didactic purposes. They were not the recipients of offerings as is a central image installed in a sanctum. Hindus express their devotion at home and in a temple by ritually enacting their daily routine. Thus, each day the deity is bathed, dressed, and fed in the morning; allowed a siesta in the afternoon; entertained with music and dance in

the evening; fed once more and put to sleep. On special occasions substitute images are taken out in procession from one temple to another or from one town to another as a part of annual rites of visitation and renewal. The sprinkling of water and unguents, rubbing with clarified butter and colored powders, such as vermilion, and offering of flowers and incense are as much a part of Hindu ritual as they are of the Buddhist and Jain. Jains, too, wash their images and apply sandlepaste, offer them food, fan them with flywhisks, and entertain them with music.

The association of animals and trees with the various deities is a standard feature of Indian iconography common to all three religious systems. Such associations point to the survivals of early forms of animism and nature cults, and some gods may have been represented theriomorphically before they were depicted anthropomorphically. Thus, Siva came to be associated with the bull; Vishnu, with Garuda, a mythical creature that is half-human, half-avian; and the Goddess, with the lion. These animals also help identify the figures and are especially important for recognizing the Jinas. Indeed, but for their trees and animals, the Jinas are often indistinguishable from one another. Trees continue to be sacred, and in almost every Indian village one or more trees are set aside as religious shrines. In the Buddhist pantheon the earliest images of the Buddha emphasize his association with the bodhi tree quite unambiguously. Later some bodhisattvas and the transcendental Buddhas like divinities in the Hindu and Jain pantheons, were given animal mounts.

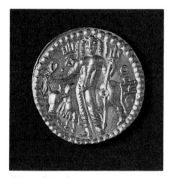

Dinar of Vasudeva I (r. c. 142–76), C13b reverse.

While in Kushan art and coins Siva was frequently represented with the bull known as Nandi, Vasudeva, or Vishnu, and the Goddess were rarely portrayed with their animals. By the Gupta period, however, the lion was included in images of the Goddess with some regularity, but Garuda was not found in standard Vishnu icons. Indeed, the iconography of the various deities is described with considerable fluidity during the Kushan period. Notwithstanding the absence of Vasudeva, or Vishnu, in the early coins, artistic evidence indicates that by the second century A.D. both Vishnuism and Sivaism had become the most important Hindu religious systems, certainly around Mathura. Buddhism appears in the northwest to have been the major religious force, although Siva is represented on coins as the principal Indian deity favored by the Kushan dynasty and many tribes in the Panjab. Vishnuism rapidly gained popularity during the Gupta period, when Vishnu became the patron deity of the emperors. In fact, all three religions flourished in Mathura during the Kushan and Gupta periods. As in the northwest, Buddhist communities also prospered throughout the extensive Satavahana Empire and Ikshvaku kingdom in present-day Andhra Pradesh. Although Hinduism may have gained an edge over Buddhism and Jainism, both continued to thrive all over the subcontinent during the Gupta period.

Notwithstanding the desire to earn religious merit to gain ultimate release from the chain of rebirth, the concern of the average person then, as it is still today, was to ensure a life of material prosperity and good health for the individual and family. Thus, the local cults of fertility deities, protective spirits, and tutelary divinities of wealth and abundance remained popular. Visible manifestations of these divine entities are the numerous terra-cotta figures of astonishing variety that are a distinct strength of the museum's collection. Some may have been intended for domestic shrines, others were used as votive offerings in local shrines in villages and cities, still others were thrown into rivers and tanks, while some were buried in the ground to increase the fertility of the land. Most such goddesses continue to be

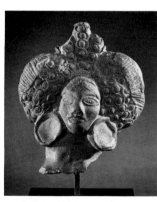

Head of a Goddess, Mathura, third century B.C., S9.

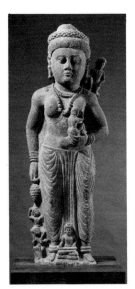

A Goddess with Children, Swat Valley, c. 250–300, S50.

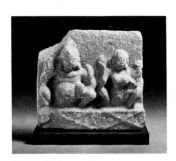

The God Kubera and Spouse, Mathura, second century, S64.

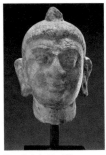

Head of the Buddha, Mathura, second century, S61.

implored and appeased for making barren women fertile, protection at childbirth, prevention and cure of diseases, and ensuring the welfare of the family and home in general. Most such deities remain nameless, but some, such as Sri-Lakshmi and Hariti among the goddesses, and Kubera, Panchika, and Kumara among the gods, became important cult figures by the Kushan period.

Although Sri-Lakshmi is a frequently depicted figure in early Buddhist art, the cult of Hariti enjoyed great popularity in the northwestern region of the subcontinent particularly during the Kushan and Gupta periods. She apparently was an ogress, who at one time devoured children but was converted by the Buddha to become a protective deity. She basically was no different from many other such goddesses who populated the folk pantheon and were adopted by Buddhists, although very likely she was feared and appeased by the population in general. Another such figure, known as Jara, was worshiped in every home in ancient Bihar, as is known from the *Mahabharata*. In Gandhara Hariti was associated with the male consort Panchika, a general of Kubera. In point of fact, however, his representation does not differ from that of his overlord.

The cult of Kubera, like that of Sri-Lakshmi, is very ancient, and he is adored by Hindus, Buddhists, and Jains alike. Before being adopted universally as the god of wealth, he was the king of yakshas. He also came to be regarded as the guardian of the North, the supposed location of his fabulous city. As a guardian he was given a spear, which he carries frequently in Gandharan and Kushan representations found in Mathura. In Gupta-period and later art the spear is not as indispensable as his bag of jewels or mongoose disgorging gems. His yaksha origins led to his portrayal as a potbellied figure in the art of Mathura, and this representation, rather than the well-proportioned Gandharan figure, remained popular with later artists. Like several other yakshas, Kubera came to be associated with the family of Siva rather than Vishnu. In Kushan Mathura he is frequently associated with Sri-Lakshmi, goddess of wealth, but later his spouse came to be called Riddhi, goddess of prosperity, while Sri-Lakshmi became the spouse of Vishnu. The god of wealth curiously was not represented on any coin of the period.

Another Hindu deity who also came to be included in the Saiva group but was of independent origin is Kumara, known variously as Skanda, or Karttikeya. Like most other major Hindu gods, Kumara has a varied and complex past and became a composite figure not much before the Gupta period. Even on Kushan coins two separate personalities are encountered; they were merged later into the syncretistic deity known as Kumara. Various gods and spirits performing related functions were assimilated into one major divinity. In antiquity Kumara and his host were malevolent spirits who had to be constantly appeased to protect children. By the Kushan period Kumara, also known as Subrahmanya, was the tutelary deity of the Yaudheyas, a militant tribe from northwestern India famous for their fighting ability. Kumara was adopted as the divine general in the *Mahabharata*, and an elaborate myth was developed that emphasized his connection with both Agni, Vedic god of fire, and Siva. His role as protector of children was not forgotten, however, as the myth provided him with six mothers to nurse him when he was born. From the Yaudheya territories in the Panjab the cult of Kumara spread rapidly across northern India during the Kushan and Gupta periods. Some Gupta monarchs were ardent devotees of this god. In post-Gupta India his cult enjoyed greater popularity in the south than in the north.

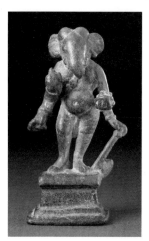

The God Ganesa, Kashmir, seventh century, S106.

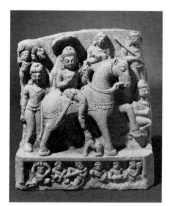

The God Revanta and Companions, Sarnath area, early seventh century, S132.

The Hindu god Ganesa (lord of the tribe, or people), like Sri-Lakshmi, has remained popular with followers of all three religions and in all countries where Indian religions have spread. He has a human body, elephant head (his most distinguishing feature), and, like the yakshas, a potbelly. Ganesa generally is adored for removing obstacles and bestowing prosperity. The word *gana* denotes Siva's dwarf attendants, and thus Ganesa is regarded specifically as the leader of the *ganas*. Like Kumara, he came to be regarded as a son of Siva and Parvati. His origins are obscure, but his elephant head may refer to a tribal or totemic past. In any event, his cult was not unknown in the Kushan period but seems to have gathered momentum during the Gupta age. In developed Hinduism he is especially important: all Hindu worship as well as all secular enterprises, such as a journey or commercial transaction, must begin by invoking this benign and auspicious deity. A small shrine to Ganesa is included in every Hindu temple, whether dedicated to Siva, Vishnu, or the Goddess, and the devout are obliged to visit it before entering the principal sanctum.

Finally, a few words should be said about a little-known deity whose cult may have begun in the Gupta period. The name of the god is Revanta, and the collection contains what may be his earliest representation in Indian art (S132). He is included in at least two Gupta-period texts and is associated with the sun god, Surya.[29] Revanta wears Surya's Scythian costume and rides a horse. He is shown principally as a hunter-god, for which there is no precedent in India. Interestingly, he appears to have been the patron deity of horse traders, most of whom came from eastern Iran and Afghanistan. There is a tradition in India that a form of sun worship was introduced into the northwest of the subcontinent from Iran during the Kushan period, which is why in north Indian images Revanta wears foreign dress. Perhaps because of their similarity in attire Revanta and Surya were associated.

More likely Revanta's image as a hunter is an adaptation by Indians of the hunter-king, who figures prominently in Sasanian metalwork. Not simply secular images illustrating the prowess of the Sasanian monarchs, these hunting scenes also held religious significance.[30] Gupta monarchs selected the theme of the hunter-king for their coins, which may have been inspired by the importance given to this motif in Sasanian art. In India so significant a motif could easily acquire further religious overtones. It is otherwise difficult to explain the sudden emergence or adoption of the motif in Gupta coins and religious art. The iconography of the Iranian god Mitra, wearing Central Asian costume and Phrygian cap, may also have contributed to representations of Revanta. Certainly in the museum's relief his attendants wear Phrygian caps as do some of Surya's companions in Gupta-period reliefs.[31]

Image and Idea

Greco-Roman influences notwithstanding, the basic principles underlying the forms of Indian gods are notably different. While the Greek idealization involved the perfecting of the human body without sacrificing naturalism, the Indian aesthetic preferred an ideal form combining a greater degree of abstraction with the rhythms of nature. The Amazonian goddess of Kushan Mathura (S54) retains the essential features of a human being, but her body is not merely an aggregate of sinews and muscles, however idealized, but a mass of curves and swelling volumes imbued with the same spirit that animates the tree climbing up her back. Indeed, by integrating the tree with her body, the artist has literally as well as figuratively depicted the goddess as symbolizing nature. She is the fruit-bearing tree, whose plenitude is essential for the sustenance of living creatures. Appropriately, in Sanskrit literature the beautiful woman is frequently said to bend slightly from the weight of her large breasts just as the branch of a tree is overweighed by its ripe fruit. Her breasts are also compared with full jars containing water, which is essential for life. Pots filled with water are obligatory in all Indian rituals, both sacred and secular, and sighting a beautiful woman (*divyanārī*) and a full jar (*purṇakumbha*) before undertaking a journey are considered equally auspicious. A synonym used frequently in Sanskrit literature to denote the female breast is *payodhara* meaning "container for milk" (the word cannot be applied to male breasts). Milk nourishes life and is considered the food par excellence for both the ascetic and the god.

Thus, whether representing a mortal or divinity, the two elements of the female form that always have been emphasized, at times even exaggerated, are the hips and breasts, whether the representation is a highly abstracted terra-cotta figure or a curvaceous goddess made of stone or bronze. The persistence of such features in an otherwise changing world of varying tastes and styles provides stability and constancy to sacred imagery. The mundane world is one of constant flux, but the realm of the divine is subject to neither the tyranny of time nor inevitability of death.

In Indian mythology and art the gods are conceived as "immortal adolescents," to use an expression of Christopher Fry's. Few divinities are ever portrayed as old or decrepit. Only Brahma and Agni and more rarely the sage-god Narayana in the Hindu pantheon are depicted with beards to suit their role as elder statesmen. Even the ascetic Siva invariably is a youthful figure of undetermined age. Almost all other divinities, whether Hindu, Buddhist, or Jain,

male or female, are represented as eternally youthful and are described as being sixteen years old. Jinas, whether or not they were historical personages, are ageless as is the Buddha, who, even in depictions of his death, is shown as a young man, although he is known to have reached the ripe old age of eighty. Although the historical Buddha assumed a corporeal body for his last earthly existence, by achieving nirvana he transcended both old age and death. Moreover, the sacred image symbolizes the idea or essence of Buddhahood rather than the Buddha himself.

When confronted with the task of creating the image of the Buddha, unlike his counterpart in Gandhara, who turned to the Greco-Roman model of the god Apollo, the unknown artist of Mathura conceived the Buddha as an ideal yogi with matted hair and seminaked body seated in the classical posture of meditation on a lion throne under a tree (S58). Two different concepts were combined in this image, that of a yogi and a monarch. All divine images in India are modeled after either a yogi or a king or a combination of the two.

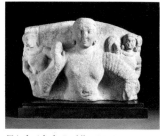

Triad with the Buddha, Mathura, 100, S58.

The antiquity of yoga as a spiritual discipline is uncertain, but figures seated in the classic posture of a meditating yogi appear on Indus Valley seals as early as the third millennium B.C. As some of these figures seem to be receiving homage, it is generally assumed that they represent gods. In subsequent Indian art, however, the image of the yogi does not occur until almost the birth of Christ. Among the countless terra-cotta figures of the pre-Christian period, few images of a yogi are found. The colossal figures of yakshas, which are often cited as prototypes for later Hindu and Buddhist images, were not modeled after the yogi. By the first century of the Christian era, however, certainly the Hindu gods Siva, Brahma, and Agni as well as the Buddhas and Jinas were conceived primarily as yogis or ascetics with matted hair and smooth, supple, relaxed bodies. While in Gandhara sculptors under Greco-Roman influence emphasized the taut, tense, articulated muscles of the body, whether in sculptures of the Buddha or representations on coins of the god Siva, in other centers of Indian art we meet with a far more abstracted, simplified body with flexible, plantlike limbs characteristic of a serious practitioner of yoga. Through physical and mental discipline, the practitioner of yoga aims to attain control over the mind and body, and, hence, the ideal yogi was considered an appropriate model for the gods. The sculptor's task was not easy, for through form he had to express the formless. The *Īśa Upanishad* states: "He [the Self] encircled all, bright, incorporeal, scatheless, without muscles, pure, untouched by evil."[32]

At the same time and somewhat paradoxically, ascetic figures are adorned with various jewels and ornaments. Often the gods, like the Buddha, sit or stand on lion thrones. Some gods, such as Vishnu and Surya, the bodhisattvas, the Buddha himself, and some Jinas are crowned with diadems and tiaras. These regal symbols were first associated with divine images only from the Kushan period. In earlier Indian art as, for example, at Bharhut, the divine yakshas and mortal kings wear turbans, and the turban embellished with gems remained the basic headdress of royalty in India until recent times. The Indo-Greek kings are generally shown wearing helmets or filleted diadems but not tiaras or crowns. While the Kushan monarchs are depicted on their coins wearing tall, peaked headgears, which may represent some sort of crown, the Satavahana and Gupta kings were never portrayed with diadems or tiaras. Rarely are later Indian kings depicted with crowns, except the Pallavas in southern India, who may have been of foreign origin. In mythology the king of the gods, Indra, is described

as wearing a tall crown. Thus, it seems that, like the lion throne, the crown was introduced from West Asia, where it was customary for diademed monarchs to sit on such thrones. Tiaras are frequently given to female deities of all three religions.

Although the Kushan monarchs were first to establish some sort of royal cult brazenly emphasizing their divinity by adding halos to their portraits on coins, the close association of religious ritual and royal symbolism is an important feature of Vedic sacrifices. Similarities abound between the royal consecration ceremony and the lustration of images in Hindu, Buddhist, and Jain rituals. For instance, forms of consecration (*abhisheka*) involve similar rites with water, while the flywhisk and parasol, the two most visible and indispensable emblems of royalty, are equally important for the worship of images. Texts on aesthetics repeatedly emphasize that kings should be depicted as gods with similar proportions. Like the gods, royal images should display the same signs of the superhuman being (*mahāpurushalakshaṇa*). The *Chitrasutra*, for instance, tells us that "universal monarchs are to be portrayed with webbed fingers and toes. The auspicious curl of hair between the brows is to be shown in its place."[33] These are also signs distinguishing a Buddha. The text further informs us that like kings, gods should have hair only on their heads, eyelashes, and brows; no hair should be shown on any other part of the body. Followed literally by sculptors and painters, such instructions account for the smooth limbs and chests of male figures. Moreover, the countenance of the gods should always be effulgent, and they should be adorned with diadems, earrings, necklaces, armlets, and bracelets exactly as a king is ornamented.

Precise instructions are also provided for the representations of women, whether mortal or celestial. In general, like men, they are divided into five ideal types each with different proportions. The height of the female is adjusted according to that of the corresponding male category. In each category the female should never be taller than the height of the male's shoulder. Her waist should be narrower by two units, and her hips should be wider than the male's by the same measurement. Yakshis and courtesans are given the same proportions and are to be "attired in flamboyant dress that is most appropriate for the erotic mood."[34] The early yakshis from Mathura (see S70) brazenly exhibit their erotic charms.

In Kushan Mathura a number of sculptures was commissioned by courtesans, and throughout the period courtesans were very influential in society.[35] Literature also informs us that artists and courtesans lived in the same part of the city, which may have proved to be an advantage in providing sculptors with beautiful models. Moreover, in large cities many courtesans came from different parts of the country and abroad, including girls from Iran and Bactria. Foreign female courtesans and male traders may well have been the models for the exotic figures that appear frequently in the terra-cottas of the period (see S78a–f). Idealized as are the sculptured forms, they nevertheless reveal an understanding of the human body that could not have been the result simply of imagination or cerebration but must have been based upon close observation. The sculptures exhibit such an astonishing variety of hairstyles and ornaments that it would have been impossible for artists to have invented them all—unless they were also imaginative hairdressers or jewelers. In most such details and even with regard to "the outward form" of divine images, the texts clearly enjoin the artist to follow the prevalent custom of the region or the country.[36] And where else but in his own neighborhood among courtesans and temple dancers could the sculptor have seen so many beautiful women adorned with exquisite ornaments and elaborate coiffures?

Dinar of Samudragupta (r. c. 335–76), C27c reverse.

Human Heads, Kausambi, third century, S78a, d.

In India there has always been a close relationship between dance and the visual arts. Not only are gods and celestial nymphs often depicted dancing, but even when the figures stand at ease they seem to strike a graceful dancer's pose. The hand gestures represented in sculptures and paintings, although ritually significant, are the same as those used by dancers to communicate ideas and emotions. Indeed, no other tradition has united the arts of sculpture and dance so joyously and with such confidence as has the Indian. Again, how could an artist confined to his atelier have depicted the various postures and gestures of the dance so skillfully had he not been well informed in the art and if he had not had the opportunity to observe the finest dancers, who, in fact, were the courtesans and the temple dancers? Nor could he create such exuberant and lively forms simply by following textual guidance. As the greatest Sanskrit poet, Kalidasa (active fifth century), sarcastically asks:

Who was the artificer at her creation?
. . .

That ancient saint there, sitting in his trance,
Bemused by prayers and dull theology
Cares not for beauty: How could he create
Such loveliness, the old religious fool?[37]

That the Indian artists were expected to know the movements of the dance is evident from the *Chitrasutra*, included in the *Vishnudharmottarapurana*. This text on the visual arts forms part of an entire section devoted to dance, drama, and rhetoric, all of which are said to be interrelated. In the opening passages on the visual arts, the sage Markandeya categorically tells the curious monarch that he must first learn the art of dancing before he can be instructed in the arts of painting and sculpture.[38] Both the dance and the visual arts are representational, imitative of the objects in the three worlds (*trailokyānukṛiti*), and hence, the various moods, gestures, and postures depicted in dance also form part of the artist's repertoire. Since dance appears to have played a greater role in sculpture than in painting we must assume that the sculptor, even more than the painter, was expected to, and in fact did, familiarize himself thoroughly with this artistic form.

Although the various arts assume different expressions, underlying all of them is the common aesthetic concept of *rasa*. The word *rasa* is difficult to translate into English, but the closest equivalent is "flavor" or "taste." Just as every edible object has its distinctive flavor or taste, so also each sculpture or painting, each poem or song, has its own *rasa*, which in the aesthetic context seems to imply mood. The moods generally are derived from the basic human emotions (*bhāva*) and roughly bear the same names, such as "the erotic, the comic, the compassionate, the cruel, the heroic, the terrifying, the horrid [or loathsome], the marvelous, and the peaceful." There are differences, however, between mood and emotion, an understanding of which is fundamental to the aesthetic experience. As noted by the eminent Sanskrit scholar Daniel Ingalls:

An emotion is seldom pure or sustained and the emotions which contaminate it, since they depend on circumstances beyond our control, are seldom aesthetically harmonious. Our bursts of energy are mixed with anger and fear; our sexual excitement is interrupted, frustrated,

forgotten, and then resumed. A mood, on the other hand, since it is created by an artist, may be purified and sustained and can be combined with other moods in an artistic fashion. Again, the emotion is personal whereas the mood is universal. When Rāma loses Sītā in real life his emotion is one of personal loss. But when this happens in Vālmīki's poem or Bhavabhūti's play, the mood embraces all men and nature as well.[39]

Or, as Ananda K. Coomaraswamy stated:

A work of art expresses moods (bhāva), *which may be "transient" or "permanent": the work as a whole must be characterized by a permanent mood to which the transient moods are subordinate. . . . A work of art is a statement "informed by rasa": its ultimate value depends on the blissful experience of beauty and not on the knowledge which may be gained from it.*[40]

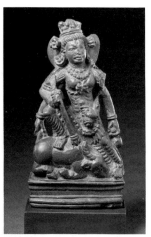

The Goddess Durga Killing the Buffalo Demon, Kashmir, seventh century, S105.

It is the expression of the universal mood rather than the transient emotion that was the primary concern of the Indian artist. Just as there are rules in poetry and conventions in dance and drama for depicting moods by combining various emotions, so also in the visual arts precise instructions govern the expression of these moods. In an image of Durga (S105) the goddess primarily expresses the heroic *rasa* by destroying the buffalo demon. At the same time, however, her opulent form conveys the erotic mood, whereas her calm demeanor expresses the peaceful *rasa.* Buddhas and Jinas are classic examples of the combination of the *rasas* known as the compassionate and the peaceful. The heroic and the terrifying are combined in representations of the wrathful aspects of divine nature when the gods are engaged in destroying the forces of evil. These moods are expressed chiefly through militant postures and exaggerated movements of eyebrows and rolling eyes. The texts also emphasize that subjects solely expressing the erotic, comic, and peaceful can be depicted in residential buildings; only in the temples of the gods and in public areas of the palace, such as the audience hall, can all nine moods be portrayed.[41]

The two most popular *rasas* depicted in Indian art in general are the erotic and the peaceful. Despite the fact that Indian artists devised an idealized and abstracted formula based on strict mathematical proportions to represent form and no matter how lofty and spiritual the purpose of the sculpture, the sensuous appeal of the human body was never ignored. In all works of Indian aesthetics it is repeatedly stressed that the most fundamental *rasa* is the erotic. Love is the absorbing theme of Sanskrit poetry and drama, and among the nine *rasas* the erotic has received the greatest attention in the literature on aesthetics. Thus, the erotic flavors all Indian art, whether religious or secular, and it would be inconceivable for an Indian artist to ignore so basic a part of human nature. Artists seem to have known instinctively that "the amount of erotic content a work of art can hold in solution is very high."[42] The second-century poet Asvaghosha did not hesitate to write the following passage in his biography of the Buddha. The scene describes the temptation of the Buddha by beautiful women in the pleasure grove:

Another {woman} repeatedly let her blue garments slip down under the pretext of intoxication, and with her girdle partly seen she seemed like the night with the lightning flashing. Some walked up and down so as to make their golden zones twinkle and displayed to him their hips veiled by diaphanous robes. Others grasped mango-boughs in full flower and leaned so as to display bosoms like golden jars.[43]

The female forms conceived by sculptors at Sanchi and Mathura as well as the contemporary poetry of the Kushan-Satavahana period abundantly exemplify the primary importance of the erotic mood.

Tranquility, or the peaceful, is yet another mood of paramount importance, especially in the creation of divine images. Most sculptures, except when expressing the heroic or the terrifying, exude a soothing serenity. Even in scenes of heroism involving death, the horrid is downplayed, as in the reliefs showing Durga's victory over the buffalo demon (S72) or Vishnu rescuing the earth goddess (S75), where each displays unruffled confidence. The effect of Narasimha's scowling face (S129) expressing fear and anger is made less severe by the intentional distortion and decorous elegance of the two attendant figures. By and large, however, most figures seem to combine two moods: the erotic and the peaceful.

Another *rasa* that the sculptor often indulged in by selecting appropriate subjects or resorting to distortions is that known as the comic. Not surprisingly many secular terra-cottas were meant to express beauty and amuse the viewer. The unusual elongation of the toy dog (S19) may well have been one such example. According to the *Chitrasutra* subjects meant to excite laughter should be deformed, like hunchbacks or dwarfs, and the mood should also be expressed through comically awkward gestures and postures. Dwarfs were often introduced in relief sculpture not only to emphasize by contrast the radiant beauty of the principal figures but also to add a comic element. Thus, in a terra-cotta plaque of a dancer, her subservient companion is intentionally made a diminutive figure (S24). The dwarf drummer of the Gupta period (S128) is obviously a merry fellow, and the distortion of his form as well as his expression clearly make him amusing. Siva's attendants, known as *ganas*, are often among the most whimsical figures in Indian sculpture. Interestingly, artists were quite free to depict them as they chose, for the texts clearly state that Siva's attendants—as well as ghosts, goblins, dwarfs, and hunchbacks—may be represented regardless of proportions.

Otherwise, correct proportions were a desideratum for figures of mortals and immortals. Five different sets of proportions were devised for the male and female figure. Like the Greeks, the Indians believed that "beauty does not consist in the elements but in the harmonious proportion of the parts . . . of all parts to all others."[44] Most texts constantly assert that to be beautiful images must conform to prescribed lineaments and proportions. "There are some to whom that which captivates their heart is lovely. But for those who know, that which falls short of canonical proportion is not beautiful."[45] By the Kushan period Indian sculptors likely had been influenced by Greek theories of proportion. Although most important iconographic manuals cite in great detail various theories of proportion, these are yet to be tested thoroughly against existing sculptures. Such studies greatly would contribute in determining how far differences in canons of proportion influenced stylistic variation in space and time. As the art historian Erwin Panofsky stated:

Not only is it important to know whether particular artists or periods of art did or did not tend to adhere to a system of proportions, but the how of their mode of treatment is of real significance. For it would be a mistake to assume that theories of proportions per se *are constantly one and the same.*[46]

Indeed, the sculptures here illustrated clearly reveal the degree to which stylistic differences between two schools, such as Mathura and Gandhara in the same

Toy Dog, Bihar (?), c. 200 B.C., S19.

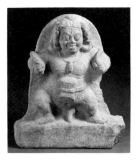

A Dwarf Drummer, Uttar or Madhya Pradesh, c. 500, S128.

period, or two periods of the same school must have been due largely to different theories of proportion. The stylistic variations between contemporaneous heads of the Buddha from Mathura and Sarnath (S119, S126) may be attributed in large measure to the distinct canons of proportion current in the two centers.

The great diversity of styles encountered in Indian sculpture indicate that notably different canons of proportion were in use in different regions. Although sculptors probably were expected to adhere to certain basic principles, they otherwise enjoyed considerable freedom. After describing at length the prescribed proportions for the *haṁsa* (gander) type of male to be used only for kings and gods, the *Chitrasutra* states, "For the rest of the princely figures, the measurements have to be provided by an intelligent understanding on the lines indicated and *from one's own experience*" (italics added).[47] The artist is specifically told to study the differences in features, complexions, ornaments, and dress from one region to another and where necessary to create proportions by his own genius.[48] Not only is the individuality of the artist acknowledged, a fact all too easily forgotten in the Indian context because little or nothing is known about him, but the differences in the forms of the gods and mortals are justified explicitly.

To emphasize the distinction Indian artists also invented other concepts. Gods, as well as asuras (superhuman, demonic creatures), were often provided with multiple limbs and heads to indicate their various functions and cosmic natures. They were most commonly given four arms or four heads, probably to symbolize the four directions. Early stone and terra-cotta images of yakshas, gods, and goddesses of the pre-Christian period do not display such supramundane appendages. Neither did Buddhists nor Jains adopt such means to emphasize the divinity of their deified teachers, although they did accept the idea of expressing the cosmic nature of their gods by representing them with multiple heads and limbs. The earliest instance of the use of multiple limbs cannot be dated earlier than the Kushan period.

Siva appears with four arms on Kushan coinage, while Vasudeva, or Vishnu, Balarama, and Durga were frequently given four arms in contemporary Mathura sculptures. Late-Kushan-period image of the Goddess display six instead of four arms (S72). In a few late-Kushan coins Siva seems to be tricephalic. On some Indus Valley seals are represented apparently meditating figures, which are said to be tricephalic, but this is by no means certain.[49] Curiously, three-headed figures and the cross-legged posture appear also in Celtic art in the early centuries of the Christian era in Europe, although there exists no evidence of a direct connection with contemporary Indian art. Both the Celtic and Indian civilizations share an Indo-European past, and it is likely that the practice of displaying the cosmic nature of the gods with multiple heads and limbs was inspired by the Vedic conceptual figure of Purusha, who is generally described in hyperbolic terms as possessing one thousand heads, eyes, arms, and legs. Thousand eyed (*sahasrākṣa*) is also a common epithet for the Vedic gods Indra, Rudra, and Agni. Although these deities were not represented in art at the time the Vedic culture flourished, the anthropomorphic descriptions composed by the Vedic seers influenced later Hindu theologians and artists during the Kushan period when it became necessary to give form to the gods. Thus, multiplicity of limbs is one feature not borrowed by the Kushan artist from either Greek iconography or earlier indigenous artistic tradition. Rather, the concept established a link between the cosmic gods of later Hinduism with the visions of the ancient Vedic seers.

Symbols and Myths

*In the art of India, every form is the symbol of a clear and
conscious thought and of consciously directed feeling. Nothing
is arbitrary or peculiar, nothing is vague or mysterious, for the
very* raison d'être *of all the imagery is to present concrete
ideas in comprehensible and easily apprehended forms.*[50]

In these two lucid sentences Coomaraswamy expressed with brevity and precision
the essentially symbolic nature of Indian art, especially sculpture. Representational
though it is and its own brand of naturalism notwithstanding, the content of Indian
sculpture is highly symbolic. Symbolic meaning is encapsulated in each detail of an
image, including the various emblems and symbols, whether attributes or gestures.
Every symbol is multivalent, and every myth is recounted in several texts in various
redactions. Moreover, a sculptural representation cannot be easily related to a
specific version of a myth.

The lotus is by far the most ubiquitous symbol in Indian art. By the
second century B.C. the lotus was not only the support of the goddess Sri-Lakshmi,
but it was also her principal attribute. By the second century A.D. the lotus had
become a seat for the image of the Buddha. His hagiographers inform us that as soon
as the Buddha was born he took seven steps to announce his spiritual sovereignty
over the earth. The seven steps are represented in art by seven lotuses. By the Gupta
period the lotus had become the principal support for most deities of all three
religious systems, and in many instances it is also the principal decorative motif on
their halos. Moreover, the lotus also came to be held by the sun god, Surya, and
Vishnu, the Buddhist Avalokitesvara and Tara, and several Jain deities.

Considered the most beautiful flower in India, the lotus not
surprisingly plays a special role in divine worship. It is unquestionably the most
frequently used metaphor for beauty, and Sri-Lakshmi herself is described variously
as lotus eyed, lotus thighed, lotus faced, or lotus complexioned. The feet of the
gods, gurus, and all other persons worthy of veneration are constantly referred to as
lotus feet. The hands are characterized as lotus hands, while the heart of the devotee,
wherein the god dwells, is the lotus heart.

The lotus (see S56a) was chosen as the flower par excellence by the
ancient Indians for at least two reasons related to its physical properties. The lotus
grows in the mud and is yet untouched by it, nor is the flower or leaf wetted by the
water on which it rests. Thus, the lotus is a metaphor for purity and hence of a man
of wisdom who lives in the world but remains untouched by its snares and sorrows.
The Buddha himself used the analogy to describe an enlightened being:

Crossbar, Mathura, first–second
century, S56a.

39

Just as, Brethren, a lotus, born in the water, full-grown in the water, rises to the surface and is not wetted by the water, even so, Brethren, the Tathāgata, born in the world, full-grown in the world, surpasses the world, and is unaffected by the world.[51]

Moreover, the lotus blooms daily with the rising of the sun and closes its petals each evening. Thus, it not only symbolizes the endless cycle of life and death but by extension the cosmic cycle of the birth and dissolution of the universe. It was therefore natural to select it as the iconographic attribute of the sun god. His two lotuses symbolize the upper (*para*) and nether (*apara*) waters, "representing respectively the possibilities of existence 'above' or 'below,' in yonder world and this world, Heaven and Earth."[52] This also explains why many of the gods from the Gupta period on, but especially the Buddhas and Jinas, are given a lotus halo behind their heads as well as a lotus support below their feet. As Coomaraswamy brilliantly observed, one symbolizes heaven and the other earth, "the two flowers, one behind the 'head' and the other beneath the 'feet,' and each a reflection of the other, representing the 'grounds' . . . of existence *in extenso* . . . between them."[53] This clearly is suggested by the following passage from an ancient Vedic text: "Fire is verily the lotus of this Earth, the Sun the lotus of yonder Sky."[54]

At another level the lotus represents earth and water, and thus, it is an appropriate receptacle for and attribute of Sri-Lakshmi, the earth mother personifying all possibilites of existence and abundance. She is described as *padmavāsinī* (dweller in the lotus) and *pushṭidā* (provider of nourishment). A frequently used Sanskrit word for the lotus is *pushkara*, which has the same root as the word *pushṭi* meaning "nourishment." The word *pushṭi* is also a synonym for Sri-Lakshmi. Furthermore, Sri-Lakshmi is shown in early Indian art (see S17) being bathed by elephants symbolizing the sky, which showers rain, thereby fertilizing the earth represented by the goddess herself and the lotus on which she stands. This act is a kind of conception and similar to that of Mayadevi, mother of the Buddha, who dreamed that the future emancipator had entered her womb as a white elephant. Immediately after his birth the infant and his mother were bathed by two nagas (the word *nāga* in Sanskrit means "serpent" or "elephant").

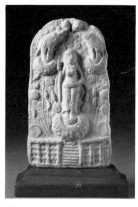

The Lustration of Sri-Lakshmi, Kausambi (?), first century B.C., S17.

The lotus also symbolizes the firmament, or middle space (*antarīksha*), which is one reason why the gods are frequently placed on lotuses. The idea is expressed first in the *Rigveda* in connection with the births of the fire god, Agni, and sage Vasishtha, which the gods are said to have watched while seated on lotuses. This idea was later adapted when the creator-god, Brahma, was shown seated on a lotus springing from the navel of Vishnu, or Narayana, while he reclined on a couch of serpents floating in the cosmic waters. Vishnu's navel is the center of the universe, and the navel of the world form of Prajapati (an appellation of the Supreme Being) is said to be the firmament. Once again, to quote Coomaraswamy, "All birth, all coming into existence, is in fact a 'being established in the Waters' and to be 'established' is to stand on any ground (pṛithīvi) or platform of existence; he who stands or sits upon the Lotus 'lives.'"[55]

Even from very early times the lotus has remained the metaphor without parallel for the devotee's heart (*hṛid-pushkara*; *hṛid-padma*), the primary abode of the deity. This lotus heart is further likened to space (*ākāśa*): its eight petals representing the four directions and four intermediate points of the compass. The eight-petaled lotus is basic to the drawings called mandalas, which later came to

play an important role in all three religions. One of the earliest uses of the lotus with this symbolic meaning is represented in the ceilings of the Gupta-period Buddhist cave temples at Ajanta. Significantly, tantric spiritual praxis requires the practitioner to pass through several stages or processes of cosmogenesis, the final plane located at the summit of the skull being known as lotus head (*ushṇīsha kamala*) to the Buddhists and thousand-petaled lotus (*sahasrāra padma* or chakra) to the Hindus. A very early representation of this idea occurs on a midsixth-century Narasimha (S129), where a lotus grows out of the god's head.

The significance of the lotus as a divine attribute held in the hand can vary according to who is holding it. The reason the lotus is the major attribute of the sun god has already been explained. That it should be given also to Sri-Lakshmi needs no further exegesis for the goddess is intimately associated with water and fertility. By extension, Vishnu came to hold the lotus, probably from about the fifth or sixth century. The close association of Vishnu and the lotus is evident from such epithets as Padmanābha (lotus naveled), Puṇḍarīkāksha (lotus eyed), Padmapāṇi (lotus handed), the last being also an epithet of the Buddhist savior-god Avalokitesvara. On one level the conch and lotus in Vishnu's hands signify his association with the waters as both a fertilizing agent and a cosmic symbol. The conch and lotus are among the most auspicious symbols, and by themselves are often painted on either side of the entrance to a domestic building. The lotus also symbolizes the earth and is even said to contain the universe, hence it is especially appropriate as an emblem for the divine preserver of the universe. The *Vishnudharmottara* specifically states that the lotus emerging from Vishnu's navel symbolizes the earth, while the stalk represents the cosmic mountain, Meru, the axis of the universe.[56] In Vishnu's hand it symbolizes water and in Sri-Lakshmi's hand, wealth. When Parvati holds the lotus the flower symbolizes detachment, while in Indra's hand it signifies prosperity. The flower also represents the idea of divine play. The universe and all its manifestations are often characterized as nothing but reflections of the Supreme Being's playfulness.

Buddhists may have first adopted the lotus as both a divine seat and an emblem held by a deity, a fact often overlooked by art historians. By the second century the lotus was adopted as a seat for the Buddha himself, certainly in Gandhara and probably in Mathura as well as in the Buddhist monuments of Andhra. The flower was also given to the bodhisattva Avalokitesvara long before it became an emblem of Vishnu. While the selection of the lotus as an appropriate seat for a Buddha was adapted from Vedic mythology and the early association of the flame with the Buddha is an attempt to identify him with the Vedic fire god, Agni, the reason the flower was given to Avalokitesvara as an emblem is not explained in early Mahayana texts. Avalokitesvara's concept was greatly influenced by the more ancient ideas of a solar deity. Both the sun god, Surya, and Vishnu, originally a solar god, also hold the lotus. Moreover, in early Buddhist literature the lotus is used as a metaphor for essence (*pudgala*; *puṇḍarīka*), and one of the most important and early Mahayana texts is called the *Lotus of the True Religion*, or *Lotus Sutra*. Thus, in the early Buddhist context the lotus symbolizes the faith itself and would be an appropriate attribute for Avalokitesvara. In later Buddhist iconography the lotus certainly is often used as a support for other emblems such as the thunderbolt or book, while the most widely uttered incantation associated with Avalokitesvara is *Om maṇi padme hum*, meaning "Om the jewel in the lotus hum." Thus, whether supporting the book symbolizing wisdom or knowledge, as in representations of the Buddhist deities of wisdom such as Manjusri or Prajnaparamita, or in itself

signifying enlightenment, "the lotus symbol," in the words of Heinrich Zimmer, "which originally gave birth to beings and existences in unending succession, now carries the powerful wisdom of Nirvana: the Word that puts an end to all individualized existence, whether in heaven or on earth."[57]

This discussion of the symbolism of the lotus in Indian art is by no means exhaustive, but it does highlight the multivalence of such a symbol. Many motifs are common to the arts of all three religions. In addition to the lotus, the tree, symbolizing nature itself and the cosmic pillar, and the serpent, representing fertility, chthonic power, and periodic renewal, are important to all three beliefs. Another symbol of universal significance is the wheel (see S56b), which has been been variously interpreted. In Jain art it is an auspicious symbol, associated with a particular Jina as his cognizant. Among Buddhists it is a conspicuous and frequently used symbol of the religion itself, and the Buddha is said to have set the wheel of the law (*dharmachakra*) in motion when he preached his first sermon at Sarnath near Varanasi. This use of the symbol was borrowed from the more ancient idea of chakravartin, a universal monarch, one who literally turns the wheel (chakra), presumably of a chariot, as he conquers the world. Alexander, Asoka, Kanishka, and Samudragupta are such universal monarchs. Buddha's conquests, of course, were spiritual rather than mundane. Like many other emblems in early Buddhist art, the wheel symbolizes the Buddha himself. Not only is the Buddha the mover of the wheel, but the wheel itself is the word set in motion, and the Buddha is the very embodiment of the word.

Crossbar, Mathura, first–second century, S56b.

In Hindu art the wheel is primarily associated with the god Vishnu or Vasudeva-Krishna, who uses it chiefly as a weapon. Because the wheel is often used as a metaphor for the sun in early Indian literature and because the Vedic Vishnu is considered to be a solar deity, his wheel is also generally regarded as a solar symbol. The wheel belonged to Vasudeva-Krishna of the *Mahabharata* and was used primarily as a discoid weapon.[58] Its fiery rim and enormous destructive power was considered analogous to the sun, and some mythographers claimed that it was made of the eighth part of the sun's rays as were the chief weapons of the other gods, such as the trident of Siva and spear of Kumara. In any event, although primarily a weapon in Vishnu's arsenal, the wheel also symbolizes various other abstract concepts, such as the seasons and time, both of which depend on the movement of the sun. The *Vishnudharmottara*, after stating that "the god Vishnu himself is immovable and he moves the wheel," provides at least three different explanations of the wheel. It informs us, "The sun and the moon represent Purusha and Prakriti, which are symbolized by the wheel and the mace respectively"; elsewhere, the wheel represents "the rotation of the world . . . the Wheel of the Law, the Wheel of Time and the circular path of the planets"; and thirdly, the wheel is said to signify air (*pavana*).[59] Yet in another text the wheel is "the mind, whose thoughts (like the weapon) fly swifter than the winds."[60] Thus, symbols, especially the more significant ones, are multivalent and represent many different abstractions.

The section on images in the *Vishnudharmottara* provides useful information about the symbolism of many images. With regard to Vishnu, for instance, we are told that all his features, including his ornaments and garments, have very precise symbolic meanings. His garment represents ignorance (*avidyā*), the gem (*kaustabha*) on his chest signifies pure knowledge, while his thick garland of flowers (*vanamala*) binds the world. The lotus symbolizes the entire world, the conch represents both the sky and the waters.

We are told that the plowshare of Balarama, or Samkarshana, represents time, and his club signifies death. The text also considers the Narasimha form of Vishnu as an aspect of Balarama, or Samkarshana. Furthermore, Narasimha is considered the embodiment of knowledge, who destroys ignorance when he tears at the bosom of the demon Hiranyakasipu. Ignorance or impurity is of three kinds related to body, speech, and mind, and Narasimha destroys all three. This interpretation is generally applicable to all demons destroyed by the gods. Thus, for instance, in the struggle between the goddess Durga and the buffalo demon the latter signifies ignorance or illusion. In south Indian images of Siva the god dances on the back of a dwarf symbolizing ignorance.

Many of Siva's iconographic features and attributes suggest abstract ideas and virtues. His five faces are said to represent the five elements: earth, water, fire or light, wind, and sky or ether. His two eyes are the sun and moon, while his third eye represents fire with which he periodically destroys the universe. The snake that forms his sacred cord signifies anger, which subdues the three worlds, and the tiger skin represents the variegated world of desire or craving. The crescent on his forehead symbolizes his divine power, although other explanations are also possible, while his matted locks represent Brahma, the Ultimate Being. The rosary and waterpot are emblems of his ascetic nature; the beads of his rosary also represent the letters of the Sanskrit alphabet. The lemon often carried by Siva is a symbol for creation because its seeds are the atoms that constitute the universe, an explanation curiously anticipating modern physics. The most important attribute of Siva is the trident, the three prongs of which represent the three qualities or constituents of Prakriti of the Samkhya system of philosophy. These are purity or brightness (sattva), activity or motion (rajas), and the darker impulses that oppose the two other qualities (tamas). These three together constitute the dynamic complex known as Prakriti, which, according to Samkhya, is the ultimate cause of all physical existence. The power or sakti of a god is Prakriti, although to her devotees she is beyond the dualism of Samkhya.

Indeed, the importance of Samkhya for an understanding of Indian iconography cannot be overestimated. A typical justification of image worship as offered by the *Vishnudharmottara* is as follows. When Vajra, the royal interlocutor, asks how Purusha, who is said to be void of all qualities of sense, can be represented in an image, the sage Markandeya replies:

Purusha has two natures: Prakriti or the noumenal state, which is invisible, and Vikriti or the phenomenal state, which can assume form. Only when Purusha is endowed with form can he be worshipped and meditated upon.[61]

Clearly such justifications follow the Samkhya system of metaphysics. Samkhya holds that Purusha is "simply present in the world and sees or witnesses the modifications of the world."[62] It is not determined by the world and is completely free. As to Purusha's interaction with Prakriti, Gerald Larson, an authority on Samkhya, has observed that they are "always in proximity to one another, never in actual contact." Purusha "is *in* the world but not *of* the world."[63] This also is the principal characteristic of an ideal yogi, and the interaction of Purusha and Prakriti

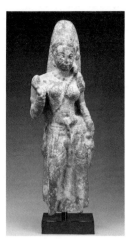

The Androgynous Form of Siva and Parvati, Mathura, second–third century, S73.

is expressed visibly in art by the image type known as Ardhanarisvara (S73, S114) in which Siva and Parvati are represented conjointly. While the image can be interpreted as expressing the nonduality or nonpolarity of the godhead or an ideal state of union between husband and wife, each representing one half of the whole, it can be interpreted also from the viewpoint of Samkhya. Although the two are shown in close proximity, each is an independent entity and cannot interact physically. Moreover, as the archetypal yogi Siva is shown in such images to have an erect penis, which signifies not his concupiscence but the highest state of yogic continence and self-control even as Parvati is depicted as a luscious female. Representing Prakriti, Parvati is the active participant, whereas the yogi, who is in this world but not of it, is merely a passive spectator.

Samkhya profoundly influenced Indian iconography in many ways, especially in its emphasis on numerology. For instance, the principal forms of the Goddess, who presides over the three sections of the *Devimahatmya*, the most important text extolling her glories, are Mahasarasvati, Mahalakshmi, and Mahakali, representing, respectively, the three constituents of Prakriti: sattva, rajas, and tamas. Hence, Mahasarasvati is white, Mahalakshmi is red or golden, and Mahakali is black, the three colors associated with the three constituents or qualities. Or again, like Purusha, Vishnu remains inert on his serpent-couch; when he does awake periodically, it is his active power (*kriyā-śakti*) or will power (*ichchhā-śakti*) that acts. Even more specifically Vaishnava theologians conceived of twenty-four emanatory forms of Vishnu, a number borrowed from Samkhya, which advocates a system of twenty-four principles (*tattvas*).

It is not surprising that Samkhya should have exerted so profound an influence on both the numerology and symbology of Hindu iconography and indirectly on Buddhist and Jain. The group of twenty-four Jinas is comparable in number to Vishnu's twenty-four emanatory forms. Indeed, the numbers three, five, ten, and eighteen are important in Buddhist iconography as well. Significantly, the emphasis on categories and numbers in the pantheons of all three religions seems to first occur during the Kushan-Gupta ages, precisely when Samkhya reached its apogee. Most important exponents of Samkhya flourished during the third to sixth centuries, and, indeed, its importance in the religious and intellectual history of the time is clearly indicated by the fact that the classic work on the system, the *Sāṁkhyakārikā* of Isvarakrishna, was translated between 557 and 569 into Chinese by the Buddhist scholar Paramartha (c. 500–570?).

Each image of a deity can be divided vertically into three sections, upper, middle, and lower, representing the heavens, midregion, and earth. Placed generally in the middle with the lotus and throne and everything below symbolizing the earth, the image of the god is, in fact, the cosmic pillar that unifies all three regions. In the case of Sri-Lakshmi (S17), the elephants showering her with rain represent the celestial sphere and continue the Vedic symbolism of Indra riding the elephant to send down rain to fertilize the earth. The analogy between the elephant and rains very likely was suggested by the animal's delight in spraying water on itself with its trunk. Apart from the lotus, the serpent, or naga, when represented below a throne or at the feet of a deity, as in the case of Varaha, signifies water or the nether world. When it forms a couch for Vishnu, the serpent represents eternity (*ananta*) or remainder (*śesha*). The serpent frequently serves as a canopy for various

deities, Buddhas, and Jinas. Moreover, while a throne carries a regal connotation, the seat also symbolizes the Vedic sacrificial altar on which oblations were offered into the fire. The Vedic altar was called *vedi*, which was the "Earth itself, where the kindling Fire, the messenger of the Gods united the Earth and the Heaven."[64] This unshakable altar, known as *vajrāsana* (adamantine seat) to Buddhists, came to be called *pīṭha* or *piṇḍika* (pedestal) by Hindus and Jains. And once again, under the influence of Samkhya, it came to symbolize Prakriti, while the image itself was a symbol of Purusha, and only when they are united is the deity established in the ensemble. By this definition a Sivalinga represents Purusha and its container or support is Prakriti. One can see how easily this idea led to the later explanation that the linga is the phallus and the support is the female organ.

A god may be represented either absolutely erect while standing with evenly placed feet (*samapada*) or seated in meditation like an ideal yogi. Early Buddhas of Kushan Mathura are invariably shown in one of these two postures. While Gupta-period Buddhas stand with a slight suggestion of movement along the vertical axis, Jains never deviated from these two modes in representing their Jinas. In classic Vishnu images the god stands in *samapada*. The image of Siva in a temple usually consists of the linga. The verticality of the image is important for several reasons. It emphasizes the symbolic nature of the image as a cosmic pillar connecting the three spheres. Here again, one can discern the influence of the Samkhya concept of Purusha, which is pure consciousness and incapable of action. Thus the seemingly inert form, motionless and unshakable, is the closest that the artist could come to representing an abstract concept that cannot be defined by the senses. Even in images of the reclining Vishnu or Buddha, the legs are frequently fully outstretched and unnaturally straight, especially if the representation is to be worshiped. Images of dancing gods are, of course, exceptions to this rule. Those depictions, which are not consecrated as icons and are intended generally for didactic purposes, can be executed in a variety of postures.

Deities often hold attributes and display various gestures (see illustration). Seated Jinas invariably demonstrate the meditation (dhyana) gesture with both hands placed in the lap one on top of the other. Standing figures place their arms along either side of the body to emphasize immobility. The meditation gesture universally is used for gods of all three religions. Common to all also are the gestures of reassurance (*abhayamudra*), with the right arm raised to the shoulder and the palm displayed outward, and charity (*varadamudra*), with the right hand hanging down and the palm facing the viewer. The gesture of charity did not become popular until the Gupta period, and most Indian deities through the Kushan age display the gesture of reassurance. Another common gesture symbolizes teaching (*vyakhyanamudra*), with the right hand at shoulder height and the palm facing outward with the index finger and thumb joining to form a circle. By the third century, if not earlier, Buddhists adapted this gesture to signify the first sermon of the Buddha, and it remained the classic gesture of wisdom in Buddhist art.

Certain trees and animals are associated with the major divinities of all three religions. While at one level, animals known as mounts or vehicles (*vāhana*) literally transport the gods, they also serve as determinants in the same way that a second symbol is added to a character in a pictographic script as in Egypt and ancient West Asia to preclude ambiguity. "Similarly," says Zimmer, "in these images of divinities the simple kingly or womanly form of the anthropomorphic figure is somewhat ambiguous; its reference becomes specified by the determinant, or parallel symbol added underneath."[65] The animals may have had earlier, sacred

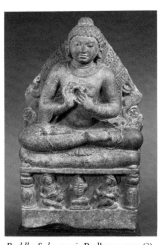

Buddha Sakyamuni, Bodhgaya area (?), 400–600, S136.

connotations separate from the gods themselves and are, in fact, their theriomorphic representations. In another sense they also emphasize the powers and characters of their respective divine masters. Thus, the elephant of Indra, the king of the gods, apart from being an appropriate royal vehicle, also reiterates Indra's might as a warrior and his role as provider of rains. Siva's bull is a symbol of his association with fertility and animals (he is known as Pasupati, "lord of animals"). The animal is also regarded as a symbol of dharma, which is characterized as four footed. The gander is the vehicle of Brahma, and one text informs us that the seven ganders that pull the god's chariot represent the seven worlds (also symbolized by the seven lotuses of the infant Buddha).⁶⁶ The gander (see S98 detail), however, is, like the lotus, a symbol of purity, as no water attaches to its back as it glides through the water, and its migratory habits make it an ideal metaphor for the free soul. Hence, all men of wisdom who have succeeded in severing the bonds of attachment are known as *paramahaṁsa* (great gander). To use one other example, Vishnu's mount is Garuda, originally a bird associated with the sun but which acquired the symbolic value of the mind, for nothing is said to be faster than the mind, an entirely appropriate mode of transportation for a preserver-deity, who constantly roams the universe.

Tile with Figures, Harwan, third–fourth century, S98 detail.

Between the third century B.C. and third century A.D. Buddhists made much use of narrative sculpture. A few fragments in the collection (see S28) provide some idea of such reliefs, and generally the subject matter consists of incidents from the life of Buddha Sakyamuni as well as didactic stories of his previous births. During the period here discussed Hindu myths depicted on temple walls generally encapsulated versions of rambling narrations incorporated in the many puranas and the *Mahabharata* and *Ramayana*. Because of the brevity of the representation and limitation of the literary source, it is never easy to precisely identify such narrative reliefs with specific versions given in the known literature. To cite only one instance, although the motif of the goddess Durga destroying the buffalo demon was frequently represented in Kushan art, the myth itself was incorporated into literature only in the Gupta period. Moreover, Kushan representations (see S72) differ significantly from all subsequent literary versions of the myth. Thus, the artistic evidence compellingly demonstrates the presence of other, earlier recensions of the myths apart from those now known. Since the early monuments through the Gupta period have crumbled, fewer Hindu narrative or didactic sculptures have survived. Furthermore, Hindus did not use their myths as enthusiastically as did Buddhists until after the seventh century. Medieval Hindu temples containing a proliferation of sculptures provide a bewildering world of myths and legends as varied and prolix as their literary versions in the epics and puranas. That story will be taken up in the next volume of this series of catalogues.

Notes

1. Majumdar 1968, p. 58.

2. For the history of the Indo-Greeks, see Narain 1980. For the general history of India, see Majumdar 1968 and Majumdar 1970.

3. For instance, Majumdar 1970, which discusses the history and culture of this period, is entitled *The Classical Age*. Chronologically it covers the period from 320 to 700.

4. See Allchin and Allchin 1982. The Daimabad bronzes (ibid., pp. 278–81) are the largest prehistoric bronzes found thus far on the subcontinent, but their dates are controversial.

5. For the classical accounts of India, see Majumdar 1960.

6. See Irwin 1973–76 and S. P. Gupta 1980.

7. V. S. Agrawala [1953] 1963a.

8. P. Shah 1961, 2: pp. 1–2.

9. Banerjea 1956.

10. See Narain 1985.

11. Mirashi 1981 and Mitra 1971.

12. R. C. Sharma 1984, p. 199.

13. Mirashi 1981.

14. Ibid., pt. 2, p. 48.

15. Fleet 1970, pp. 37–39.

16. Ibid., p. 47.

17. Ibid., pp. 52–56.

18. Ibid., p. 68.

19. Ibid., pp. 79–87.

20. P. Shah 1961, 2: p. 2.

21. Pal et al. 1984, p. 147.

22. Ibid., p. 146.

23. V. Kumari, *The Nilamata Purana* (Srinagar: J & K Academy of Art, Culture, and Languages, 1973), 2: p. 181.

24. Majumdar 1968, p. 214.

25. Ibid., p. 105.

26. Banerjea 1956, p. 565.

27. Gonda 1970, p. 30.

28. B. Bhattacharyya 1974, p. 11. This book provides a good introduction to Jain iconography.

29. Banerjea 1956, pp. 437, 442. See also B. N. Sharma 1975.

30. D. G. Shepherd 1980 and "Banquet and Hunt in Medieval Islamic Iconography" in *Gatherings in Honor of Dorothy G. Miner*, ed. U. E. McCrachen, L. M. Randall, and R. H. Randall, Jr. (Baltimore: Walters Art Gallery, 1974), pp. 79–92.

31. Pal 1977, pp. 38–39.

32. J. B. Alphonso-Karkala, ed., *An Anthology of Indian Literature* (Harmondsworth: Penguin, 1971), p. 66.

33. Sivaramamurti 1979, p. 171.

34. Ibid., p. 187.

35. See M. Chandra 1973a.

36. Banerjea 1956, p. 586.

37. Ingalls 1965, p. 586.

38. P. Shah 1961, 3: p. 3.

39. Ingalls 1965, p. 14.

40. Coomaraswamy 1923, p. 39.

41. P. Shah 1961, 2: p. 135.

42. K. Clark, *The Nude: A Study in Ideal Form* (New York: Doubleday Anchor, 1956), p. 29.

43. E. H. Johnston, ed. and trans., *The Buddhacharita* (New Delhi: Oriental Book Reprint Corporation, 1972), 2: p. 49.

44. As quoted from *Placita Hippocratis et Platonis* by E. Panofsky, *Meaning in the Visual Arts* (New York: Doubleday Anchor, 1955), p. 64.

45. P. Shah 1961, 2: p. 137.

46. Panofsky, p. 55.

47. Sivaramamurti 1978, p. 170.

48. Ibid.

49. D. Srinivasan, "The So-Called Proto-Siva Seal from Mohejo-Daro: An Iconological Assessment," *Archives of Asian Art* 24 (1975–67): 47–58.

50. Coomaraswamy 1923, p. 38.

51. As quoted from *Samyutta Nikaya* by Coomaraswamy 1935, p. 21.

52. Ibid., p. 20.

53. Ibid., p. 71 n. 38.

54. As quoted from *Śatapatha Brāhmaṇa* by Coomaraswamy 1935, p. 71.

55. Ibid., p. 19.

56. P. Shah 1961, 2: p. 185.

57. Zimmer [1946] 1963, p. 100.

58. See Begley 1973 for a thorough discussion of the wheel of Vishnu.

59. P. Shah 1961, 2: p. 141, and Begley 1973, pp. 23–34.

60. Begley 1973, p. 24.

61. P. Shah 1961, 2: p. 139.

62. G. J. Larson, *Classical Śāṁkhya*, 2d ed. (New Delhi: Motilal Banarasidass, 1979), p. 169.

63. Ibid., p. 273.

64. T. Bhattacharya 1963, pp. 414–15.

65. Zimmer [1946] 1963, p. 71.

66. P. Shah 1961, 2: p. 140.

Color Plates

Dinars of *Kanishka I (C10a)* *Huvishka (C12a)*

Vasudeva I (C13b) *Chandragupta I (C25)*

Samudragupta (C27b) *Chandragupta II (C28c)*

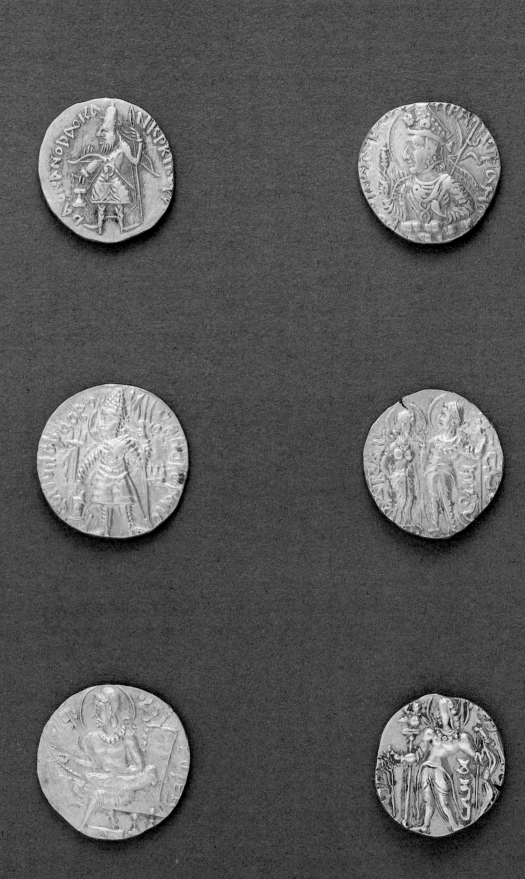

S23 A Boy Feeding a Parrot

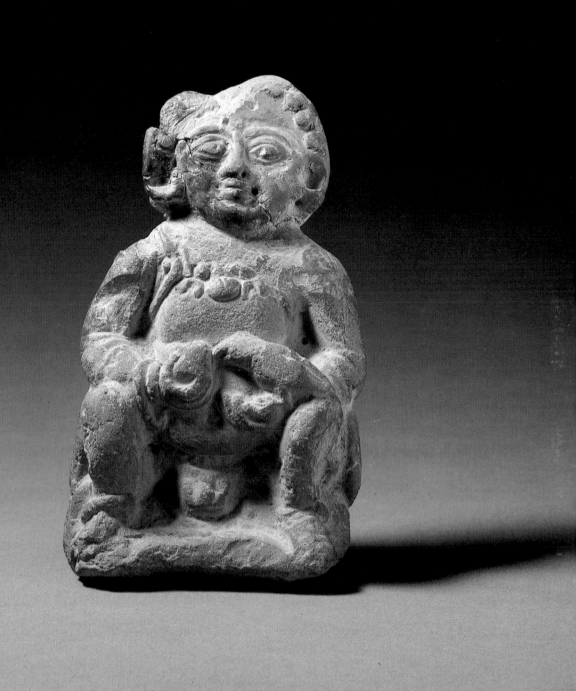

S29 Two Addorsed Tree Dryads (side a)

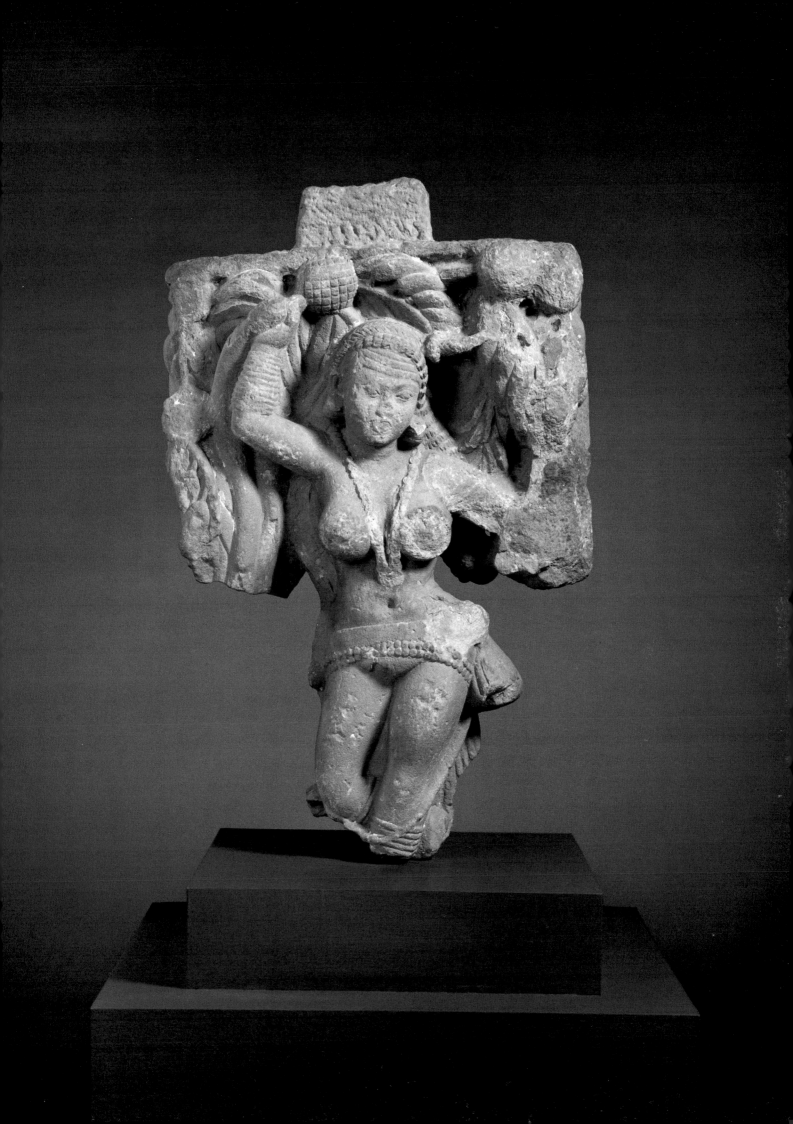

S55 Railing Pillar with Figures

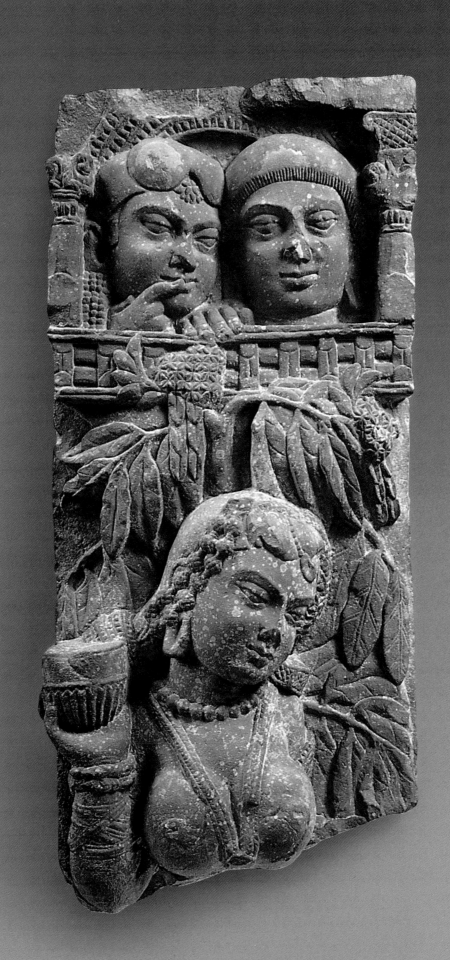

S91 *Head of a Bodhisattva*

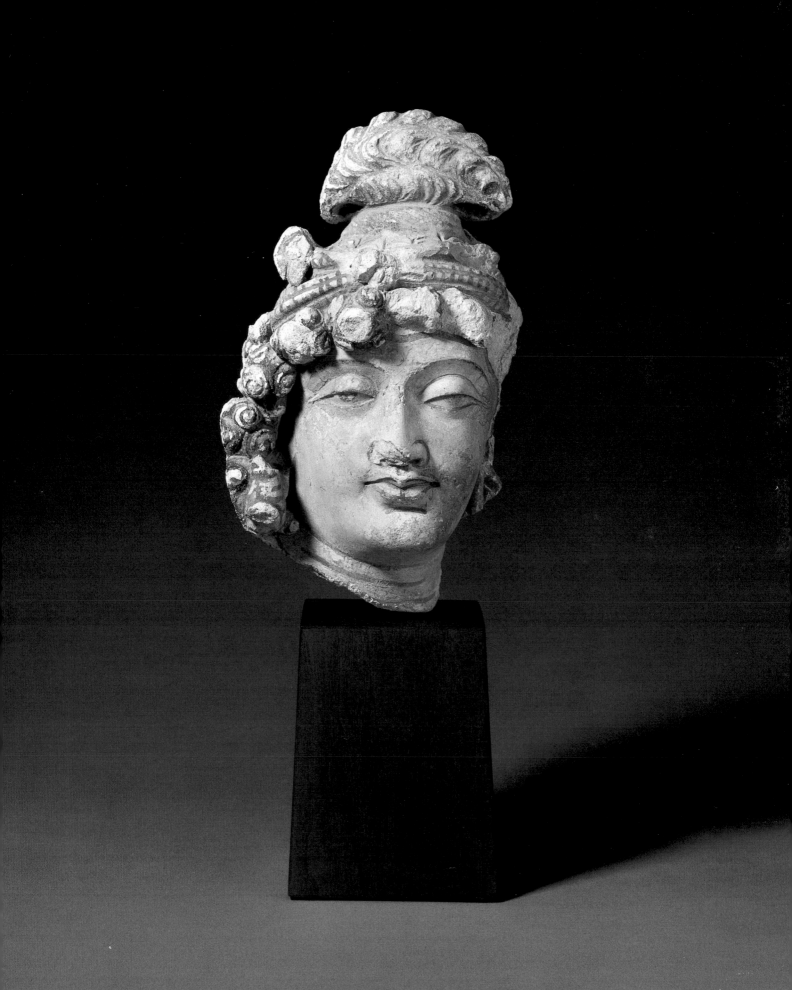

S129 The Man-Lion Avatar of Vishnu

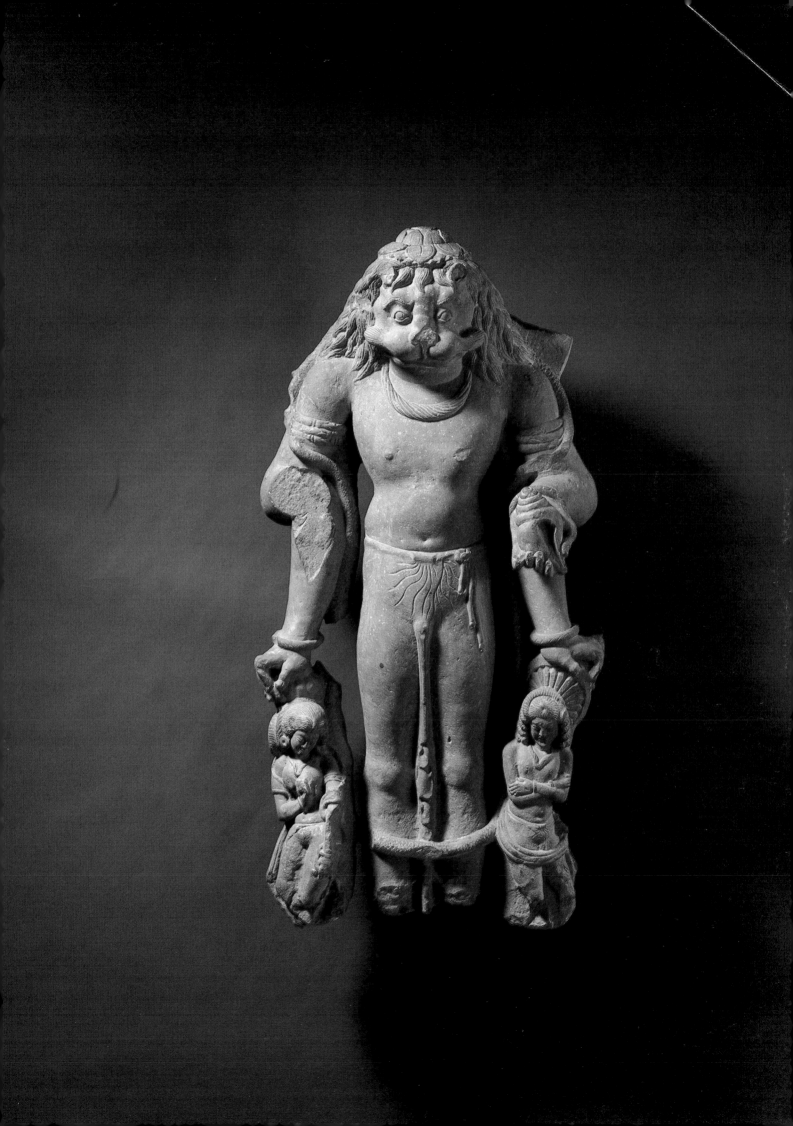

S131 Buddha Sakyamuni

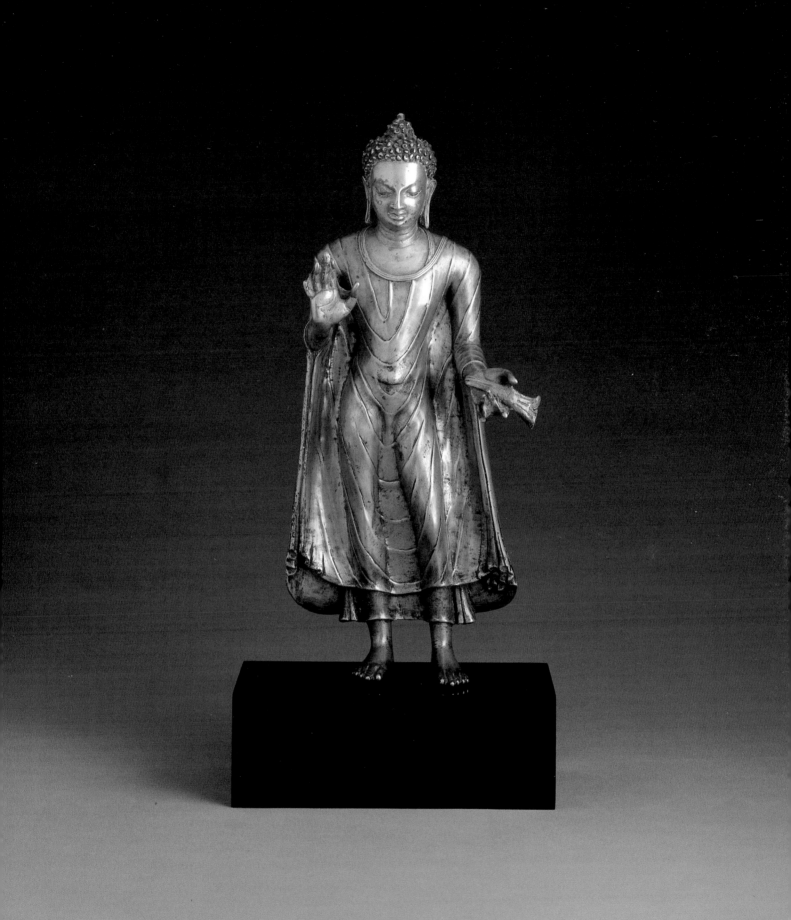

S134 Shrine with Four Jinas

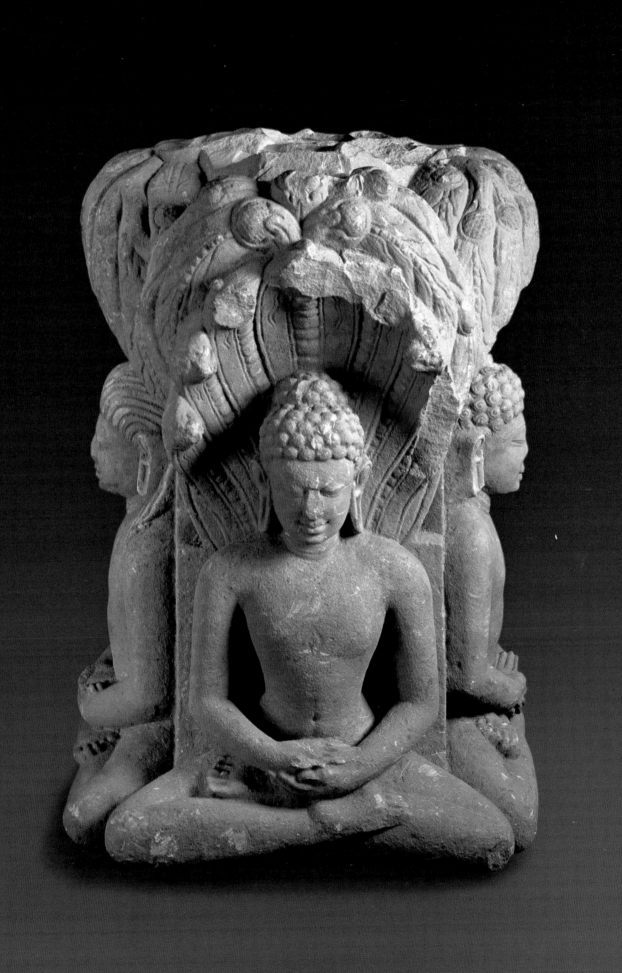

Numismatic Art

Introduction

The importance of coins for the study of Indian art history is yet to be fully recognized. While some scholars have used coins to enhance our knowledge of iconography and the history of early Indian sculpture, most art historians have generally ignored this material.[1] Yet both for iconography and style, ancient coins often provide vital evidence for the artistic norms of a given period. Royal portraits on coins are frequently the only surviving testimony of secular imagery, while representations of gods and goddesses, important as they are for the study of religious history, are no less significant for an analysis of the stylistic development of sculpture. This is especially true of the coins of the Gupta period (c. 320–600), which are often more firmly datable than the architectural monuments of that age. Moreover, since the coins were designed and manufactured in royal mints, they help us determine the aesthetic inclinations of particular monarchs on the assumption that they exercised some influence on the selection of imagery.

The coins in the museum's collection are made of gold, silver, and copper or bronze. The majority are gold coins known by the Persian term *dinar* and are the equivalent of the Hellenistic stater. The silver coins are referred to by the Greek term *drachma* for convenience rather than the Indian word *karshapana* or its variants, *purana* and *dharana*. The coppers are known simply as *pana*.[2]

The earliest coin in the collection is made of silver and is known generally as a punch-marked coin because of the technique of its manufacture. Individual punches were used to hammer symbols on one or both sides of silver sheets or bars. The sheets were then cut up into oblong or roughly rectangular and, occasionally, circular shapes. Neither the shapes of the coins nor their number of symbols are uniform. Often small bits were snipped from the edges to make the coins conform to a standard weight, but even in this there are notable divergencies. No inscriptions occur on punch-marked coins, and while the symbols on these coins probably held religious and cosmic significance, their exact meaning has not been ascertained. Generally, these coins circulated over a large area of the subcontinent from about the sixth century B.C. until the second century A.D. and even later in some areas of southern India.

Cast and die-struck coins bearing images, symbols, and legends were introduced to India about the middle of the third century by the Indo-Greek rulers of Bactria. Occupying present-day Afghanistan, Bactria is the ancient name of the

region between the Hindu Kush mountain range and Amu Darya River (formerly the Oxus). While people of Greek origin had been settling in the area since at least the sixth century B.C., it was only after the conquests of these regions by Alexander the Great in 327–326 B.C. that the Greeks became a significant political presence. It is generally believed that sometime around 256–255 B.C. the Greeks of Bactria under Diodotus I seceded from the Seleucids, who had inherited Alexander's eastern conquests, and established an independent kingdom. Known as Greco-Bactrians or Indo-Greeks, these rulers of Greek origin held power in the region until about the middle of the first century B.C. It must be remembered, however, that there was more than one Indo-Greek kingdom during this period and their rulers did not control the entire northwest of India (including present-day Pakistan, Kashmir, and Jammu regions).

Coins meant for circulation in the Indian regions generally were the silver and copper issues and differ slightly from the Attic standard. The legends on the reverse were written in the Prakrit language with Kharoshthi script, the obverse being reserved for legends written in Greek. The image on the obverse is invariably a royal portrait, while usually a Greek deity is represented on the reverse. Subsequent dynasties, with the exception of some tribal governments, continued the Greek monetary tradition and generally displayed a royal portrait on the obverse and a divine figure on the reverse, at least until A.D. 600, through the Gupta period. Greek letters continued to be used by other foreign dynasties in India, such as the Scythians, or Sakas, Parthians, and Kushans, but rulers of Indian origin, such as the Satavahanas and Guptas, replaced Greek legends with Brahmi script.

The Indo-Greeks were succeeded by the Scythians (Sakas) and Parthians, who descended upon India from eastern Iran and, like their predecessors, wielded power mostly in the northwest. The collection contains no coins of the Parthian monarchs, but the museum does have one copper (C8) and three silver coins (C5–7) issued by Saka kings. While their coins introduce a few novel devices and are artistically different, by and large they follow the Indo-Greek tradition.

At about the time of the birth of Christ the Scythians and Parthians were replaced by yet another Central Asian tribe, known as the Kushans. After conquering Bactria the Kushans advanced south and by the end of the first century of the Christian era had consolidated a vast empire stretching from Soviet Central Asia in the north to, perhaps, the Deccan in the south and Bihar in the east. Although the political power of the Kushans declined during the third century, their coins continued to be imitated in the northwest long after the coinage of the Guptas had become current in northern India. The Kushans were not only the first dynasty to issue gold coins on the subcontinent but were also responsible for introducing many new motifs in their coinage. For the study of Indian art Kushan coins are of even more interest than those of the Indo-Greeks.

While the Kushans were the major political power in northern India, much of southern India was dominated by a dynasty of Indian origin known as the Satavahanas. As with the Kushans, the principal wealth of the Satavahana Empire was derived from foreign commerce. While the Kushans controlled the land-borne trade between Rome and China across Central Asia, the Satavahanas took advantage of the sea trade through the great emporia of both eastern and western coasts of

peninsular India. The collection contains silver portrait coins of four well-known Satavahana monarchs (C21–24). The Satavahanas did not issue gold coins.

The largest group of gold coins in the collection is from the Gupta dynasty. Gupta coinage is not only rich in artistic imagery, but as the early coins are firmly datable they are especially significant for establishing the chronology of contemporary sculpture. Although the early Gupta monarchs adapted Kushan coin types, they also were responsible for the Indianization of the coinage. No longer does a preponderance of foreign deities appear on the reverse of the coins as on those of the early Kushan monarchs. In the presentation of the obverse royal portrait the Gupta artists introduced many interesting images that inform us of the monarchs' ambitions and personalities. These ruler portraits are often complemented by poetic legends. The Gupta administration adopted Brahmi characters with Sanskrit rather than Greek letters and the Bactrian language, which further testifies to the greater Indianization of the coinage system. Although the Satavahanas led in this process of Indianization, Gupta rulers produced coinage that not only displays a much greater variety in the use of images but is also aesthetically superior.

Royal Portraits

Of the four portrait coins of the Indo-Greek monarchs, one belongs to Eucratides (C2) and three to Menander (C3a–c). As characteristic of Greek art, the portraits may be taken to represent idealized likenesses. The features of both monarchs are sensitively rendered, and, although at first glance the royal portraits look somewhat alike, subtle differences are perceptible in their faces and headdresses. Eucratides has a larger nose, wider eyes, sunken cheek, and furrowed brow. Indeed, in one example (C3c), King Menander is very likely portrayed as an older man. No doubt the engravers responsible for these Indo-Greek coins were familiar with their subjects.

Although the Saka rulers of northwestern India continued the basic Indo-Greek coin type, they dispensed with the realistic portrait bust and instead presented the king as an equestrian figure (C6–7). As evident by a comparison of these coins, no attempt was made to distinguish the two monarchs. On the reverse of each coin is a Greek god, but the figural representation is quite different from the predominantly classical style of Indo-Greek coins. Animal and human figures are depicted in a much more attenuated, abstracted style with a strong emphasis on elongated, linear forms. While the rendering of the figures on Maues's coin (C5) is perfunctory, the images still retain vestiges of the classical tradition with its emphasis on modeled surfaces, naturalistic draperies, and elegant postures. The two animals on the copper coin of Azes II (C8) are lively delineations of naturalistic forms. Thus, while some engravers associated with the Saka mints continued to work in the classical tradition, there were others who introduced a more linear style with sketchy, almost caricaturelike forms. Indeed, the royal equestrian portraits anticipate by many centuries the humorous representations of Don Quixote in European art. To date, no parallel for this style has been traced in the art of the region. It is possible that the engravers responsible for this distinctive figural treatment were themselves Scythians familiar with the animal style generally associated with their culture.

A wide variety of royal portraits is found on Kushan coins, which are interesting both for their diverse iconography and forceful style. Although some Kushan monarchs, such as Vima Kadphises (C9) and Huvishka (C12a–c), were represented in portrait busts, by and large, full-length portraits were preferred. Vima's solitary coin in the collection not only displays the bust of the king but represents a unique type: the bust is surrounded by a thick frame intended, perhaps, to appear as a window or imitate a bas-relief. The exact significance of this unusual portrait remains unexplained.

The most prominent, frequently depicted portrait device of the Kushan coins is the representation of a king offering oblations at a sacrificial fire altar. This form was introduced by Vima Kadphises and, with the exception of Huvishka, was used by all Kushan monarchs and Kushano-Sasanian rulers who governed the Kushan territories in the north, which came to be known as Kushanshahr after the fall of the Kushans as an imperial power. As was the custom with Iranian dynasties, the fire cult probably was an integral part of both the state and religious functions of Kushan monarchs, regardless of their personal faith. In terms of its use on Kushan coins, the fire altar is clearly more closely related to the Parthian representation than to the Sasanian display of the fire altar as a principal motif on the reverse of the coin.

In general the portrait of the standing Kushan monarch cuts an impressive figure. The head is always shown in bold profile, and the figure with its hieratic frontality is imposing and even awesome. Without doubt, the Kushan engravers were required to represent their monarchs as larger than life, just as were the portrait sculptors at Mathura, an important center of Indian art in Uttar Pradesh. Kushan artists achieved their unique representations by skillfully manipulating symbols and images. With their tall headgears, flowing, volumetric tunics (also evident in the stone portraits at Mathura), columnar legs, and splayed feet placed firmly on the ground, the royal portraits convey a monumental physical presence. In addition, the divine nature of kingship is represented by various symbols, such as the flaming shoulders (C10a–c), symbolizing royal glory, and the nimbus (C12a–b). In the artist's attempt to depict the divinity of the king Huvishka's bust seems to float or emerge from a sea of clouds. The full-length coin portrait and stone sculptures at Mathura clearly demonstrate the stylistic and iconographic correlation between the two types of portraiture. One can be certain that the engravers did not work in isolation. On the contrary, there must have been an established norm, controlled by the imperial chancery determining the type of image that would be represented. Thus, there was probably a close relationship between the art of the engraver and sculptor, and the same person may even have executed work in both media. Notwithstanding their dependence on earlier Indo-Greek or Scytho-Parthian coins, the die designers of the Kushan mints began a great age of Indian coinage.

Of particular interest are the emblems held by the kings. Vima Kadphises is generally shown holding a club or mace. Sometimes he holds a flowering branch or twig, occasionally, a staff, and in the elephant-rider image, appropriately, an elephant goad. With his right hand held above a fire altar, Kanishka also grasps the elephant goad. This emblem was certainly adopted by the Kushans after their conquests of Indian territories, where the elephant brigade was among the primary instruments of warfare. In a coin issued to commemorate Alexander's victories in India, the Macedonian is seen charging the Indian ruler's elephant.[3] Indeed, considering that the horse must have been the principal animal used by the Kushans, it is surprising that equestrian portraits were not used on coins. Vima Kadphises is, however, shown riding an elephant, a representation for which there is no Indo-Greek or Scytho-Parthian prototype. In addition, Huvishka holds the spear prominently with his left hand. Not only an important tactical weapon for the Scythians and Parthians, the spear probably was also emblematic of royal glory.[4] In the Iranian pantheon Pharro, god of royal glory, is portrayed with the spear. In classical imagery the spear is the prominent weapon of the Dioscuri, while in the Indian pantheon the weapon is associated with the gods Kubera and Skanda, or Kumara. The former is the regent of the North, and the latter, the divine general. Thus, the spear was a particularly appropriate emblem for a Kushan king. The spear continued to be held by Huvishka (C12b) but was replaced by the trident in the coins of Vasudeva I (C13–15). Thereafter, the trident remained the standard emblem held by Kushan kings, and beginning with Vasudeva I it was also added behind the fire altar. This repeated use of the trident on the obverse of Vasudeva's coins, together with the predominance of Siva on the reverse, is generally taken by scholars to reflect the monarch's strong devotion to Sivaism.

In the Kushan busts and full-length portraits the early monarchs are quite easily distinguished. When shown full length, the king is usually attired in close-fitting trousers, flaring tunic that stops short of the knees, and leather boots. A wide variety of headgear, both in the busts and full-length portraits, is displayed. Vima wears a soft, round felt hat with ribbons (C9), while Kanishka wears a soft cap (C10c) or tall rounded hat (C10a–b), similar to the headgear worn by Parthian monarchs. The greatest variety of headgears is presented in the Huvishka portraits (C12a–c), while for Vasudeva I and his successors a single type, consisting of a tall, conical crown with minor variations, was used (C13a–b). Standing figures invariably display a sword tied at the waist.

Even in the full-length portraits, the physiognomical features are distinctly depicted. Most monarchs have large, assertive noses, and at least two have prominent warts on their faces. Kanishka is always portrayed with a fairly long and rather unkempt beard, while Vima Kadphises is clean shaven. Vasudeva has a generous moustache, Huvishka is shown both as clean shaven and with a short beard, perhaps in old age. The diecutters of Huvishka's coins must have been familiar with their subject. Not only are his features particularized, but he is portrayed both as a youthful and elderly figure. Thus, these portraits are remarkable for their variety and perceptive realism.

Among the many innovations introduced by Huvishka's mints, the most significant perhaps is the addition of the nimbus behind the king's head. Although his predecessors, beginning with Vima, were first to claim divinity by adding flames to their shoulders, strangely, it was Huvishka, rather than the

more powerful Kanishka, who emphasized the concept further by enhancing his image with a nimbus and showing his bust emerging from clouds. Interestingly, although other contemporary early rulers, such as the Seleucids, Parthians, and Romans, pronounced their divine nature, in none of their coins was the nimbus used to legitimate the claim. Curiously, no halo of any kind was added behind the heads of the deities on Indo-Greek coins, except on certain images of Zeus and Apollo or Helios with a radiating nimbus. This seems to have been the prototype for the standing Zeus in Azes's coin (C6), where the halo appears as an aura of flames. It also is used selectively behind the divine heads on some of Vima's coins. In Kushan coins the halo is a plain circle. After Huvishka the king is never without a halo, although sometimes the gods are (C12b, C13a). In Kushan sculpture the halo is frequently a divine attribute common to the three major Indian religions, although the flame-bordered nimbus does not appear until the Gupta period. The halo was retained for the ruler's image in some Kushano-Sasanian coins but was not used by the Satavahanas. The Guptas, however, continued to use the halo on most of their royal portraits.

Following no doubt the mandate of the state, Kushan engravers presented the monarch as a superhuman, divine figure, which may have been one reason why the full-length presentation was preferred. Even in diminutive scale, his monumentality cannot be doubted, especially when compared with the larger-than-life royal portraits preserved at Mathura.[5] The Kushan rulers obviously wanted to overawe their subjects by projecting themselves as veritable colossi, and so the royal sculptors and engravers adopted a style of representation that was both monumental and hieratic. From at least the second century B.C. Indian sculptors had been carving monumental images of yakshas. The greater formalization, frontality, and hieraticism of the Kushan figures may have been borrowed from contemporary or earlier Parthian imagery. In Kushan coinage, however, the head of the royal figure is always depicted in profile, and the unnaturalistic placement of the feet, a convention employed by Kushan artists in their stone portraits, is not encountered in Parthian art. This peculiar representation of the feet pointing out is much more ubiquitous in coins than in stone sculptures. The same degree of splaying is found only in Kanishka's statue at Mathura. In Huvishka's portrait the feet are placed quite normally, while in the fragmentary statues recovered from Surkh Kotal (the Bactrian royal gallery or shrine), the splaying is less pronounced.[6]

Contemporaneous with the Kushans, the Satavahanas ruled a vast empire in the Deccan. Although their silver portrait coins do not possess the wide variety of Kushan coinage, they are nevertheless interesting both historically and artistically. The Satavahanas were the first dynasty of Indian origin to issue coins with royal portraits. The use of only the mature Brahmi script and Dravidian language is also interesting and reflects the strong nationalistic attitude of the Satavahanas.

The portrait heads represented on Satavahana coins are remarkable for their clarity and articulation. Facial features are distinct and well modeled, allowing a clear differentiation among the royal visages. Satavahana monarchs appear not to

have worn any elaborate headgear, neither crown nor turban, which is rather surprising. Some monarchs adorned their foreheads with a round, floral (?) crest, and all seem to have worn distinctive, heavy, anchor-shaped ear ornaments. Although the Satavahanas may have derived their coin portraits from the Western Kshatrapas, certainly the Satavahana royal representations are much sharper, bolder, and more individualized than are those models.

The history of Indian coins entered a glorious phase with the emergence of the Gupta dynasty about 320. The very first coin of the Guptas, the solitary issue of Chandragupta I, introduces a new type of royal imagery on the obverse (C25). Both the king and his queen are represented together and are nimbated. While the queen is dressed in the Indian fashion, the king is attired in the Kushan manner but with a different tunic. Both wear doughnut-shaped earrings. The tall, conical hat worn by Kushan rulers is replaced by a close-fitting, soft cap tied with a fillet. The royal couple's graceful stance is particularly significant. Gupta engravers obviously were not interested in the stiff, hieratic postures assumed in Kushan royal portraits. Interestingly, while in their standard types both Kacha and Samudragupta (C26–27a) are represented with the linear fluency and elegance of Gupta sculpture, their feet are still splayed as in the Kushan coins. There are as well iconographic similarities between Kushan and Gupta coins. Gupta monarchs continue to offer oblations into a fire altar, although it is unlikely that in actual practice they observed this Kushan royal cult. The trident behind the altar in the Kushan coin type has been replaced by a column crowned with Garuda (the mythical bird-mount associated with the Hindu god Vishnu).

Two other coins of Samudragupta reflect some of the artistic innovations of the royal mint. In one the king is seated informally but elegantly on a couch and plays a lyre (C27b). In another his portrait on the obverse is replaced by a representation of a sacrificial horse (C27c).

The Guptas were remarkably astute in using their coins to project a flattering image of the monarch. The inclusion of his queen's portrait and announcement of her distinguished lineage on Chandragupta I's coin (C25) were clearly motivated by political needs. Since the Guptas themselves were of obscure origin, it was necessary for Chandragupta I to marry into a family of impeccable social and political pedigree. What better media to publicize this alliance than gold coinage, which would circulate among the wealthy and influential members of society. Similarly, Samudragupta used coins to announce to the world that he was not only a great conqueror but also a man of culture and devotion. In his lyrist coin type Samudragupta eschewed Kushan dress for the simple Indian dhoti. In the coins of his successors the monarchs are dressed in Scythian costume or wear the dhoti instead of trousers. Boots also are dispensed with, except, perhaps, when the king is portrayed riding. Other Gupta monarchs, particularly Chandragupta II and Kumaragupta I, also issued coins with images that clearly distinguish them for their physical prowess and intellectual acumen. Still other examples announce their military and political achievements and are as artistically imaginative as they are historically important.

One of the most popular representations on Gupta gold coins was the depiction of the king as an archer. The portrait type was created by Samudragupta's engravers and popularized by his successor, Chandragupta II. The collection contains

three examples of Chandragupta's archer coin type (C28a–c). Clearly this was a modification of the portrait with fire altar issued by Kacha and Samudragupta. Here the fire altar has been dispensed with altogether, and the king holds a bow in his left hand and arrow in his right hand. A distant prototype for the portrait may be seen in some Indo-Greek coins where Apollo stands similarly with bow and arrow.[7] No numismatist has yet attempted to explain Samudragupta's adoption of the archer portrait and its popularity among successive Gupta monarchs. Very likely, the image was selected because of its association with Rama, legendary hero of the Indian epic the *Ramayana*. By the Gupta period Rama had become the Indian prototype of an ideal king. Across northern India the expression *Rāmarājya* (the kingdom of Rama) is still popularly used to describe a lost golden age. Ardent Vaishnavas, the royal Guptas would naturally have chosen to model their standard portrait type on the idealized image of Rama. While it will not be possible to discuss the epigraphical and literary evidence, it should be noted that the most graphic parallel is presented by a fifth-century terra-cotta figure of Rama (S107). Identified by inscription as Rama, it clearly illustrates the close iconographic and stylistic affinity with Chandragupta's archer portrait.

The royal equestrian portrait was introduced by Chandragupta II (C29a–b) and was continued by Kumaragupta I (C30a). This portrait type was prevalent in the Scytho-Parthian coinage (C6–7), but it is unlikely that the Gupta diecutters knew of such early issues. Moreover, the Gupta images are aesthetically superior and much more spirited and sculpturesque. Indeed, if any comparison is to be cited, one may consider the equestrian royal figures of Sasanian art.[8] This seems particularly relevant when discussing the greater importance of hunting and animal combat on the coins of Chandragupta and Kumaragupta. Samudragupta was the first to issue the tiger-slayer portrait. His son Chandragupta presented himself as the great destroyer of lions; while Kumaragupta is shown in combat with both these animals as well as the rhinoceros. In the museum's coin (C30b) Kumaragupta fights a lion while riding an elephant.

These scenes of animal combat were meant to proclaim the king's courage and symbolize his conquests of regions where the animals predominated. Thus, Samudragupta's tiger-slayer portrait may symbolize his conquest of Bengal, the habitat of the tiger, and his son's lion-slayer portrait may represent his victory over the Scythians of Gujarat and Kathiawar, the range of the lion. One cannot fail to draw a parallel with the representation of hunting scenes on Sasanian silver plates, a contemporaneous practice of the rulers of Iran. The royal hunt was unquestionably the most popular theme on such plates, and usually the king is shown on a horse hunting lions, boars, or stags with a bow and arrow. In the Sasanian context these hunting scenes not only symbolize the king's courage and prowess but also had cosmic significance. As Prudence Harper has written:

Representations of the hunt on silver plates are more than reflections of court life. They are allegories for human combats such as those carved on the rock reliefs. Many of the plates were sent to rulers and allies abroad, particularly to areas bordering on the Sasanian Empire, where as official works of art, they were expected to impress the recipient with the valor and prowess of the donor.[9]

Even without direct evidence, one can assume that the Guptas maintained diplomatic relations with the Sasanians. Chandragupta II had certainly conquered the western kingdoms of the Scythians and may well have extended the empire as far as Afghanistan, which would imply a conflict with the Sasanians. In any event, either as presents or as loot, the Gupta court was probably familiar with the royal silver plates of the Sasanians, which may have inspired the adoption of motifs and compositions proclaiming the intrepid heroism of the Gupta kings.

Divine Images

Images on the reverse of most coins in the collection consist of divine figures. One Indo-Greek drachma (C4) has animals on both sides: a bull on the reverse and an elephant on the obverse. Similarly, on both sides of a Saka copper coin (C8) are two animals: a bull and a lion. Satavahana coins have only symbols on the reverse, while on the reverse of a Gupta silver drachma issue is a highly stylized Garuda (C31). Animal symbols are generally regarded as theriomorphic representations of the deities. Thus, the bull signifies Siva; the lion symbolizes the goddess Durga, whose mount it is; and the elephant, Indra. The elephant on Apollodotus's coin (C4), however, occurs on the obverse and may signify the city deity of Kapisa (present-day Begram in eastern Afghanistan). Animals may also symbolize the prowess and nobility of the monarchs: the bull, lion, and elephant are often used as metaphors for regal qualities in Sanskrit literature.

The divinities represented on Indo-Greek coins generally are from the Greek pantheon. Deities depicted on coins in the collections include the Dioscuri (C2), Pallas Athena (C3a–c), Zeus (C6), Nike (C5, C7), and Tyche (C12b). Semidivine twins, whose paternity is attributed to Zeus, the Dioscuri are the Greek counterparts of the celestial twins of Vedic mythology, known as the Asvins. In entry C2 they are shown riding two spirited chargers in a composition well known in classical art. The image of Pallas Athena in Menander's coins is also familiar from Greek art. She is represented in two poses as she is about to hurl her thunderbolt. An interesting detail in one coin (C3b) is her snake-frilled aegis. As Athena was a warrior herself and protected such heroes as Hercules, Perseus, and Odysseus, her appeal for such conquerors as Menander is understandable. It is possible that her cult and concept exerted some influence upon her Indian counterpart, the goddess Durga.

Just as Greek continued to be the major administrative language in a wide area from Bactria to the Panjab even after the eclipse of the Indo-Greek kingdoms, so also Greek divinities continued to grace the coins of the Scythians, Parthians, and Kushans. The fully robed figure of Zeus carrying a scepter appears on the obverse of the coin of the Saka king Maues (C5), while on the reverse the winged Nike holds a diadem. In a somewhat different form in Azes's coin (C6) the god holds the thunderbolt prominently with his right hand. Indeed, this particular representation of Zeus is interesting for other reasons as well. His slim, attenuated form, covered only with what appears to be a dhoti, is quite unlike the more heavy-set, majestic figure familiar in classical art and approximates much more closely the slightly effeminate image of the male body preferred by Indian sculptors. Equally

noteworthy is the disproportionate enlargement of the thunderbolt in the right hand. This implement in later Indian art became a well-known attribute of the Hindu god Indra, with whom Zeus has much in common, and the Buddhist god Vajrapani. Certainly in Gandharan art the form of the thunderbolt and of Vajrapani is derived ultimately from the thunderbolt held by Zeus or Athena (see S84). So conceptually similar are Indra and Zeus that to the Indians, who used such coins, the figure may well have represented Indra rather than the Olympian.

The goddess on the reverse of one of Azilises's coins (C7) is basically of Greek origin and appears to have been modified by Iranian concepts. She is identified as Nike, but a comparison with the more classical version on Maues's coin (C5) reveals not only iconographic, but also strong stylistic differences. Instead of a diadem, she holds what appears to be a vessel with flames, symbolizing, perhaps, the Iranian concept of royal glory. Thus, she could be a syncretistic deity combining Greek and Iranian religious concepts. Stylistically, the robust and fully modeled figure on Maues's coin has been replaced by an abstracted, attenuated form characteristic of Scythian numismatic images. Unlike the more classical, fully draped Nike, the goddess here displays a bare torso as is typical in Indian art, but the swelling volume and plasticity so pronounced in Indian modeling is totally absent.

Although Greek divinities are not represented on Kushan coins in the collection, at least four examples reflect the syncretistic tendencies already encountered in Scythian coinage. Portrayed on the reverse of one of Kanishka's dinars is the Iranian solar deity, Miiro, known in Sanskrit as Mihira (C10c). The same figure was also used by Huvishka's engravers to represent Ashaeixsho, the Iranian god personifying royal glory. The image with radiating nimbus—whether of Miiro or Ashaeixsho—was based on that of the Greek sun god, Helios. The engraver was probably unfamiliar with Iranian images of Miiro and Ashaeixsho and so employed a familiar Greek model. In fact, certain features, particularly the clothing and boots, are further attempts to make the figure more Iranian. The choice of the name Miiro on Kanishka's coin was deliberate, for its Sanskrit cognate—Mihira— would have made the figure familiar to the Indians. Further, this image type of Miiro wearing Scythian dress became the model for north Indian representations of the sun god, Surya. Classical models were used by Kushan engravers to represent other Iranian deities, such as Ardoxsho (C12b) and the wind god (C11), although the latter is clad in the Indian manner in a dhoti.

Thus, although the repertoire of Hellenistic or Roman divinities on Kushan coins is not large, indirectly they contributed liberally toward the iconography and forms of Iranian deities. The Kushans were distinctly partial to the Iranian pantheon, but their engravers seem to have relied on the more familiar Hellenistic models. This is to some extent true also of the few Indian gods, principally Siva, encountered on Kushan coins. This dependence on classical imagery may have been dictated by both monetary and cultural considerations. It established a continuity with earlier Indo-Greek coins, thereby, assuring a more stable currency in a rapidly changing political world.

It is rather curious that Siva should have been the Kushans' most popular divinity to the complete exclusion of Vishnu. While neither deity was predominant in the northern regions of the empire, including Gandhara, certainly around Mathura, which appears to have been the southern capital of the Kushans, Vishnuism was a stronger religious force than Sivaism.[10] Yet from Vima Kadphises onward, all Kushan monarchs, including those that bore the Vaishnava name Vasudeva, represented Siva on their coins. Very likely the Kushans placed such emphasis on Siva because most major tribes with whom they came into contact, such as the Audumbaras, Kunindas, Malavas, and Yaudheyas, venerated Siva and either included on their coins Siva himself, his mount (the bull), or his symbols (such as the trident with battle-ax). Thus, Vima Kadphises's representation of the combined trident with battle-ax on his coin (C9) may have been copied from coins of the Audambaras after his conquest of their territories. Whether or not all Kushan emperors personally believed in Siva, his image without doubt is the most prominent on Kushan coins. It is somewhat peculiar, however, that in Kushan coins the god is never called Siva but is known by the strange epithet Oesho, the exact derivation of which remains uncertain.

In the common depiction of Siva on Kushan coins he stands gracefully in front of his bull (C13a–b). Although the figure is modeled on the earlier Indo-Greek Hercules type, the composition with bull appears to be an innovation formulated by Kushan engravers. Generally in such images he has two arms and his attributes are the trident and fillet or noose. In some early issues he holds the waterpot instead of the noose, imitating, no doubt, earlier tribal coins. While the noose is not an inappropriate attribute of Siva, it is certainly not very common and may indicate an attempt to Indianize the filleted diadem held so frequently by Hellenistic deities. This image of Siva standing against the bull remained the prototype for subsequent sculptural representations of him (see S114).

A second Siva image appears to have been introduced by the engravers of Kanishka (C10a). In this type the bull is excluded, and the figure is more Indian than classical and is endowed with four arms: probably among the earliest representations in India of a multilimbed god. Objects held in the four hands are the waterpot (sometimes along with an elephant goad), thunderbolt, trident (held diagonally across the left shoulder), and an animal identified as an antelope, but which may be a goat. Whether an antelope or goat, either animal would be an appropriate attribute of Siva as Pasupati (lord of the animals). Although in later Indian art a goat is found on a rare Kashmiri bronze and appears on a coin, only in south Indian images does Siva hold an antelope with his upper left hand. Several Greek divinities hold animals or birds as attributes, but they are held more gently than they are here.

Although not common, the thunderbolt is a prescribed emblem of Siva in some texts. Of particular interest is the shape of the implement. Curiously, the engravers seem to have used the type of thunderbolt held by the bodhisattva Vajrapani in Gandharan art rather than that held by Zeus or Athena in earlier coins. Like the trident, the waterpot, symbolizing Siva's ascetic nature, has remained a popular emblem in later iconography. Particularly noteworthy on Kanishka's coin is the Roman or Iranian vase held by the four-armed Siva rather than the usual waterpot. Moreover, the vase is held in the extended arm with the mouth pointed down as if something is being poured. Very likely this presentation was meant to symbolize the investiture by the god of the king, whose effigy occurs on the obverse,

and is perhaps an attempt at Indianizing the Hellenistic investiture ceremony in which a deity offers a diadem to the king. Finally, in some Kushan coins Siva has been given three heads, but the representations are not very clear.

The only other Hindu deities depicted on the museum's Kushan coins are Skanda, or Kumara, and Visakha, both of whom stand facing each other on a coin of Huvishka (C12c). Although by the Gupta period Skanda and Visakha had coalesced into one personality, in Huvishka's coin they are still separate entities notwithstanding their identical representations. The inclusion of Skanda in Huvishka's pantheon must have been motivated by his appeasement of the militant Yaudheyas, who were politically troublesome for the Kushans and who considered Skanda as their tutelary deity. To hold Mathura the Kushans must have subdued the Yaudheyas, who were settled in parts of present-day Haryana, centering around the town of Rohtak, and adjacent areas of Rajasthan and Panjab provinces.

The iconographic features of the two deities on Huvishka's coins are interesting. Both seem to wear a long flaring dress or cloak. Short swords are attached at the waist, a feature seen in Gandharan images of Skanda rather than in those created in Mathura. Interestingly, each holds what looks like a staff with a knob at the top, which may be an adaptation of Eros's thyrsus from Hellenistic imagery. The top of the spear is not always represented clearly in numismatic art. While the models for the figures must have been the standing Dioscuri in the coins of the Indo-Greek monarch Diomedes (r. c. 110–80 B.C.),[11] these images are considerably modified. Their hair is tied in the topknot worn by young ascetics in early Indian art, and they are dressed in Indian fashion wearing dhotis. The modeling is not as naturalistic, and rather than standing frontally as in Indo-Greek coins, here the two deities face one another. Whether these effigies imitate cult images of the Yaudheyas is not known. The representations certainly differ from the earliest known cult image of Skanda dedicated in the year 11 (= A.D. 89?), now in the museum at Mathura.[12]

By and large, the divinities on Kushan coins, whether of the Greek, Iranian, or Indian pantheons, are modeled on Hellenistic figures. The clarity of relief and degree of naturalism differ from one figure to another depending on the skill of the diecutter. Some figures, such as the wind god (C11), Siva (C13a–b), or Ardoxsho (C14), are elegantly modeled, displaying the refined naturalism characteristic of Hellenistic sculpture. Others (C10a–c), even though the type is derived from the Hellenistic repertoire, are rendered in a more abstract and linear style reminiscent of Scythian coins. Most Kushan coins were minted either in Bactrian or Gandharan mints. In both regions the engravers were obviously more familiar with Greco-Roman styles than Indian.

By contrast, the divinities portrayed on the reverse of Gupta coins are much more Indian in style. While the Gupta coins do not display the iconographic diversity of the Kushan coins, the representation on most being limited to the Goddess, her disposition displays interesting variations and artistic ingenuity. She is shown frontally, seated on a lion (C25) or throne (C27a), with relaxed elegance on a wicker seat (C27b), or in the meditation posture on a lotus (C28a–c). She usually stands in a lively and graceful posture, either alone (C26) or in the company of a dancing peacock (C30a–b). In some coins she wears Hellenistic dress (C25), but generally she is attired in the Indian manner with her upper body bare. With few exceptions (C27c), the Goddess's right hand carries what is usually identified as a noose. The left hand holds either the cornucopia or lotus flower.

In general, the noose- and cornucopia-bearing goddess of the Gupta coins is a continuation of a goddess identified as Ardoxsho in later Kushan coins. Whereas in Kushan coins the attribute in the goddess's right hand is usually identified as the diadem, in the Gupta context the same emblem in slightly varied form is generally identified as the noose. Although the name Ardoxsho is an Iranian epithet, the goddess is neither conceptually nor iconographically different from the Greek Tyche or Roman Fortuna. All three are essentially goddesses of abundance and royal fortune and are closely related to the Indian Sri-Lakshmi, who serves the same functions in the Indian pantheon and mythology. Obviously the early Gupta engravers, continuing the conservative numismatic tradition, saw nothing amiss in using the Ardoxsho figure to represent Sri-Lakshmi or more specifically Rajyalakshmi, presiding goddess of royal fortune. The cornucopia was already accepted as an auspicious symbol of good fortune (*nidhi*) in Indian literature and was appropriate for Sri-Lakshmi.[13] The problem, of course, arises with the noose, which is not prescribed for Sri-Lakshmi. The emblem, however, can be regarded as a diadem symbolizing royal glory. She certainly holds it as if she were offering it to the king, which is how goddesses were represented on earlier coins. The early Gupta engravers probably did not consider it inappropriate to retain the familiar Ardoxsho image and may have done so intentionally just as they modeled their royal portraits on those of the Kushans. Obviously, the designer of the early Gupta coins could have replaced Ardoxsho with the more familiar, and Indian, image of Sri-Lakshmi (S17), but he did not do so, perhaps to ensure both continuity and stability in the new kingdom's monetary system. Once Samudragupta consolidated his position, his mint issued coins with newer images on both sides.

Some comments are necessary regarding the reverse image of the very first issue of the Gupta dynasty (C25). In the dinar attributed to Chandragupta I the Ardoxsho, or Sri-Lakshmi, figure sits on a lion. Chandragupta II also used this device. In Kushan coinage Ardoxsho is never associated with the lion, the mount of Nana. In the Kushan art of Mathura, however, the lion is definitely represented as a mount of Durga, and certainly by the early fourth century the association became firm. In at least one Gupta image of Durga the goddess is seated on a lion as she is on Chandragupta I's coin.[14] In the northwest, especially in Kashmir, the goddess frequently is shown seated on a lion, holding a lotus in one hand and cornucopia in the other while being bathed by two elephants (S103). Except for the lion and cornucopia, this was, in fact, the classic form of Sri-Lakshmi since at least the third century B.C. Very likely the image in Kashmiri representations and Gupta coins either depicts a syncretistic portrait of the Goddess combining both Sri-Lakshmi and Durga or simply follows an iconographic tradition in which the lion was associated with Sri-Lakshmi. After all, the presiding deity of the first section of the *Devimahatmya*, the sacred book of the Goddess, is called Mahalakshmi.

Equally difficult to identify precisely are two other figures: a flywhisk-bearing lady on the reverse of Samudragupta's *asvamedha* coin (C27c) and a female feeding or sporting with a peacock on Kumaragupta's coins (C30a–b). The former generally has been identified as the chief queen of Samudragupta.[15] The figure may instead represent Vijaya, goddess of victory, corresponding to the

Greek Nike. Significantly, she stands before a festooned spear, which may represent a victory column, although the spear is also the emblem of the war god, Kumara. Certainly in Kumaragupta's coin the goddess is associated with Kumara, whose mount is the peacock. The figure could, thus, represent Kaumari, the goddess who personifies Kumara's power or energy (sakti). While one cannot be certain of the exact identity of either figure, it would not be inappropriate to suggest that both broadly depict different aspects of the tutelary goddess of the imperial Guptas, who was probably Sri-Lakshmi.

There seems little doubt that even in the early representations based on Kushan prototypes, the figures already reflect stylistic differences commensurate with the aesthetic norms of the Gupta period. The engraver of Chandragupta I's coin (C25) has taken particular care to reveal the physical charms of the figure beneath her well-defined robes. Unlike the hieratic posture of Ardoxsho on Kushan coins, she sits much more gracefully in *lalitasana* as do goddesses in Gupta sculpture. With her narrow waist, wide sweep of the hips, and exuberant posture, the figure on Kacha's coin (C26) definitely represents the Indian ideal of feminine beauty rather than the Hellenistic model followed by the Kushan engravers. This is even more evident in the coins of Samudragupta. Whether standing or seated (C27a–c), the figures are closely related in style to the female figures of contemporary Gupta sculpture. Typical of Gupta sculpture, the swelling masses and elegant curves of the body are emphasized, while at the same time the rhythmic interplay of lines and shapes restrains the exuberance and vegetative abundance of the form. Indeed, the general quality of the figures on both sides of Gupta coins is so consistent that we must assume that the finest engravers in the kingdom worked for the imperial mints. They were also creative artists, who did not hesitate to invent new and varied images that are appealing both for their content and style.

Notes

1. Banerjea 1956 for the most comprehensive survey of iconography and Mukherjee 1983 and 1985 for the study of art in coinage.

2. For a brief, but useful survey of Indian coins see Sircar 1968.

3. M. Beiber, *Alexander the Great in Greek and Roman Art* (Chicago: Argonaut, 1964), pl. XII, no. 22.

4. Rosenfield 1967, pp. 54–55.

5. Ibid., pls. 1–2.

6. Ibid., pls. 119–20. Splayed feet are also not seen in the royal portraits found at Hatra in Syria, although a divine sacrificer (ibid., pl. 145) stands almost like Kanishka. Incidentally, figures with splayed feet occur frequently in earlier Indian relief sculpture, especially at Bharhut (cf. Barua 1979).

7. Mitchiner 1978, p. 267, nos. 1759–61.

8. Harper 1978.

9. Ibid., p. 26. See also Shepherd 1980.

10. Although the evidence for the prevalence of Vaishnava cults in pre-Christian times in Gandhara and Afghanistan is slim, recent discoveries in Pakistan, not yet published, may indicate a greater popularity of the religion during the Kushan period.

11. Mitchiner 1978, p. 292, nos. 1968–72; cf. also p. 324, nos. 2251–54 for tetradrachmas of Azes I with the standing Dioscuri.

12. Rosenfield 1967, pl. 49.

13. M. Chandra 1966.

14. Williams 1982, fig. 80. Interestingly, Williams dates this sculpture around 430–60 but does not compare it with the representation on the coin.

15. Gupta and Srivastava 1981, p. 13. See also Sivaramamurti 1979, pp. 60–61.

Catalogue

C1 Punch-marked Coin
C. 500–300 B.C.
Silver; ¾ x ½ in (1.9 x 1.2 cm)
Gift of Anita Spertus and Jeff Holmgren;
M.75.89.2

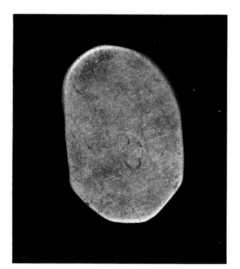

C1 obverse C1 reverse

Obverse: Five symbols (bottom, clockwise): rayed sun; two ovals connected by horizontal line or bar; four-squared square with bull and dumbbell in diagonal squares; arrows and ovals with alternating dot placed around circle with conspicuous dot, known as six-armed symbol; tree with railings. Reverse: Crescent roughly shaped in form of human face (?) on right.

Punch-marked coins are the oldest form of Indian currency and were circulated for a long time, from about the sixth century B.C. to the fifth century A.D. in some parts of southern India. Consisting primarily of irregularly shaped silver bars, they were often clipped to conform to a standard weight. Symbols were punched on the obverse, and the reverse was either left blank or impressed with a single sign or symbol.

While some symbols on punch-marked coins are familiar, others remain unexplained. Two symbols on this example, the rayed sun and tree with railings, are well-known religious symbols. Some symbols resemble those on the seals and small copper plates of the Indus Valley civilization (third millennium B.C.), while others survived into later Indian coinage. The reverse mark here corresponds to that seen in some others discovered in Taxila in Pakistan, which may have been the source of this example.

C2 Coin of Eucratides I (r. c. 171–155 B.C.)
Bronze; ¹⁵⁄₁₆ x ⅞ in (2.4 x 2.2 cm)
Purchased with funds provided by Anna Bing
Arnold and Justin Dart; M.84.110.4

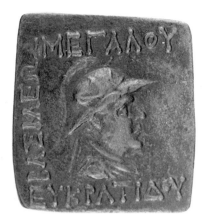

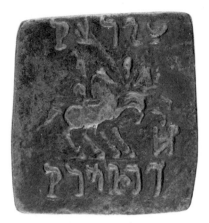

C2 obverse C2 reverse

Obverse: Bust of king to right wearing helmet. Legend, Greek: *Basileus metaaoy Eukratidoy* (of the great king Eucratides). Reverse: Mounted Dioscuri charging right, holding palms and spears. Legend, Prakrit with Kharoshthi: *Maharajasa Evukratidasa* (of the great king Eukratides).

Eucratides I began his career by usurping the throne in Bactria about 171 B.C. By the time he was killed, probably by one of his sons about 155 B.C., he had extended his kingdom as far south as Gandhara, although probably not beyond the Indus River. His conquests clearly indicate that he was a military genius as well as an excellent leader. His assumption of the epithet Megas (great) was well justified; the Roman historian Justin considered him to be one of the great Indo-Greek monarchs.

The high relief and excellence of the portrait indicate that the coin was more than likely produced in a Bactrian mint; that it was meant for the Indian possessions is evident from its square shape, Kharoshthi legend on the reverse, and correspondence to the Indian standard.

The device of the charging Dioscuri was adopted from earlier Seleucid coinage. In classical mythology the Dioscuri are Castor and Pollux, the two sons of Zeus and Leda. They are the patrons of athletes, soldiers, and mariners and may have had special appeal for Eucratides, an ambitious conqueror.

C3a–c Three Drachmas of Menander I
(r. 155–130 B.C.)
Silver; diameter, *a–b*, ¾ in (1.9 cm),
c, ⅝ in (1.5 cm)
a, Indian Art Special Purposes Fund;
M.81.154.5
b–c, Purchase with funds provided by Anna Bing
Arnold and Justin Dart; M.84.110.5–6

a, obverse: Bust of king to right wearing Medusa helmet. Legend, Greek: *Basileus soteros Menandroy* (of the king Menander, savior). Reverse: Pallas Athena standing left hurling thunderbolt. Legend, Prakrit with Kharoshthi: *Maharajasa tratarasa Menandrasa* (of the great king Menander, savior).

b, obverse: Bust of king, diademed, to left wearing aegis over left shoulder, thrusting javelin with right hand. Legend: Same as *a*. Reverse: Pallas Athena standing right, hurling thunderbolt, wearing aegis draped across left arm. Legend: Same as *a*.

c, obverse: Bust of king, diademed, to right. Legend: Same as *a*. Reverse: Same as *a*.

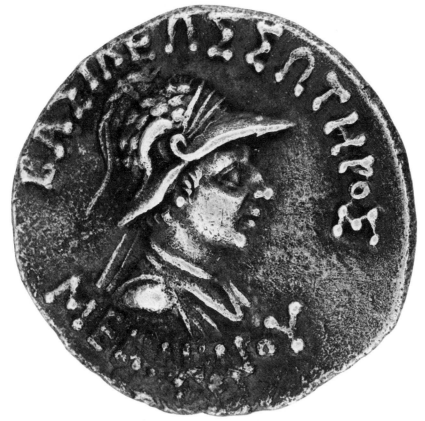

C3a obverse

C3b obverse

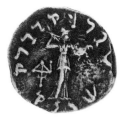

C3b reverse

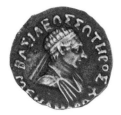

C3c obverse

C3a reverse

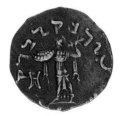

C3c reverse

Menander was one of the greatest Indo-Greek rulers of northwestern India and has remained a legendary figure in Indian literature. He probably penetrated as far into India as the Yamuna River and may have ruled over the most extensive Indo-Greek kingdom on the subcontinent. Classical sources remember him as a conqueror and just ruler, and the Indian tradition has preserved his memory as a philosopher-king, who was deeply interested in Buddhism. King Milinda, one of the principal characters in the well-known Buddhist philosophical work the *Milindapañho* (Questions of king Milinda), is usually identified with Menander.

Although the three coins may seem similar, there are interesting differences among them. The portrait busts in *a* and *c* are similar, except that in *a* the king wears a Medusa helmet (rather than the smooth helmet worn by Eucratides I [see C2]), whereas in *c* he is diademed as in *b*. The Medusa helmet was apparently introduced into India by Menander I.

Although the heads in *b*–*c* are diademed, the treatment of the ends of the diadem are different. In *c* they are quite thick and fall in almost parallel straight lines over the shoulders. In *b* they are much thinner, and, in keeping with the greater animation of the javelin-thruster image, one strand flies in the wind while the other falls down the neck. The king's name is separated from the rest of the legend and placed more symmetrically on the surfaces of *a*–*b*; in *c* it is a running inscription as was more customary.

Menander may also have introduced the effigy of Pallas Athena hurling a thunderbolt instead of a spear, the goddess's usual weapon. The substitution is not inappropriate since she is the daughter of Zeus, whose weapon is the thunderbolt. The thunderbolt-hurling Athena of Menander's coins is very similar to the thunderbolt-hurling Zeus of the commemorative coins of Agathocles (r. 180–165 B.C.) (see Lahiri 1965, pl. I, nos. 10–11). While the representations of Athena are

similar in *a* and *c*, interesting differences occur in *b*. In both *a* and *c* she stands on her toes, faces left, and hurls the thunderbolt. The viewer sees her from the back, and she is clearly a militant figure. In both her helmet is crested, although the crest is somewhat less prominent in *c*. In *b* the helmet is smooth, and she stands frontally facing to the right. In fact, her graceful and relaxed stance as well as her costume, a short tunic and pleated skirt, are reminiscent of the famous statue of Athena Parthenos by Phidias (*Larousse Encyclopedia*, p. 118). In the other two representations, she wears an aegis over her shoulder, and, curiously, a chlamys or scarf is thrown over her arms. In classical art the chlamys is usually depicted on the nude Zeus or Apollo and not on Athena. While in both *a* and *c* the goddess holds a shield with her left hand, in *b* a fringed aegis is draped over her left arm. This is very likely the snake-frilled aegis

she is said to have fashioned from the skin of the giant Pallas. Writhing snakes are clearly visible hanging from the aegis in *b*.

Although all three coins were issued for Menander's Indian possessions, it is very likely that *a–b* were produced earlier in a Bactrian mint. The modeling of Athena in both appears to be of a distinctly higher quality than in *c*. The royal bust, however, is sensitively rendered in all three coins. Each is a well-observed portrait, with the facial features articulately defined. The king's face is dominated by a strong, sharp nose and rather penetrating eyes. By contrast to *a–b*, in *c* an older king is portrayed with slightly sunken cheeks, furrowed brow, and mature expression. Thus, not only does *c* seem to be a later issue, but the poorer quality of the reverse device suggests that the engraving was done in an Indian mint, perhaps by a less competent engraver than those responsible for *a–b*.

C4 *Drachma of Apollodotus* (r. c. 115–95 B.C.)
Silver; 9/16 in (1.4 cm) square
Indian Art Special Purposes Fund; M.81.154.6

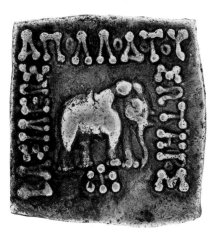

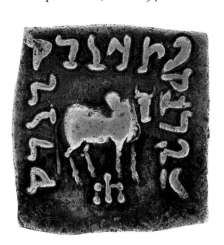

C4 obverse C4 reverse

Obverse: Elephant standing right. Greek monogram below. Legend, Greek: *Basileus Apollodotoy soteros* (of the king Apollodotus, savior). Reverse: Humped bull standing right. Greek monogram below. Legend, Prakrit with Kharoshthi: *Maharajasa Apaladatasa tratarasa* (of the great king Apollodotus, savior).

Scholars disagree about the number of kings who were known as Apollodotus. Some believe that two Indo-Greek kings bore this name (see Lahiri 1965, pp. 90–92), while others consider there to be only one King Apollodotus, a son of Menander (see Narain 1980). In any event,

Apollodotus was among the few Indo-Greek monarchs who issued square coins that do not include a royal bust. The naturalistic modeling of the animals on this coin is characteristic of Indian art.

The bull is closely associated with the Hindu god Siva and is a frequent device on early Indian coins. Its presence on coins is generally regarded as the theriomorphic representation of the god himself. The elephant

may be the symbol of the god Indra, whose mount he is considered to be. Like the bull, the elephant was a popular device on coins of the Seleucids and other Indian tribes and kingdoms (Marshall [1951] 1975, 2: p. 158). The elephant appears to have been a sacred animal in Taxila and Kapisa, cities located very likely within the realm of Apollodotus. Both animals are also represented on the contemporary coins of the Audambaras and Yaudheyas. Significantly, coins of Apollodotus were found together with coins of

the Audambaras, which resemble the ruler's hemidrachmas, near Pathankot in Panjab, the center of Audambara activity (Sharan 1972, pp. 219–20, 235). This coin type may have been struck by Apollodotus after he conquered these tribal territories.

According to Sivaramamurti (1979, pp. 44–45), the animals may have been used as allegorical or metaphorical symbols for the political power of the sovereigns. In Sanskrit the bull and elephant are constantly cited as metaphors for the best in any given class.

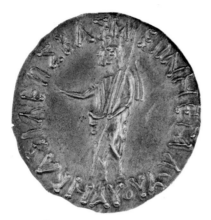

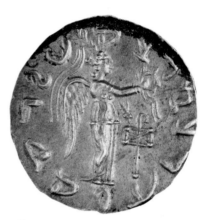

C5 obverse C5 reverse

C5 *Drachma of Maues* (r. c. 75–57 B.C.)
Silver; 1 ⅛ in (2.9 cm)
Purchased with funds provided by Anna Bing Arnold and Justin Dart; M.84.110.7

Obverse: Bearded Zeus standing left, wearing himation, extending right arm. Long scepter in left hand. Legend, Greek: *Basileus basileon magaloy Mayoy* (of Maues, the great king of kings). Reverse: Winged Nike standing right. Palm bound with fillet in left hand, beribboned diadem in right. Monogram below outstretched arm. Legend, Prakrit with Kharoshthi: *Rajatirajasa mahatasa Moasa* (of Maues, the great king of kings).

Maues is generally considered to be the first Saka king of northwestern India, although he may have had a predecessor (Srivastava 1972, p. 4). Maues not only overran the Indo-Greek kingdom in eastern Panjab but also extended his rule as far south as Mathura. Although his lifedates are uncertain, it is likely that he ruled around 75 until 57 B.C. On his coins Maues adopted the Iranian royal appellation, calling himself "Rajatirajasa mahatasa" (the great king of

kings), but he continued the Indo-Greek tradition of using effigies of Greek gods. Curiously, however, on this coin he did not use his own portrait on the obverse but that of Zeus. Usually the Indo-Greek monarchs preferred the enthroned figure of Zeus, but in a coin of Agathocles the god is portrayed standing and holding the torch-bearing Hecate in his outstretched right hand. Maues's engraver seems to have employed this type of standing image of Zeus.

The proportions of this figure are, however, different; Zeus is stocky and bulkier. The scepter also is held differently. The Nike figure was very likely borrowed from the coins of Antialcidas (r. 115–100 B.C.) in which Zeus is shown seated but holding the figure of Nike proffering a wreath in her outstretched right hand. Nike is the Greek goddess of victory, an appropriate model for a king who must have won many victories in the establishment of the Saka kingdom.

C6 Drachma of Azes I (r. c. 57–35 B.C.)
Silver; diameter 1 1/16 in (2.6 cm)
Indian Art Special Purposes Fund; M.81.154.3

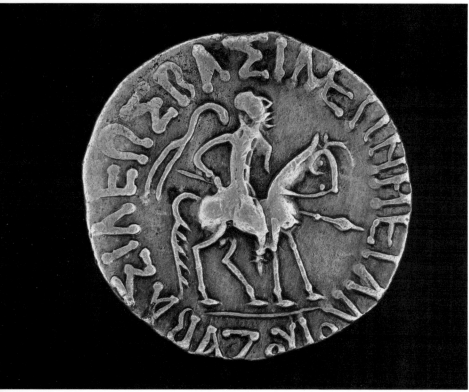

C6 obverse

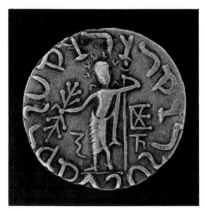

C6 reverse

Obverse: King riding right on horse and holding couched spear. Legend, Greek: *Basileus basileon megaloy Azoy* (of Azes, the great king of kings). Reverse: Zeus standing. Thunderbolt in right hand, scepter in left. Snake symbol beside right leg; two monograms below left arm. Legend, Prakrit with Kharoshthi: *Maharajasa rajarajasa mahatasa Ayasa* (of Aya, the great king of kings).

Azes was the successor of Maues and may have been related to him by marriage. He was also related to Spalarises, Parthian king of ancient Arachosia in southern Afghanistan, west of the Indus. Not much is known about Azes except that his kingdom probably included Arachosia, Gandhara, and western Panjab including, perhaps, Mathura. His lifedates are not known, but he is considered by many as the initiator of the era of 58–57 B.C., known commonly as the Vikrama era in India.

This particular coin type seems to continue the type issued by Vonones, a Parthian ruler of Arachosia and predecessor of Spalarises, with whom Azes had jointly issued a coin while he was in Arachosia. Although representations of a mounted horseman and the god Zeus were prevalent in Indo-Greek coins, the style in which they are depicted in Azes's coins is notably different. The slim, abstracted forms of the mounted king and his horse appear as comic caricatures of a latter-day Don Quixote and his steed. The figure of Zeus, with its simplified torso and serpentine arms and legs, lacks the elegance of the more classical representations on Indo-Greek coins. The thunderbolt is disproportionately larger than the figure, as if the engraver wanted to draw the viewer's attention to the attribute rather than to the effigy.

C7 *Drachma of Azilises*
C. 50 B.C.
Silver; diameter 1 1/16 in (2.6 cm)
Indian Art Special Purposes Fund; M.81.154.4

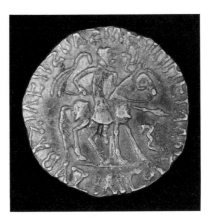

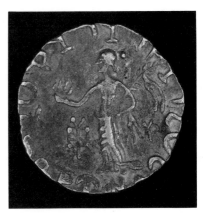

C7 obverse C7 reverse

Obverse: King riding right on horse and holding couched spear. Snake symbol below spear; Greek monogram above horse's head. Legend, Greek: *Basileus basileon megaloy Azilisoy* (of Azilises, the great king of kings). Reverse: Nike standing left flanked by two monograms. Ribboned palm in left hand, flame in right. Legend, Prakrit with Kharoshthi: *Maharajasa rajarajasa mahatasa Ayilisasa* (of Ayilisa, the great king of kings).

Azilises was a coruler and successor of Azes I and may have been his son. He issued some coins jointly with Azes I and continued Azes's coin type. Once again, as with his predecessor's coin, the complete effigy of the king conforms to a type and is not an individual portrait. The attire of the king can be recognized easily. It consists of tight-fitting trousers, long coat, and peaked hat. The king's face appears to have been beardless.

More interesting is the representation of the goddess on the reverse of the coin. She is identified as Nike and is the same figure as in Maues's coin (C5), except that here she is without wings and holds a vessel containing fire rather than a diadem. The flames may symbolize the Iranian concept of royal glory. As suggested by Rosenfield (1967, p. 199), "the vessel of flames is probably the royal fire which

was the mark of an independent king, to burn unceasingly through his reign." This figure obviously represents a synthesis of the Hellenic Nike and Iranian concept of royal glory. The type was first adopted by Azes I, who appears to have replaced the diadem with the fire vessel. In Parthian coins the goddess is shown holding a diadem. The royal fire thus may have been given special significance by Azes I and was continued both by his Saka and Kushan successors.

This particular issue of Azilises is stylistically and aesthetically similar to that of his predecessor. It displays the same cursory and linear treatment of form and reflects the preferences of an individual artist. Other coins of Azilises reveal much greater refinement and assurance in the execution of the figure.

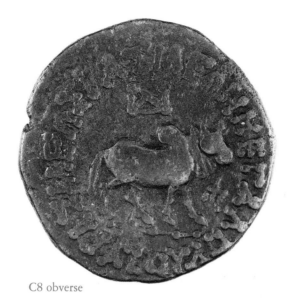

C8 obverse

C8 reverse

C8 Coin of Azes II (r. c. 20–1 B.C.)
Copper alloy; diameter 1 ¹⁄₁₆ in (2.7 cm)
Purchased with funds provided by Anna Bing
Arnold and Justin Dart; M.84.110.8

Obverse: Bull standing right. Monogram above.
Legend, Greek with Kharoshthi: *Basileus basileon
megaloy Azoy* (of the great king of kings, Azes).
Reverse: Lion standing right. Monogram above.
Legend, Prakrit with Kharoshthi: *Maharajasa
rajatirajasa mahatasa Ayasa* (of the great king of
kings, Azes).

Azes II was very likely a grandson of Azes I and
son of Azilises. He appears to have ruled the
Panjab region sometime during the last two
decades of the first century B.C.

The animals depicted on this
copper coin are religiously significant and also
symbolize regal qualities. The bull is the mount
of the god Siva, while the lion bears his spouse,
the goddess Durga. Both animals also are meta-
phors for the majesty and prowess of the king.
Two animals, one of which is the bull, were used
earlier in a drachma of Apollodotus (C4).

C9 Quarter Dinar of Vima Kadphises
(r. A.D. 1–50?)
Gold; diameter ½ in (1.3 cm)
Gift of Dr. and Mrs. A. J. Montanari;
M.77.56.5

Obverse: Bust of king to right within square
frame. Legend: None. Reverse: Trident with
battle-ax and ribbon in stand flanked by two
monograms. Legend, Kharoshthi
(reconstructed; Mitchiner 1978, p. 404):
Maharaja rajatiraja Vima Kapisasa (of Vima
Kapisa, the great king of kings).

The curious feature of the portrait is the
placement of the bust in a frame. This framed
bust also occurs on a dinar issued by Vima
Kadphises (Rosenfield 1967, pl. II, no. 27). In
that coin the image looks like a framed painting

with the king holding a flowering twig in his right hand. In the quarter dinars, such as this example, the king's fingers appear to rest on the lower arm of the frame or square, which has led to the suggestion that the square in fact represents a window (Rosenfield 1967, pp. 24–25). The image may represent a framed portrait (perhaps a bas-relief) of the monarch. Although such a device is encountered neither in imperial Roman nor Parthian coins, the idea is not unknown in much earlier Greek coins of Asia Minor (P. Gardner, *Archaeology and the Types of Greek Coins* [Chicago: Argonaut, 1965], pl. IV, nos. 4, 33–34, 39). In any event, this is a most unusual method of depicting a bust portrait and had neither any precedence nor following. Although this particular bust is somewhat faded, the strong features of the monarch, more easily perceptible in better-preserved coins, can still be discerned. Vima Kadphises was obviously a powerful king, and the images on his coins "are among the most impressive statements of Kushan art in any medium" (Rosenfield 1967, p. 19)

The reverse device of the trident is also not a very common emblem on early Indian coins. By itself the trident may be an emblem of either the Greek god Poseidon or Indian god Siva. Since the trident-bearing Siva occurs on other coins of Vima (Rosenfield 1967, pl. II, nos. 19–27), it seems reasonable to conclude that the trident in this example relates to Siva.

C9 obverse

C9 reverse

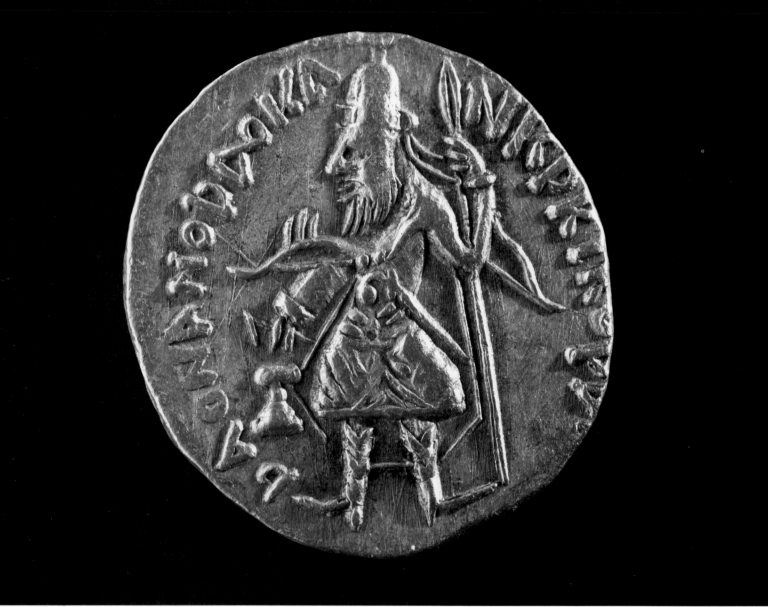

C10a obverse

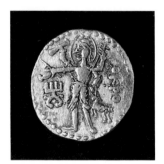

C10a reverse

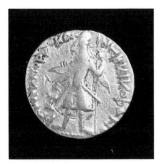
C10b obverse

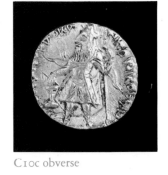
C10c obverse

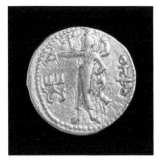
C10b reverse

C10c reverse

C10a–c Three Dinars of Kanishka I
(r. c. 78–102)
Gold; average diameter ¾ in (1.9 cm)
Gift of Dr. and Mrs. A. J. Montanari; *a*,
M.77.56.4, *b–c*, M.77.56.7–8

a, obverse: Bearded king standing left before altar, wearing boots, trousers, tunic, cape, tall helmet rounded at top and surmounted by crest. Three vertical lines, which may represent flames, rising from shoulder above right arm. Belt with curved handle attached at waist. Elephant goad in right hand, spear in left. Legend, Bactrian or Saka with Greek letters: *Shaonanshao kaneshki, kosha{no}* (of the king of kings Kanishka, the Kushan). Reverse: Four-armed Siva, nimbate, standing left, wearing dhoti. Thunderbolt in upper right hand, waterpot in lower right hand, trident in upper left hand, animal in lower left hand. Monogram below extended arm. Beaded border around edge. Legend, Bactrian with Greek letters, written vertically: *Oesho.*

b: Same as *a*.

c, obverse: Similar to *a–b*, except that headgear appears to be soft cap. Reverse: Male deity, nimbate, standing to left, wearing long, transparent tunic, cape (?) over shoulders. Right arm fully extended; left arm resting on sword. Monogram below right arm. Pearl border around edge. Legend, Greek: *Miiro.*

The full-length portrait of the monarch is characteristic of most of Kanishka's coins. Although the representation is more generalized than an Indo-Greek bust, nonetheless the facial features are distinctive. The large eyes, strong nose, wide mouth, and thick beard combine to characterize a powerful personality. The portrait probably reflects the advanced age of the monarch. While the form of the headgear in *c* is not clear, that in *a–b* is similar to the crowns worn by Kanishka's predecessor, Vima Kadphises (Rosenfield 1967, pl. II). The presence of the elephant goad and spear reinforces the martial nature of the portrait, while the firm, hieratic stance and flames near the right shoulder indicate the king's superhuman stature.

Kanishka I was the greatest Kushan king and is remembered in the Indian tradition both as a bloodthirsty conqueror and patron of Buddhism. Certainly during his reign the Kushan Empire was most extensive, stretching from Soviet Central Asia in the north to the Deccan in the south. Kanishka is said to have presided over an important Buddhist council held in Kashmir, which may have witnessed the emergence of Mahayana Buddhism. Kanishka discarded the Greek and Indian languages and Kharoshthi script on his coins, except for what are known as the inaugural issues, and began the use of the Bactrian language on both sides. Greek letters, however, were retained.

Kanishka also seems to have had a distinct preference for Iranian rather than Indian or Hellenistic gods. He is certainly the only monarch to have introduced the Buddha on his coins. Even though Buddhists claim him as their own, it is doubtful that he was a Buddhist. The variety of Hellenistic, Indian, and Iranian deities represented on his coins indicates his particular care in demonstrating his religious eclecticism.

In *a–b* the deity referred to in the legend is Oesho, probably the Bactrian version of Mahesa, or Bhavesa, both synonyms of Siva, who first appeared on the coins of Vima Kadphises (Rosenfield 1967, pl. II, nos. 18–27). Kanishka's engraver seems to have preferred another iconographic form. Siva's hairstyle is different, the topknot being prominent here, and his head is surrounded by a nimbus. Moreover, he is given four instead of two arms and is not shown with his bull. Of his attributes, the thunderbolt (or kettledrum according to some) is a novel feature and may have been included to emphasize a syncretism with Zeus. The vase or waterpot and trident are familiar symbols. The animal held in his lower left hand is generally identified as an antelope, but it may be a goat. These attributes are appropriate for Siva according to ancient literature, and if Kanishka lived during the first century, then these images are among the earliest four-armed representations of Siva in Indian art. More interesting is the manner in which the god holds the vase. It is not the conventional ascetic's waterpot (*kamaṇḍalu*), which is normally held with the lower left hand. Rather, it is a tall vase,

like an Iranian wine vessel, and Siva is clearly holding it upturned as if he were pouring a liquid. In some of Huvishka's coins representing this particular iconographic type, water pours out of the vase (Rosenfield 1967, pl. VIII, nos. 158, 160–61). This peculiar display may imply that Siva is actually engaged in lustrating the king or performing an investiture ceremony. The act was important for the Kushans and their predecessors; generally, the Romans and Iranians represented the act of divine investiture by showing a deity presenting a wreath or diadem to a king. In the Indian context, however, an initiation ceremony would consist of lustration by a brahmin, precisely what Siva is doing here.

The reverse device on coin *c* is of the sun god, whose Iranian name is used in the legend, further illustrating the king's predilection for Iranian deities. The icon, however, is neither Indian nor Iranian. Rather, the image was adopted from that of Helios, the Greek sun god, as seen, for instance, on a coin of the Indo-Greek ruler Philoxenus (r. 125–115 B.C.). As with Siva, the outstretched right arm of the god implies that he is either blessing the king or investing him with regal splendor.

CII *Coin of Kanishka I* (r. c. 78–102)
Copper alloy; diameter 1 ¹/₁₆ in (2.8 cm)

Purchased with funds provided by Anna Bing Arnold and Justin Dart; M.84.110.9

CII obverse

CII reverse

Obverse: King standing left before altar (see C10a–c). Legend: Damaged, but from remaining letters appears to have been the same as in C10a–c. Reverse: Man wearing dhoti, running left while holding shawl billowing behind and around him. Faintly visible monogram in front. Legend, only two letters visible, known from other examples: *Oado*.

The expression *Oado* on the reverse is Bactrian for *Vata*, the Indo-Iranian wind god. This deity occurs only on the copper coins of Kanishka I and Huvishka (Rosenfield 1967, p. 91), and his inclusion in the Kushan pantheon was obviously inspired by Iranian religious ideas. Iranians offered sacrifices not only to control the power of the wind but also to ask it for wealth. The naturalistic delineation of the bearded running

figure is based not on an Iranian prototype but on classical imagery. The description of the Indian wind god, known as Vayu in the iconographic section of the *Vishnudharmottarapurana*, says that he is "two-armed, his two hands holding the two ends of the scarf woven by him, his garment being inflated by wind (*vāyyāpuritavastra*), emphasizing his swift motion, his mouth being open and his hair dishevelled" (Banerjea 1956, p. 527). Clearly this iconographic description is based on representations on such Kushan coins. This dynamic form of the wind god, however, did not become popular in later Indian art, although occasionally he is shown holding a billowing scarf over his head while standing frontally (Asher 1980, pl. 222).

C12a–c Three Dinars of Huvishka
(r. c. 106–38)
Gold; average diameter ¾ in (1.9 cm)
Gift of Dr. and Mrs. A. J. Montanari;
a–b, M.77.56.11–12, *c,* M.77.56.9

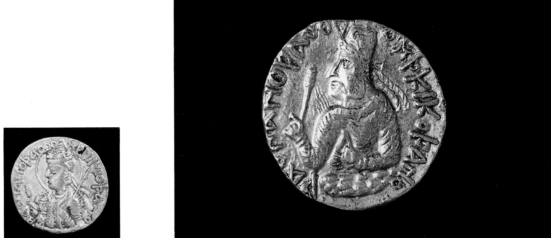

C12a obverse C12b obverse C12c obverse

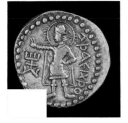

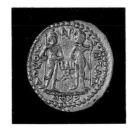

C12a reverse C12b reverse C12c reverse

a, obverse: Bust of king, nimbate, to left, emerging from rock or cloud formations, wearing tunic, peaked metal helmet adorned with bird head (?), earflaps. Flames rising from shoulders. Short mace in right hand, elephant goad in left. Legend, Bactrian with Greek letters: *Shaonsanoshao Oeshko Koshano* (of the king of kings, Huvishka, the Kushan). Reverse: Male deity, nimbate, standing left with legs widely apart and laterally placed, wearing diadem, chiton, chlamys. Left hand against waist, right hand outstretched with two fingers raised. Monogram below right arm. Beaded border around edge. Legend, Bactrian with Greek letters: *Ashaeixsho.*

b, obverse: Similar to *a*, except headgear is different and sides of face are not covered by earflaps. King's long curly hair clearly visible. Weapon in left hand seems to be a spear rather than elephant goad. Legend: Same as *a*, except that name is spelled Oeshki rather than Oeshko. Reverse: Goddess standing right, holding cornucopia with both hands. Monogram in front as in *a*. Beaded border around edge. Legend, Bactrian with Greek letters: *Ardoxsho.*

c, obverse: Bust of king to left, emerging from rock or cloud formations, wearing loose tunic quite different from that in *a–b*, rounded helmet with crest ornament. Flames rising from shoulders. Face of king unlike that in *a–b*, distinguished by heavy sideburns and what appears to be a wart. Scepter in right hand. Left hand brought across body, holding weapon not clearly distinguishable. In other coins (Rosenfield 1967, p. III, nos. 47–48) instrument appears to be an elephant goad. Legend: Same as *a–b*. Reverse: Separated by same monogram as in *a–b*, two gods wearing dhotis facing one another on a narrow base adorned with rinceau pattern. Hair seems to be arranged in a topknot. One hand held at hip, other hand holding long staff with knob. Legend, Bactrian with Greek letters: *Skando-Komaro Bizago* (Skanda-Kumara and Visakha).

Although the collection contains only three examples of Huvishka's coins, they provide us with some idea of the variety of images for which the emperor's coins are justly well known. Huvishka appears to have succeeded Kanishka I, but their exact relationship is unknown. It is certain, however, that he was a grandson of Vima

Kadphises. Huvishka seems to have preferred the bust portrait rather than the full-figure representation found on Kanishka's coins. The busts are presented in such wide variations that they cannot easily be organized in any chronological sequence. For instance, in *b* the king appears to be young and clean shaven. Although the side flaps of his helmet cover his face in *a*, it is probable that this, too, is a portrait of a youthful, clean-shaven emperor. Notwithstanding their similarity, there are notable differences among the coins. The features are much sharper in *a* with a strongly curved nose. In *b* the nose is substantial but not as gracefully aquiline and the face in general is more jowly. In *c* an altogether different personality is encountered, with a harsher face dominated by bushy sideburns and a sizable wart on the cheek. The headgears and attire differ in all three coins. Full regalia is worn in *a* and is slightly more elaborate than in *b*. The attire in *c* seems somewhat less formal. Interestingly, the halo is absent in *c*.

A chronological sequence based on the royal portraits alone would suggest that the ruler is much younger in *a–b* than he is in *c*. It seems unlikely, however, that a mature king would dispense with the nimbus, and, moreover, taxonomic studies of these coins belie a simple chronology (Göbl 1984). Besides, are we to assume that the wart was not congenital and the sideburns were an affectation of age rather than youth? That such a blemish should be so meticulously retained in a portrait intended to emphasize the king's divinity is interesting. Rather than establish any chronological sequence, these royal effigies may be considered idealized representations (*b–c*) and a less formal, individualized likeness (*c*). In the former the blemishes are eliminated and the regal character of the monarch is emphasized. In the portrait with the wart and sideburns the king is portrayed as he was seen by his contemporaries.

Huvishka was clearly not reticent about announcing his own divine status. This is indicated by the bust emerging from cloud formations (which seems to be the more likely interpretation than rocks) as well as the flaming shoulders and nimbus. Of these, only the flaming shoulders were employed by both Vima and Kanishka I. The flames were meant to symbolize the Iranian concept of royal glory. The king may also be identifying himself with the Iranian deity Pharro, the personification of royal glory, who occurs on the coins of Kanishka and Huvishka. Such symbolism would also be compatible with the Indian fire god, Agni. The nimbus, however, appears to have been introduced by Huvishka, since none of his predecessors employed it on their coins. Interestingly, the halo is not always shown in the representations of deities on the reverse (see *b–c*).

With regard to the reverse devices, the image on *a* is identified in the legend as Ashaeixsho, who is none other than Asa Vahista of the Iranian pantheon (see Rosenfield 1967, pp. 75–76). Known also as Amesha Spentas, he is the embodiment of truths and "the smiter of death, of fiends and illness." Regarded as the Bright Asa, he is closely associated with Atar, personification of fire. A comparison with Kanishka's coin (C10c) clearly illustrates that this image of Ashaeixsho is a modified version of that of the Iranian sun god, Miiro or Mihira. The sword has been removed, and the classical elegance and movement of Kanishka's figure have been eschewed for a more hieratic image. The upraised fingers of the extended right arm may indicate blessing or investiture.

The goddess depicted in *b* is Ardoxsho, whose name is Iranian but whose image is based on the classical Tyche. Although scholars disagree (Rosenfield 1967) as to the origin of her name, the fact that she holds the cornucopia and is modeled after Tyche clearly makes her a goddess of abundance and good fortune. An important figure in the Kushan pantheon, she was closely associated with Pharro. There seems little doubt that she is the Iranian counterpart of the Greek Tyche, Roman Fortuna, and Indian Sri-Lakshmi.

The confronting paired gods in *c*, identified as Skanda, or Kumara, and Visakha, are clearly Indian, as their names and representations indicate. Skanda and Kumara are two of several names of the Hindu god of war or divine general. Visakha was later identified with Skanda, but it seems that they were separate divinities during the Kushan period. Skanda, and Kumara, are also known as Karttikeya, the tutelary deity of a republican tribe known as the Yaudheyas. An ancient tribe, the Yaudheyas were militant and powerful during the Kushan rule. It is presumed that they were subjugated by Kanishka I, but they may have created trouble for his successor, Huvishka, who may have reconquered them or established an alliance with them by recognizing their legitimacy. This may explain the sudden appearance of the images of the patron deity of the Yaudheyas on Huvishka's coins. Whatever the political significance of this particular device, the gods are represented as purely Indian deities, depicted in the Indian fashion wearing dhotis and topknots. The youthfulness of Kumara appears to have been emphasized in Gandhara rather than in Mathura (see S67). The device may also have been a variation of the lance-bearing, erect Dioscuri on some of the coins of the Indo-Greek king Diomedes, who ruled early during the first century B.C. (Gardner [1886] 1971, pl. VIII, nos. 11, 14).

C13a–b Two Dinars of Vasudeva I
(r. c. 142–76)
Gold; diameter, *a*, ¾ in (1.9 cm),
b, ⅞ in (2.2 cm)
Gift of Dr. and Mrs. A. J. Montanari;
a, M.77.56.14, *b*, M.77.56.16

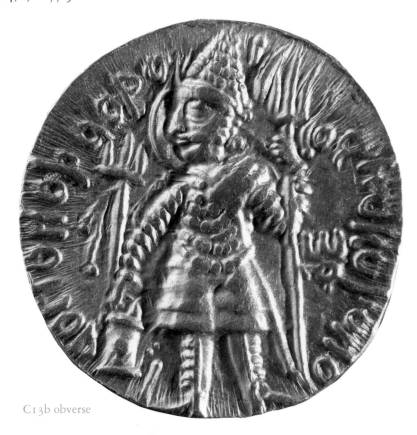

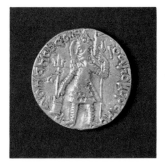

C13a obverse

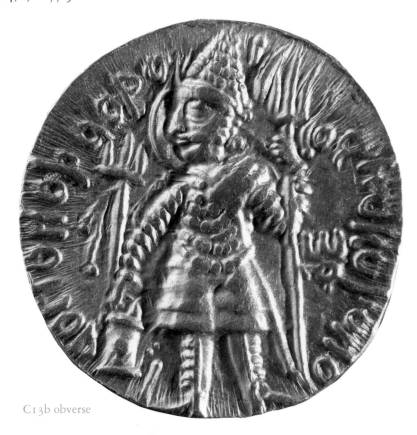

C13b obverse

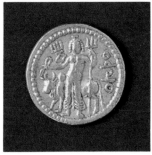

C13a reverse

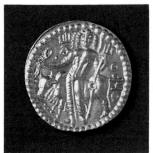

C13b reverse

a, obverse: King, nimbate, standing left, wearing long tunic, trousers, peaked crown. With right hand offering oblations at fire altar placed before beribboned trident. Long sword attached at waist on left. Monogram near left arm. Legend: Bactrian with Greek letters: *Shaonanoshao Bazodeo Koshano* (of the Kushan Vasudeva, king of kings). Reverse: Siva with small topknot and curly hair, wearing dhoti, standing in front of bull. Fillet or noose in right hand, trident in left. Monogram above right shoulder. Beaded border around edge. Legend, Bactrian with Greek letters: *Oesho*.

b: Similar to *a*, except without monogram on obverse. According to Göbl (1984, no. 642), this coin belongs to Vasudeva II.

Vasudeva I succeeded Huvishka, but their exact relationship is not known. The reign of Vasudeva I dates from the year 64 or 67 to 98, presumably of the Kanishka era. The most common device on the reverse of Vasudeva's coins is a representation of the god Siva. This, together with the fact that a trident is placed behind the altar on the obverse and the king himself frequently holds a trident instead of a spear, is taken to indicate his devotion to Siva. Yet the name Vasudeva is a synonym of Vishnu. In any event, Vasudeva is the first Kushan monarch to assume a Sanskrit name. It may well reflect a conscious attempt at Indianization, although this could have been achieved more easily by representing Siva and adopting an Indian script rather than the Bactrian word *Oesho* in Greek letters as on this coin.

When enlarged and compared with other Kushan coin portraits, it becomes clear that the monarch's face on these dinars represents an individual likeness. It differs considerably from those of Huvishka or Kanishka I and is dominated by a strong aquiline nose, rather thin lips, prominent moustache, and substantial chin.

Both examples typify Vasudeva's standard coin type with the full figure of the king on the obverse and Siva and his bull on the reverse. Vasudeva obviously preferred the full-length royal portrait rather than the bust favored by his predecessor, Huvishka. In the reverse device Vasudeva adopted the two-armed image of Siva standing against the bull used by Vima Kadphises rather than the four-armed Siva of the coins of Kanishka I and Huvishka. Rarely do other deities appear on Vasudeva's coins (see C16). Vasudeva's coin type remained a model for the later Kushan monarchs and Sasanian governors of Kushanshahr (see C19a–b).

The image of Siva in Vasudeva's coins has changed notably from that in Vima's coins (Göbl 1984, pls. 1–3). Siva here is a much-better modeled figure, who stands gracefully en face. In Vima's coins the figure is not as articulately rendered and the head is turned to the right. Moreover, in Vasudeva's coins the dhoti is clearly represented, while in earlier issues the garment is much more transparent and often the god appears nude. The trident is common to both images but is held in different hands. The other emblem in Vima's coins is a waterpot (?); in Vasudeva's coins a diadem or noose is shown. Perhaps the most noteworthy difference is perceptible in the hairstyles. In Vima's coins (as also in those of Kanishka I and Huvishka) Siva's hair is gathered into a chignon resembling the *kapardin* hairstyle of early Buddha heads (see S61).

C14 *Dinar of Vasudeva I (?)* (r. c. 142–76)
Gold; diameter 7/8 in (2.2 cm)
Gift of Dr. and Mrs. A. J. Montanari;
M.77.56.20

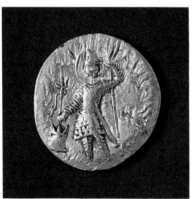

C14 obverse

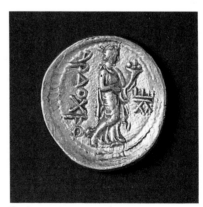

C14 reverse

Obverse: King, nimbate, standing left, wearing long tunic, tight trousers, peaked crown. With right hand offering oblations at fire altar placed before beribboned trident. What must have been a trident in left hand. Long sword attached at waist on right. Legend: Illegible. Reverse: Goddess standing right with right leg bent. Cornucopia filled with fruit in both hands. Monogram in front. Legend, Bactrian with Greek letters: *Ardoxsho*.

Without the legend on the obverse, it is difficult to ascertain the ruler's identity. The most likely candidate, however, is Vasudeva I. The representation of the king and fire altar on the obverse and monogram on the reverse (cf. Göbl 1984, pl. 3, nos. 541–42) suggest that the coin belongs to Vasudeva I. Martha Carter (personal communication) suggests that this coin may have been issued by Kanishka II. If it is, this coin is the first to be discovered with the standing figure of Ardoxsho as the reverse device.

The Ardoxsho device may have been copied from the coins of Huvishka (C12b). In some rare issues of Vasudeva's (Göbl 1984, pl. 30, no. 514), the representation of the goddess Nana is very similar to that of Ardoxsho except for the attribute. The figure of Ardoxsho on this unique coin is depicted with consummate artistry and much more elegantly than in Huvishka's coin.

C15 *Coin of Vasudeva I* (r. c. 142–76)
Copper alloy; diameter ¹³⁄₁₆ in (2.1 cm)
Gift of Anita Spertus and Jeff Holmgren;
M.75.89.1

The devices on both sides of this coin are similar
to Vasudeva I's Oesho coin type discussed in
C13a–b. The legends are illegible, but the
monogram is prominent on the reverse.

C15 obverse

C15 reverse

C16 *Quarter Dinar of Vasudeva I or II*
Second–third century
Gold; diameter ½ in (1.2 cm)
Gift of Dr. and Mrs. A. J. Montanari;
M.77.56.19

C16 obverse

C16 reverse

Obverse: Device and legend similar to Vasudeva
I's Oesho coin type (C13a–b), except that king's
long hair is delineated in loose strands falling
down shoulders rather than in curls as in two
larger coins. Wearing what seems to be filleted
soft cap rather than more characteristic conical
crown. Reverse: Siva standing in front of bull as
in C13a–b. Left leg bent at knee and placed
diagonally behind right leg. Legend and mono-
gram: Same as in C13a–b.

While most scholars consider these quarter
dinars to be Vasudeva I's (Rosenfield 1967, pl.
XI, no. 219), Göbl (1984, pls. 32, 526–27,
529–30) attributes them to Vasudeva II, who
may have ruled between about 230 and 260
(Mukherjee 1967, pp. 59–64). Although he
enjoyed a long reign, he was overpowered by the
Sasanians. In the year 230 Vasudeva likely sent
an envoy to the Wei court in China.

 The coin is most interesting for
the posture of Siva on the reverse. In no example
of Kushan art does Siva stand in this manner. In
early Kushan sculpture, however, yakshis often
assume this pose (Bachofter 1929, 2: pls. 91,

93). A male guardian figure in the first-century B.C. Buddhist cave at Bhaja in the Poona district of Maharashtra also strikes this cross-legged standing posture (ibid., pl. 653). In later Indian art Krishna generally assumes this posture when he plays the flute, although in a well-known south Indian early-eleventh-century bronze Siva stands with his legs crossed at the ankles (P. Chandra 1985, no. 95 and cover). It is unlikely that the engraver responsible for this coin was familiar with the Bhaja example, and he must have used figures like the Mathura yakshis as his model.

C17 Dinar of Kanishka III or Vashishka
Second–third century
Gold; diameter ¹⁵⁄₁₆ in (2.4 cm)
Gift of Dr. and Mrs. A. J. Montanari;
M.77.56.18

Obverse: King, nimbate, standing left, wearing long tunic with pointed ends, tight-fitting trousers, peaked crown, prominently tied fillet behind head. With right hand offering oblations at fire altar placed before trident. Brahmi letter beside trident in left hand. Legend: Illegible.
Reverse: Same as C13a–b.

The basic type is that of Vasudeva I's Oesho dinars (C13a–b), but numismatists disagree as to the identity of the ruler, who is particularly difficult to identify because of the partially preserved legend on this example. Göbl (1984, pl. 48) assigns the type to Vashishka, but B. N. Mukherjee (1967, pl. VI) considers it to be one of Kanishka III's. There is uncertainty regarding the dates of Kanishka III's reign, but very likely he ruled around 200 (Mukherjee 1967, pp. 79–84).

No matter who the ruler is, there is little doubt that the coin belongs to a later imperial Kushan monarch. Characteristic of these coins is the rather clumsy delineation of the bull on the reverse. On the whole, the animal is much better modeled in Vasudeva I's coins. The prominent fillet also does not generally occur in Vasudeva I's coins, and there are other minor differences in the design of the garments.

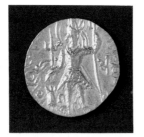

C17 obverse

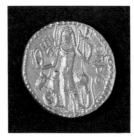

C17 reverse

C18 Dinar of Vasudeva II (?) (r. c. 230–60)
Gold; diameter ¹⁵⁄₁₆ in (2.4 cm)
Gift of Dr. and Mrs. A. J. Montanari;
M.77.56.17

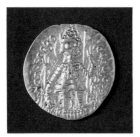

C18 obverse

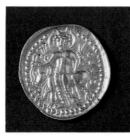

C18 reverse

The devices and legends on both sides of this dinar are similar to Vasudeva I's Oesho coin type discussed in C13a–b. Only the differences will be noted here.

The flan is thinner and larger, and the images and legends are executed more crudely. The figures are modeled in shallow relief and lack the elegance and finesse of those appearing on Vasudeva I's coins. The king's head is disproportionately enlarged, and his features are coarsely rendered. Instead of a topknot, Siva's head features a crescent, an appropriate iconographic element for the god that does not appear in the coins of Vasudeva I.

Although some scholars ascribe these coins to Vasudeva I (Rosenfield 1967, pl. XI), others consider them to have been struck by a second Vasudeva (Mukherjee 1967, pp. 84–85; Göbl 1984, pl. 32). Considering the differences noted above, this conclusion seems correct. The thin, broad flans and crude execution relate these coins much more closely to later Kushano-Sasanian coins (C19a–b) than to those of Vasudeva I's.

C19a–b *Two Kushano-Sasanian Dinars*
300–400
Gold; diameter, *a*, ⅝ in (1.5 cm),
b, 1 ½ in (3.8 cm)
Gift of Dr. and Mrs. A. J. Montanari;
a, M.77.56.22, *b*, M.77.56.1

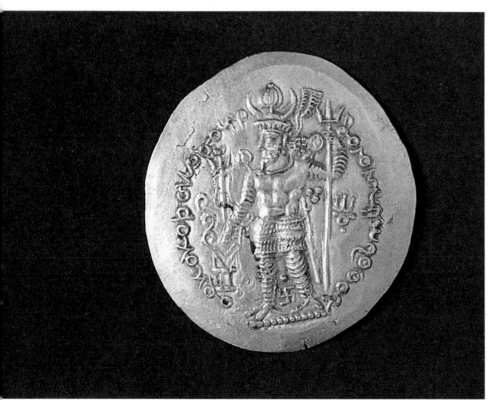

C19a obverse

C19b obverse

C19b reverse

C19a reverse

Obverse of each: King, crowned and bearded, standing left, wearing Sasanian dress. With right hand offering oblations at fire altar. Trident in left hand. Legends, Bactrian with Greek letters (reconstructed; Bivar 1956), *a: Bogo Perozo ooz/orko kosana saho* (Lord Peroz, great Kushanshah); *b: Bo oroh{?}rono oo/zooko kosa{??}o s {bogo oorshrano oo/zorko kosano saho}* (Lord Vahram, great Kushanshah). Reverse of each: Siva, standing in front of bull with legs placed well apart. Diadem or noose in right hand, trident in left. Hair seems to be flying around his head. In *a* wearing dhoti and may have more than one head; in *b* wearing Sasanian dress. Legend of each: Illegible.

Sometime around 225, with the decline of the imperial Kushans, the regions known as Bactria, Gandhara, and Sogdiana (present-day Uzbek, SSR) passed under the rule of the Sasanian dynasty of Iran. It has been generally held that Sasanian emperors routinely appointed one of their sons as governor to rule these newly acquired territories, which came to be known as Kushanshahr (see Bivar 1956). A recent theory (Carter 1985), however, proposes to identify them as independent rulers. The coins issued by these rulers largely continued Vasudeva I's Oesho coin type (C13a–b) with important differences. In general, the coins are thinner and larger with much wider flans and the workmanship is not as refined.

The ruler represented on the coin is dressed in Sasanian attire and wears a characteristic crown. Indeed, despite the fact that the legends are illegible, the figure can be identified by the design of the crown. The portrait in *a* certainly represents Peroz II, who had a short reign, from around 325 to 330 (see Carter 1985). According to Carter only two other examples of this rare coin type are known, one in the Kabul Museum, the other in the British Museum. The figure in *b* probably depicts Varahram III (born c. 350).

The Siva image on the reverse also varies from that seen in Vasudeva's coins. The arrangement of the god's coiffure may represent flames or simply depict wildly flying hair, not inappropriate for Siva. His stance and proportions, however, are quite different from other representations. Lacking the contrapposto of the prototypes, the figure here is more static and hieratic, perhaps to conform to Iranian taste. Indeed, dressing Siva in tunic and trousers also indicates attempts at Iranization.

C20a–b Two Dinars of Unidentified Kings
300–500
Gold; diameter, *a*, ¹¹⁄₁₆ in (1.7 cm),
b, ¾ in (1.9 cm)
Purchased with funds provided by Anna Bing Arnold and Justin Dart; *a*, M.77.55.27, *b*, M.84.110.10

a, obverse: King, nimbate, standing left, wearing prominently beaded tunic, trousers, hat. With right hand offering oblations at fire altar placed before beribboned trident. Legend, Brahmi letters: Illegible. Reverse: Enthroned goddess with head missing. Cornucopia in left hand.

b, obverse: Similar to *a*, except different attire and headgear. Legend, Brahmi letter, near left arm: *Bhri* [?]; legend, right field: *Shaka*. Reverse: Much-effaced figure of enthroned goddess similar to *a*.

A large number of coins of this type bearing apparently meaningless letters are generally regarded as issues of local rulers or governors, possibly of Scythian origin, from the northwestern part of the subcontinent or Afghanistan. In general, they are imitations of the Ardoxsho type of later imperial Kushan

dinars, with some notable differences. In addition to the legend, Shaka, most have a single or conjoint Brahmi letter below the left arm of the royal image. None of the coins has marginal legends, and the script used is Brahmi rather than the Greek letters employed in Kushan coinage. Indeed, a comparison with the early Gupta coins (C25) clearly indicates that the location of the Brahmi letters under the arm follows the Gupta practice of placing the king's name in the same position. Moreover, the Guptas were the first kings in northern India to use on their coins Sanskrit written with Brahmi letters. It is thus possible that these coins were minted by rulers after the rise of the Guptas in regions on the periphery of the Gupta Empire but still under Kushan influence.

While the word *Shaka* or *Shka* seems to have been used consistently on many of these coins, a wide variety of single or conjoint letters also has been recognized (see Göbl 1984, pls. 40–43). The legend in the right field in *b* is clearly *Shaka*, but in *a* it is composed of at least three letters as seen in several other examples (Göbl 1984, pl. 43, no. 595). Moreover, apart from minor differences in the facial features of the two royal portraits, the material and shape of the attire and headgear also vary. Thus, the coins may belong to two different kings.

C20a obverse

C20a reverse

C20b obverse

C20b reverse

C21 Coin of Gautamiputra Satakarni (?)
(r. c. 108–32)
Silver; diameter ⅝ in (1.5 cm)
Purchased with funds provided by Anna Bing
Arnold and Justin Dart; M.84.110.3

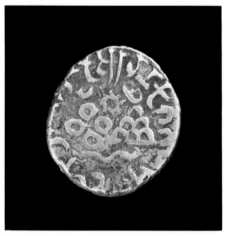

C21 obverse

C21 reverse

Obverse: Bust of king to right, wearing prominent jewel crest on forehead, heavy anchor-shaped ornament from distended earlobe. Legend, Prakrit with Brahmi letters: *Gotam{i}pu{??} s{i}r{i} {?}ta*. Reverse: In center Ujjaini symbol (four circles connected by cross, surmounted by crescent), radiate solar disk, and crescented hill of six arches; at bottom, serpentine configuration. Legend, Dravidian with Tamil-Brahmi letters: *Arahaṇasha {or ku} Gotam{i}puku{or sha} {????}sha {or ku}*.

Following a reading of the incomplete legends by B. N. Mukherjee (personal communication) and by comparing the portrait with others (Mirashi 1981, pl. XXII, fig. 36), the monarch can be identified as Gautamiputra Satakarni, who is regarded as the greatest Satavahana ruler. He revived the glory of the Satavahanas, and at its height his empire extended from sea to sea.

A comparison with portraits of other Satavahana rulers (C22–24) clearly shows that this representation is distinctly individualized. As in the other depictions, the monarch has rather thick lips, but his face is dominated by an exceptionally large flaring nose. As was also usual with Satavahana portraits, the large eyes have an intensely penetrating gaze. In general the facial features are naturalistically modeled.

C22 Coin of Vasishthiputra Pulumavi
(r. c. 132–59)
Silver; diameter ⅝ in (1.6 cm)
Indian Art Special Purposes Fund; M.81.154.1

C22 obverse C22 reverse

Obverse: Bust of king to right, originally wearing prominent jewel crest on forehead, heavy anchor-shaped ornament from distended earlobe. Legend, Prakrit with Brahmi letters (several letters above the head are missing): *{Vā}sithīputasa siri Puḷum{ā}visa* ([of] Pulumavi, son of Vasishthi). Reverse: Same as C21. Legend, Dravidian with Brahmi letters: *Arahana{sha} {Vā}hiṭṭimakanasha tiru Puḷam{ā}visha* (of Pulumavi, son of Vasishthi).

Vasishthiputra Pulumavi was one of the sons and successor of the illustrious Gautamiputra Satakarni (see C21), the greatest Satavahana monarch, whose empire probably stretched across the Deccan. After his death his empire appears to have been divided, and Vasishthiputra Pulumavi ruled over the region where a Dravidian language was spoken and which is known today as Andhra.

 The head of the king is a fine attempt at portraiture. The facial features, dominated by a strong nose and thick, protruding underlip, are articulately delineated. Rather interesting is the long, distended earlobe adorned with what appears to be an anchor-shaped ornament. The hair is a mass of knoblike curls. The head is not crowned with a diadem. The earlobe and nose, more aquiline in the portrait of Satakarni (C23), may reflect a certain idealization; otherwise we can assume that the portrait is a reasonable likeness.

The symbols on the reverse are familiar from earlier indigenous coins. Of these, the Ujjaini symbol, so called because it first appeared on the cast coins found in Ujjain (in present-day western Madhya Pradesh), is the most difficult to explain. It may signify the four directions, or it may represent a double thunderbolt. The motif may have been adopted by the Satavahanas after they conquered the Ujjaini region (Sarma 1980, p. 69). Indeed, if this symbol does signify the four directions, then together with the six-arched hill (first appearing on the coins of Gautamiputra Satakarni), solar symbol, and water, they may collectively symbolize the extent in all directions of the Satavahana Empire. Sivaramamurti (1979, pp. 55–56) suggests that the crescent symbolizes Satavahana fame, which had spread over the four oceans (indicated by the Ujjaini symbol), mountains, and netherworld (indicated by the snake). They may also have had a cosmic significance since the Satavahanas were brahmins who often performed Vedic sacrifices.

C23 *Coin of Vasishthiputra Satakarni*
(r. c. 159–66)
Silver; diameter ⅝ in (1.6 cm)
Indian Art Special Purposes Fund; M.81.154.2

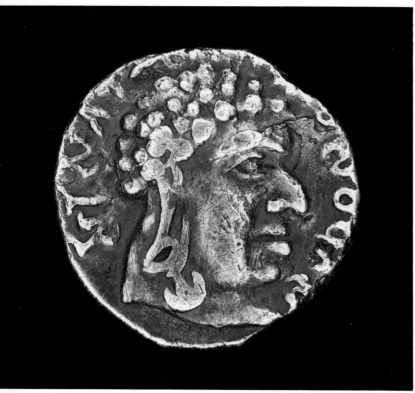

C23 obverse

C23 reverse

Obverse: Bust of king to right. Legend, partial, Prakrit with Brahmi letters: *D{i}ṭh{i}putasa siri Sātak{ṇisa}* (of king Satakarni, son of Vasishthi). Reverse: Same as C22. Legend, Dravidian, only a few Brahmi letters remain: *Arahanasha . . . Hātakaṇisha* (of king Satakarni, son of Vasishthi).

Vasishthiputra Satakarni was the younger brother of Vasishthiputra Pulumavi (see Mirashi 1981). He was also the son-in-law of the powerful Western Kshatrapa monarch Rudradaman (r. c. 130–50). Rudradaman defeated Pulumavi but spared him because they were related. Not much is known about Satakarni, but Mirashi (1981, pp. 40–41) believes that he may have inherited parts of the Satavahana kingdom on the western coast from his father, Gautamiputra Satakarni, and then ruled over Andhra Pradesh after the death of his brother Pulumavi in about 159. In any event, the diecutter of this coin seems to have copied Pulumavi's coin (C22). Except for the more aquiline nose, the portrait on this coin is undoubtedly of Pulumavi. B. N. Mukherjee (personal communication) has suggested that either the diecutter did not have a portrait of the new king or Satakarni may have ruled as regent during the last years of Pulumavi's reign. In any event, this coin definitely demonstrates that Satakarni was the immediate successor of Pulumavi.

C24 *Coin of Yajna Satakarni* (r. c. 174–203)
Silver; diameter ⅝ in (1.5 cm)
Purchased with funds provided by Dr. and Mrs.
A. J. Montanari; M.84.110.2

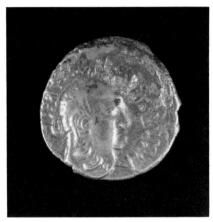

C24 obverse

C24 reverse

Obverse: Bust of king to right, wearing crest on forehead, anchor-shaped ornament from distended earlobe, tight-fitting cap with knotted string or tassel hanging along top of head. Traces of another portrait occur below. Legend: Illegible. Reverse: Same as C21. Legend: Illegible.

According to B. N. Mukherjee (personal communication), an older coin was apparently restruck with the portrait of Gautamiputra Yajna Satakarni, and for this reason the legend is blurred. His kingdom seems to have included both Maharashtra and Andhra Pradesh in the Deccan. He ruled for at least twenty-nine years.

Although this portrait is not as clear as other known examples (Mirashi 1981, pl. XXIII, fig. 42), it is nonetheless an individual likeness. Not only are the features cleanly rendered, but the ear is delineated with remarkable realism (cf. the distended lobes in C21–23). The monarch's distinctive headgear or hairstyle readily identifies his portrait.

C25 *Dinar of Chandragupta I* (r. c. 320–30)
C. 320
Gold; diameter ¾ in (1.9 cm)
Gift of Anna Bing Arnold and Justin Dart;
M.77.55.15

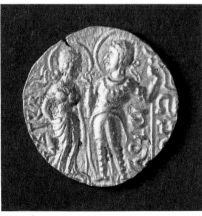

C25 obverse

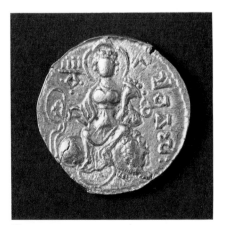

C25 reverse

Obverse: King and queen, nimbate, standing facing one another. King wearing tunic, trousers, pearl-bordered headdress with fillets. Also adorned with necklace, earrings, armlets. Staff surmounted by crescent, decorated with fluttering ribbons, in left hand. Right hand raised to shoulders with index finger and thumb forming circle. Queen wearing sari, otherwise adorned like the king. Right hand resting on hip, left hand hanging along side. Legends: Sanskrit with Brahmi letters: *Chandragupta, Kumāradevī*. Reverse: Goddess, nimbate, sitting en face on couchant lion, wearing scarf, pearl tiara. Noose in right hand, cornucopia in left. Feet resting on circular carpet. Legend, Sanskrit with Brahmi letters: *Lichchhavayaḥ* (of the Lichchhavis).

The legends clearly identify the king and queen as Chandragupta I and Kumaradevi, who was a Lichchhavi princess. The fact that the very first issue of Chandragupta I, founder of the Gupta Empire, should include the queen on the obverse, an uncommon practice, although not without precedence, indicates that the monarch was proud of his connection to the Lichchhavi heritage. His successors also continued to display this pride and emphasized their Lichchhavi relationship in their inscriptions.

While the coin borrows several elements from Kushan coin types, it nevertheless introduces many novel features. Although the king is dressed in Kushan costume, his headdress is unique. The crescent-topped staff is also an innovation; the crescent may refer to the king's name, Chandra, which means "moon." In Satavahana coins (C21–24) the crescent occurs on the reverse and may symbolize fame, which could also be its meaning here and on Chandragupta II's coin (see C29a–b). Although coins of some Indo-Greek kings represent both the busts of the monarch and his queen, this is the first instance in which the full-length figures of the two are shown together. The composition was very likely borrowed from Huvishka's coins in which Siva and Nana are sometimes portrayed together (Rosenfield 1967, pp. 165–66, pl. VIII). The figures here are modeled with much greater plasticity, as is the goddess on the reverse.

The device on the reverse was borrowed from the well-known Kushan Ardoxsho coin type and the much rarer type in which the goddess Nana is seated on a lion (Göbl 1984, p. 359, pl. 26, and p. 660, pl. 54; also Mukherjee 1969). By the Gupta period the lion had become the mount of the Indian goddess Durga. Thus, this figure on a Gupta coin is generally identified with Durga, even though the cornucopia is not associated with her. Obviously, we are once again confronting a composite figure, who has assimilated elements of Ardoxsho, or Nana, of the Kushan pantheon and the Indian goddesses Durga and Sri-Lakshmi (see S103). Some scholars have suggested that she may have been the titular goddess of the Lichchhavis.

C26 *Dinar of Kacha*
Gold; diameter ¾ in (1.9 cm)
Gift of Anna Bing Arnold and Justin Dart;
M.77.55.18

Obverse: King, nimbate, standing left, wearing trousers, tunic, large earrings, cap. Staff surmounted by wheel in left hand. Right hand placed above altar. Legend, under left arm: *Kacha*; surrounding legend (reconstructed; Altekar 1957, p. 87): *Kācho gāmavajitya karmabhir-uttamair-divam-jayati* (having conquered the earth, Kacha wins the heaven by excellent deeds). Reverse: Goddess, nimbate, standing left with right arm outstretched. Cornucopia in left hand. Sanskrit legend with Brahmi letters: *Sarvarājochhettā* (the exterminator of all kings).

The identification of Kacha remains one of the major mysteries of the political history of the Gupta dynasty. While he was certainly a Gupta ruler, his position in the Gupta succession is uncertain. His coin is similar to the standard type of Samudragupta (C27a), and many scholars think Kacha was another name for that emperor. His obverse device, however, differs from Samudragupta's standard coins in two significant ways. None of Kacha's coins displays the Garuda standard behind the altar and Kacha's left hand holds a standard with a wheel, while Samudragupta grasps a staff or standard without an emblem. Thus, if they were the same person, these deviations are difficult to explain. Moreover, the fact that the Garuda standard is missing in Kacha's coin may indicate that it was issued before Samudragupta's standard type. He may well have been a predecessor, perhaps an elder brother of Samudragupta, and succeeded to

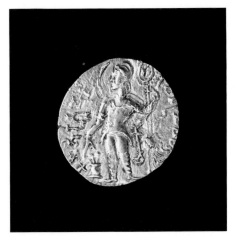

C26 obverse

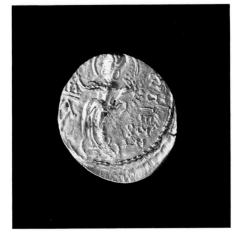

C26 reverse

the throne after Chandragupta I but was soon overthrown by his brother. Curiously, Kacha was never included in later Gupta genealogy. It is possible, however, that Kacha was the given name of Samudragupta, which he changed after his conquests, when the new standard coin type was also devised.

The king's portrait clearly continues the standard Kushan type, although it is doubtful that the altar had the same significance with the Guptas as it did with the Kushans. The king's headdress and cut of his tunic are different, and the trident behind the altar has been eliminated. Although the king's feet are unnaturalistically placed, the figure itself is more elegantly modeled than the hieratic representations on Kushan coins. The goddess on the reverse is also a continuation of the Kushan Ardoxsho type (C14), and, even if the impression on this example is not very clear, the form is quite different and less Hellenized than the prototype.

C27a–c *Three Dinars of Samudragupta* *Color plate, p. 49*

C27a–c *Three Dinars of Samudragupta*
(r. c. 335–76)
Gold; diameter, *a*, ¾ in (1.9 cm),
b–c, ⅞ in (2.2 cm)
a–b, Gift of Anna Bing Arnold and Justin Dart;
M.77.55.17, M.77.55.16
c, Purchased with funds provided by Dr. and
Mrs. A. J. Montanari; M.84.110.1

a, obverse: King, nimbate, standing left, wearing dress, headdress, ornaments similar to Chandragupta I's (C25). Right hand offering oblations at fire altar placed before standard bearing effigy of Garuda. Beribboned staff or standard in left hand. Legend, below arm (reconstructed; Altekar 1957, pp. 47–48): *Samudra*; around rim: *Samara-śata-vitata-vijayo jita-ripurajito divaṁ jayati* (the invincible [king], who had won victories on a hundred battlefields and conquered the enemies, wins the heaven). Reverse: Goddess, nimbate, sitting on throne, feet resting on circular carpet. Noose in right hand, cornucopia in left. Beaded border around edge. Legend: *Parākramaḥ* (valiant).

b, obverse: King, nimbate, with head turned to right, sitting on couch with backrest, playing lyre (vina), wearing short dhoti or loincloth adorned with string of pearls, large earrings, tight-fitting cap with pearl fringe in front. Small footrest placed near left foot. Legend, partially visible (reconstructed; Altekar 1957, p. 76): *Mahārājādhirāja śrī Samudraguptaḥ* (Samudragupta, the king of kings). Reverse: Goddess, nimbate, sitting left on wicker seat or stool, wearing sari, blouse, which closely hugs torso leaving stomach exposed. Adorned with plain necklace, headdress like king's. Noose in right hand, cornucopia in left. Standard or simple line separating her from legend. Beaded border around edge. Legend: *Samudraguptaḥ*.

c, obverse: Horse standing left on shallow platform before sacrificial post (*yūpa*) emerging from pedestal. Ribbon tied to post at about level of horse's mouth. Upper half of post curved twice to form a sort of cusped arch above horse's

head. Pennon fluttering from top of post above animal's back. Legend, partially preserved (reconstructed; Altekar 1957, p. 67): *Rājādhirājaḥ pṛithivimavitvā* [or *vijitya*] *divaṁ jayatyāhṛita-vājimedhaḥ* (the king of kings, who had performed the *vājimedha* {*aśvamedha*} sacrifice, wins heaven after protecting [or conquering] the earth). Reverse: Woman standing on lotus, looking left at festooned spear planted in ground, wearing sari held at waist with chain girdle, plain necklace, large earrings, anklets. Right hand holding flywhisk across shoulder, left arm hanging along side. Legend: *Aśvamedhaparākramaḥ* (the valiant one who has performed the horse sacrifice).

These three coin types of Samudragupta are known as standard (*a*), lyrist (*b*), and *aśvamedha* (*c*) and were probably issued in that order. The standard type is clearly derived from Kushan coins. Not only is the king shown offering an oblation into a fire altar, but he is also dressed like a Kushan monarch, except for the headdress and earrings. The trident of the Kushan coins

has been replaced by a staff held in the king's left hand and by the Garuda-bearing standard behind the altar. The image of Garuda remained the crest of the dynasty and reflects the strong Vaishnava inclination of the family. The reverse device is also borrowed from Kushan coins, but the cornucopia-bearing goddess with noose is not identified here as Ardoxsho as she is in Kushan coins. The goddess usually is identified as the Indian Sri-Lakshmi, but neither in Gupta art nor in literature is she portrayed with a noose.

Samudragupta's lyrist and *aśvamedha* coin types are among the finest and most innovative of ancient Indian coinage. Despite the nimbus, Samudragupta's portrait on the lyrist coin is radically different from the formal, hieratic effigy on the standard coin. The king sits in a relaxed, informal manner on a low couch as he plays his instrument. A human and approachable figure, the great conqueror appears eager to project the image of peace lover to his subjects. The effigy of the goddess on the reverse

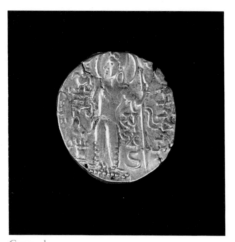

C27a obverse

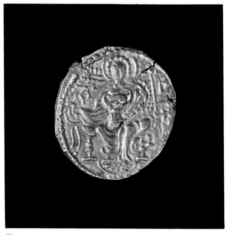

C27a reverse

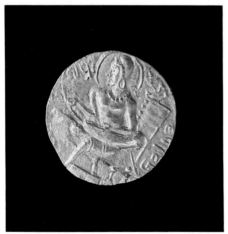

C27b obverse

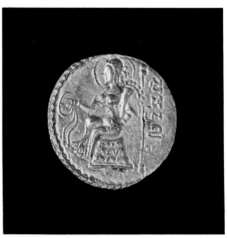

C27b reverse

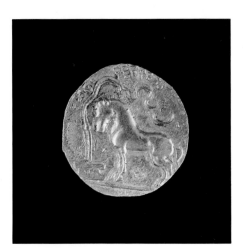

C27c obverse

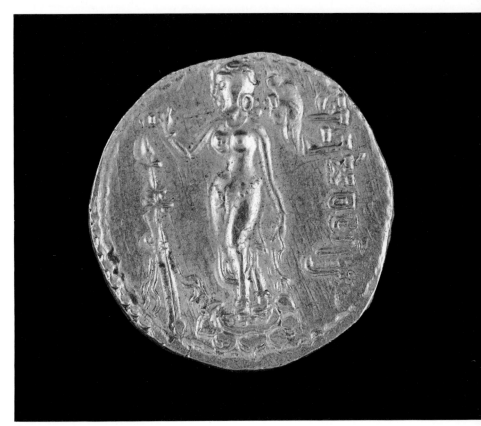

C27c reverse

is also informed with the same relaxed naturalism. The goddess sits with her body turned slightly to the left on a wicker stool instead of a throne. The modeling, whether of the full and fleshy form or of the drapery, reveals a much greater sense of volume than is apparent in the en face representations.

One of the latest issues of the monarch, the *aśvamedha* coin was devised to announce to the world that the king indeed had performed the great horse sacrifice. The performance of a horse sacrifice, the survival of a Vedic ritual, was clearly intended to proclaim the monarch's imperial authority. Although earlier kings of the Satavahana and Pandya dynasties had performed the sacrifice and issued commemorative silver coins with representations of a horse, Samudragupta's gold coin is more distinctive both for its artistic quality and explicit legend. This coin type thus represents another instance of the use of currency for propaganda.

The unknown engravers of the imperial mint were obviously highly skilled craftsmen. Not only have they given us a credible representation of a horse (Indian artists generally have never been very comfortable with this animal), but the graceful figure on the reverse is a superb rendering of the female form.

In the traditional Indian manner she is slim waisted and wide hipped. Her full breasts are not covered. Indeed, her graceful, naturalistic posture and svelte plasticity make her a much more elegant and provocative figure than the seated goddess (*b*), whose body is decorously draped following the classical mode as in Kushan coins.

Scholars disagree as to the identity of this figure. Most name her Dattadevi, chief queen of Samudragupta, but others (Gupta and Srivastava 1981, pp. 12–13) regard her as Vijaya, personification of victory, or Rajyalakshmi, goddess of sovereignty (Sivaramamurti 1979, p. 61), waiting on the mighty emperor with a flywhisk. She clearly stands on a lotus, holds nothing in her left hand (articulately rendered with long, graceful bean-podlike fingers), and wears a diadem. The spear in front of her may in fact represent a victory column.

C28a–c Three Dinars of Chandragupta II
(r. c. 376–414)
Gold; diameter, *a–b*, ¾ in (1.9 cm),
c, 15/16 in (2.4 cm)

Gift of Anna Bing Arnold and Justin Dart;
a–b, M.77.55.19–20, *c*, M.77.55.23

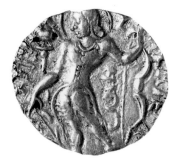

C28a obverse

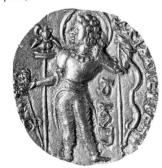

C28b obverse

C28c obverse

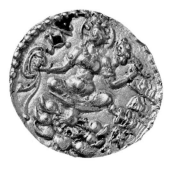

C28a reverse

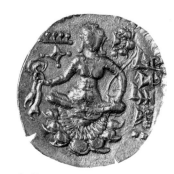

C28b reverse

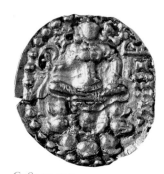

C28c reverse

a, obverse: King, nimbate, standing left, wearing trousers, flaring coat with buttons, tight-fitting cap, plain necklace, earrings. Bow in left hand, arrow in right. Garuda standard behind right arm. Legend, below left arm: *Chandra*; around rim (reconstructed; Altekar 1957, p. 93): *Deva śrī mahārājādhirāja Chandraguptaḥ* (the divine great king of kings, Chandragupta). Reverse: Goddess, nimbate, sitting en face on lotus with legs folded in lotus position. Diadem or noose in right hand, lotus flower turned toward her in left. Symbol near right shoulder. Beaded border around edge. Legend: *Śrī-vikramaḥ* (the courageous one).

b, obverse: Similar to *a*, except that king's jacket is without buttons and, but for flaring ends at either side of thigh, upper torso appears to be bare. Adorned with pearl necklace, armlets. Does not wear cap; curly locks indicated by circles. Reverse: Similar to *a*, except without beaded border.

c, obverse: Similar to *b*, except that king seems to wear short dhoti rather than trousers. Reverse: Same as *b*, except with beaded border.

A great king, Chandragupta II, son of Samudragupta, has remained one of the most legendary figures in Indian history. Not only was he a valiant conqueror, but he is also remembered as a munificent patron of the arts and culture. Many new coin types were invented during his reign, and he was also the first Gupta monarch to issue both silver and copper coins.

This particular coin is an imitation of the archer coin of Samudragupta (Altekar 1957, pl. II, nos. 12–14). Increasing Indianization is apparent in Chandragupta's coins. The goddess Ardoxsho of the father's coins is now closer to the Indian Sri-Lakshmi. Not only is she clad in the Indian manner, but she sits on a lotus instead of a throne and the West Asiatic cornucopia has been replaced by a lotus. While in *a* the king clearly wears a long jacket with buttons, in *b–c* the jacket is only vaguely suggested and it appears as if the monarch is bare chested in keeping with the Indian tradition.

Although the three coins are of the same type, they differ in minor ways. For example, in *a* the king holds the arrow quite differently than in *b–c*. Also, the left hand of the king in *a* does not go under the bow but over it. On the reverse in *a* the goddess holds the lotus by a short stem with her hand raised to the shoulder level, whereas in *b–c* the hand is placed upon her knee alongside of which a stalk sinuously rises. The diadem or noose is held differently in *a* than in *b–c*. Such minor variations are not in themselves significant, but they do indicate artistic individuality.

C29a–b Two Dinars of Chandragupta II
(r. c. 376–414)
Gold; average diameter ¾ in (1.9 cm)

Gift of Anna Bing Arnold and Justin Dart;
M.77.55.21–22

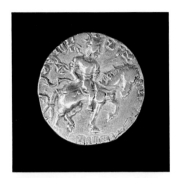

C29a obverse

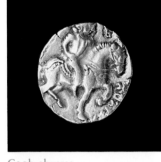

C29b obverse

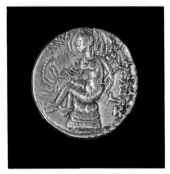

C29a reverse

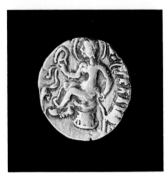

C29b reverse

a, obverse: King riding right on caparisoned horse. Right hand resting near waist. Reins in left hand. Attire cannot be clearly determined, but in most other examples of same coin type (Gupta and Srivastava 1981, pl. IX) he wears a dhoti and jacket. Headgear not recognizable; crescent attached to head. Legend (reconstructed; Altekar 1957, p. 123): *Paramabhāgavata mahārājādhirāja śrī Chandraguptaḥ* (the devout Bhagavata, the great king of kings Chandragupta). Reverse: Goddess, nimbate, sitting left, similar to C27b. Diadem or noose in right hand, lotus in left. Legend: *Ajita-vikramaḥ* (one of invincible courage).

b, obverse: Variant of *a*, with king's head and much of legend missing. Reverse: Variant of *a*, with wicker stool more clearly discernible.

The royal equestrian portrait introduces a new coin type issued by Chandragupta II, although the horse-rider type was common to Saka kings (C6–7). On the earlier coins, however, the motif is static, whereas in both coins of Chandragupta the representation is much more animated and the animals are much better rendered. In *a* the horse seems to be cantering, while in *b* the king appears to have pulled the reins to stop the

animal. The crescent above the royal head in *a* is not a common device and is reminiscent of the crescent standard of Chandragupta I (C25). Here, too, the crescent may symbolize the rising fame of the monarch.

The reverse device is clearly imitated from Samudragupta's lyrist type (C27b), in which the goddess appears in this elegant and naturalistic posture for the first time. The most noteworthy difference is iconographic: Chandragupta's goddess holds the lotus instead of the cornucopia, and she is clothed in a transparent sari, which allows us clearly to see how her feet are placed, while in the earlier coin her lower garment completely covers her feet. In the Kushan context the goddess represents Ardoxsho, in the Gupta coins she has become Sri-Lakshmi. Although the object held in her right hand generally is identified as a noose, very likely it represents a diadem, which the goddess offers to the monarch on the obverse.

C30a–b Two Dinars of Kumaragupta I
(r. c. 414–55)
Gold; diameter ¾ in (1.9 cm) each
Gift of Anna Bing Arnold and Justin Dart;
a, M.77.55.25, *b*, M.77.55.24

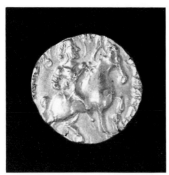

C30a obverse

C30b obverse

C30a reverse

C30b reverse

a, obverse: King, nimbate, riding right on horse. King's attire cannot be clearly determined, but in most other examples of same coin type (Altekar 1954, pl. XXV) he wears a dhoti and coat. Adorned with ornaments; head bare. Legend: Illegible. Reverse: Goddess, nimbate, sitting left on wicker stool, wearing sari and plain necklace; torso bare. Hair gathered in bun at nape of neck. With right hand feeding peacock, with left hand holding lotus. Legend: *Ajitamahendraḥ* (the invincible Mahendra).

b, obverse: King riding right on elephant while fighting lion placed beneath raised left leg of elephant. Elephant driver behind king. Legend: Illegible. Reverse: Goddess, nimbate, feeding peacock with right hand, wearing sari and scarf. In other examples of same coin type (Altekar 1954, pl. XXX, nos. 1–4) left hand placed at waist holds lotus, which is not distinct here. Legend (reconstructed; Altekar 1957, p. 196): *Siṁhanihanta mahendragajaḥ* (the elephant of king Mahendra, destroyer of lion).

Kumaragupta I succeeded Chandragupta II and enjoyed a long and eventful reign. Like his grandfather he also performed the horse sacrifice. Not only did he issue a wide variety of coins, but several represent interesting innovations important both for historical and artistic

reasons. Of the two coins discussed here *a* shows minor variations from the equestrian portrait of Chandragupta (C29a), while *b* is a completely new type.

It appears that the horse in *a* does not wear a saddle, or the saddle is so prefunctorily delineated as to be scarcely visible (cf. Altekar 1957, pl. X, no. 13; Gupta and Srivastava 1981, pl. IX, nos. 158–59). Moreover, the modeling of the animal is quite different from the caparisoned horses on other coins (C29a). The horse here seems larger with a fleshier forepart and narrow head.

The royal image in *b* is one of the most animated compositions among all the obverse devices of Gupta coins. Not only are the portrayals of the two animals highly naturalistic, but the unknown engraver has accommodated them with great skill within the circular frame. Although the king is shown as a combative figure with his right arm raised (probably holding a goad or small dagger), the drama of the occasion is clearly conveyed by the two animals. The elephant is majestic as it raises its front left foot to crush the powerfully modeled lion, whose snarling, open mouth and tense, arched body effectively express the animal's

strength and ferocity. The engraver succeeded in illustrating the message of the legend: "The elephant of king Mahendra, destroyer of lion." Usually the legend on the obverse of such coins reads: "Kumāragupta, who has destroyed his enemies and protects [feudatory] kings, is victorious over his foes" (Altekar 1957, p. 194). The lion obviously symbolizes the royal foes.

On the reverse of both coins a goddess, either standing or seated, feeds a peacock. The iconographic device was a very distinctive innovation of Kumaragupta's mint and generally is considered to indicate the king's devotion to the god Kumara, whose mount is the peacock. In some other issues (Altekar 1957, pl. XIII, nos. 11–14), the king himself is shown riding or feeding the peacock. The goddess has variously been identified as Sri-Lakshmi, Sarasvati (goddess of learning and wisdom, who sometimes has the peacock as her mount), and even Kaumari, one of the Mother Goddesses and personified energy of Kumara. In contemporary art, however, none of these goddesses is shown feeding a peacock, and it would appear that the composition was invented expressly for coins.

C31 *Drachma of Kumaragupta I*
(r. c. 414–55)
Silver; diameter 9/16 in (1.4 cm)
Indian Art Special Purposes Fund; M.84.110.11

Obverse: Bust of king to right. Legend, Sanskrit with Brahmi letters: *Varsha* (year). Reverse: Highly abstracted Garuda symbol in center. Legend, Sanskrit with Brahmi letters: *Paramabhāgavata mahārājādhirāja śrī Kumāragupta mahendrādityaḥ* (the devout Bhagavata, the great king of kings, Kumaragupta Mahendraditya).

This is a standard silver coin type issued by Kumaragupta for circulation primarily in the western regions of the country, which had been conquered by Chandragupta II from the Western Kshatrapas. Although the royal head conforms generally to the type seen in Saka coins (Mirashi 1981, pl. XXVI), the features are sufficiently individualized for us to glean some idea of what

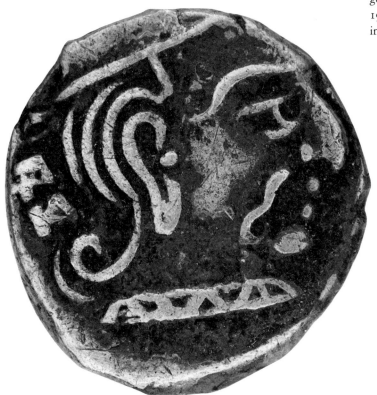

C31 obverse

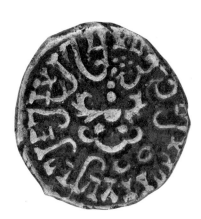

C31 reverse

the monarch looked like. The long flowing hairstyle, however, is normally seen in Saka coins rather than in Gupta dinars. In any event, the representation is quite striking with articulate features delineated with bold strokes. The legend meaning "year" is rather strange because no numeral appears to have been added in most such coins.

The highly abstracted Garuda symbol on the reverse is an innovation of the Gupta moneyers and does not occur on Saka coins. Representations of Garuda were incorporated as the insignia of the Gupta dynasty, although in gold coins the mythical bird is represented less symbolically. The Guptas also replaced the Greek letters of the Saka coins with Brahmi letters.

C32 *Dinar of Prakasaditya*
Early sixth century (?)
Gold; diameter ¾ in (1.9 cm)
Gift of Anna Bing Arnold and Justin Dart;
M.77.55.26

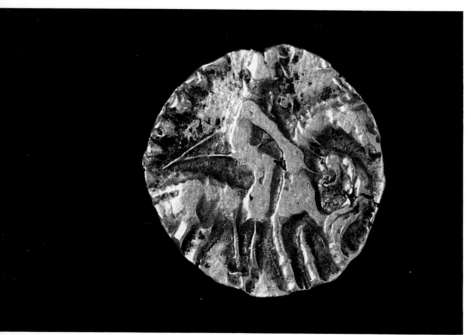

C32 obverse

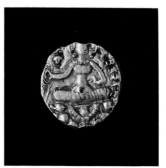

C32 reverse

Obverse: King riding right on horse while striking rearing lion with sword. Legend: Illegible. Reverse: Goddess Sri-Lakshmi sitting on lotus. Filleted diadem or noose in right hand, lotus in left. Legend: *Prakāśādityaḥ*.

Although several other examples of this coin have been found, the complete legend on the obverse is legible in none. (See Gupta and Srivastava 1981, p. 83, for a partial reconstruction.) The king's name is, therefore, not known, but on the reverse his title is given as Prakasaditya. It is generally assumed that he preceeded Narasimhagupta Baladitya II (died c. 535–37). Certainly the representation of the goddess on the reverse is very similar to that on Narasimhagupta's coin (C33). Narasimhagupta, however, issued only the conventional archer coin type (Altekar 1957, pl. xv, nos. 1–2),

whereas the motif on the obverse of Prakasaditya's coin is more innovative in that the mounted king fights a lion. The epithet *prakasaditya* is generally regarded as a Gupta conceit, and the monarch has been identified with various Gupta rulers (see B. N. Mukherjee, "An Interesting Gold Coin," *Monthly Bulletin: Asiatic Society* 14, no. 7 [July 1985]: 3–4).

The lion-slayer motif was introduced by Chandragupta II. In Kumaragupta I's coins the king is shown slaying the lion from an elephant and killing the rhinoceros from a horse. Prakasaditya, thus, is the only Gupta king who issued the equestrian lion-slayer type. Apart from the novelty of the motif, the animals are not as naturalistically rendered as in the earlier imperial issues and the composition is less dramatic. The forms are defined with greater linear abstraction, and the lion looks almost like a dragon.

C33 *Dinar of Narasimhagupta Baladitya I*
(r. c. 510–32)
Gold; diameter ¾ in (1.9 cm)

Gift of Dr. and Mrs. A. J. Montanari;
M.77.56.24

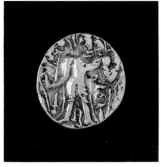
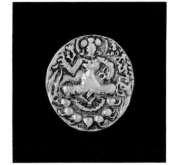

C33 obverse C33 reverse

Obverse: King, nimbate, standing with head turned left, presumably before fire altar, which is missing. Garuda standard behind outstretched right arm. Bow in left arm. Legend between feet, Sanskrit with Brahmi letters: *Gre*; below left arm: *Nara*. Reverse: Goddess, nimbate, sitting with legs folded on lotus. Filleted diadem or noose in right hand, lotus in left. Legend: *Bālādityaḥ*.

Narasimhagupta Baladitya was probably the last of the Gupta dynasty to have ruled over an extensive empire. He is traditionally remembered for defeating the Huns, who intermittently proved to be a menace from about the midfifth century. He was also a generous patron of the Buddhist university at Nalanda in Bihar.

Like most other Gupta monarchs of the sixth century, Narasimhagupta issued only the archer coin type. The sole innovation in his coins is the introduction of the Brahmi letter *gu* or *gre* between the feet of the royal image. Why this was done, however, remains unexplained. The workmanship on Narasimhagupta's coins shows definite signs of decline.

C34 *Dinar of an Unknown King*
Sixth century
Gold; diameter ⅞ in (2.2 cm)

Gift of Anna Bing Arnold and Justin Dart;
M.77.55.1

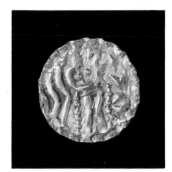

C34 obverse C34 reverse

Obverse: King standing with right hand resting on arrow. Bow in left hand. Standard with unrecognizable capital behind right arm. Crudely delineated horse below left arm. Reverse: Multiarmed goddess standing in center.

This coin, issued by an unknown king, is considered to be one of many ancient imitations of Gupta coinage (Altekar 1954, pl. XXXII, nos. 14–15). It may have been issued by the later Gupta kings of Bengal (Allan [1914] 1967a, pl. XXIV, nos. 17–18). In some examples the capital of the standard consists of a horse and the letter *śrī* can be recognized beside the king's face (Altekar 1954, pl. XXXI, no. 14). The significance of the horse below the left arm is not known. The goddess on the reverse seems to be multiarmed; apparently she has eight arms, but no attributes are recognizable. The workmanship is very crude on both sides.

C35a–b Two Dinars of Yasavarmana
Fifth century or later
Debased gold; average diameter ¹³⁄₁₆ in (2.1 cm)
Gift of Anna Bing Arnold and Justin Dart;
M.77.55.2–3

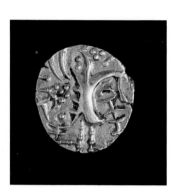

C35a obverse

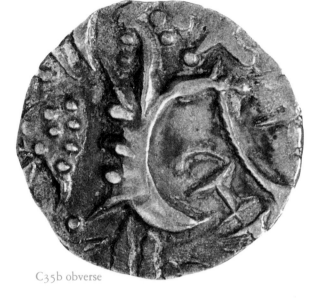

C35b obverse

C35a reverse

C35b reverse

Obverse of each: King, standing, represented in abstracted design. Legend: *Kidara*. Reverse of each: Goddess, enthroned, represented in abstracted design. Legend, Brahmi script: *Śrī Yasa*.

Similarly debased gold coins with severely truncated images have been found in Panjab, Kashmir, and other parts of northern India. The obverse legend usually reads *Kidara*. Considered to be related to the Kushans, the Kidaras ruled parts of Panjab and Kashmir sometime after the downfall of the Kushan Empire during the third century. The reverse legend usually identifies various kings, most of whom are not known from the ancient Kashmiri histories. The name given in these two coins is Yasa, which may be an abbreviation of Yasavarmana, although no Kashmiri ruler of this name is known. While some scholars date these coins to the fifth century, others consider them to have been issued much later.

The coins clearly were copied from late-Kushan coinage, and the process of barbarization had continued so long that the images are hardly recognizable. Indeed the forms on both sides are abstract designs. The metal content of these coins is highly debased, and they must have been circulated locally.

C36 Dinar of Khingila
Sixth century (?)
Gold; diameter 1 in (2.5 cm)
Gift of Dr. and Mrs. A. J. Montanari;
M.77.56.3

C36 obverse C36 reverse

Obverse: King standing left, wearing Sasanian crown, long coat, boots. Right hand hanging down near trident. Flower (?) in left hand. Legend: *Deva Shāhi Khingila* (the divine king Khingila). Reverse: Illegible.

Several coins of a king named Khingila have been found in northwestern India and in Afghanistan. The name suggests that he may have been a Hun. Khingila is usually identified with Khinkhila, also known as Narendraditya, a Kashmiri king mentioned in the *Rājataraṅginī* (Chronicle of the kings of Kashmir).

The diecutter of this coin seems to have borrowed features both from late-Kushan and Kushano-Sasanian coins. The thin flan and headgear of the king are derived from Kushano-Sasanian coins; the royal attire and awkward delineation of the feet continue the Kushan royal image. The figure is rather stocky, and the proportions differ from both earlier types.

Sculpture

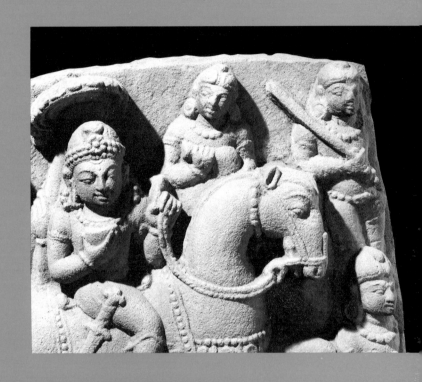

Age of the Mauryas, Indo-Greeks, and Sungas

(fourth–first centuries B.C.)

Introduction

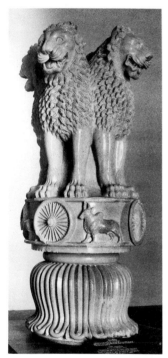

Asokan lion capital, third century B.C., sandstone. Sarnath Museum. Photograph courtesy American Institute of Indian Studies, Ramanagar.

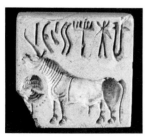

Seal with unicorn and inscription, Indus Valley civilization, 2500–1500 B.C., steatite. The Cleveland Museum of Art, purchase from the J. H. Wade Fund; CMA73.161.

As surviving evidence indicates, the principal sculptural medium during the Maurya period (c. 324–187 B.C.) was terra-cotta. Palaces and mansions, as well as temples, were probably built with timber and brick, and wood sculptures were used more extensively as architectural adornments than present evidence demonstrates. Stone seems to have been employed for monumental sculpture first during the reign of the great Maurya emperor Asoka (r. c. 273–236 B.C.). These consist mostly of polished sandstone capitals, which were placed on top of tall stone pillars at various sites throughout the empire. The most well known among these is the lion capital now preserved in the Sarnath Museum.

In contrast to these imperial commissions, the small stone objects in the collection from this period (S2–4) are not as sophisticated or naturalistic. Rather, they reveal a greater degree of abstraction in rendering plastic mass, whether of human figures or animals. This may be easily perceived by comparing the lion capital with the bull (S1), elephant (S5), and lion head (S8) in the collection. Although these forms lack the monumentality and rich plasticity of the stone sculptures, they are nonetheless equally attractive both for their simplicity and spontaneity. Abstraction notwithstanding, these animal studies are delightfully animated and occasionally, as in the case of the lion head, informed with engaging whimsy. Both the naturalistic and abstract traditions of representing animals can be traced to the much earlier Indus Valley civilization, the former in small stone seals and bronzes and the latter mostly in terra-cotta.

Indeed one of the remarkable features of the terra-cotta art of the northwestern region of the subcontinent during the last half millennium B.C. is the astonishing persistence of the abstract style in delineating female figures (S6–7). These highly simplified, flattened forms, conceived in broad geometrical shapes with peglike legs, stumps for arms, and cowrie-shell eyes, are clearly descendants of similar figures of the earlier period. Such figurines symbolizing fertility continued to be produced in the region well into the early centuries of the Christian period.

A far more varied and distinctive style of terra-cotta sculptures flourished during the Maurya period. Partly modeled (usually the body) and partly molded (the head), these terra-cottas are distinguished by their gray-black slip, which appears to have been a characteristic of Mathura during the Maurya period. The museum's group of such terra-cottas consists of female figures, both standing and seated (S9–12), and a partially restored elephant with riders (S13). The legs and arms are usually stumpy with hands and feet rarely represented, but the torso is more fully modeled with prominent breasts and wide hips. Indeed, as is clear from a remarkably well-preserved and well-executed example (S11), the lower portion of the body is conceived architectonically as an arch supported by columns. The ladies invariably wear short skirts and are richly adorned with heavy appliquéd jewelry. The most intriguing feature about these figures, identified generally as Mother Goddesses, is the prominence given to the head adornments consisting of dotted disks and the substantial ear ornaments, which generally overwhelm the face. In most instances the back is left plain thereby indicating the frontal viewing of such figures. Their exact function remains unknown. While most are broken, the pristine condition of some would indicate that they were not objects of regular worship but were probably buried in the ground soon after manufacture to enhance the fertility of the fields. This practice is recounted in the *Atharvaveda*, a Vedic text composed probably around 1000 B.C. that contains much useful information about such rites and practices. Because they have no feet, the standing figures cannot stand without support, another indication that they may have been buried. The seated figure (S10) may have been used as a votive offering or icon for domestic worship. This figure is important as it is one of the earliest representations of this posture, known later as *pralambapadasana* or *bhadrasana*. It became a more common posture for both gods and kings from the Kushan period. Despite their stumpy and awkward arms and legs, the figures are quite elegant; their elaborate headdresses add a touch of urbane sophistication, which is also evident in the impressive elephant with riders (S13). The same conceptualization that characterizes the human figures is evident in the modeling of the animal's body, but the head and trunk are more naturalistically modeled. The exact function of such sculptures is not known, but the subject became popular as a prominent architectural embellishment in Buddhist monuments of the succeeding centuries.

The most important monument for the history of stone sculpture after the Asokan columns is the Buddhist stupa of Bharhut in Madhya Pradesh. Sometime around 100 B.C. the stupa was surrounded by stone gateways and railings richly carved with figures, animals, and symbols. Two fragmentary sculptures in the collection (S27–28) once belonged to this monument. Characteristic of the Bharhut style, the carving is shallow and almost two-dimensional. Very likely the Bharhut sculptors used earlier scroll paintings or murals as their models for the rich array of narrative themes they were required to execute along copestones and on the crossbars of railings. The two addorsed females (S27) are miniature versions of the larger figures that adorn the uprights and columns and perhaps because of their smaller size are modeled with greater technical sophistication. The lion on the fragmentary crossbar (S28) is rendered in a far more sketchy and rudimentary fashion than those on the Asokan capital.

Inscriptions on the Bharhut railings inform us that sculptors from all over northern India, including the northwestern part of the country, were employed at the site. Nevertheless the overall style at Bharhut is remarkably coherent, even if somewhat tentative.

At the same time highly accomplished sculptors and engravers were working in ancient Bactria and Gandhara for the Indo-Greek monarchs, as is clearly evident from the coins. The engravers responsible for such specialized carving were highly skilled craftsmen. There is no way to determine whether they were from the Hellenistic world or the local regions in which the royal mints were established. Considering the overwhelming preponderance of Hellenistic styles and technical proficiency, an obvious conclusion would be that the master artists were of Greek origin who recruited and supervised local craftsmen. It would be difficult to imagine that all the engravers, who not only worked in the mints but also supplied other aesthetic and religious needs of the people of these regions, were imported from the Hellenistic world. In any event, what seems significant is that works of art, as well as mansions and temples, were created in Gandhara and Bactria during the Indo-Greek period in a strongly Hellenistic style, but sculptors at Bharhut or, for that matter, Mathura were not much influenced by the classical modes. Apart from some coins, two pottery fragments in the collection (S4, S8) were clearly influenced by Hellenistic forms.

While Buddhists were engaged in raising impressive stone gateways and railings around their stupas and excavating monasteries and shrines from rock mostly in western India, terra-cotta production continued with undiminished zeal in various urban centers across the riverine plains of northern India. Sunga-period (187–75 B.C.) terra-cottas were made primarily from molds, and thematically they reveal a much greater variety than those produced during the Maurya period. Many of these terra-cottas are plaques with figures executed in relief. If they are objects in the round, such as toys (S18–19, S26), they were generally made from two separate molds and joined together. Significantly, while terra-cotta figures of the earlier periods bear little relationship to contemporary stone sculptures, during the Sunga period a closer affinity developed. For example, the enigmatic narrative scene on a small terra-cotta plaque (S14) is very closely related in style and composition to similar narrative panels on the Bharhut railings. The females, whether goddesses (S16–17) or mortals (S24), are far more naturalistically delineated with well-proportioned bodies and graceful postures. During the Sunga period a distinct change in aesthetics occurred in most centers of terra-cotta production, stretching from Mathura in the west to Chandraketugarh in the east. This new interest in a more naturalistic representation may have spread from the Patna region in Bihar where, unlike at Mathura during the Maurya preriod, a remarkably lively and realistic school of terra-cotta art developed.

Most terra-cotta objects of the period in the collection are from either Uttar Pradesh or West Bengal. They include conventional, but well-preserved representations of goddesses and a number of objects meant for secular purposes. Among them is an exceptionally fine toy elephant with riders generally attributed to Uttar Pradesh (S18), which is clearly stylistically different from the earlier Mathura depiction of the same subject (S13). Although not as majestic, the elephant is certainly more naturalistically represented in the later sculpture. This emphasis on close observation is also evident in the forepart of a ram from Chandraketugarh in West Bengal (S26), which also served as a child's toy.

Indeed, the group of terra-cotas from West Bengal, most of which are from a site known as Chandraketugarh, reveal an astonishing thematic variety, which is characteristic of this school. Chandraketugarh was a bustling port on a small river some twenty-nine miles northwest of Calcutta. Extensive archaeological excavations have uncovered the remains of a fortified city that may have flourished from the pre-Maurya through Gupta periods. The ruins have also proved to be a remarkably rich source of terra-cotta art, which was certainly the principal artistic medium at the time in this region and in other ancient cities in northern India.

In terms of stone sculpture one of the most important early sites after Bharhut was Sanchi near Bhopal in Madhya Pradesh. Although the Buddhist stupas at the site predate Bharhut and the gateway of one of the smaller stupas (Stupa II) is considered to be stylistically coeval with or earlier than Bharhut, the gateways of the Great Stupa were erected between 50 B.C. and 25 A.D. The museum's examples of sculptures (S29–30) that once adorned one of the four gateways demonstrate an assured handling of form. The shallow carving and awkward postures of the Bharhut figures are eschewed for a greater depth and more graceful, naturalistic posture. The linear, sharper contours and flat treatment of mass are replaced by fluid outlines that define the surging volumes to create a much more plastic and sensuously elegant form. In the lavishly carved gateways of the Great Stupa at Sanchi the early Indian sculptural style reaches its apogee. Although the sculptors of Kushan Mathura did not evince the same interest in the luxuriant and lively narrative reliefs of their forebears at Sanchi, they did continue to delight in the Sanchi artists' impulse to imbue the simplified, but expressive shapes of the human body with an unabashed sensual rhythm.

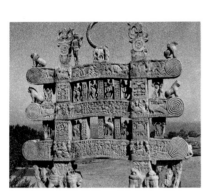

View of North Gate, Stupa 1, Sanchi, 50 B.C.–A.D. 25. Photograph courtesy Mrs. J. LeRoy Davidson.

S1 Bull
Pakistan; c. 300 B.C.
Red terra-cotta; length 4 ¾ in (12.1 cm)
From the Nasli and Alice Heeramaneck
Collection

Museum Associates Purchase; M.73.4.4
Literature: Rosenfield et al. 1966, p. 26;
Trubner 1968, p. 4, fig. 2; Pal 1985a, p. 68,
fig. 4.

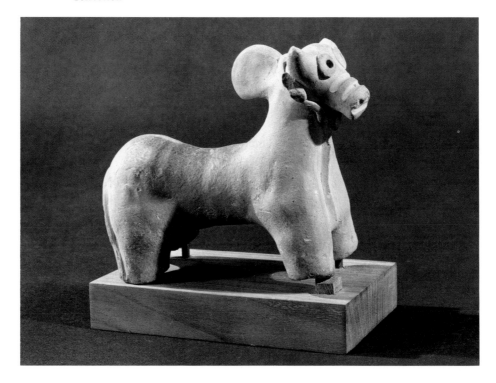

This impressive sculpture is remarkably well
preserved. The schematized bull is strongly
modeled, its plastic qualities emphasized by the
prominent rump and powerful legs. The dewlap
and tail are minimally indicated by a narrow
strip. The hump is unnaturalistically placed
high on the neck. A halter encircles the neck,
and the eyes are indicated by deeply pierced
circles of clay. The significance of the two
parallel indentations across the broad nose is not
known. In the rear is a hole; the tail hangs down
along the right rump and thigh.

Because the lower legs are broken, it cannot be determined whether or not holes for axles were bored into them, as with the terra-cotta from Bihar (S19). If they were, then this bull, too, could have been a toy. Stone chips may have been inserted into the hole so that the toy would rattle when pulled. If the animal was a votive object, then offerings may have been inserted into the hole.

When first published, the bull was attributed to the Indus Valley civilization (third millennium B.C.), but this seems to be a much too early date. Despite some similarities with Indus Valley bulls, the object conforms much more closely to bulls dating to the later half of the first millennium B.C. found in Taxila (Marshall [1951] 1975, 3: pl. 135) and other sites in ancient Gandhara, a region in the north of the subcontinent comprising the northern parts of present-day Pakistan and contiguous areas of southern Afghanistan. Others, one of which is quite similar to this example, although not as well preserved, have been excavated from Shaikhan Dheri, about twenty-two miles north of Peshawar, and are dated as late as the second century A.D. (Dani 1965–66, p. 73, pl. XXXVI, 1).

S2 *Fish*

S2 *Fish*
Pakistan; third century B.C.
Gray schist; length 1 ⅝ in (4.2 cm)
Gift of the Honorable David Salmon;
M.84.105.1

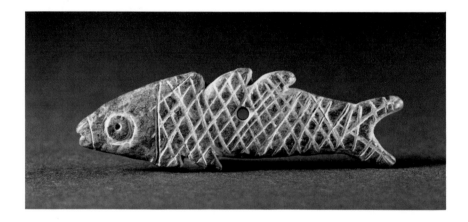

The eyes, mouth, fins, and tail of the fish are clearly delineated. The scales are crosshatched. A thin string was probably passed through the tiny hole at the center of the figure. The object was very likely used as an ornament or charm. Several small metal fish were excavated from Taxila (Marshall [1951] 1975, 3: pl. 172, nos. 28, 109; pl. 179, no. 79; pl. 181, no. 197), where the fish was a popular motif among jewelers. From very ancient times the fish has remained a symbol of fertility and good fortune and is not restricted to any particular religious group.

S3 Ringstone with Goddesses
Pakistan or northern India; third century B.C.
Steatite; diameter 3 ½ in (8.9 cm)
Gift of Dr. and Mrs. Pratapaditya Pal;
M.83.255.1

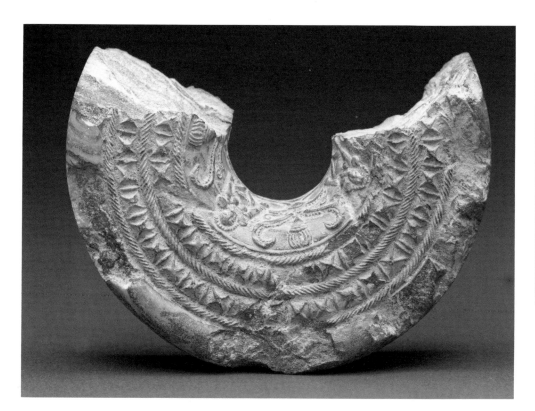

S3 detail

Such objects with or without central holes are known generally as ringstones. Altogether between sixty and seventy Indian ringstones have been discovered from Taxila, in ancient Gandhara, to Patna, in Bihar (see Gupta 1980, pp. 53–77). Their general distribution appears to have been at urban centers along the ancient trade route linking Gandhara with Bihar. Most are considered to have been made during the third and second centuries B.C.

Around the slightly tapering circle of this fragment are two identical nude female figures alternating with two plants of the honeysuckle variety. The flower has also been identified as the *nāgapushpa*. The female figure stands in a hieratic posture with her feet pointing out and her arms hanging straight down. Except for her ornaments—large solid disks and bangles—she appears to be nude. Her form is distinguished by large breasts, very narrow waist, and wide, flaring hips that accentuate her sexual organs. Beyond this inner circle are three ropelike coils containing two narrow bands decorated with what appears to be alternating bars and stars.

Although much has been written about these ringstones, their exact significance and function remain a mystery. This particular example may have been manufactured in Taxila, although very similar examples have been discovered in various sites as far east as Patna (Gupta 1980, pls. 17a–b, 23a, 28a, 30b, 30d, 36b). These disks or ringstones may have traveled along the northern trade route and been carried by traders as some sort of charm. That such a fertility goddess associated with vegetation should only be found in urban sites along trade routes with a rather limited temporal circulation remains inexplicable. An identical figure adorns a gold plaque found in a funerary context (Gupta 1980, pl. 35b). The goddess and her cult may have been imported from West Asia, although no such ringstones have been found there. The ancient Chinese made ringstones in jade, some of which are said to symbolize heaven. These jade ringstones, however, are usually plain, although some are carved with shallow vegetal or geometric designs. In the Indian context the goddess may represent a divinity of abundance like Sri-Lakshmi. The disk may also be a descendant of the ringstones discovered at Mohenjo-Daro and other Indus Valley sites or a precursor for later mandalas or yantras (mystical diagrams used in tantric rituals).

S4 Fragment of a Pot Handle
Pakistan; third–first century B.C.
Steatite; 1 ¼ in (3.2 cm)
Gift of the Honorable David Salmon;
M.84.105.2

This fragmentary figure probably once formed the handle of a small pot or vase. The practice of decorating handles of vases and pots with human figures, especially female, was quite common during the first century B.C. (R. C. Agrawala 1970) and very likely derived from Hellenistic tradition.

The head and feet of this particular fragment of a female figure are lost, but the trunk is well preserved. Although she wears a lower garment, indicated by parallel incisions on the thighs, her genitalia are fully exposed. In the typically Indian fashion, she wears multiple girdles, which turn sharply around her waist, and the navel is prominently shown. An arrow rising from the navel divides the torso (cf. S7). Based on comparisons with other terra-cottas from the northwestern part of the subcontinent, the breasts must have been unusually small.

S5 Elephant

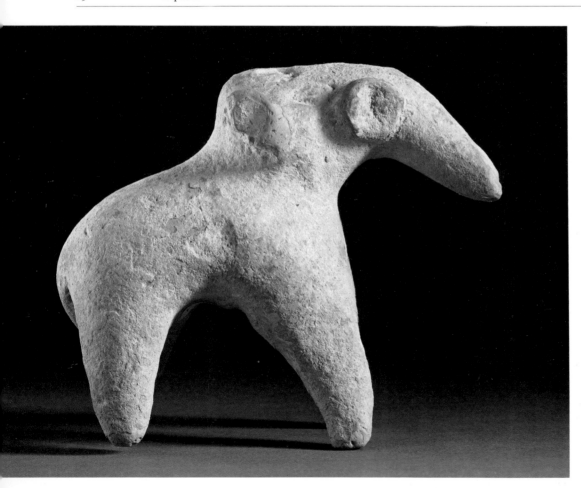

S5 Elephant
Pakistan, Taxila (?); c. 200 B.C.
Red terra-cotta with calcium accretion;
4 ½ in (11.4 cm)
Indian Art Special Purposes Fund; M.83.24

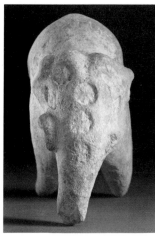

Except for some stamped decorations and two applied circles on the trunk, the elephant is plain and has no trappings. Although generally conforming to several elephants discovered at Taxila, from the Sirkap and Bhir mounds (Marshall [1951] 1975, 2: pp. 454–55, 3: pl. 134), this example is less naturalistically modeled. Similar elephants also have been discovered from ancient sites near Peshawar, but they are too fragmentary to afford a proper comparison. Of the three well-preserved examples illustrated by Marshall, the most similar figure was recovered from the Bhir mound from a stratum dated to the Maurya period ([1951] 1975, 3: pl. 134, no. 72).

Detail

The legs and body of the elephant are perfunctorily modeled, although the animal's bulk is adequately described. Only a short tail is seen at the back. The head and proboscis are modeled with great subtlety. The ears are not disproportionate, and the eyes are stylized diamonds. The function of the two applied disks on either side of the base of the trunk is not known. Characteristic of several such elephants excavated from the Bhir mound, the head and trunk are adorned with five stamped circles enclosing a star-shaped design found on other subjects as well (cf. Marshall [1951] 1975, 3: pl. 131, no. 245).

S6 A Goddess

Pakistan, Peshawar division; second century B.C.
Red-brown terra-cotta; 4 ¼ in (10.8 cm)
From the Nasli and Alice Heeramaneck Collection
Museum Associates Purchase; M.73.4.3
Literature: *Art of India and Southeast Asia* 1964,
p. 13; Larson et al. 1980, p. 41.

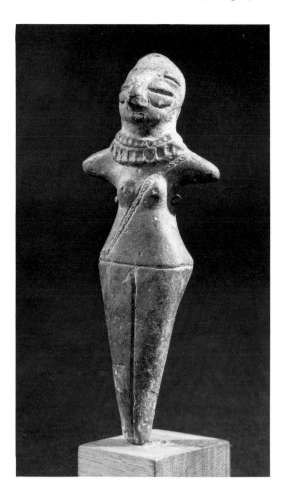

Such highly abstracted terra-cotta female figures (see also S7) have been excavated in large quantities from various sites in the Peshawar division of Pakistan. Known as Pushkalavati in ancient times, Peshawar was the most important entrepôt in the northwestern part of the subcontinent. Discussing a large number of such figures in Charsada, the eminent archaeologist Sir Mortimer Wheeler characterized them as "baroque ladies" and generally dated them to the third–second century B.C. (1962, pp. 104–8, pls. XX–XXVI). Wheeler's dates have been generally confirmed by subsequent excavations (Dani 1965–66, pp. 46–48), although the type was found to have continued into the second century A.D.

Both this and a companion piece (S7) were probably made in three parts: triangular lower half, torso, and head. The ornaments, mouth, eyes, and breasts are appliquéd, and some elements, such as the cross-belts (*channavīras*) and waistbands, are incised.

The triangular lower half of the figure is divided by a vertical incision into two peglike legs. A horizontal line appearing only in the front divides the torso from the legs. A cross-belt or sash stretches from the left shoulder across the body, and the breasts are pierced. The two arms are simple stumps, and two decorated neckbands adorn the neck. The conical head is rather small, and the face is dominated by two cowrie-shell eyes. The applied headgear is missing. Except for the prominently thrusting buttocks, the back is not modeled.

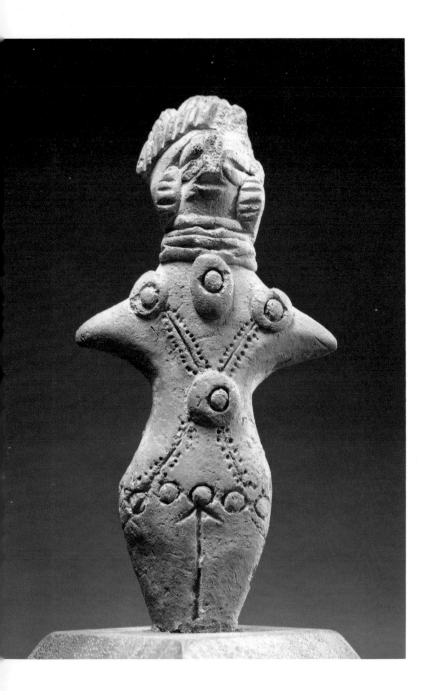

S7 A Goddess

Pakistan, Peshawar division; second century B.C.
Red-brown terra-cotta; 2 ⅞ in (7.8 cm)
Gift of Jane F. Ullman; M.76.148
Literature: Otsuka and Lanius 1975, no. 1.

This figure, although more elaborately adorned, is in some ways even more abstract than the other example in the collection (S6). The breasts are not represented, and the buttocks are not emphasized. Despite the more fluid definition of the outline, the figure is remarkably flat. The vertical line dividing the legs ends in an arrowhead. Immediately above, a chain girdle encircles the hips. Cross-belts or sashes flanked by dots are indicated on both sides of the torso. Four pellets or disks enclosing dots are attached to the front and three to the back. The neck is curved only in the front with four plain bands; grooved ornaments adorn the ears. The headdress is not clearly distinguishable, but from the back it appears to have consisted of a ring of some sort. Four incised lines down the head and neck are meant to indicate locks of hair.

When first published the piece was considered to belong to the Indus Valley civilization, but it undoubtedly is of the same vintage as the other example in the collection. Similar examples have been excavated from Shaikhan Dheri (Dani 1965–66, pl. XXVI, nos. 5–6). Not only do these have similar pellets or beads as adornments, but at least in one example identical incisions indicate flowing hair at the back. These comparable pieces were excavated from the lowest level, dated from the third–second century B.C.

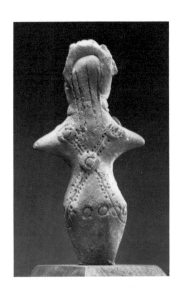

S8 Head of a Lion
Pakistan, Taxila area;
first century B.C.–first century A.D.
Red terra-cotta; diameter 2 in (5.1 cm)
From the Nasli and Alice Heeramaneck
Collection
Museum Associates Purchase; M.72.1.3
Literature: Montgomery and Lippe 1962, p. 35;
Art of India and Southeast Asia 1964, p. 13;
Rosenfield et al. 1966, p. 37, no. 25; Czuma
1985, p. 124.

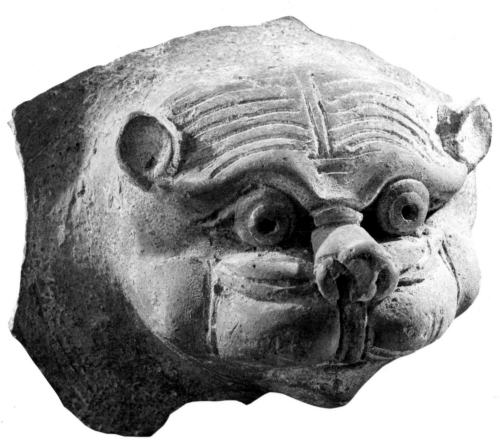

This thin pottery fragment is decorated with a stylized, finely modeled lion head. The partially open and expressive mouth exposes a row of teeth; the whiskers are applied. The eyes are especially prominent, the eyeballs emerging from deep cavities. The eyebrows with their curled ends are particularly decorative, and the furrowed brow is incised with horizontal lines. Although the head is not naturalistic, the modeling is remarkably skillful and animated.

This fragment has been consistently attributed to Mathura and dated to the second century A.D., although no comparable material from that region was cited (see Literature). Very similar lion-head embellishments were excavated from Taxila from a stratum dated to the Parthian Empire (first century B.C.–c. A.D. 40), and there now seems no doubt that this lion, too, belongs to that group (Marshall [1951] 1975, 3: pl. 131, nos. 252–53). In the words of the excavator (Marshall [1951] 1975, 2: p. 436):

In Class XXXC may also be included a number of small lion masks in relief used for decorating the sides of vessels. They come only from the Sirkap and Dharmarajika sites, and are of Parthian date and almost certainly imitated from Hellenistic prototypes. That they were made with the help of the moulds is clear, not only from the masks themselves but from the discovery of one of the actual moulds from which they were struck. These masks are of a piece with the walls of the vessels and cannot be detached from them. Evidently a blob of clay was worked into the wall while it was still wet, moulded into shape with the matrix, and then finished off by hand.

S9 *Head of a Goddess*
Uttar Pradesh, Mathura; third century B.C.
Gray-black terra-cotta; 3 ⅝ in (9.2 cm)
Indian Art Special Purposes Fund; M.73.46.2

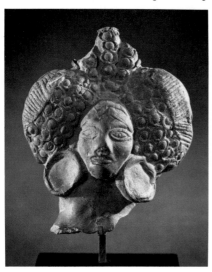

The oval face is distinguished by rather high cheekbones, broad nose, and large fish-shaped eyes. The hair, parted in the middle, covers most of the forehead. The earrings and headdress are exceptionally large and enhance the monumentality of the figure. The neck is not differentiated, and the rather unusual absence of any torque or pectoral indicates that the bosoms hung rather low on the chest. The elaborate headdress, nearly forming a trefoil, is decorated with a dot-enclosed-by-a-circle pattern, a variation of which appears on a punch-marked coin (C1). The headdress probably was formed with pieces of cloth folded inward along the edges. The back is completely flat.

S10 *A Goddess*
Uttar Pradesh, Mathura; third century B.C.
Gray-black terra-cotta; 6 ¾ in (17.1 cm)
Indian Art Special Purposes Fund; M.82.18.2

The goddess is seated with her stumpy legs placed widely apart and her hands resting on her knees. The feet and toes are not delineated, and the fingers of the undamaged left hand are rudimentarily defined. The seat of her stool is simply a piece of flat clay attached to the buttocks. An apron or short skirt is spread between the thighs. The breasts are almost fully covered by a wide torque. The elegantly tilted head is framed by an elaborate headgear decorated with various ornamental designs, now much effaced. Other adornments include large earrings, bracelets, and anklets.

Typical of Mathura terra-cottas of the period and characteristic also of other examples (S9, S12), only the face was produced from a mold, the rest of the figure being modeled by hand in several parts. Distinctive also of Maurya-period terra-cotta figures, the eyes are simple ellipses without eyebrows and no vertical folds mark the corners of the mouth.

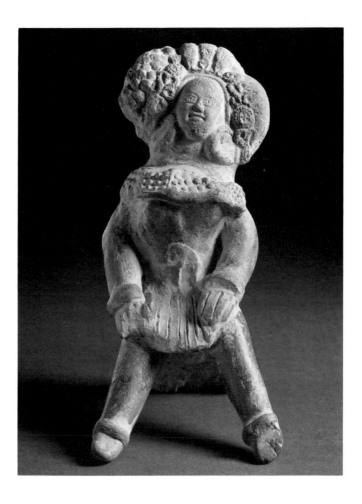

S11 A Goddess
Uttar Pradesh, Mathura; c. 200 B.C.
Gray-black terra-cotta; 5½ in (14.0 cm)
Indian Art Special Purposes Fund; M.73.46.1

Although the legs are broken, this is a standing
figure. The arms may have been folded back and
held at the breasts, as in a more complete seated

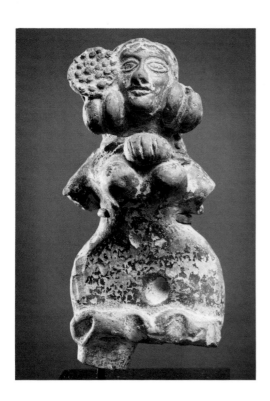

Mother Goddess with child, also from Mathura
(Gupta 1980, pl. 78a–b). Indeed, stylistically,
the two examples are remarkably similar. So alike
are their faces that the heads may have been
made from the same mold. They each have the
same doughnutlike ear ornaments, and the
design of the disklike crests on the head is
similar. The better-preserved example flaunts
three such crests, whereas only one remains on
the museum's example. The hair is parted in the
middle and is adorned with a string of pearls
slightly above the hairline. Three strips of clay
are appliquéd on the back of the head to indicate
braids, as in the excavated example mentioned
above. In both examples, a heavy, oblong
pendant rests on the ample, slightly pointed
breasts. The arcs of the wide, expansive hips
seem almost to form a circle in the midregion of
the body. The flat stomach is dominated by a
large navel placed off center, below which is a
girdle attached only in the front.
　　　　Although she is stylistically
related to two others in the collection (S10, S12),
a slightly later date is suggested for this example
because of the indication of eyebrows and
comparison with excavated pieces from Mathura
and Kausambi (in Uttar Pradesh, northwest of
Allahabad), which also have yielded a large
number of similar terra-cotta figures in gray-
black.

S12 A Goddess
Uttar Pradesh, Mathura; c. 200 B.C.
Gray-black terra-cotta; 9½ in (24.1 cm)
Gift of Mr. and Mrs. Subhash Kapoor;
M.85.72.3

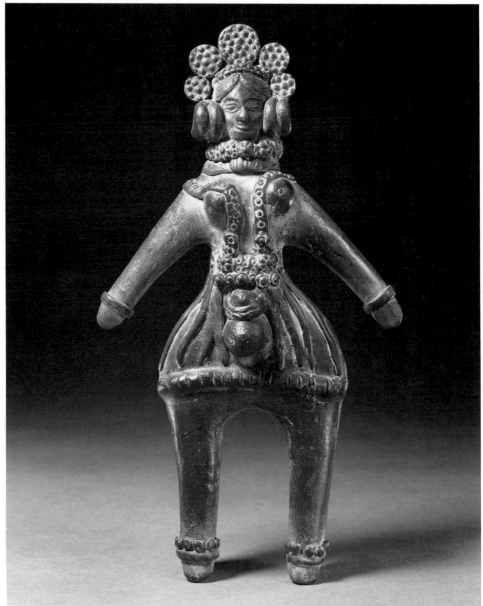

Remarkably well preserved, this is one of the finest and most luxurious gray-black terra-cotta figures from the Maurya period. Except for the high, full breasts and naturalistically delineated features of the rather small, smiling face, the form is simplified into abstract, architectonic shapes. The hands and feet are mere amputated stumps, but the hips are wide and fully rounded. All accoutrements are appliquéd; ribbonlike strips of clay suggest the skirt, and other strips with pellets are generously used to form the ornaments. Indeed, the figure is sumptuously bejeweled with necklaces and torques, large, heavy ear ornaments, strings of pearls arranged in the parted hair, and five crests forming the elaborate headgear. Five braids are articulately rendered on the flatly modeled back. Perhaps the

most curious feature in this example is the tumorlike projection partly covering the navel. Very likely it represents a waterpot symbolizing the goddess's fertility and abundance.

The exact identification of such figures is not known, but the lavish ornamentation and hieratic posture of the figure clearly indicate that she is an important goddess. Her bearing is majestic and highly dignified, and she exudes well being and a sense of expansiveness. A late-third–early-second-century date seems consistent with comparable material excavated from Mathura (S. P. Gupta 1980, pl. 78a–b; R. C. Sharma 1976, fig. 10).

S13 *Elephant with Riders*
Uttar Pradesh, Mathura;
third–second century B.C.
Gray-black terra-cotta; 11 ¼ in (28.6 cm)
Gift of Mr. and Mrs. Subhash Kapoor;
M.85.72.1

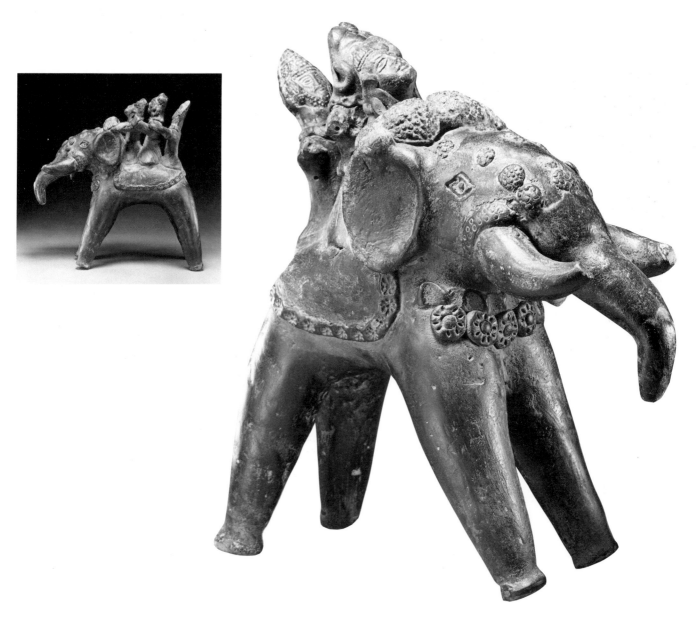

Of the many terra-cotta elephants, with or without riders, that have been found from Mathura, this example is one of the largest. Characteristic of such Maurya-period terra-cotta elephants, the highly simplified animal is not realistically modeled. Nevertheless, the sculptor has convincingly conveyed the majestic dignity of the noble animal. All three riders are male. The head of the third figure at the back is not part of the original sculpture and is of a somewhat later date. The two other figures wear turbans typical of the Maurya period. Each figure extends his stumpy arms. While the figure in front balances himself by holding onto the elephant's ears, those behind him cling to the rider in front. The elephant is gaily caparisoned with a blanket or carpet thrown across his body. Floral pellets and garlands are separately attached to the neck, tusks, and forehead. Three larger floral roundels or crests adorn the top of the head.

Although stylized, this representation of an elephant with riders faithfully depicts an essential component of Maurya processionals. The collection includes another, later elephant with riders (S18), which was certainly used as a toy. The exact function of this impressive Maurya sculpture is not known, but one must consider the possibility that such figures were used for domestic decoration.

S14 *Plaque with Three Figures*
Uttar Pradesh; c. 100 B.C.
Red terra-cotta; 2 ⅜ in (6.0 cm)
Gift of E. Sham; M.80.156.3

In this narrative plaque three figures are depicted within an architectural setting. Two slender columns with a pot and human-head capital support a plain lintel or crossbar, over which a curtain hangs in the center. Above the curtain are three rosettes, and on either side are two honeysuckle motifs. Two more rosettes are added to the background near the column capitals. Of the three figures the most prominent is the individual seated on the left with his right hand supporting his thigh. He wears a long pearl necklace with rectangular pendant, ear ornaments, and a turban with three crests. He apparently is watching one of the other figures perform a dance, while between them stands a third figure carrying what appears to be a basket on his shoulder. One dancer appears to be bald, another may have an animal head.

 The plaque represents either a secular or mythological depiction of a court scene. The potbellied, turbaned figure may portray Kubera, god of wealth, seated in his palace in the North. He may well be witnessing the antics of his yaksha attendants, one of whom seems to be carrying a bag of jewels on his shoulder.

 Whatever the exact identification, the plaque stylistically is closely related to the narrative reliefs at Bharhut, in figural form, mode of delineation, and composition. Particularly relevant is the well-known roundel depicting monkeys extracting a giant's teeth (Barua 1979, pl. XCVII). Similar rosettes are frequently used at Sanchi and Bharhut to indicate the divine presence, while the honeysuckle is a common symbol of abundance in early Indian art (see S3). The use of human heads as capitals for the columns is unusual. At Sanchi columns usually support pot and animal capitals, although at Amaravati in Andhra Pradesh pots are surmounted by yakshas (Coomaraswamy 1935, pl. I, no. 2).

 While one cannot be certain of the provenance of this interesting terra-cotta, another plaque, also decorated with rosettes and the simplified honeysuckle motif, now in the Museum of Fine Arts, Boston, has been attributed to Kausambi in Uttar Pradesh, which has yielded a substantial amount of plaques with narrative themes (Paulson 1977, p. 39, no. 58; Kala 1950). For similar plaques depicting narrative subjects discovered from Kausambi, see Kala 1980, figs. 146–47.

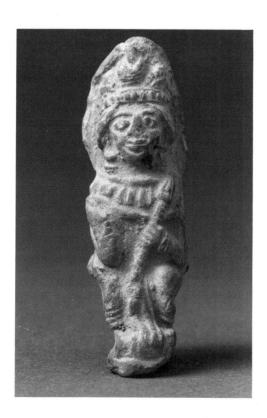

S15 *A Divine Figure*
Uttar Pradesh; c. 100 B.C.
Red terra-cotta with calcium accretion;
3 in (7.1 cm)
Gift of E. Sham; M.80.156.21

A male figure wearing a dhoti and turban is seated on a plain seat with his legs forming the position known as *pralambapadasana*. His jewelry include bangles, pendant ear ornaments, and a torque across his chest. The turban is held in place with a band of pearls across the forehead, parts of which overhang the face like an earmuff. The right arm is folded back at the elbow in the gesture of reassurance, and the left hand holds what appears to be a spear.

The gesture of the right hand almost certainly suggests that the figure is meant to portray a divinity. The spear or lance may refer to either Kubera or Kumara, both of whom in early representations carry this weapon. Generally, however, in Gandharan art Kubera or one of his companion yakshas holds a spear, while in the riverine plains of northern India the emblem is more commonly associated with Kumara. Moreover, Kubera is generally obese (see S64), and this figure is not. Thus, if an identification with Kumara is accepted, then the figure is among the earliest representations of the deity. Or, the figure may simply portray an earthly general. A large number of similar figures representing yakshas have been recovered from Kausambi (see Kala 1980, figs. 142–45).

S16 A Goddess with Fish

Uttar Pradesh; c. 100 B.C.
Red terra-cotta; 6 1/8 in (15.5 cm)
Gift of Marilyn Walter Grounds; M.83.221.2

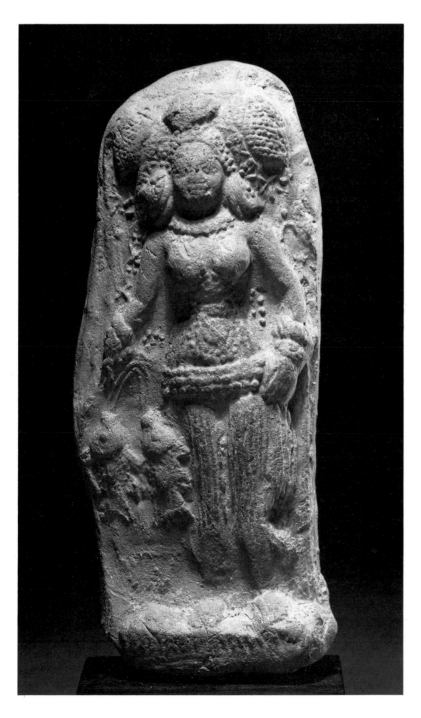

The molded plaque depicts a well-proportioned female standing with her legs slightly bent. A striped garment drapes her legs and is secured low on her hips by a chain girdle. Her torso is adorned with a torque and long necklace that falls to her stomach. She wears an elaborate headdress and large ear ornaments. Her left hand rests on her hip, and her right hand holds a pair of fish. Stars or floral motifs enliven the background near the deity's torso and arms.

This figure is a fairly common iconographic type popular in Mathura and Kausambi in Uttar Pradesh and also known in Chandraketugarh in West Bengal (Ghosh 1973, pl. XLV). One scholar (V. S. Agrawala 1939) attempted to identify her as an ancient goddess of abundance, called Vasudhara, while another (M. Chandra 1973b) argued that she is an Indian adaptation of the Iranian Anahita, a fertility goddess, whose symbol is the fish. A pair of fish, however, is an auspicious symbol of great antiquity in India and was adopted with equal zeal by Hindus, Buddhists, and Jains. The fish is also a symbol of the Indian god of love, Kamadeva, and generally signifies fertility and plenitude. Furthermore, a pair (*mithuna*) of fish symbolizes completeness. Thus, it seems unnecessary to search beyond India to explain the currency of this motif as an attribute for a goddess of abundance. Curiously, in later Indian iconography the fish does not appear as an emblem of Vasudhara, Buddhist goddess of wealth, but is associated with the boar-headed Mother Goddess known as Varahi.

S17 The Lustration of Sri-Lakshmi
Uttar Pradesh, Kausambi (?); first century B.C.
Red terra-cotta; 5 ¾ in (14.6 cm)
Indian Art Special Purposes Fund; M.85.62
Literature: Pal 1985b.

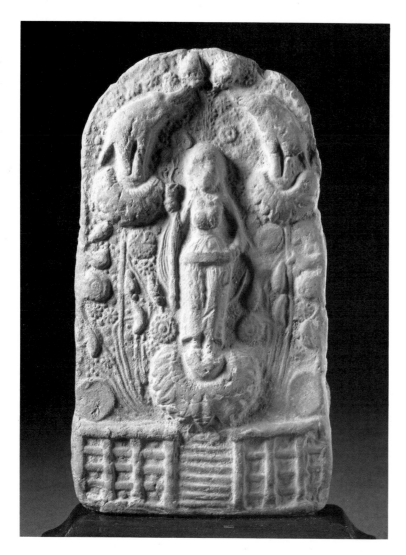

Except for the damage to the goddess's face and slightly effaced lotuses at her left, this is a fine example of a molded terra-cotta votive plaque of the first century B.C. It is also a rare, early depiction of a shrine. The surrounding railing and central flight of stairs clearly demonstrate that the image must have been placed on a fairly high platform. Since no walls or superstructure are shown, the image probably depicts an outdoor shrine.

The well-proportioned goddess stands in a hieratic posture on a large lotus, evidently rising from a pool. She is framed by other lotus plants with flowers and leaves. Two elephants are perched on two more lotuses at the height of her shoulders. The animals are bathing or lustrating the goddess with water poured from waterpots held by their raised trunks. The theme is popularly known in Sanskrit as Gajalakshmi, the elephants symbolizing rain clouds and the

water, the rains. The goddess's right hand probably holds a lotus flower; the left hand rests on a plain, flat band encircling her ample hips.

The unknown creator of this well-formed plaque was a talented craftsman. Not only is the composition lively, but the details are articulately rendered. The artist was equally adept in delineating flora and fauna with perceptive naturalism. At least two plaques representing Gajalakshmi were found in Kausambi, although neither are as well preserved or as detailed (Kala 1980, figs 69–70). Nevertheless, stylistically the museum's plaque is so similar to the Kausambi examples that it is possible that they are all from the same site. Indeed, it is not improbable that these plaques are miniature representations of the city goddess of Kausambi.

S18 Elephant with Riders
Uttar Pradesh (?); first century B.C.
Buff terra-cotta; 5 ⅝ in (14.3 cm)
From the Nasli and Alice Heeramaneck
Collection
Museum Associates Purchase; M.80.6.3
Literature: Montgomery and Lippe 1962, p. 31;
Art of India and Southeast Asia 1964, p. 18;
Rosenfield et al. 1966, p. 27; Heeramaneck
1979, no. 4; Czuma 1985, pp. 116–17.

This charming elephant with riders was cast in
two pieces joined together to form a sculpture in
the round. The smooth, curved base with a lug
and hole indicate that the object was used as a
rocking toy. Such clay rocking toys are still made
in northern India. The object may have come
from Uttar Pradesh, from either the Mathura or
Kausambi area, although the subject was also
enormously popular in the Deccan.

The elephant is caparisoned
with a frilled headcloth and decorated rug. The
four riders include a turbaned male flanked by
two females, one of whom carries a pot, and a
more coarsely delineated mahout bringing up
the rear. The turbaned male and female in front
seem to hold the end of the halter straps, which
are fitted to the animal's nose and mouth. The
ropelike object in the mahout's right hand
cannot be identified, but it should be an
elephant goad.

The representation of elephants
with riders was a common motif in the art and
architecture of the period (see S13), especially on
Buddhist monuments. There they represent
affluent or princely worshipers who have come to
adore the Buddha, but such terra-cotta versions
probably served a more secular function.
Although the piece has been dated generally to
the first century A.D., stylistically it could well
belong to the first century B.C. The riders are
more reminiscent of Sunga-period sculptures
than they are of Kushan-period figures.

S19 Toy Dog
Bihar (?); c. 200 B.C.
Brown terra-cotta; length 6 in (15.2 cm)
From the Nasli and Alice Heeramaneck
Collection
Museum Associates Purchase; M.73.4.5
Literature: Rosenfield et al. 1966, p. 26, no. 8.

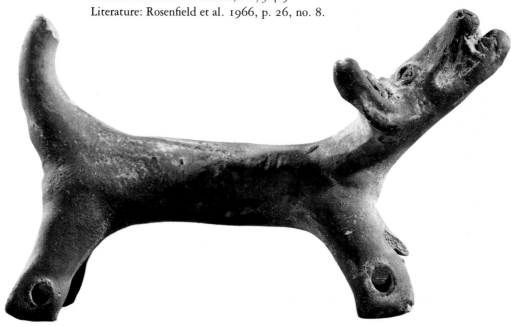

Wheel axles were inserted into the holes of the legs of this mobile toy. The snarling expression of the animal seems hardly appropriate, however, for the amusement of a child. Indeed the tense body with stiff ears, raised tail, and firm posture together with the growling expression indicate that the artist intended to represent an angry rather than affectionate dog. He might also well be a dog howling at the moon. In any event, despite the highly abstracted form, the animal is remarkably lively and expressive. The representation may be an attempt at stylization or, in fact, a depiction of a type of dachshund.

The exact provenance of this spirited canine is not known, and dogs were not a very popular subject for terra-cotta sculpture. A possible source may be Bihar, where a number of toy horses with straight, stiff legs and holes similar to those on this dog have been discovered (Shere 1961, Bulandibagh 12 and Patna 18–19). These examples are generally dated to the third–second century B.C.

West Bengal

S20 An Earth Goddess
West Bengal, Chandraketugarh; c. 100 B.C.
Buff terra-cotta; 2 ¼ in (5.7 cm)
Indian Art Special Purposes Fund; M.77.36.2
Literature: Larson et al. 1980, p. 41, no. 2.

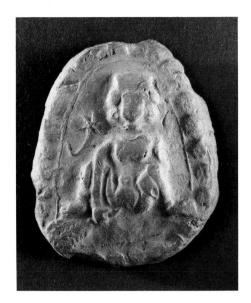

A nude goddess is seated with her legs spread wide apart in the posture of giving birth, which is generally identified as *utthānapād* (with legs raised). She wears a bouffant hairdo, and her ornaments include plain anklets, necklace, and earrings. With her right hand, the goddess extracts an ear of corn from her vagina. Near her right shoulder is a sprig with a star-shaped bloom. The oval plaque is bordered with beads.

That the figure represents a primitive earth goddess seems certain. The earliest depiction of this subject occurs on a seal from Harappa (c. 2500 B.C.), which depicts a female figure with legs placed widely apart issuing a plant from her sexual organ (Vats 1940, 2: pl. XCIII, no. 304). Clearly these figures were meant to represent an earth goddess from whom springs all corn and vegetables. The concept has survived in later literature and art. In the *Devimahatmya*, a fifth-century text glorifying the Goddess, she declares: "Next O Ye Gods, I shall support the whole world with the life-sustaining vegetables, which shall grow out of my own body, during a period of heavy rain. I shall gain fame on earth then as Śakambharī" (Pargiter 1969, p. 518). The term *Śakambharī* literally means "herb nourishing" or "herb nourisher." These terra-cottas are related to stone sculptures of headless, nude goddesses, who sit similarly exposing their genitalia. Such icons have been discovered in various parts of the subcontinent and are still venerated as cult objects. The plaque stylistically is very similar to another found in Chandraketugarh (D. Desai 1975, fig. 9).

S21 Plaque with Bust of a Goddess
West Bengal, Chandraketugarh; c. 100 B.C.
Buff terra-cotta; 1 ¾ in (4.5 cm)
Indian Art Special Purposes Fund; M.77.36.5

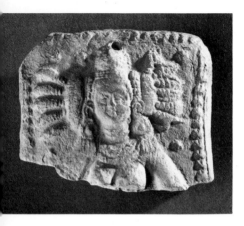

The terra-cotta media, beaded border, and hole above the figure's head clearly associate this molded plaque with others from Chandraketugarh (see S22). Distinguished by her headgear, she represents, perhaps, the most popular iconographic type, with the exception of Gajalakshmi, from Mathura to Bengal in the two centuries before Christ. The chief distinction between this goddess and other such cult figures of the period is that her headgear consists of what appears to be five projecting palm fronds on the right and five emblems on the left. The emblems cannot be distinguished in this specimen, but certainly they include an elephant goad, which can be clearly identified in all other examples. Among other objects are a cornucopia or horn, trident, and arrowhead.

The identification of this goddess remains highly controversial. Classified generally as the *pañchachūḍā* (five-crested) type, she has been variously identified as a yakshi or apsaras (specifically the celestial nymph called Panchachuda), the goddess Mayadevi or Sri-Lakshmi, and Sinivali (a Vedic fertility goddess [D. Desai 1975, p. 13]). This last identification has been suggested because a similar plaque was discovered near a fire altar during excavations at Kausambi (G. R. Sharma 1960, pp. 93, 122). Doubts, however, have been expressed regarding the interpretation of the Kausambi fire altar. Thus, while her exact identification remains uncertain, her importance in the religious life of the Ganges Valley is evident both from the wide dispersion of her image and her weapons and elaborate headgear with vegetative symbols. In this regard she seems to anticipate the later concept of Durga.

S22 A Winged Deity
West Bengal, Chandraketugarh; c. 100 B.C.
Buff terra-cotta; 3 ¼ in (8.2 cm)
Indian Art Special Purposes Fund; M.77.36.1

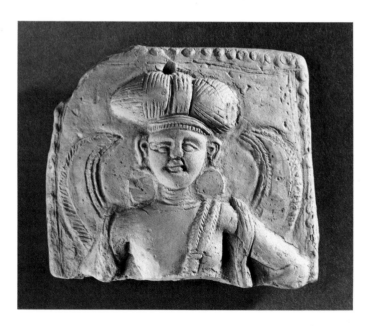

This molded plaque represents within a beaded border the upper half of a winged male figure. The complete plaque was probably six inches high. A hole above the turban of the figure indicates that the plaque may have been worn as an amulet or hung on a wall.

When complete, the figure probably wore a dhoti. A gathered shawl is slung across both upper arms, and an animal skin, perhaps that of an antelope, drapes the left shoulder. The figure wears an elaborate turban and circular earrings. The features of the youthful face are articulately delineated. The arms were very likely placed akimbo. The most distinguishing iconographic feature are the wings projecting from the upper arms.

That the figure is from Chandraketugarh, a rich archaeological site in West Bengal, can be firmly established by a comparison with several other similar plaques. All are rectangular with beaded borders and one or two holes at the top, indicating their probable function as amulets. Perhaps most similar are three fragmentary plaques, each showing a man, elephant (Ghosh 1960, pl. LXVC), and lotus-bearing goddess (Ghosh 1973, pl. XLVa). Indeed, the three plaques stylistically are so similar that they may have been made in the same workshop.

Similar winged deities of both sexes have been found in various sites from Bihar and West Bengal and are generally dated to the second century B.C. (Auboyer 1981). Indeed, Chandraketugarh has yielded another fragment showing a richly bedecked goddess (Ghosh 1973, pl. XLVd). The exact identification of these divinities remains elusive. The females have been identified as Sri-Lakshmi, while the males may represent a lunar deity. In several others the deity, whether male or female, holds the lotus and stands on the lotus flower. In the more complete examples the deity is more richly attired and ornamented. The animal skin of this figure is unusual and indicates his ascetic nature. The wings may well represent a crescent moon, in which case this figure could be Soma, the moon god, who is an ascetic brahmin and hence may wear the animal skin.

S23 A Boy Feeding a Parrot
West Bengal, Chandraketugarh;
first century B.C.
Reddish brown terra-cotta; 5 ⅛ in (13.0 cm)
Indian Art Special Purposes Fund; M.85.35.1

A slightly rotund boy with genitalia exposed is seated on his haunches. While his lower garment is not discernible, his arms seem to be draped in a shawl. He also wears anklets, bracelets, and a necklace consisting of a pendant flanked by tiger claws. Tiger-claw necklaces were popular charms worn by children in ancient India. The boy's large ears appear to have holes in them but no ornaments. Knobs along the hairline define his curly hair. In his left hand he holds a bird, probably a pet parrot. With his right hand he feeds the bird a sweet or piece of fruit.

A hole at the bottom of the flat base probably indicates that the object was a child's rattle. The discoloration on the face, from magenta on the chin to almost black on the right half, denotes that the piece may have been in a fire. Otherwise, except for minor damage on the head and right arm, the object is remarkably well preserved.

The attribution of the object to Chandraketugarh is not certain. The round face, distinguished by very large eyes, is characteristic of figures discovered from Chandraketugarh (Biswas 1981, pls. XV, XXXII). The posture also seems to have been favored by artists of that area, and at least another figure, perhaps of a young prince, holds a parrot in a similar fashion (Biswas 1981, pl. XXXVb).

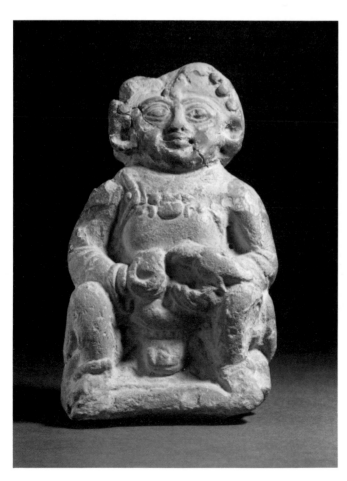

S24 A Lady with an Attendant
West Bengal, Haroa (?); first century B.C.
Red terra-cotta; 5 in (12.7 cm)
Indian Art Special Purposes Fund; M.85.35.2

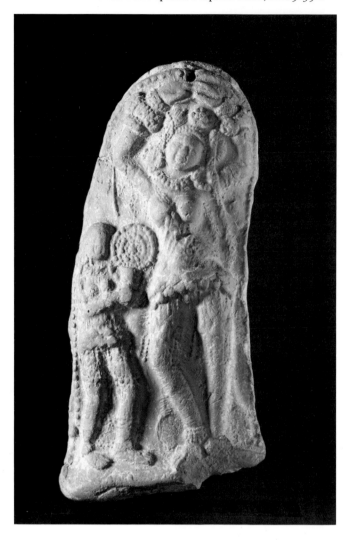

A slim, elegant lady strikes a graceful posture as she stands with her arms clasped above her head. She wears a diaphanous garment below the hips, chain girdles, necklace, and elaborate hairdo with central crest. Her anklets and bracelets were probably made of fresh flowers. Beside her stands another female, who holds a mirror. Her gesture and much smaller size identify her as an attendant. Although the posture of her mistress is taken from the repertoire of a dancer, the lady is obviously admiring her reflection in the mirror. Perhaps she is a dancer examining herself before a performance.

An almost identical plaque, although broken from the waist of the attendant, was found in Haroa, a village not far from Chandraketugarh (Biswas 1981, pl. xxxd). Indeed, the two are so similar that they may have been cast from the same mold. Biswas identifies the subject as the birth of the Buddha and dates the piece to the second century A.D. Neither suggestion is correct. He has also published another fragment, showing an even more seductive figure in the same pose, which he identifies as an apsaras and dates to the first century B.C.–A.D. (Biswas 1981, pl. xxxvIa). Indeed, the museum's figure stylistically can be compared with similar figures from Kausambi in Uttar Pradesh, which are generally dated to the first century B.C. (Kala 1950, pls. IV, XXI; Kala 1980, fig. 115). The finding of two other representations of the danseuse, although in two distinct styles, at Haroa demonstrate the popularity of the theme in that region. Noteworthy is the design and shape of the mirror, which must have been made of metal, polished on one side and adorned on the other. The close stylistic and iconographic similarity between these plaques found as far apart as Kausambi and Haroa may indicate that they were made at one of the two sites and transported to the other.

S25 A Corpulent Male Figure
West Bengal, Chandraketugarh;
first century B.C.
Buff terra-cotta; 4 ½ in (11.4 cm)
From the Nasli and Alice Heeramaneck
Collection
Museum Associates Purchase; M.72.1.1
Literature: *Art of India and Southeast Asia* 1964,
p. 18; Rosenfield et al. 1966, pp. 27–28,
no. 10; Heeramaneck 1979, no. 6.

This is probably one of the best preserved terra-cotta figures from West Bengal. The specimen is closely akin to one found in Chandraketugarh (Biswas 1981, pl. XV; see also pl. XVI). Biswas dates all three pieces to the second century A.D., although other examples have been dated to the second century B.C. (Ghosh 1964, p. 106, pl. CLV, no. 3). An example from Harinarayanpur, also from the 24 Parganas district, may be compared with those from Chandraketugarh (Ghosh 1958, pl. LXXXIVb).

Like the others, this object is hollow with a plain back and hole at the bottom. It is assumed, therefore, that it was used as a rattle, although the subject generally has been identified as a yaksha, specifically as Kubera, god of wealth (Biswas 1981, p. 81). If indeed the figure represents a divine being, then relics or charms may have been inserted into the hole to increase the icon's potency, as was done later by Buddhists with bronze images and stupas.

Seated on its haunches and elaborately adorned, the corpulent figure is undoubtedly a yaksha. Whether or not he is clothed cannot be determined. A girdle around the waist is discernible, and his genitalia are prominently displayed underneath. A shawl is wrapped around his arms, which are bedecked with thick bangles. Three necklace strands fall down to his ample belly, and his disk ear ornaments are embellished with tassels. The tall headdress is distinctive of most of these squatting yakshas and is even taller in the Harinarayanpur example. The object held between the thumb and forefinger of the right hand is not recognizable, but the left hand certainly forms a ritualistic gesture, which would weigh in favor of the figure being intended for a religious rather than secular function. In all other examples the left hand simply rests on the knee, while in one figure the right hand holds a flower. It has been suggested that the object in the right hand is a lemon, an attribute of Kubera in later iconography. Whether or not these figures can be identified as Kubera, one may at least regard them as prototypes of the potbellied image of the god that became standard from the Kushan period.

This figure is better preserved than the other examples, and the workmanship of this particular sculpture is superior. Not only is the figure well modeled, but details are crisply rendered. Despite the hieratic posture, the genial facial expression and expressive hand gestures make this a lively representation.

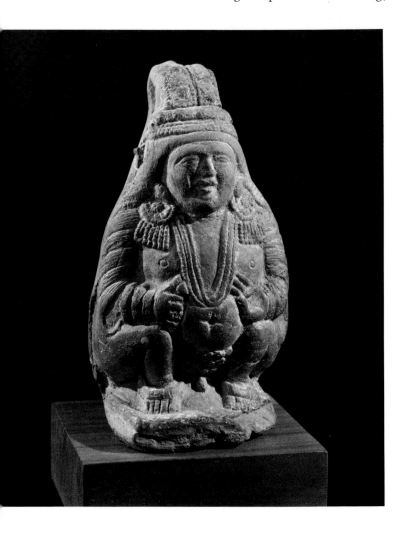

S26 *Toy Ram*
West Bengal, Chandraketugarh;
first century B.C.
Reddish brown terra-cotta; 6 ¼ in (15.9 cm)
Gift of Marilyn Walter Grounds; M.84.220.8

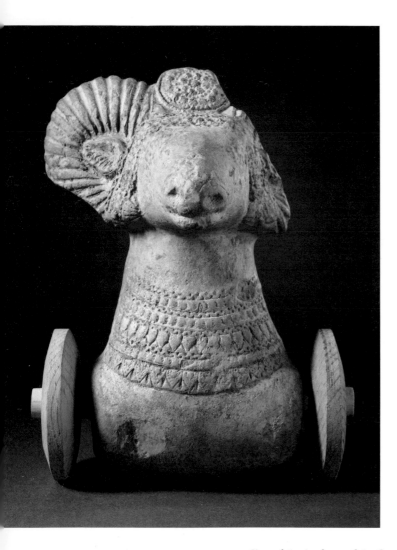

Shaped in the form of the forepart of a ram, this toy originally was used as a cart. Through the rolled, hollow chest of the ram, an axle would have been attached to two wheels. A little above the center of the smooth back is another hole into which a stick would have been inserted, to be used as a handle to push the cart. The neck of the animal is decorated with several rows of necklaces. Ornaments also adorn the head. The wheels are modern.

Although ram carts were commonly used in many parts of northern India (in Gandharan reliefs the young Buddha is often shown riding a cart drawn by rams), this particular example can be assigned to West Bengal with some certainty. Not only have similar toy rams been found in significant numbers there (Biswas 1981, pp. 186–87, pl. LI), but the design of the necklaces of this particular example is remarkably similar to that seen in another representation of the animal found at Chandraketugarh (Biswas 1981, pl. XIVb). The realistic representations of the animal in terra-cotta, including the museum's toy, clearly indicate that artists were quite familiar with this domesticated animal. Indeed, this head with its wonderfully delineated right horn (the one on the left is broken) is carefully modeled and demonstrates the artist's perceptive observations. Most such pieces, found at Chandraketugarh and Tamluk, are dated to the first–second century B.C.

S27 *Two Addorsed Females*

S27 *Two Addorsed Females*
Madhya Pradesh, Bharhut; c. 100 B.C.
Rust sandstone; 11 in (28.0 cm)

From the Nasli and Alice Heeramaneck
Collection
Museum Associates Purchase; M.76.2.29
Literature: Rosenfield et al. 1966, pp. 23–24.

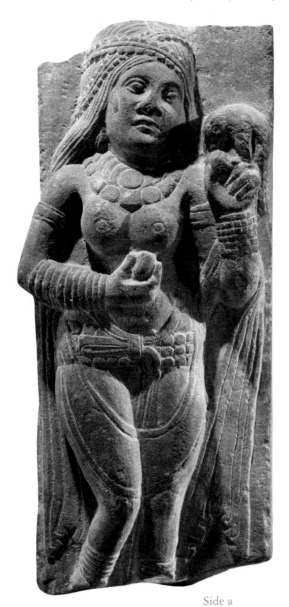

Side a

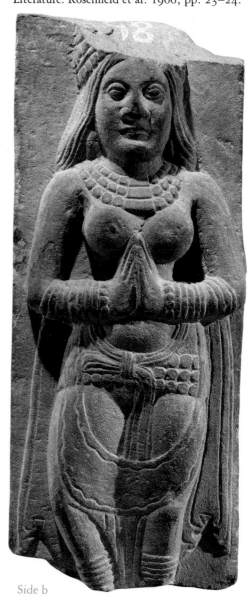

Side b

This relief with two female figures on both sides once supported the arches of one of the gateways (torana) of the great Buddhist stupa at Bharhut in Madhya Pradesh. The gateways were constructed by the king Dhanabhuti and members of his family during the reign of the Sungas. One of the earliest Buddhist monuments in India, Bharhut remains a landmark in the history of Indian sculpture. Most of its remaining sculptures are now housed in the Indian Museum, Calcutta.

The fragment depicts two females engaged in adoring the Buddha. One (*a*) holds an unidentified object in the right hand, perhaps a fruit or gem, and a flywhisk in the raised left hand. The other (*b*) makes the typically Indian gesture of salutation or greeting with the hands joined below her breasts. The lower part of the body of each is draped with a diaphanous garment tied at the waist with a knotted single bow. Around the lower hips is a chain girdle. A shawl loops across the thighs and flows over the arms. Each figure is adorned with many bangles, two or three necklace strands,

and earrings. In addition, the lady with the fly-whisk (*a*) wears two armlets. Her long hair comes down on either side of her face, which is adorned with two chain strands crossing above the right eye. The hair of the other figure (*b*) also must have been treated in a similar fashion. The figures are generally identified as celestial nymphs.

The rather shallow relief, heavy and squat proportions, broad faces with flaring noses, large staring eyes, and somewhat awkward stance are characteristic of Bharhut sculptures. The lady with her hands joined (*b*) seems to have been rendered slightly more naturalistically. Not only is her posture a little less awkward, but the foreshortening of the hands is rather unusual for Bharhut sculpture. When other figures are shown making this gesture, a flat, side view of the hands usually is afforded. There are one or two other instances when a sculptor deviated from the norm (Barua 1979, pl. XV, no. 12a; P. Chandra 1970, pl. XXXII).

S28 Fragment of a Pillar
Madhya Pradesh, Bharhut; c. 100 B.C.
Rust sandstone; 13 ⅝ in (34.5 cm)
Indian Art Special Purposes Fund; M.85.39

This fragment once formed part of a pillar of the great stupa at Bharhut, which was built sometime about 100 B.C. (see S27). When complete, it would have formed a half-moon as the upper part of a railing pillar. Animals seem to have been a favorite theme for the decoration of these half-moon medallions, and in this example only the forepart of a seated lion remains. In front of the lion is part of a stylized tree, and above his back is a segment of a pendant lotus of a type seen quite commonly in Bharhut medallions (Barua 1979, pl. XXIX, nos. 21–24). Although the lion is not rendered naturalistically, the representation is quite lively. If the tree rises from a pedestal, the scene may depict the lord of the animals adoring the bodhi tree (pipal) under which Sakyamuni was enlightened (see Barua 1979, pl. LXXX, no. 108, for a scene in which lions and deer surround the sacred tree).

S29 *Two Addorsed Tree Dryads*

Madhya Pradesh, Sanchi; 50 B.C.–A.D. 25
Cream sandstone; 24 ½ in (62.2 cm) each
From the Nasli and Alice Heeramaneck
Collection
Museum Associates Purchase; M.85.2.1
Literature: Rosenfield et al. 1966, pp. 23–24;
Meister 1968, p. 108 (*b* only); Trubner 1968, p.
2, fig. 1; Los Angeles County Museum of Art
1975, pp. 18–19, 146; Craven 1976, p. 71;
Heeramaneck 1979, no. 3; Newman 1984, p.
48; Pal 1985a, p. 68, fig. 8 (*b* only).

The sculpture once served as an end bracket
between two arches or lintels on one of the
gateways of Stupa I, or Great Stupa, at Sanchi,
one of the most important Buddhist sites on the
subcontinent. The carved gateways at Sanchi are
of fundamental importance for an understanding
of the early history of Indian sculpture. Both
sculptural and epigraphical evidence indicates
that all four gateways at Sanchi were constructed
sometime between 50 B.C. and A.D. 25, the
earliest being the southern gateway. It is not
possible to be more precise about the date of this
bracket sculpture as, except for the northern
gate, the bracket figures are missing from each of
the other three gates.

 Unlike the few still in situ,
which show only one figure per bracket, in this
example two females are represented back to
back. On side *a* the figure stands gracefully
with her right leg bent behind the left. Her left

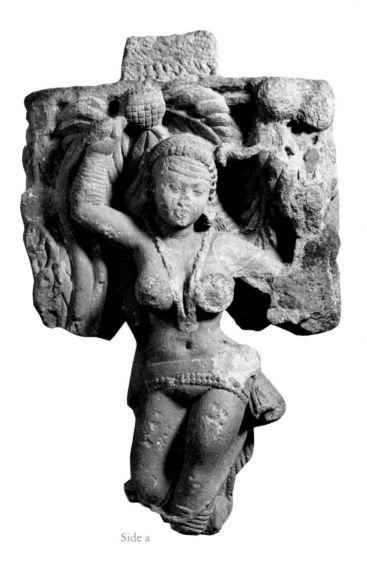

Side a

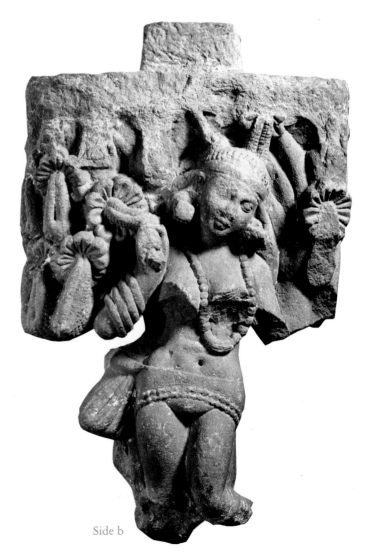

Side b

arm is broken from the elbow, her right arm is raised and holds the branch of a fruit-bearing or flowering tree. If it is a fruit, it looks like a pineapple, but if it is meant to be a flower it may represent the kadamba. The tree under which the other lady stands in *b* has stylized flowers with garlands emerging from the blooms. She holds one of the garlands in her right hand, her left arm is broken. She stands with both legs bent at the knee, as if she were swinging. Indeed, the sense of motion is also conveyed by the representation of the pearl necklace swaying to the left, looping around her breast. In the other figure the necklace falls between the breasts. Both wear many bracelets and anklets, and two strands of chains hug their lower hips.

Although the lower part of their body is draped, the garments forming elegant loops along the side, the figures, in fact, seem quite naked. Their ear ornaments and hairstyles appear to be similar.

Both figures introduce a theme that has remained popular with Indian artists. Known as *śālabhañjikā*, it emphasizes the close relationship between woman and nature, each transferring its fecundity to the other. Both figures are carved in high relief and modeled with remarkable naturalism. Their many ornaments and accoutrements do not obstruct the sensuous curves and swelling volumes of the figures.

S30 *Bust of a Tree Dryad*

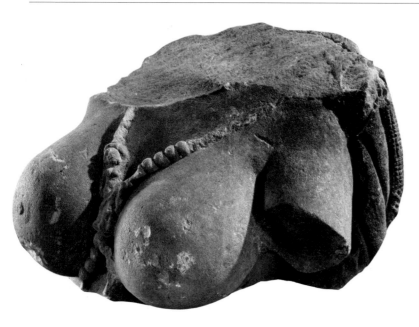

S30 *Bust of a Tree Dryad*
Madhya Pradesh, Sanchi; 50 B.C.–A.D. 25
Cream sandstone; 9 ½ in (24.1 cm)
From the Nasli and Alice Heeramaneck Collection
Museum Associates Purchase; M.79.9.1
Literature: Lee 1942, pp. 21, 39; Trubner 1950b, p. 12, fig. 7; Montgomery and Lippe 1962, pp. 40–41; Rosenfield et al. 1966, pp. 23, 25; Heeramaneck 1979, no. 2.

This almost life-size bust once belonged to a tree dryad that served as a bracket figure joining the post and lintel of one of the gateways of the Great Stupa at Sanchi (see S29). Each gateway had two such fully carved figures. When complete, the figure would have stood with one leg crossed behind the other and one hand grasping the branches of a fruit-laden tree.

Between the ample breasts is a pearl necklace adorned with two miniature female figures, one of which is broken at the waist. Both appear to be standing with the left arm raised above the head. Basically, each is a miniature version of the larger figure. What remains of the curved back is covered with two broad plaits of hair adorned with garlands.

In their proportion and naturalistic modeling, these bracket figures are much more impressive than the smaller sculptures placed between two lintels (S29). While these voluptuous breasts seem weighty in their present state, the in situ figures, in fact, are remarkably buoyant. Indeed, these bracket figures at Sanchi are among the most elegant and animated representations of the female form in the entire history of Indian sculpture. The unknown master sculptors responsible for them were completely self-assured in their aesthetic vision and technical mastery of the material.

Age of the Kushans and Satavahanas

(first–third centuries A.D.)

Introduction

During the first three centuries of the Christian era several important schools of sculpture flourished in different parts of India. Stone became the principal sculptural medium, although terra-cotta continued to be popular in the urban centers of the riverine plains. Images in gold, silver, copper, and bronze were also produced in quantities, but few examples have survived.

Two prolific schools of sculpture evolved in the Kushan Empire, which at its height, between around A.D. 50 and 200, encompassed parts of Bactria in northern Afghanistan and the Mathura region in northern India. One is known as Gandhara, which covered a region comprising parts of today's southern Afghanistan and northern Pakistan. The other school flourished in Mathura, which grew into an important commercial and religious entrepôt during the early Kushan period. At about the same time much of the Deccan comprised the empire of the powerful Satavahana dynasty, which also, like the Kushans, thrived on foreign trade. Rich traders seem to have been the principal patrons in both empires, and Buddhism, with its organized monastic establishments along the trade routes, seems to have especially profited from mercantile activities. Not only did their strategically located monasteries in Gandhara and further north in Central Asia and in Mathura and on both the eastern (along today's Andhra Pradesh) and western (Maharashtra) coasts serve as hospices or caravansaries for merchants, but they may also have served as banks. In any event, much of the art produced in Gandhara, Andhra Pradesh, and the coastal region of Maharashtra is Buddhist, and only in Kushan-period Mathura was art produced for the Jains and Hindus as well.

Continuing its Hellenistic legacy, a remarkably eclectic school of sculpture developed in Gandhara during this period. While other aesthetic traditions, such as Scythian and Parthian as well as Indian, contributed to its development, the dominant characteristics of the school were Hellenistic, strongly related to the contemporary centers of art in the Asian provinces of the Roman Empire. Although Parthians acted as buffers between Roman West Asia and the Kushan Empire, they, too, were strongly influenced by philhellenism, so that Gandhara can be regarded as the easternmost region in the ancient world influenced by classical aesthetics, although much modified along the way. Thus, just as the West Asiatic sites of Hatra or Palmyra reveal their eclectic style within the broader philhellenic cultural milieu, so also the artists of Gandhara combined Hellenistic artistic norms and techniques with Indian iconography and artistic ideas to create a

hybrid, but recognizably Indian school of sculpture to meet the local religious needs. Whatever the inspiration and whether or not artists were imported into the region from West Asia, by the end of the first century various aesthetic traditions had coalesced into a coherent, recognizable Gandharan style. There are, of course, striking variations in style and quality among Kushan-period Gandharan sculptures. In the Swat Valley, for instance, there developed a more provincial, archaizing style than that which flourished in the Taxila and Peshawar regions (see, for example, the Swat Hariti [S50]).

Despite much archaeological excavation in Gandhara and other northern sites of the Kushan period, scholars disagree regarding the chronology of the Gandharan school. Generally the gray schist sculptures are considered to precede those made from stucco, although both materials were used during the Kushan period and later. The problem is compounded further by the survival of only a few inscribed and dated sculptures. These dates, however, do not mention a specific era, which has further led to much controversy. The dates suggested for the sculptures of this period, therefore, must be regarded as tentative.

Some five hundred miles south of Gandhara in the environs of Mathura a completely different style of art developed at the same time. Unlike the artists at Gandhara, those at Mathura employed the locally available, softer, mottled red sandstone, and it was never replaced by stucco. The material itself contributed somewhat to the striking differences between the two styles. Unlike the sandstone of Mathura, the harder schist of Gandhara allowed the sculptors to carve the folds of garments and details of features and jewelry much more crisply and with greater volume. The distinct aesthetic norms preferred in the two centers also contributed to such differences. Influenced by Hellenistic ideas, Gandharan artists were more concerned with naturalistic modeling and the rendering of garments and embellishments in realistic detail. They faithfully reproduced what the eye perceived, as witnessed, for instance, in the sculpture of a bodhisattva in the collection (S45). Mathura sculptors, conversely, were not reluctant to represent the human body in all its sensuous elegance. The body was conceived as an aggregate of swelling forms and sinuous curves. Realistic modeling was eschewed for abstraction, without, however, sacrificing the sensuality of the form. In this Mathura artists were clearly expressing the same ideals and formalistic approach to the human body evident in second–first-century B.C. sculptures. Indeed, a comparison between the bracket figures from Sanchi (S29) and the Amazonian nature goddess from Mathura (S54) clearly demonstrates the close affinity of the two styles, whereas a comparison between the Mathura Balarama (S59) and Gandharan bodhisattva (S45) reveals the striking variation between the two styles. The Gandharan bodhisattva is a palpable figure and, except for his broken halo and idealized features, may well have been modeled after an aristocratic nobleman who has taken great care to maintain a healthy body. By contrast, the Mathura Balarama, with its greater abstraction and idealized form, is less naturalistically modeled. Yet, paradoxically, the Mathura figure seems to be more earthbound and tactile than the Gandharan statue. Although Gandharan sculptors, strongly influenced by classical sources, were adept at depicting spatial dimensions, fluid postures, and realistic drapery patterns, their Mathura colleagues achieved forms that express a stronger sense of rhythmic vitality and joie de vivre.

Noteworthy is the preponderance of sensuously rendered female forms on the railings of the various monuments, largely Buddhist, which appears to have been a hallmark of Kushan Mathura (see S55). Similar figures had also been used in earlier Buddhist monuments but in a more restrained fashion. In Kushan

Mathura as a devotee approached a stupa he would pass by a bevy of voluptuously endowed ladies striking coquettish poses and indulging in frivolous conduct. It would seem that the use of such motifs was deliberate, as if the visitor were expected to pass through the world of mundane passion before entering the calming spirituality symbolized by the abstract stupa. The contemporary Sanskrit poet Asvaghosha (active first century) describes such an experience in chapter 4, entitled "Putting Away Desire," of his *Buddhacharita* (Life of the Buddha):

> *The prince on entering the garden, the women came around to pay him court; and to arouse in him thoughts frivolous; with ogling ways and deep design.*
> *Each one setting herself off to best advantage. . . .*
> *But all the women beheld the prince, clouded in brow, and his godlike body not exhibiting its wonted signs of beauty; fair in bodily appearance, surpassing lovely. All looked upwards as they gazed, as when we call upon the moon Deva to come; but all their subtle devices were ineffectual to move Bodhisattva's heart {Cowell (1894) 1968, p. 38}.*

Similarly the devotee circumambulating the stupa was very likely not expected to be affected by the charms of the beguiling ladies, whether celestial or mortal, carved with such abandon on the pillars.

Because Mathura artists were called upon to produce art for Jains and Hindus, as well as Buddhists, their repertoire was more diversified than that of their Gandharan counterparts. In fact, if any single artistic center can be regarded as the birthplace of Indian iconography, then Kushan Mathura has the best claim. Although for more than fifty years scholars have debated about which school— Gandhara or Mathura—originated the image of the Buddha, most Hindu and Jain images were first created in the ateliers of Mathura. The museum's collection of early Mathura art is remarkably varied for both Hindu and Buddhist iconography. It is also stylistically rich, representing the three centuries in which Kushan Mathura flourished.

Mathura continued to be a productive center for terra-cotta sculpture during the Kushan period. Curiously, no other site in Uttar Pradesh or Bihar was as prolific as Mathura for stone sculpture as well. A local school may have existed at Ahichchhatra, but most other cities seem to have imported sculptures from Mathura. Even Sarnath, which became so active during the Gupta age, seems to have been dormant during the Kushan period. In most other north Indian cities, terra-cotta remained the primary medium of sculpture until the Gupta period. Most Kushan-period terra-cotta sculptures in the collection are from Uttar Pradesh, and although some have been attributed to specific sites, such as Mathura or Kausambi, their exact provenance cannot be determined. These terra-cottas vary widely in style and quality. Generally, the larger sculptures seem to have been freely modeled with many of the features and salient details rather roughly rendered (see S60). The smaller figures, especially from Kausambi, however, are more sophisticated and elegant. In general Kushan-period Mathura terra-cotta sculptures are not as refined as the stone sculptures, while those from Kausambi, Ahichchhatra, and other sites reflect a greater sensitivity in the modeling of figures and rendering of embellishments.

Much sculpture must also have been produced during the Kushan period in various forms of metal, such as gold, silver, copper, and bronze. Gold was a popular metal with the Kushans themselves, particularly because of their Scythian background. Certainly, gold and silver ornaments were popular among the Indians. Whether in the form of ornaments or statues intended for worship, not much early metalwork has survived because of the general practice of melting the metal and reusing it to cast new adornments or images. In addition, the constant application

of ritual unguents causes the metal images to become effaced, thereby requiring their replacement from time to time. This is particulary true of Hindu and Jain images, and hence very few early figures have survived. Excavations in Taxila and other important Kushan sites in Afghanistan have brought to light substantial amounts of gold ornaments, and both gold and bronze objects of diverse types demonstrate the popular use of metal during the Kushan period. Recent political events in Afghanistan have caused a good deal of small metal objects to enter the Western market. Although small, they are interesting for their diversity, reflecting the eclectic cultural environment of ancient Afghanistan. Perhaps the most fascinating of these is an intriguing female figure, who may represent the Iranian goddess Anahita (S52). Tentatively attributed to the third–fourth century, it reflects a mixture of Iranian and Indian styles.

Unquestionably the most important metal sculpture of the Kushan period in the collection is a fragmentary bronze of a reclining lady, probably the mother of the Buddha (S57). It is certainly a product of the Mathura school from which less than a dozen Kushan-period bronzes are known (see Czuma 1985, pp. 104–5, 114–15). Apart from representing a rare iconographic type, it is also an attractive sculpture, bearing a remarkable formal affinity with the much-admired stone females of the period.

A third important school of stone sculpture during this period flourished in the Guntur district of Andhra Pradesh first during the rule of the Satavahanas and then during the short-lived Ikshvaku dynasty. Distinguished by its white or greenish white limestone, the school, which had several sites along the fertile Krishna Valley, is referred to as the Amaravati school, after one of the most important ancient cities of the region. Although the collection possesses no sculpture from Amaravati itself, it does have one relief from Nagarjunakonda (S81), a celebrated town in Andhra Pradesh associated with the famous Buddhist scholar Nagarjuna (active second century), and four pieces most likely from Gummadidurru in Andhra Pradesh (S82–85).

Most Amaravati sculptures, like those of Gandhara, were produced for Buddhist monuments. Also, like Gandharan artists, Amaravati sculptors of the period appear to have been aware of Roman art, for Roman traders seem to have visited the eastern coast. Amaravati artists, however, did not succumb to the charms of Hellenism as readily as did their northwestern colleagues. While the reliefs of the second–third century clearly reveal that local sculptors had absorbed some of the technical artifice of Roman sculptural forms, by and large their sculpture is distinctly Indian.

In contrast to Gandhara, and even Mathura, Amaravati sculptors preferred shallower carving with greater emphasis on linearity. Although characterized by broad, heavy shoulders for male figures and large breasts and wide hips for females, Amaravati sculptural figures are extraordinarily supple and willowy. This formal exuberance is also reflected in the compositions of the narrative panels, where at times the activity seems almost frenzied, as if the sculptors were obsessed with demonstrating their skill in depicting the human body in every conceivable posture and in constant motion. Indeed, of all schools of early Indian sculpture that of Amaravati is the most intensely dramatic, and as one eminent scholar has observed:

A passionate sense for everything terrestrial manifests itself {in the art of Amaravati}, as if Indian art had taken leave of this world with a tumultuous feast, before deliberately entering the cold fields of spirituality {Bachofer 1929, 1: p. 55}.

S31a–c Three Cosmetic Trays
Pakistan, Taxila area

a, first century or earlier
Steatite; diameter 4 ⅛ in (10.5 cm)
Purchased with funds provided by Mr. and Mrs.
Willard G. Clark; M.85.224.4

Large numbers of such objects were found in
Sirkap, excavated from various levels ranging
from the second century B.C. to the first century
A.D. Describing them as toilet or cosmetic trays,
Marshall ([1951] 1975, 2: pp. 493–98) noted
their similarity with Hellenistic trays discovered
in Egypt and West Asia. Curiously, no such trays
were found in the Shaikhan Dheri excavations
(Dani 1965–66) either from pre-Kushan or

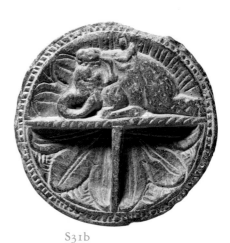

S31b

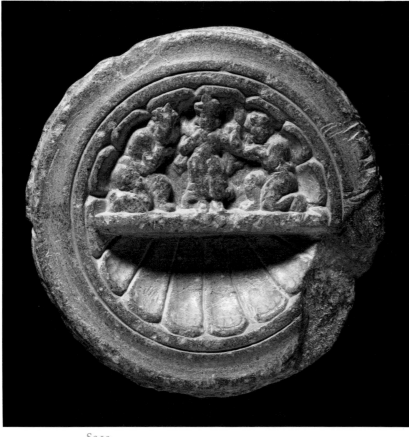

S31a

S31c

Kushan strata. The precise provenance of the three in the collection, unfortunately, is not known. From Marshall's work in Taxila it appears that such trays were in great demand during the Saka-Parthian period (first century B.C.–c. A.D. 40), although they may have continued to be manufactured during the Kushan period (see Czuma 1985, pp. 144–53).

Although generally characterized as toilet or cosmetic trays, no example has been found to contain any traces of cosmetic substances. While some are divided into two or three compartments, one of which may have served as a palette, and are adorned with reliefs of a wide variety of subjects, many are completely covered with figures. (Of the nine illustrated by Czuma 1985, only one has a separate compartment.) Some may have served as lids of cosmetic trays with another half containing the cosmetic substances, like a modern compact. The small sunken section could then have been used to mix the unguents. It is also possible that those without compartments were simply decorative.

The sunken section in the center of this tray is decorated with floral petals, although they look like clamshells. The wide border is left unadorned, which is rather unusual. The subject of the relief in the upper compartment is also uncommon. The compositions on such trays generally depict Hellenistic myths, drinking scenes, amorous couples, or animals. In this particular example, however, a standing central figure seems to be receiving obeisance from two kneeling personages. His right hand is bent against his chest, the billowing scarf forms a sort of halo around his head. All three figures otherwise seem to be similarly clad in dhotis and turbans. Although the central figure cannot be identified precisely, there seems little doubt that all three individuals are Indian and that the scene is religiously significant, an unlikely subject for a cosmetic tray. Even though the figures are much effaced, their form and attire do not conform to those seen in art of the Kushan period. The tray may well have been carved in the first century B.C.

b, first century
Gray schist; diameter 5 ¼ in (13.3 cm)
Indian Art Special Purposes Fund; M.85.224.2

Larger than the other stone example (*a*), this tray is divided into three compartments. The background is carved with bold lotus petals, and the narrow border is edged with a toothed design. The back is adorned with wide, floral petals.

Much of the upper compartment is filled with a well-modeled kneeling elephant carrying an unrecognizable object on his head with a rider behind. If the object represents a reliquary, then the tray may be related to a Buddhist ritual. Neither the quality of the stone nor the carving is as fine as in tray *a*.

c, first century
Copper with green patina;
diameter 3 ⅞ in (9.9 cm)
Gift of Mrs. J. LeRoy Davidson; M.85.281

Although smaller than the two stone examples (*a*–*b*), this cosmetic tray is a rarer example as it is a solidly cast copper object. Stylistically it is closer to *b*. The space is divided in exactly the same manner into three compartments with a border decorated with the same beaded or toothed design. The two lower compartments are adorned with bold lotus petals, which lack the additional parallel lines of the petals found in tray *b*.

The upper fragment is mostly filled with two figures wearing garments. The faces of the figures and details of the garments have rubbed off. The couple appear to be male. Each also seems to hold an object with one hand; the figure on the left appears to be holding in his right hand a shallow dish. Similar vertical ribs are found behind the figures in this bronze tray and the kneeling elephant in tray *b*.

Almost identical couples holding bowls or wine cups occur on at least three stone trays discovered by Marshall from the Saka-Parthian stratum ([1951] 1975, 3: pl. 144, nos. 67–69). In fact, one (no. 67) is so close to the metal tray that very likely the artists used the same model.

S32 Bowl with Cover
Pakistan, Taxila area; first century
Gray schist; 5 ⅛ in (13.0 cm)
Purchased with funds provided by Mr. and Mrs.
Willard G. Clark; M.85.224.1a–b

This well-preserved covered bowl is decorated with broad lotus petals alternating with chevron bands. Its excellent condition indicates that it probably was used as a reliquary and inserted into a stupa, where it escaped injury from man and nature. The contents of the reliquary have been removed.

Stylistically, the design is closely related to that on a vase excavated from the Saka-Parthian level at Sirkap in Taxila (Marshall [1951] 1975, 2: p. 492, 3: pl. 143n). There, too, similarly shaped lotus petals alternate with chevron bands.

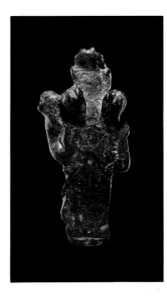

S33 The Goddess Tyche or Fortuna
Pakistan or Afghanistan; first–second century
Copper alloy; 2 ¼ in (5.7 cm)
Gift of Neil Kreitman; M.85.73.1

This small bronze represents Tyche or Fortuna, the Greco-Roman goddess of fortune and abundance, who was very popular in Afghanistan and Gandhara during the two centuries before and after the birth of Christ. She also appears frequently in coins (C12b) and became closely identified with her Indian counterpart, the goddess Sri-Lakshmi. Wearing a chiton and mural crown, she holds a cornucopia with both hands. The back is not modeled; the two quiverlike attachments to her shoulders probably represent lotuses.

The somewhat crudely rendered sculpture is similar to several other such small, solid-cast statuettes found from the Parthian level (c. first century) at Taxila (Marshall [1951] 1975, 2: pp. 604–5; 3: pl. 186a–e). As Marshall has remarked ([1951] 1975, 2: p. 575), "The vast majority . . . were copies of Graeco-Roman originals, and, like the contemporary gold jewellery and silverware, afford striking testimony of the extent to which the Parthians at Taxila were indebted to the material culture of the Western world." Most likely such small bronzes were used as charms or emblems.

S34a

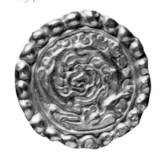

S34b

S34a Pendant
Pakistan or Afghanistan; first–second century
Repoussé gold; diameter ⅛ in (.3 cm)
Purchased with Harry and Yvonne Lenart Funds;
M.85.224.3

The exact provenance of this gold object is not known. Very likely it is from Pakistan and was once used as an ear pendant; or it may have been deposited in a reliquary (see Czuma 1985, p. 166–67). A large number of gold ornaments, including similar ear pendants, was discovered at both the Sirkap and Bhir mounds at Taxila (Marshall [1951] 1975, 3: pls. 190–91). An even larger horde of gold objects dating to the

period between 100 B.C. and A.D. 100 was discovered among the ruins of Emeshi-tepe in northern Afghanistan a few years ago by the Joint Soviet-Afghan Archaeological Expedition (see Sariandi 1985).

The central section of this pendant is filled in with what appears to be a long, spiraling flower or leaf, surrounded by a border of large globules or beads. If it is a leaf, it may be a stylized acanthus.

For more information regarding such jewelry and their molds see M. Chandra and P. L. Gupta 1962–64.

S34b Earrings

Pakistan; first–second century
Repoussé and cast gold; length 2 ¼ in (5.7 cm)
Given anonymously; M.85.282a–b

The precise provenance of these beautiful ear-
rings is also unknown. Their style and tech-
nique, however, relate them closely to jewelry
recovered from Taxila (Marshall [1951] 1975, 3:
pl. 190). Most were found at Sirkap in stratum
III, dated by Marshall to the first century. Thus,
a Pakistani rather than Afghani provenance for
these earrings seems likely.

The ornaments consist of two
disks hammered in the shape of a turtle or
tortoise, attached to long, cast tubular buds by
means of hinged clasps. The back of each tortoise
is realistically delineated, and the edges are
decorated with fine granulation. Rings and
clusters of granulation also adorn the buds that
terminate in clusters of globules and granules.
The beauty of the design, excellence of
workmanship, and fine state of perservation are
in the best tradition of Scythian ornamental art.
The use of the tortoise as a decorative motif is
somewhat unusual, but the animal is an ancient
cosmogonic and religious symbol in India.

S35 Triad with the Buddha

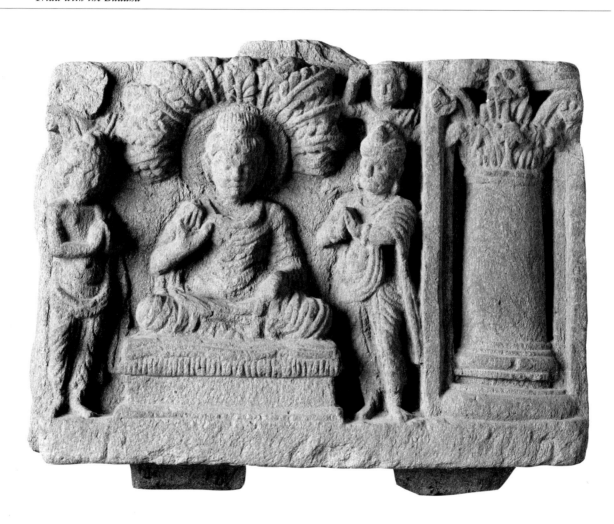

S35 Triad with the Buddha

Pakistan, Gandhara; first–second A.D.
Gray schist; 6 ½ in (16.4 cm)
Gift of Edward M. Nagel; M.84.225.1

The relief probably was attached to the wall of a
stupa or shrine, as evident by the presence of
three lugs, two at the bottom and one at the top.
The principal scene is carved in a recessed section
flanked on one side by a Corinthian column, a
popular architectural device in the region. In the
center of the niche, Buddha Sakyamuni is seated
in the yogic posture on a seat covered with a mat,

the fringe of which is represented by uneven,
parallel horizontal lines above a row of vertical
incisions.

The Buddha had attained
enlightenment while meditating on a platform
covered with grass given to him by a grass cutter
just after the Buddha's bath in a river. The
stylized tree above his nimbus is the bodhi tree.
His shoulders and feet are completely covered by
a shawl, a part of which is held in his left hand;
with his right hand raised to shoulder level he
forms the gesture of reassurance. The Buddha's
hair is pulled away from the temple and tied in a

fairly substantial bun at the top. He is flanked on either side by an ascetic and a turbaned figure, who both are adoring him. Above each is a flying angel also adoring the master.

The scene doubtlessly represents the occasion after Buddha's enlightenment when Indra and Brahma came down to entreat him to go into the world and preach. The subject was quite popular with Gandharan artists (Lyons and Ingholt 1957, figs. 70–73), who were very particular in delineating the grass mat covering over the Buddha's seat. Such triads may have been modeled after early Mathura reliefs, such as that illustrated in entry S58 (van Lohuizen-de Leeuw 1981, pp. 377–400). If van Lohuizen-de Leeuw's date of about 50 B.C.–A.D. 50 for some early Gandharan reliefs of this theme is acceptable, then a first–second century A.D. date for this example may not be unlikely.

S36a–b *Two Lions*

S36a Two Lions
Pakistan; first century

a, copper alloy; 2 in (5.1 cm)
Indian Art Special Purposes Fund; M.81.153.2

This heraldic bronze lion and the eagle (S43) are said to have been found in Pakistan. The form of the lion with its prominently curved chest, hairy mane, and curling tail is very similar to several other representations of the animal in stone and terra-cotta found in Taxila (Marshall [1951] 1975, 3: pl. 131, no. 242, pl. 145, nos. 75, 78–79). According to Marshall, most of these objects came from the Saka-Parthian strata and are, therefore, unlikely to date later than the first century. This lion may also be compared with similar Kushan-period representations from Mathura.

The lion may have served as a support for a throne or capital atop a column. The former alternative seems unlikely since neither the head nor back bears any tenon or groove for attachment to a throne. The shallow base on which the animal sits indicates that the figure may have served as a capital for a column rising from the platform of a bronze stupa, as in a silver stupa from Gandhara (Pal et al. 1984, p. 136).

S36a

b, gray schist; 8 in (20.2 cm)
Gift of James H. Coburn III; M.85.279.7

The lion was a popular architectural motif in Gandharan art and was frequently used as a throne support, protoma, or divider in panels decorating stupas. This lion, which was once fed by a cherub or yaksha, is stylistically very similar to another in the Peshawar museum (Lyon and Ingholt 1957, no. 453). In that representation a boy is seen feeding the animal. Only the feet and bowl remain in this example. The lion's tongue is lapping up the contents of the bowl. The stylization of the lion's form, hair, and mane are characteristic of Gandhara. Unusual, however, is the garlanded head. Only the forepart of the animal is fully carved, as the back was attached to a larger composition. A square aperture behind the garland on the lion's right indicates how it was affixed to a relief.

S36b

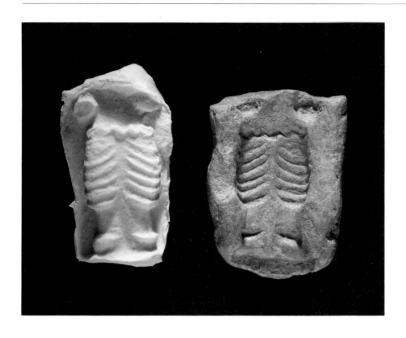

S37 Mold for a Terra-cotta Figure
Pakistan; first–third century
Buff terra-cotta; 2 ⅞ in (7.3 cm)
Gift of Joel L. Malter; M.83.252

The mold and positive impression show the
lower half of a male figure wearing a dhoti and
possibly boots (the feet are rather crudely
delineated). The terra-cotta is said to have come
from Pakistan. Molds with similar garments
have been found in Taxila (Marshall [1951]
1975, 3: pl. 133, nos. 26, 30, 35a, 44). Those
are dated by Marshall to the second–first century
B.C., but this example may be later. The folds of
the dhoti are bolder. This mold demonstrates
how figures were made in sections and joined
together.

 For a stone jeweler's mold
showing a similarly clad figure from Kausambi
dated to the second century A.D., see M. Chan-
dra and P. L. Gupta 1962–64, figs. 12a, 13a.

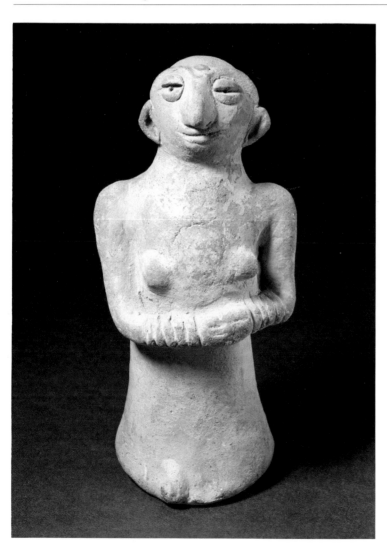

S38 Female Figure
Pakistan, Bajaur (?); first–third century (?)
Brown terra-cotta; 5 in (12.7 cm)
Gift of Mr. and Mrs. Julian Sherrier; M.76.117

The lower portion of the body of this female
figure is shaped like a hollow cylinder, with
slightly flaring bottom. A footlike projection is
attached slightly off center along the lower edge.
The breasts are indicated by two small knobs.
The long arms are bent at the elbow and are
brought across the body. The forearms are
adorned with bracelets, and the hands clasp one
another. The broad face is distinguished by an
enormously large, thick nose with two tiny
nostrils above naturalistically shaped lips;
appliquéd cowrie-shell eyes; and raised, high
eyebrows that extend down to the ears. The *urna*
is placed between the eyebrows. The back is flat.

 This strange figure is said to have
come from Bajaur in Pakistan and has the
same cylindrical body as the seated figure said to
have been found in neighboring Dir (S48). Terra-
cotta figures of this type are in museums in
Pakistan, Afghanistan, and Europe, but none
has been found in an excavation nor have any
similar figures been published. In general, the
upper part of this figure with its small breasts,

curiously shaped nose, and cowrie-shell eyes continues the forms seen in earlier terra-cotta goddess figures discovered from Taxila, Shaikhan Dheri, and other sites in ancient Gandhara. The hollow cylindrical body, however, is unusual and is reminiscent of clay figures of the Kulli culture in southern Baluchistan (Pakistan) dating to the third millennium B.C., about which more will be said in entry S48 (Piggott 1950, pp. 107–9, fig. 9). Unlike the Kulli figures, this lady is completely without ornaments. Similar cylindrical figures, also belonging to the fourth millennium B.C., have been found in Iran (Fairservis 1971, p. 225, fig. 56).

S39 *Votive Stupa*
Pakistan; second century
Gray schist; 5 ⅞ in (15.0 cm)
Indian Art Special Purposes Fund; M.85.224.6

Such small stupas were used by Buddhists either as reliquaries or votive offerings. Although the finial of this stupa is inserted into a deep narrow shaft, it is unlikely that it was used as a reliquary principally because of its diminutive size. Whatever its exact function, it is an attractive example for the simplicity of the design and fine craftsmanship.

The stupa consists of three sections: a molded circular base, hemispherical drum embellished with plain moldings, and finial. The hemispherical drum is the *anda* (egg). The finial comprises a *chhatra* (parasol; umbrella), staff rising from an inverted pyramidal section, *harmika* (small mansion; chamber), and three circular disks. Several meanings for this Buddhist symbol par excellence are possible, but generally and in essence it symbolizes the cosmic mountain with the shaft serving as the cosmic pillar. It is also used as a symbol of the Buddha's death and is the most distinctive symbol of the religion.

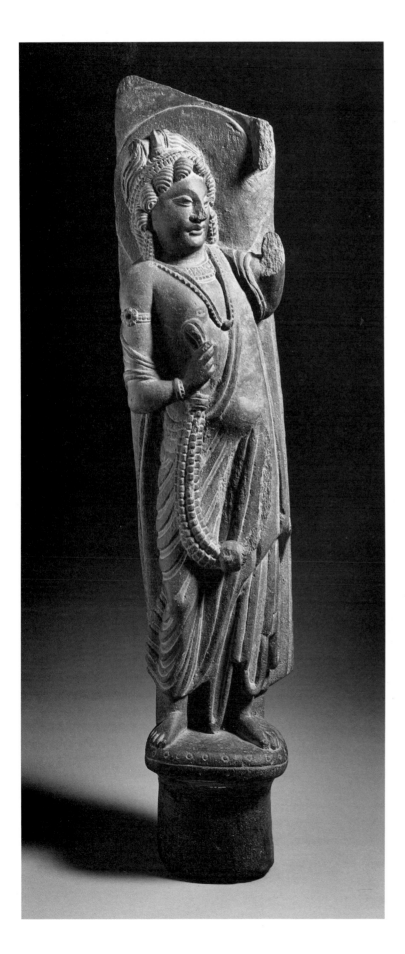

163

S40 *A Divine Garland Bearer*
Pakistan; second century
Gray schist; 24 in (61.0 cm)
William Randolph Hearst Collection; 47.8.13
Literature: Pal 1974b, pp. 28, 50.

A youthful figure holding a garland and wearing
a dhoti, shawl, and shallow turban stands on a
lotus calyx. The nimbus behind his head
indicates that he is a divine garland bearer rather
than a mortal. This deeply carved figure very
likely flanked an image of the Buddha. Except
for his stance and the heavy folds of his garment,
reflecting Hellenizing influences, the figure is
quite Indian. Noteworthy are his oblique eyes
and prominently rendered sausage curls. The
garland is typical of Gandharan art, appearing
frequently as an attribute or adornment (see
S45). The original disposition of the sculpture
may be surmised by comparing several complete
reliefs depicting theophanic scenes (Lyons and
Ingholt 1957, figs. 254–57).

S41 The God Kumara

Pakistan, Peshawar division; second century
Gray schist; 9⅛ in (23.1 cm)
Gift of James H. Coburn III; M.85.279.3

Although small, this is one of the best-preserved representations of a warrior god from Gandhara, who may be identified as a syncretic deity or as Kumara, the divine general of the Hindu pantheon. His two principal attributes are a festooned spear and a cock. The martial character of the figure is emphasized by his sword, coat of mail, and bow slung across his chest. He wears a dhoti and turban, and his feet are bare. The diminutive donor or devotee offering a bouquet of flowers wears, in contrast, a Scythian costume consisting of a knee-length coat or tunic and leggings or pajamas. He may also be wearing boots. A plain halo behind Kumara's head indicates his divinity, which is further emphasized by his colossal size in contrast to the human devotee. Both figures stand naturalistically on a rectangular pedestal.

The spear is the most distinctive attribute of Kumara, although it is also held by Kubera, or Panchika, as well as other warrior gods in West Asia. The cock or rooster is yet another of Kumara's attributes and is included in the iconographic section of the *Matsyapurana* and *Vishnudharmottarapurana*, Gupta-period texts. By the Kushan period it had become a familiar emblem of the deity both in Gandhara and Mathura. In the Iranian pantheon the cock is an attribute of Sraoša, one of the sons of the supreme Ahura Mazdah, while in Roman art young boys are often encountered holding the bird in a similar fashion. The cock has remained a popular offering for sacrifice across a vast region of Asia from ancient times and is considered a symbol of fertility among many cultures. Since Sraoša is the guardian of the sun god's paradise, it is not surprising that he was associated with the cock, who announces the dawn. Indeed, the spear, too, would be appropriate for a guardian deity, and hence such figures, at least in the Gandharan region, may represent a syncretism between the Iranian Sraoša and the Indian Kumara.

It has also been suggested by Taddei (Agrawala and Taddei 1966, pp. 84–85) that this form of Kumara in Gandhara bears a close resemblance to images of the ancient Palmyran deity Shadrafā, a healer god who is generally dressed in a cuirass and holds a spear. He also holds what looks like a scorpion with his left hand as does Kumara. It is possible therefore that Gandharan images of the martial Kumara were modeled after Palmyran images of Shadrafā. Scholars have long recognized astonishing resemblances between the arts of Gandhara and that of Palymra in the early centuries of the Christian era. Both regions were strongly influenced by Roman aesthetics. In later Indian art the sword and bow are generally associated with Kumara in his cosmic form (Pal 1974, fig. 249).

In present-day Bengal the two-armed Kumara carries a bow and arrow instead of a spear. In the literary tradition Kumara further came to be identified with Kama, god of desire, whose attributes are the floral bow and arrow of love.

A noteworthy feature of Kumara's spear in this sculpture is that the design of the spearhead is also repeated at the bottom of the shaft. A similar weapon is held by the Jamalgarhi Kubera (Rosenfield 1967, pl. 75), while the shape of the spearhead is identical to that in the hand of a Kubera/Panchika now in the Karachi museum (Rosenfield 1967, fig. 62). The crisply articulate carving of the museum's image and graceful postures of the two figures relate them closely to the Karachi sculpture and other second-century reliefs.

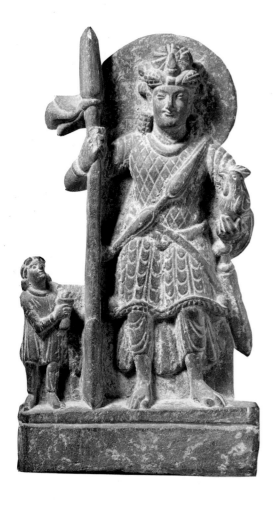

S42 *Bachanalian Scene*
Pakistan; second century
Gray schist; 12 ¼ in (31.1 cm)
Gift of Carl Holmes; M.70.76.1a
Literature: Pal 1974b, pp. 29, 50.

A couple standing under a gable appears to be engaged in conversation. Each holds a wine cup in one hand. The man is old, bearded, and not particularly handsome, while the woman is young and attractive. She wears a Roman-style chiton and skirt. He wears a garment gathered in a heavy roll below his ample belly. The identification of the scene with drinking is evident by the presence of the wine cups and bunches of grapes hanging from the voluted ends of the arch. The arch itself represents the chaitya-window motif and was a popular element in Buddhist monastic architecture. Typical of classically inspired Indian architecture, the side column rises from a pot. A lunette beneath the arch is decorated with the honeysuckle motif (cf. S14). A turbaned male stands outside the arch with his hands forming the gesture of adoration.

His attitude may indicate that the figures below the arch are divine rather than human. Bachanalian scenes frequently were used in Gandhara as architectural embellishments (Lyons and Ingholt 1957, figs. 397–98; Dohanian 1961, no. 6), and this relief may relate to a Dionysian theme. The figure, and his attire, is very similar to a priest making an offering to Priapus in a first-century Roman relief (Bandinelli 1971, p. 107, fig. 96).

S43 Eagle
Pakistan; second century
Copper alloy; 1 ⅜ in (3.5 cm)
Indian Art Special Purposes Fund; M.81.153.1

An eagle with prominent wings stands on a base, which is circular in front but truncated and uneven in back. Similar birds were found in Taxila from the Sirkap and Bhir mounds. This particular bird could have been used as either a support for a bowl (see Marshall [1951] 1975, 2: p. 596; 3: pl. 184, no. 323) or symbol on a stupa, as in the bronze stupa from the Gai collection in Peshawar (Lyons and Ingholt 1957, fig. 496). There, four similar eagles alternate with four palmettes on the top of dome. The surface of the object is much too corroded for any of the details to be discerned.

S44 A Tutelary Couple
Pakistan; 100–150
Gray schist; 12 in (28.4 cm)
Gift of Tom and Nancy Juda; M.83.66
Literature: Larson et al. 1980, p. 49.

A couple sits in a relaxed manner as if engaged in conversation. The divinity of both is emphasized by the presence of the nimbus. The man sits with his right leg raised and bent, the left leg placed on a footstool. Wearing a dhoti, scarf, and turban, he holds in his right hand a spear or staff, parts of which are attached to his knee; his left hand rests on his knee. The woman, elegantly coiffed with a garland decorating her hair, wears a garment covering her entire body. Her feet rest on a footstool. Her left hand supports the back of a child, who sits in her lap and embraces her neck with both hands. The object in her right hand is no longer recognizable.

This type of relief was common in Gandhara, and the pair generally is identified as Panchika and Hariti (cf. S64). She is always shown with one or more children, and he is either dressed in a tunic and leggings, like a Roman soldier, or dhoti, in the Indian fashion. He usually carries a spear or staff and money bag. A tutelary deity-cum-yaksha, Panchika is the general of Kubera, or Vaisravana, god of wealth. Hariti was a Mother Goddess extremely popular in Gandhara (see also S50), especially among Buddhists. Images of both were placed in monasteries; this small relief, however, probably was intended for a domestic shrine.

Typical of Gandharan sculptures, all three figures interact with one another. The folds of Panchika's dhoti are rendered with greater naturalism than one encounters in Mathura. This sense of naturalism, derived from Hellenistic tradition, is also evident in the delineation of the muscles of Panchika's body. Stylistically, the figure of Hariti compares closely with another discovered from the ruins of a private house at Shaikhan Dheri (Dani 1965–66, pl. xvi). The stratified context of the excavation allows the sculpture to be dated to the rule of Kanishka I (c. 78–102). Thus, a date around 100 and certainly no later than 150 seems probable for this relief.

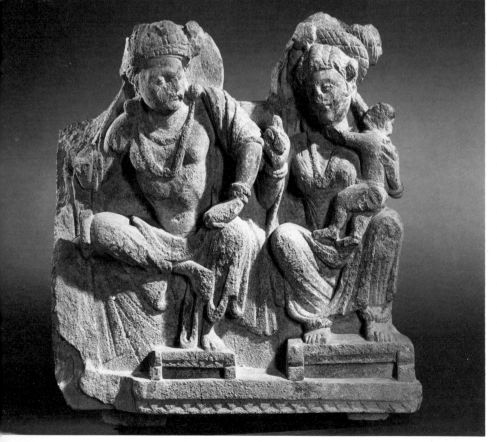

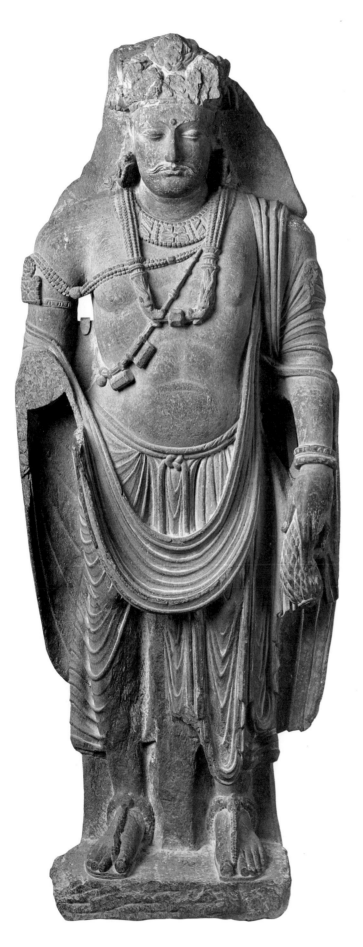

Pakistan; second–third century
Gray schist; 68 in (172.7 cm)
From the Nasli and Alice Heeramaneck
Collection
Museum Associates Purchase; M.83.105.1
Literature: Heeramaneck 1979, no. 11; Pal
1985a, p. 71, fig. 10.

Wearing a dhoti and shawl, the figure stands
with his left knee slightly bent on a plain,
shallow base, which may have been inserted into
a more elaborate pedestal. The Gandharan
subject characteristically wears sandals. A
plethora of ornaments adorns his body. In
addition to an articulately carved torque, he
wears a necklace decorated with two makaras and
a strand of pearls around his right arm. A cord
with three amulets diagonally crosses his body.
His ear ornaments are in the shape of a lion
(*siṁhakuṇḍala*), and his armlet is decorated with
floral designs. He has a moustache and *urna*, and
his head once was covered with an elaborate
bejeweled turban, now damaged, the design of
which may be reconstructed from the better pre-
served head in the collection (S46). The circular
nimbus behind his head and right forearm are
broken. He holds a garland in his left hand.
 Although the exact
identification of the figure is uncertain, that it
represents a bodhisattva is beyond doubt. Many
such figures have been found from various sites
in Gandhara, but in most cases the left arm is
broken (Lyons and Ingholt 1957, figs. 288–98).
In examples where the arm is undamaged, the
hand holds a waterpot, the distinctive attribute
of the bodhisattva Maitreya. In a theophanic
relief showing a preaching Buddha (Lyons and
Ingholt 1957, fig. 254; see also fig. 316), one of
the flanking bodhisattvas holds a garland with
the left hand. Since the Buddha in such reliefs
usually is flanked by Maitreya and Avalokites-
vara, whose emblem is a lotus flower, one could
identify the garland-bearing bodhisattva as
Avalokitesvara.
 Stylistically, this bodhisattva
image is remarkably similar to several others,
the closest being more than six feet tall,
recovered from Takht-i-bahi and now in the
Lahore museum (Lyons and Ingholt 1957, fig.
289). With its halo, the Los Angeles bodhisattva
probably would have been as tall. The turban of
the Los Angeles bodhisattva is even more
elaborate, although the modeling is, perhaps,

somewhat drier and less sensitive than that seen in the Lahore Maitreya. Nevertheless, both bodhisattvas cannot be too far removed from the two that flank the Buddha in a relief dedicated in the year 5, which is considered to refer to the Kanishka era (Pal et al. 1984, p. 191). Thus, even if one believed the Kanishka era began in 142, the dated sculpture cannot be later than 150. Even more solid evidence is offered by the Shaikhan Dheri excavation, where a similar statue of Maitreya, not as elaborately ornamented, was discovered from a layer that can be firmly dated to the period of the Kushan monarch Vasudeva I (Dani 1965–66, pl. XIX, no. 2). Vasudeva probably ruled between 142

and 176, certainly no later than the year 200. A fourth-century date for the Lahore Maitreya and other such bodhisattvas, as suggested by Ingholt, therefore, seems unacceptable. More likely, these were carved within a century of the Buddha triad of year 5 and, hence, a date around 200 for this impressive cult image of a bodhisattva seems to suit the evidence better.

S46 *Head of a Bodhisattva*

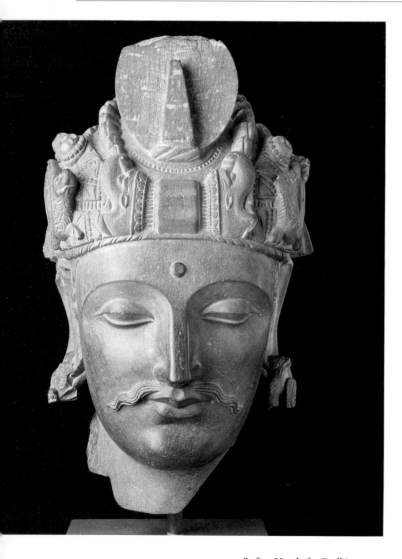 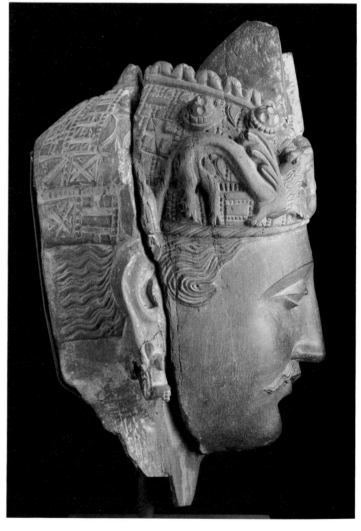

S46 *Head of a Bodhisattva*
Pakistan; second–third century
Gray schist; 18 ¹⁄₃₂ in (47.0 cm)
From the Nasli and Alice Heeramaneck Collection
Museum Associates Purchase; M.71.1.45

This head once belonged to a bodhisattva figure that was even larger than the life-size bodhisattva in the collection (S45) and may have stood well more than seven feet tall. The head is remarkably similar to that of another large bodhisattva figure discovered from Sahri Bahlol in Gandhara (Bachofer 1929, 2: pl. 147, top left), probably carved sometime in the second century. The museum's head displays a more

elaborately carved turban. The principal difference between the two is in the presence of the prominent crest with tapering tenon in the museum's head. Several other bodhisattvas display this feature (Lyons and Ingholt 1957, figs. 313–15). The tenon is not a decorative device; it was used to attach a medallion containing a tiny Buddha or meditating bodhisattva. Such medallions, with grooves at the back to fit onto a tenon, were discovered at Sahri Bahlol (Lyons and Ingholt 1957, p. 140).

The bodhisattva's oval face is characterized by sharply outlined features: long nose with broad, flat bridge, moustache, half-shut eyes, and prominent *urna*. The elongated carlobes are decorated with two springing lions, whose forepaws merge into garlands. The turban obviously represents a head covering made of printed textile and encrusted with gems. Its most prominent features are the makara pendant attached to the front and prancing winged lions or griffins at the sides. Their elongated, arched bodies make them remarkably agile, and, but for the hind legs, they would appear to be makaras. The form, in fact, anticipates that of a dragon. Such extensions of the lion's body may reflect influences of the animal type favored by the Scythians. (For a similar lion handle on an incense burner, see Lyons and Ingholt 1957, fig. 493.) The hair is delineated as sideburns and horizontal wavy lines at the back.

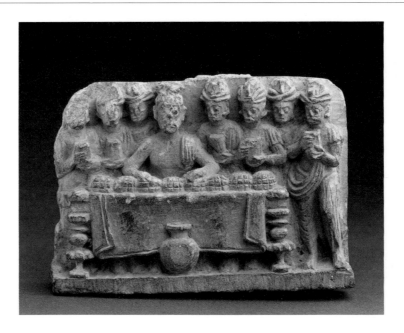

S47 The Distribution of the Buddha's Relics
Pakistan; second–third century
Greenish gray schist; 4 ¼ in (10.8 cm)
Indian Art Special Purposes Fund; M.84.151

This small relief depicting the distribution of Buddha Sakyamuni's bodily remains after his cremation at Kusinagara once embellished a stupa. Behind a rectangular table is seated the brahmin Drona, who was selected to distribute the relics to representatives of eight tribes. On the cloth-covered table with elaborate legs are eight portions of crushed bones and ashes, which must have been brought in the pot in front of the table. Drona is flanked by four figures on his left and three on his right. At the extreme right a fourth figure, whose foot can still be seen on the base, almost certainly has broken off. Attired in dhoti, shawl, and turban, each tribal chief holds a cup or container to carry away the relics, which Drona is about to distribute.

Although several such reliefs depict the scene (Lyons and Ingholt 1957, figs. 147, 152–54, 167), this is one of the best preserved. Moreover, it is quite rare to see all eight tribal chiefs represented, and in none is the pot included. The table legs differ in all examples, which together exhibit considerable design variation. In fact, these reliefs are the earliest representations in Indian art of such tables, which must have been introduced by the Bactrian Greeks. These reliefs further demonstrate that cloths were used to cover tables.

Such reliefs should be of interest to students of Christian iconography because they anticipate artistic representations of the Last Supper of Christ.

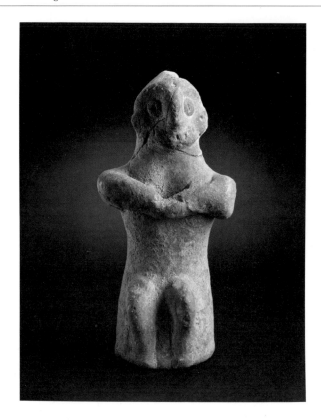

S48 Male Figure
Pakistan, Dir; c. third century (?)
Red terra-cotta; 4 ¾ in (12.1 cm)
Gift of Wallace Thompson; M.70.95.1

The manner in which the legs protrude from the hollow cylindrical body indicate that the figure is seated. Shallow pellets with pinholes mark the beard along the chin. The sunken eyes are also similarly fashioned with pierced pellets. The eyebrows are fairly heavy, and the head seems to be shaven, except for a substantial tuft extending down the center of the head like a molding. The back bulges out considerably, and the arms are folded in front of the chest.

The piece is supposed to have been found in Dir, near Swat in Pakistan. The body's unusual cylindrical shape is similar to clay figures of the Kulli culture of southern Baluchistan, dating to the fourth–third millennium B.C. (Piggott 1950, pp. 107–9, fig. 9). The characteristic features of Kulli figures are described by Piggott:

They all terminate at the waist in a slightly splayed, flat-bottom pedestal, and the arms are akimbo with hands on the hips (once only, raised above the breasts). There is no attempt at naturalism in the face, which is pinched out of the clay into a fantastic aquiline profile, making an absurd caricature resembling nothing so much as a sacred hen, with the eyes made from centrally pierced applied pellets and no indication of the mouth.

The description of the facial features of the Kulli figures is appropriate for the bearded male here discussed. All Kulli sculptures, however, are female.

While not as old as the Kulli figures, this object clearly demonstrates the remarkable continuity of the type. It is a graphic example of what has been characterized as the timeless variety of Indian terra-cottas.

S49 Gods and Animals on the Rocks
Pakistan, Peshawar division (?);
early third century
Gray schist; 15 ¼ in (39.4 cm)
From the Nasli and Alice Heeramaneck
Collection
Museum Associates Purchase; M.73.4.6
Literature: Zimmer [1955] 1960, pl. 70;
Dohanian 1961, no. 8; Rosenfield et al. 1966,
pp. 28–29; Heeramaneck 1979, no. 12; Czuma
1985, pp. 193–94.

The fragment once formed the upper right-hand portion of a relief depicting an incident from the life of the Buddha. Frequently represented by Gandharan artists with ebullience and complexity, the scene describes the visit of Indra, lord of the gods, to Buddha Sakyamuni while he was living in a cave near Rajagriha. Unlike their counterparts in the subcontinent, Gandharan sculptors lavishly depicted the rocky exterior of the cave with angels and animals rejoicing at this special occasion.

In this deeply cut relief are represented three gods, one with a garland, flying down from the heavens in attitudes of respect. The rocks are filled with cavorting animals and birds, including lions, monkeys, goats, deer, and peacocks. Although the forms of the animals

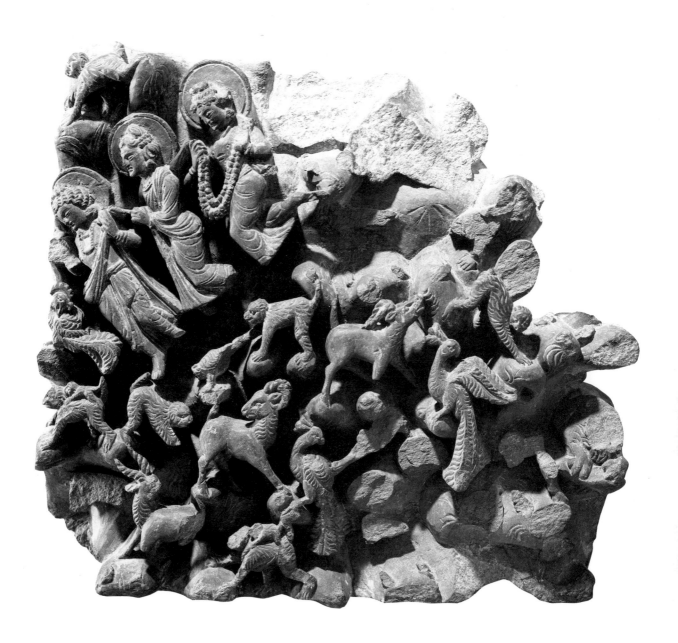

are conceptualized, they are a remarkably animated lot. The scene is observed with sensitivity and gentle acuity: note the pair of female monkeys carrying their babies on their backs. The undercutting of the figures is so deep, as much as an inch from the background, that the relief acquires a strong chiaroscuro, thereby making the forms more articulate and lively.

Complete examples of this subject have been found in the Peshawar and Taxila regions (Lyons and Ingholt 1957, figs. 130–31). The Peshawar example is dated to the year 89, which, if referring to the Saka era of A.D. 78, would correspond to A.D. 167. The carving is much deeper in the museum's fragment, more reminiscent of early Byzantine reliefs of the story

of Orpheus found in West Asia (Lyons and Ingholt 1957, pl. XVIII, nos. 1–2). To produce such reliefs during the second and third centuries Gandharan artists must have seen earlier Hellenistic versions of the Orpheus theme. While most scholars have dated this charming fragment to the third century, Czuma (see Literature) has suggested that the piece may in fact be slightly earlier than the A.D. 167 relief.

S50 *A Goddess with Children*
Pakistan, Swat Valley; c. 250–300
Gray phyllite; 43 ½ in (110.5 cm)
Gift of Mr. and Mrs. Harry Lenart; M.78.105
Literature: Pal 1978a, p. 46; Carter 1982, p. 255.

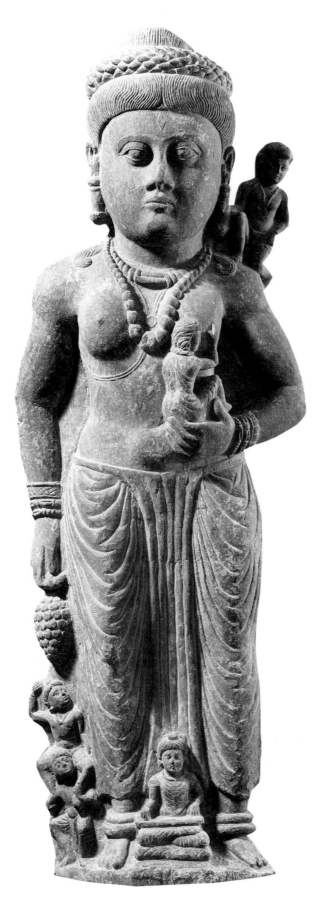

Striking a columnar, frontal position, the goddess stands with her feet placed well apart. Her lower garment is worn like a long skirt, and her bare torso is adorned with two strands of pearls. She also wears bracelets, anklets, and two different ear ornaments. Her hair is finely delineated and arranged in a bun adorned with a garland. Her right hand holds a cluster of grapes (cf. S42), and her left hand supports a child at her breast. Another child kneels on her left shoulder, and three more are depicted near her feet. The boy writing on a slate between her feet looks like the Buddha. The other two, one carried on the other's shoulders, appear to be after the woman's grapes.

In the context of Gandharan Buddhist art, this goddess is identified as Hariti, who may be represented independently or along with her consort (see S44). This figure doubtlessly was modeled after the well-known Hariti image discovered from Skarah Dheri, north of Peshawar (Bachofer 1929, 2: pl. 150, right). Both figures wear a similar hairstyle, garland, and ear ornaments and hold a cluster of grapes in their right hand. Moreover, in their left hand they hold a child in a similar fashion at the left breast and another sits on their left shoulders. Although the feet and base of the Skarah Dheri Hariti are broken, the outline of a seated figure can still be discerned between her feet. Thus, the iconographic relationship between the two figures is evident.

There are, however, stylistic differences. The Skarah Dheri Hariti is fully clad, while this figure has a bare upper body and arms. The other Hariti stands with slight *déhanchement*, while this figure is more rigid. A distinctly provincial quality marks the modeling of the form and proportions of the Los Angeles figure, noticeable especially in the treatment of the muscle-bound arms and stiff garment. In fact, the plastic qualities of this figure is much closer to those apparent in sculptures found from the site of Butkara in the Swat Valley (Faccenna 1962, pls. CL, CLIII, CLXVI, CXCIV). There, too, the female breasts are somewhat flat and left uncovered, the faces are similarly broad, with open eyes and clearly delineated pupils, and the garments are rather crudely rendered. The Butkara sculptures are, of course, of the Kushan period, while the Skarah Dheri Hariti is inscribed and dated to the year 291. This date, if referring to the Vikrama era of 57–58 B.C., would make it a sculpture of about A.D. 233–34 (see Khandalavala 1984). According to others (see Czuma 1985, p. 232), the Skarah Dheri Hariti should be dated to A.D. 277. In either case, a date in the second half of the third century for the Los Angeles Hariti seems reasonable from the Butkara and Skarah Dheri evidence.

S51 A Bodhisattva
Pakistan or northwestern India;
third–fourth century
Copper alloy; 6 ½ in (16.5 cm)
Gift of the Ahmanson Foundation; M.74.9
Literature: von Schroeder 1981, pp. 112–13.

Originally the bodhisattva probably stood on a small rectangular base. He wears a dhoti with a rather heavy sash tied in large knots around his hips. Parts of the sash fall in a V-shaped loop in front and down the legs. A scarf is draped around his shoulders and held over the left breast by a clasp, somewhat as in the Mathura yakshi (S70). He also seems to wear a sacred cord diagonally across his body. His ornaments include bracelets, armlets, ear ornaments, and torque. The left arm is empty. The right arm, slightly turned toward the body, is raised in the gesture of reassurance. A crested turban covers the head. The back of the figure was neither modeled nor finished.

Because the figure is without any emblems, it is difficult to identify. If one can assume that the left hand held a waterpot, as in entry S99, then the figure represents Maitreya. In Gandharan stone reliefs Maitreya is frequently represented as a princely figure, like other bodhisattvas, distinguished only by the waterpot or flask held in his left hand. This figure probably flanked a central Buddha image in a triad.

The style of the figure is even more intriguing. Von Schroeder (see Literature) suggests without supporting evidence that the figure is from Kashmir and of the sixth century. The treatment of the garment, especially in the rendering of volume, is characteristic of Gandhara, although the folds are simplified. Unusual is the attention and importance given to the sash tied below the waist, which is more characteristic of Mathura Kushan figures, such as the Balarama (S59). The circular, flat torque is common to Mathura and Gandharan bodhisattvas and gods, while the crested turban is more typical of Mathura. The peculiar capelike treatment of the scarf is also found in Mathura sculpture. Another Mathura trait is reflected in the disposition of the right hand, which is similar to the right hand of the Mathura Buddha (S58) than it is to the Gandharan bodhisattvas, who seem to turn the palm completely toward the body (see S99–100). Finally, the plastic qualities of the simplified, almost abstracted body are quite unlike the modeling characteristic of Gandharan figures but is more typical of Gupta sculptures. Thus, the bronze may have been created by an artist strongly influenced by the artistic conventions of Gandhara and Mathura.

S52 The Goddess Anahita (?)
Afghanistan; third—fourth century
Copper alloy; 5 ¼ in (13.3 cm)
Ancient Art Council Fund and Indian Art
Special Purposes Fund; M.85.116

This figure is said to have been found in
Afghanistan. Both technically and artistically
the sculpture raises interesting problems.
Nothing quite like it is known from any
archaeological site in Afghanistan. First of all,
one is struck by the very flat treatment of the
form, as if the sculptor deliberately wanted to
emphasize its two-dimensionality. The relatively
shallow depth and flaring garment give the
figure a plaquelike appearance. Another curious
feature is the extended, rectangular lug attached
to the back. Almost three inches long, its exact
function remains unknown. Such lugs usually
were attached to a nimbus, but in this case the
nimbus would have been a disproportionate
distance from the figure.

 The slim-waisted goddess
stands frontally on a now-missing base. Her feet
are broken. She wears a chiton with a clasped
belt around her narrow waist. The volume of the

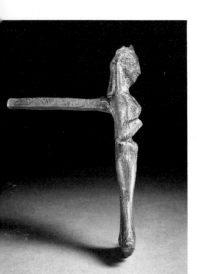

garment hugging her hourglass figure is
indicated by the flaring and undulating hem at
her ankles and etched, stylized folds in the front
and along the arms. She wears a necklace and
shallow crown tied by strings behind her head.
Only one bracelet remains on the left arm, which
is placed on her hip. The right hand is broken.
Her plaited hair falls in six strands behind her
ears. A few locks of hair also come down her face
and curl up against her cheeks.

 Although she has few
attributes, it seems possible to identify her as
Anahita, the great goddess of the ancient
Iranians. Indeed, the shape of her figure with
high breasts, pinched waist, and flaring hips
probably has specific iconographic significance.
In the *Avesta*, the ancient religious text of the
Iranians, the goddess is described:

*Ardvi Sûra Anâhita, who stands carried forth in the
shape of a maid, fair of body, most strong, tall-
formed, high-girded, nobly born of a glorious race,
wearing along her . . . a mantle fully embroidered
with gold. Ever holding the baresma in her hand,
according to the rules, she wears square golden earrings
on her ears bored, and a golden necklace around her
beautiful neck, she, the nobly born Ardvi Sûra
Anâhita; and she girded her waist tightly, so that her
breasts may be well-shaped, that they may be tightly
pressed {Darmesteter 1969, 2: pp. 82—83}.*

She is further said to wear a golden crown with
"fillets streaming down" and a garment made of
young beaver skins. Indeed, the heavy folds of
her garment may well indicate that it is made of
animal skin. An interesting parallel is offered by
the relief of Anahita in the well-known Sasanian
investiture scene at Naqsh-i-Rustam in Iran
(Goddard 1965, pl. 100). There seems no doubt
that the wavy folds here are a linear version of the
more voluminous and lively rendering of the
garment's bottom edge around the feet of the
goddess in the Naqsh-i-Rustam relief. The
pattern may also be noted in the slightly earlier
relief of Shapur I (Goddard 1965, pl. 101) and in
a second—third century portrait of a princess at
Hatra (Colledge 1977, pl. 136).

 In the modeling of the goddess
the sculptor has adhered much more closely to
textual descriptions than to the contempo-
raneous Naqsh-i-Rustam relief. The constricted
waist of the goddess indeed gives added
emphasis to her breasts, whereas in the monu-
mental relief no such distinct transition is made
between the waist and hips and the breasts are
almost nonexistent. Indeed, her full breasts and
general physiognomy reveal Indian influences,
which is not surprising for an object created in
Afghanistan. Because of the rarity of compara-
tive materials (cf. Staviski 1979, fig. 169), the
date suggested for this stylistically enigmatic
bronze is tentative.

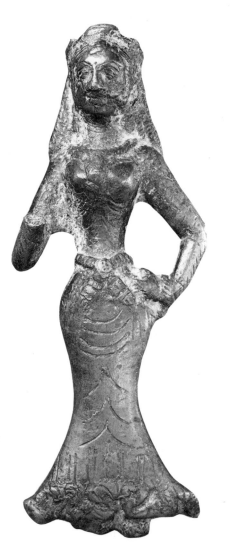

S53a–b *Two Fragments of a Copestone*

S53a

S53b

S53a–b Two Fragments of a Copestone
Uttar Pradesh, Mathura area (?); 50 B.C.–A.D. 5
Mottled red sandstone; height 6 ½ in (16.5 cm)
each; width, *a*, 39 ¾ in (101.0 cm);
b, 25 ½ in (64.0 cm)
From the Nasli and Alice Heeramaneck
Collection
Museum Associates Purchase; M.81.90.21a–b
Literature: Hartel 1977 (*b* only); Heeramaneck
1979, no. 5.

Although now in two pieces, originally these
fragments belonged to a single copestone (cf.
S17) at least six feet long. As with most such
copestones, only one side is carved. Generally
these copestones are associated with Buddhist or
Jain monuments, although some must also have
formed parts of railings for Hindu temples. The
exact location of where this copestone was found
is not known, but Mathura is a strong possibil-
ity. Several other fragments are in the National

Museum, New Delhi, and Museum für Indische
Kunst, West Berlin. All, including the smaller
fragment (*b*), contain a single line of inscription
incised on the rolling top of the stone.

A recessed frieze of animals
alternating with a honeysuckle motif is carved
on each fragment. Of the animals, three are
lionesses and one is a horned goat or sheep. But
for the heads, faces, and slightly more rotund
belly of the sheep, the animals are identical. The
modeling is remarkably simple, the hoofs and
legs are sparingly articulated. Nevertheless, each
is an agile animal and from the position of their
forelegs seem ready to pounce.

The honeysuckles assume two
different forms. The four leaves of each spring
from a half-lotus, but their positions are reversed
in alternate representations. In one the upper

leaves are plain and curl up at the end and the lower leaves are palmettes with vertically folding tips. In another the lower leaves are plain and curl up at the end and the palm leaves above fold back onto themselves. Above this frieze is a row of alternating bells and buds suspended from an astragal. This particular design may be seen in other railings at Bodhgaya, Mathura, and Kausambi (P. Chandra 1970, p. 59).

The incomplete inscription on copestone *b*, written in the Prakrit language and Brahmi script, can be read: "Rāṃño Gopālyā putrasa Suryamitrasa piṭhamadena Kāśī[p]." From other fragments Hartel (see Literature) has reconstructed the entire inscription and proposed the following translation: "Caused to be made by Kāśīputra Yaśaka, the confidant of king Sūryamitra, the son of Gopāli."

Hartel further identifies this Suryamitra as a king of the ancient Panchala kingdom with its capital at Ahichchhatra, about 150 miles northeast of Mathura. Suryamitra is generally considered to have ruled sometime in the second half of the first century B.C. Hartel, however, considers the fragment *b* to have been carved somewhat later than the others because of certain paleographical considerations and because the bells do not have horizontal lines. The first seven bells in *a*, however, do have horizontal striations, which may simply have been omitted from the others due to chance or lack of time and need not necessarily indicate a later date. Similar bells also adorn copestones at Bharhut (Cunningham 1879, pls. XL–XLVIII).

S54 *A Nature Goddess*

S54 A Nature Goddess
Uttar Pradesh, Mathura; first century
Mottled red sandstone; 63 in (160.0 cm)
From the Nasli and Alice Heeramaneck Collection
Museum Associates Purchase; M.86.21
Literature: Heeramaneck 1979, no. 18; Pal 1985a, p. 69, figs. 6–7.

This larger-than-life figure probably once graced an outdoor shrine and was very likely circumambulated by devotees. The figure is fully sculpted in the round, and a tree is attached to the back. Whatever her exact identification, the close association with the tree clearly signifies her importance as a nature goddess. Despite her damaged condition, she is a monumental figure with a majestic presence.

She stands in a columnar, hieratic posture, her left hand with its closed fist placed resolutely near her abdomen. Typical of Kushan-period sculpture, the mons veneris is emphasized. The garment is indicated by the gathered folds between the legs, a tassel across the right thigh, and striations below the knees. A multilayered chain belt secures the garment around the hips. A scarf is carefully draped across the bent left arm so that it does not interfere in any way with the display of the torso. The now-broken right arm very likely was originally raised, with the hand forming the gesture of reassurance as was usual with early divine figures. She wears a necklace, her ear ornaments are now damaged beyond recognition. The hair was almost certainly rendered in the same style worn by females in the railing pillar (S55). The tree at the back, rising from the bottom with slender shoots and clusters of leaves springing from the trunk, extends to her head.

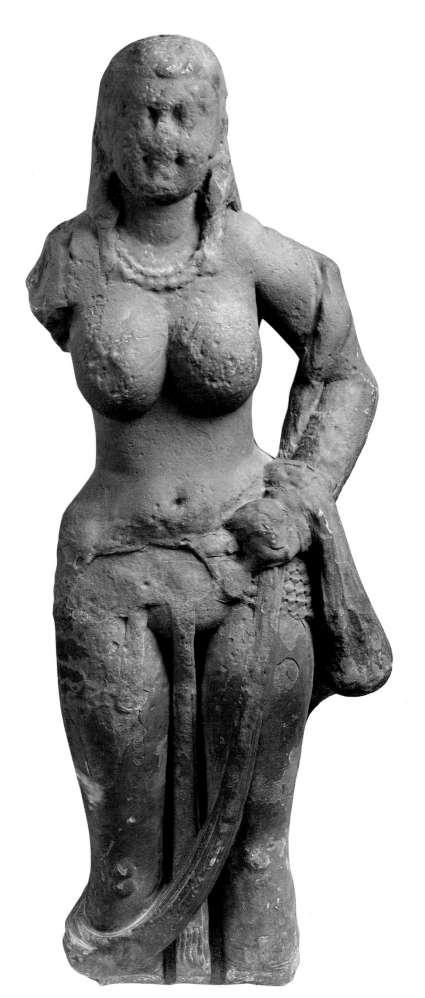

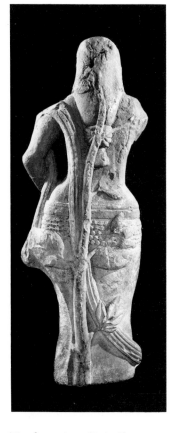

The figure is stylistically similar to the Sanchi tree dryads (S29). The differences are largely in matters of details and subtle nuances of modeling. For instance, the outline of the torso in this figure falls almost perpendicularly to the waist, flares out rather sharply and straight until the middle of the thigh, and then tapers to the knee. The abdomen is indicated by a very slight bulge, and the kneecaps are prominently rendered. Although the heavy breasts, ample hips, and fleshy thighs emphasize the sheer physical presence of the figure, the clear and taut outline restrains the swelling volume. The back is summarily modeled, with emphasis on the tree. Nevertheless, the sensuous quality of the body is enhanced by the upper edge of the garment that closely hugs the hips and the two fleshy arcs that indicate the buttocks.

S55 Railing Pillar with Figures
Uttar Pradesh, Mathura; first century
Mottled red sandstone; 21 in (53.3 cm)
From the Nasli and Alice Heeramaneck
Collection
Museum Associates Purchase; M.85.2.2
Literature: Rosenfield et al. 1966, pp. 30–31;
Beach 1967, p. 162; Meister 1968, p. 108;
Trubner 1968, p. 5, fig. 3; Glynn 1972, fig. 1;
Pal 1974b, p. 27; Trabold 1975, p. 12, no. 2;
Heeramaneck 1979, no. 21; Fisher 1982, p. 40;
Czuma 1985, pp. 91–92.

This railing part or upright once supported a
copestone such as that discussed in entry
S53a–b. Indeed, the balustrade above the tree in
this relief depicts such a railing, which
surrounded religious edifices in Kushan Mathura

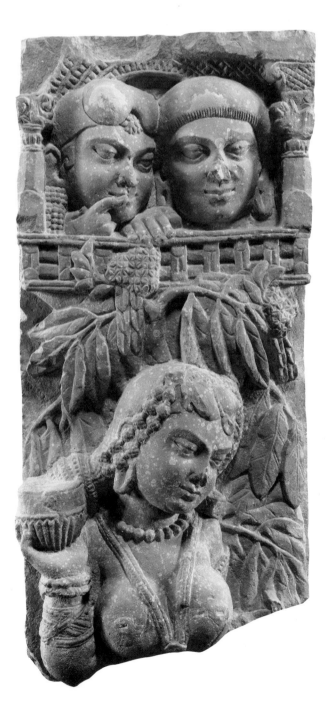

and other places. The exact religious affiliation
of this pillar cannot be determined; the subject
itself is not particularly sacred.

Most of the pillar was once
occupied by an elegant female, whose bust now
only remains. She holds a partly fluted cup in her
right hand. The bejeweled lady stands below a
flowering tree and is observed by a couple from a
balcony. The pillars supporting the arched roof
are topped with lion capitals. The couple above
undoubtedly are watching some sort of rite.
Placing her right index finger to her lips, the
woman at the left admonishes her male
companion to be quiet. Very likely they are
watching the bejeweled lady, perhaps a princess,
perform a particular and popular rite known as
dohada. During this rite young girls touch or
caress a particular tree to increase its capacity to
blossom. The word *dohada* is derived from *doha*,
meaning "milking" or "to yield." The popularity
and antiquity of this rite, also regarded as a
sport, is vouchsafed in ancient Indian literature
and provided a frequent theme for sculptors
(Sivaramamurti 1970, pp. 1–2, 39–41).

In an earlier publication
Rosenfield (see Literature) identified the tree as
the asoka and commented upon its realistic
representation. He did not, however, identify
the scene as an *asokadohada*. It is believed that
the asoka flowers when the trunk is kicked by a
young girl who carries a cup in her right hand. A
wine cup is also necessary when a girl attempts
to make the bakula tree flower by spraying the
tree with wine from her mouth. Indeed, the
flowers on this tree are not the asoka but clusters
of bakula. As the fifth-century Sanskrit poet
Kalidasa wrote, "In the vicinity of the *mādhavī*
creeper bower fenced by *kuruvaka* trees are the
raktāśoka tree with its waving tender shoot and
the lovely *bakula* tree; the one, along with me,
longs for the foot of this lady friend of yours and
the other mouthfuls of wine on the pretext of
blossoming again" (Sivaramamurti 1970, p. 40).

The decorating of railing pillars
with beautiful females engaged in mundane
activities appears to have been a characteristic of
Kushan-period architecture at Mathura.
Furthermore, Kushan-period sculptors were
fond of dividing the pillar into two sections, a
larger, lower section containing a voluptuous
lady, much more deeply cut and naturalistic than
the earlier Bharhut relief figures, and a smaller,
upper section representing a balcony, usually
with a couple watching the female below.
Typical also of Kushan-period sculptures are the
distinctive hairstyles. Men wear their hair
combed into the shape of a cap with a fringelike
row of striations along the front. Women display
a prominent *coque de chevelure*. The design of the
fluted cup held by the lady can be traced to
Hellenistic sources (Marshall [1951] 1975, 3:
pl. 130, no. 226a).

S56 Crossbar
Uttar Pradesh, Mathura; first–second century
Mottled red sandstone; 9 ¾ in (24.7 cm)
Purchased with Harry and Yvonne Lenart Funds;
M.85.224.5

Crossbars were used in railings as in two
sculptures in the collection (S29). Carved on
both sides with two different motifs, this
example probably is from an ancient Buddhist
shrine in Mathura.

On one side (*a*) is a wheel
surrounded by a garland. The seventeen spokes
of the wheel alternate with knobs, the exact
function of which is not known. They may be
imitations of pinheads used in a real wheel. The
garlanding of the entire wheel rim is unusual,
quite different from the use of similar garlands at
Bharhut, which hang from a projecting wheel
hub (Barua 1979, pls. L–LI). The wheel is one of
the most important symbols in Buddhist art,
signifying the religion itself and more specif-
ically the first sermon of Buddha Sakyamuni at
Sarnath, near Varanasi.

On the reverse (*b*) is the lotus,
which appears to have been the most popular
motif in early Buddhist art, especially in
Mathura for decorating crossbars. As on the
other side, the corners of the central raised
section are filled with lotus buds. (For other
examples of similar crossbars from Govindnagar
in Mathura, see R. C. Sharma 1984, figs.
20–25.)

Side a

Side b

S57 Mayadevi
Uttar Pradesh, Mathura; c. 100
Copper with green patina; 2 ⅞ in (7.3 cm)
Gift of Mr. and Mrs. Subhash Kapoor;
M.84.169.2
Literature: Pal 1985a, p. 71, fig. 9.

The figure is identified as Mayadevi, mother of Buddha Sakyamuni. When viewed vertically, the disk behind her head appears as a nimbus. A standing figure, whether divine or mortal, usually does not place the right hand behind the head in such a gesture more commonly assumed by a recumbent figure, as in early representations of Mayadevi or the Buddha himself in his death scenes (Pal et al. 1984, pp. 77, 121). That the nimbus behind the head is, in fact, a cushion is evident by its form. A nimbus is flat and straightedged. Here, however, not only is the form depressed where the head rests, but the edge is rounded and substantial and, thereby, clearly three-dimensional. Furthermore, lines indicating folds or seams radiate at regular intervals from the center, a feature not seen in any early nimbus but which is characteristic of cushions (Pal et al. 1984, p. 138). Indeed, that the figure is lying down is also suggested by the manner in which the pearl necklace slips down her left shoulder. Thus, this fragment was part of a more complex bronze showing a female lying on a cot with her head resting against a cushion or pillow supported by her right hand. The figure probably represents Mayadevi dreaming about the future Buddha, who would enter her womb in the form of the elephant. The function of the hole on the cushion is not clear. It may have been made later.

Whatever its exact identification, the bronze probably was made in Mathura during the Kushan period. In general, the modeling of the figure with swelling breasts is very similar to stone figures in the collection (S54–55, S70). Among the three, the closest comparison is offered by the figure in entry S55. The slightly varied form of the *coque de chevelure* of the bronze figure is similar to that seen in some of the well-known Bhuteswar ladies, while the arrangement of the bouffant is identical to that worn by a tree dryad from Kankali Tila (Roy 1979, figs. 31, 59). Few bronzes can, with such certitude, be assigned to Kushan Mathura, and the two that were excavated from Sonkh are of rather mediocre workmanship (Hartel 1976, figs. 33–34). This fragmentary bronze Mayadevi with its elegant coiffure, however, is superbly crafted in form and detail. The unknown sculptor was observant and skillful and no less self-confident than those responsible for the much-admired voluptuous stone females of Kushan Mathura.

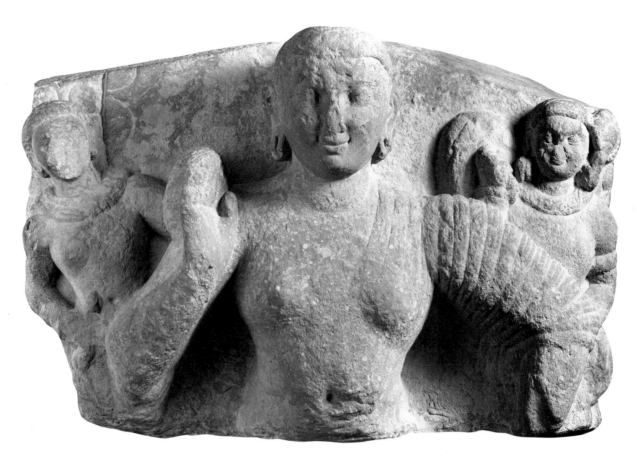

S58 *Triad with the Buddha*
Uttar Pradesh, Mathura; 100
Mottled red sandstone; 16 ½ in (41.9 cm)
From the Nasli and Alice Heeramaneck
Collection
Museum Associates Purchase; M.71.1.44
Literature: Dohanian 1961, no. 2; Montgomery
and Lippe 1962, pp. 36–37; Rosenfield et al.
1966, pp. 34–35; Heeramaneck 1979, no. 19.

Buddha Sakyamuni is flanked by two divine
attendants on the upper half of a slightly curv-
ing, rectangular stele. In the complete stele
Sakyamuni would have been seated in the lotus
posture on a lion throne. The disproportionately
smaller size of the two attendants emphasizes
the Buddha's importance. His left shoulder and
arm are covered by a garment, his left hand with
clenched fist would have been placed on the
knee. The right arm is raised to the shoulder
with the hand turned sideways, displaying the
gesture of reassurance. The figure is supported
by a buttress ornamented with a floral design.
Sakyamuni's face is distinguished by wide, star-
ing eyes and a gently smiling expression. The
earlobes are extended as a sign of his superhu-
manity. The *urna* and spiral topknot are absent.

The two figures behind
Sakyamuni are rather similarly fashioned except
for a few noteworthy differences. The figure near
his left arm wears a turban with the crest
projecting above his left ear ornament. His left
hand cannot be seen; in his right hand he holds a
flywhisk. The other figure inclines so far right
that parts of his head and arm project beyond the
edge of the stele. He is without ear ornaments or
turban and wears a necklace and what has been
identified as an animal skin. Interestingly, his
hair is indicated by tiny curls that later became a
characteristic of Sakyamuni (see S110). With his
right hand, he holds a dumbbell-like object,
generally identified as the thunderbolt.

The upper part of the stele
would have displayed a scalloped nimbus. Three
scallops are visible near the thunderbolt bearer's
head on the left. Also missing are the two flying
angels bearing garlands and, perhaps, branches
and leaves of the bodhi tree under which
Sakyamuni was enlightened.

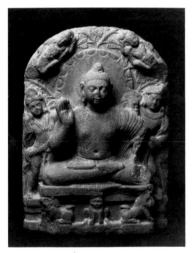

Buddha Sakyamuni, Uttar Pradesh,
c. 100, sandstone. Mr. and Mrs. James
W. Alsdorf, Chicago.

This Buddhist image very likely was fashioned in the first century by sculptors at Mathura, and it remained the standard probably into the third century. Several complete examples remain (see Pal et al. 1984, p. 192). All are very similar with only minor variations. The most noteworthy innovation in this stele is the manner in which the thunderbolt bearer's hair is rendered in tiny curls. In all other examples he and his companion wear a turban, usually with a prominent crest rising from the center. The small snail-shell curls occur on Jina figures and a few other Buddhist figures, the best known being the inscribed Maitreya from Ahichchhatra (Rosenfield 1967, fig. 54).

The divinity of the two attendants generally is not disputed, their exact identity, however, is yet to be established. In some reliefs, such as the well-known Katra example (Coomaraswamy [1927] 1985, pl. XXIII, no. 84), the figures hold only the flywhisk and, therefore, cannot be distinguished. In others, such as this example, one figure is distinguished not only by his hairstyle and accoutrements, but also by the thunderbolt in his hand. Coomaraswamy sought to identify this figure as a yaksha called Vajrapani (thunderbolt bearer), while van Lohuizen-de Leeuw argued strongly for his identification with Indra, whose

principal attribute is the thunderbolt (1949, pp. 172–77). The problem with van Lohuizen-de Leeuw's suggestion is that Indra is well represented in the art of this period at Mathura and elsewhere and he is never shown without a turban or tall crown, the latter serving as a distinctive attribute. Moreover, he is always dressed, both in Gandhara and Mathura, as an Indian prince, whereas the thunderbolt-bearing attendant in such Buddhist triads is often clad in a short skirt with an animal skin tied around his neck, both inappropriate garments for Indra. The hairstyle of this figure certainly mitigates against his identification with Indra. The thunderbolt is an attribute of the bodhisattva Vajrapani, who frequently appears as the Buddha's guardian in Gandharan art of the period. While the identification of these two attendants as bodhisattvas may not be certain, they undoubtedly represent two yakshas, one of whom was at times distinguished as Vajrapani, who in the Buddhist tradition is known both as a yaksha and a bodhisattva. The dumbbell-like thunderbolt occurs only in the hands of these figures, and neither Vajrapani in Gandhara nor Indra in Mathura or Gandhara holds a similarly shaped implement. The thunderbolt in the early Buddhist art of Andhra Pradesh is quite different (see S84), more closely resembling a shaft with three prongs.

S59 *The God Balarama or A Serpent-King*
Uttar Pradesh, Mathura; 100–125
Mottled red sandstone; 55 in (139.7 cm)
From the Nasli and Alice Heeramaneck Collection
Museum Associates Purchase; M.73.4.7
Literature: Rosenfield et al. 1966, p. 33.

A larger-than-life male figure stands with legs spread wide apart against a coiling serpent, whose hood, if preserved, would have formed an impressive canopy above him. Part of the hood is still attached to the raised right arm. The figure wears a dhoti, recognizable by the hemline below the knee and pleated section between the legs. Cord tassels hang down the right thigh, and a scarf, tied diagonally below the prominent navel, forms a very substantial knot beside the right hip. A broad necklace hugs the neck, and a garland of flowers adorns the chest. The left hand almost certainly held a cup, the outline of which can still be discerned; the right hand once displayed a gesture characteristic of a universal monarch (chakravartin) in ancient India.

Although all such figures are usually identified as Nagaraja, king of serpents, there seems a strong probability that this figure represents Balarama, or Samkarshana, one of five deified heroes worshiped as a group by the Vrishnis at Mathura. The identification can be deduced from the outline of the wine cup in the left hand, a distinctive attribute of Balarama rather than Nagaraja, particularly in Kushan Mathura. Balarama was inordinately fond of drinking and, in fact, died while inebriated. The serpent-king usually holds a pot containing an elixir in his lowered left hand. Indeed, the same iconography was used in another Mathura sculpture, where the context clearly identifies the figure as Balarama represented against a multihooded serpent with his right hand raised and his left hand holding a wine cup (Joshi 1966, fig. 38).

Stylistically, the sculpture is clearly related to the equally monumental figure of a nature goddess in the collection (S54). Both images exhibit the surging volume and heroic quality characteristic of Mathura sculpture of the Kushan period. Notwithstanding the emphasis on mass and expressive contour with subtle

modulations of outline, conscious deviation from the vertical axis, asymmetrical disposition of the projecting knot, and flattened, but animated coils of the serpent, this is a sculpture of enormous power and vitality. Noteworthy is the prominent delineation of the genital organ, a typical Kushan-period feature.

This Balarama stylistically parallels an example from Chargaon near Mathura, dated by inscription to the fortieth year of the Kanishka era (Bachofer 1929, pl. 97). If the inscriptions refers to the Saka era beginning in the year 78, the Chargaon Nagaraja would have been sculpted about 118. The museum's example, therefore, could safely be dated to the first quarter of the second century.

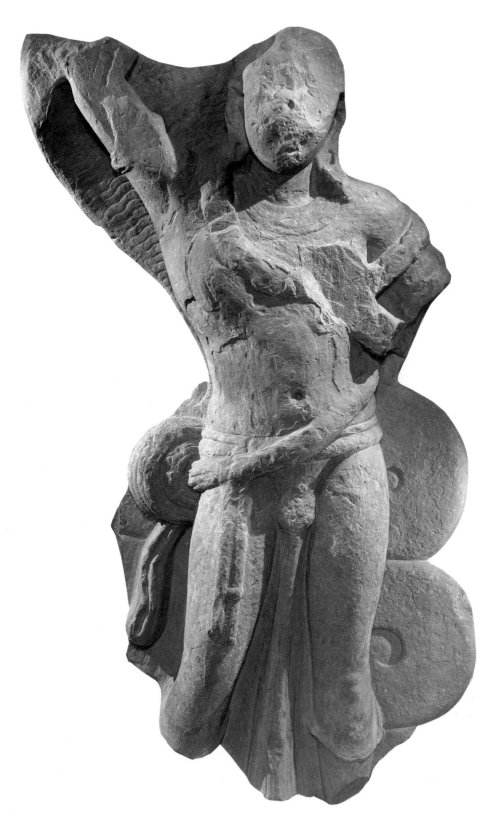

S60 Head of the Buddha
Uttar Pradesh, Mathura; 150–200
Mottled red sandstone; 14 ¼ in (36.2 cm)
From the Nasli and Alice Heeramaneck
Collection
Museum Associates Purchase; M.69.13.9
Literature: Glynn 1972, fig. 2.

This strongly modeled head once belonged to a
standing figure of the Buddha Sakyamuni. The
impressive proportions indicate that the image
originally must have been at least life size if not
larger in the tradition of the well-known
examples dedicated by the Buddhist monk Bala
in the first half of the second century
(Coomaraswamy [1927] 1985, pl. XXII, no. 83).
A nimbus was once attached to the head.

Except for slight damage on the
nose, lips, and chin, the head is well preserved
and proportioned, forming a perfect oval. The
essential features are articulately defined, and
the modeling is subtle and expressive. The
remarkably calm visage expresses an inner seren-
ity. The *urna* is indicated by a circle above the
bridge of the nose. The earlobes are elongated.
The hair was arranged into a spiral topknot,
now broken.

On most such heads (see S58)
the hairline usually is delineated by a straight
line following the curve of the temple rather
than the undulating line of this example. The
deviation is, therefore, interesting as is the facial
expression and treatment of the eyes. The eyes
are not quite as open as in other faces, and the
broader lids make the countenance more
contemplative, thereby anticipating the
expression that became typical of Gupta-period
Buddha images (see S110). In other respects,
however, the head is not dissimilar to the
standard Kushan type. Thus, these deviations
may indicate the work of a highly individual
sculptor and a date in the second century.

S61 Head of the Buddha
Uttar Pradesh, Mathura; second century
Mottled red sandstone; 4 in (10.2 cm)
Gift of Mr. and Mrs. Michael Phillips;
M.82.230.1

This diminutive head once belonged to a small
Buddha image that may have been intended for a
domestic shrine. With its large, staring eyes and
smiling countenance, it is closely related in style
to two other examples in the collection (S58,
S60). The workmanship of this piece, however, is
not quite as sophisticated, although it is no less
interesting. The nose is not as finely chiseled as
in other Kushan-period figures and flares rather
disproportionately. The eyebrows are simple
incisions and lack the modeled articulation of

the larger heads, and the ears are more
summarily rendered. Indeed, the ears are
precisely rendered in the other examples. The
urna probably was a circle between the eyebrows,
and part of the spiral topknot still remains. Of
interest are the parallel incisions along the
hairline indicating the long hair of the Buddha.
In fact, the caplike hairstyle has more volume in
this little head than it does in the other two.
Generally, no attempt is made in most other
early-Kushan-period Buddha images to indicate
the hair in this manner, although in other figures
(S55) the hairline is similarly demarcated with
small, parallel incisions. Once again, we see an
artist deviating from the norm.

This hairstyle, with the hair pulled back and gathered in a spiral knot, is known in Sanskrit as *kaparda* meaning "cowrie shell." It appears to have been used in Mathura only for early-Kushan-period Buddha images, and, hence, the figure is often characterized as *kapardin*. In any event, the hairstyle clearly demonstrates that one of the important supernatural signs of the Buddha—his short, curly hair—was a later invention. According to tradition, the Buddha cut off his hair at the time of his renunciation and presumably was a tonsured monk after his enlightenment. Early sculptors of Mathura, however, preferred to represent him as a *kapardin* yogi rather than a tonsured monk.

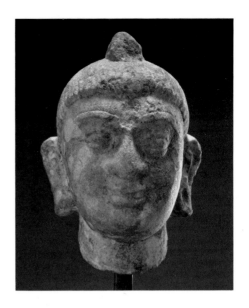

S62 *Head of a Bodhisattva*
Uttar Pradesh, Mathura; second century
Mottled red sandstone; 4 ½ in (11.4 cm)
Gift of Dr. and Mrs. Pratapaditya Pal;
M.76.147.2
Literature: Czuma 1985, pp. 82–83.

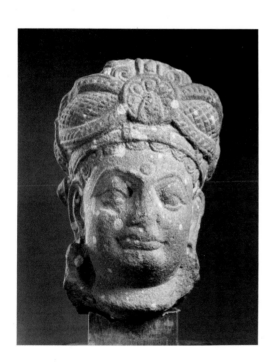

This little head probably once belonged to a bodhisattva image. This identification is supported by the presence of a dot between the eyebrows and by a comparison with a more complete relief of a bodhisattva seated in the yogic posture receiving homage from a monk and flying divinity (Coomaraswamy [1927] 1985, pl. XXIII, fig. 87). Known as the *urna*, the dot is a sign of greatness that appears primarily on the forehead of the Buddha as early as the first century A.D. Although intended to represent a tuft of hair, in most images it appears as a dot. The head may have belonged to an image of either Avalokitesvara or Maitreya, although the latter is more likely.

Stylistically, the head is very similar to the bodhisattva relief illustrated by Coomaraswamy, who dated it generally to the early Kushan period. The facial features are almost identical, and both heads are covered with turbans consisting of a prominent bow held in the center by a clasp adorned with an open lotus and garlands. This type of turban differs significantly from the more characteristic Kushan-period turban with prominent crest that is distinctly taller than the height of the turban. The manner in which the hair is shown in curls along the front edge of the turban is also a rare feature in early-Kushan-period art (Rosenfield 1967, figs. 43, 54). The style of this head is closely comparable to the Mathura museum Karttikeya dated in the year 11 (Rosenfield 1967, fig. 49), a meditating bodhisattva in the Kronos collection (Lerner 1984, pp. 30–35), and a small bodhisattva recovered from the Govindnagar site at Mathura (R. C. Sharma 1984, fig. 160). The exact date of this image, therefore, would depend on whether or not the year 11 of the Karttikeya image refers to the Saka era of A.D. 78, about which there is a difference of opinion among scholars.

S63 Male Head
Uttar Pradesh, Mathura; second century
Mottled red sandstone; 6 ¾ in (17.1 cm)
Purchased with Harry and Yvonne Lenart Funds;
M.85.159.2

Although only partially preserved, the back of the head having been sliced off along with the ears and parts of the turban, the head is an unusual example of a portrait sculpture. Stylistically, it is closely related to a more monumental head also from Mathura, now in the National Museum, New Delhi (P. Chandra 1985, p. 64, no. 16). Long considered a fine and rare example of Kushan-period portraiture, the head has been frequently published. The present head is no less a sensitive rendering, perhaps of an important donor. Notwithstanding the idealization preferred by Indian artists, the features seem sufficiently particularized. The modeling is especially refined, and various planes have been delineated with subtle plasticity. Altogether, the representation is lively and expressive, and even if the figure cannot be identified, there is no doubt about his aristocratic and dignified bearing.

In addition to their general, formal kinship, the heads have similar sideburns and delicately expressive eyes. The design of their turbans, however, is different. This figure wears a turban similar to that of the small bodhisattva head (S62). The absence of the *urna* and more individualized delineation of the features identify this portrait as a mortal rather than divine representation.

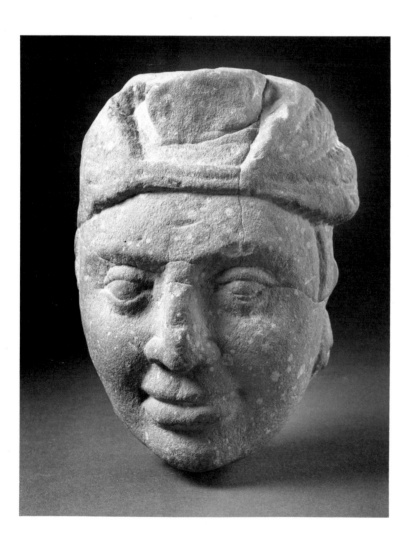

S64 *The God Kubera and Spouse*
Uttar Pradesh, Mathura; second century
Mottled red sandstone; 6 ½ in (16.5 cm)
Gift of Mr. and Mrs. Subhash Kapoor;
M.85.72.2

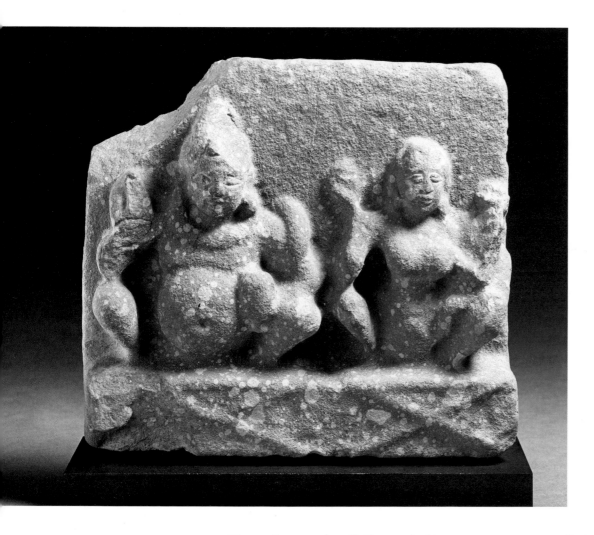

The small rectangular relief is carved with two figures, each squatting on a base decorated in front with two widely crossed staves or bamboos. Mortals and divinities were commonly represented in this posture in Kushan-period Mathura. The corpulent male figure represents Kubera, god of wealth. The object in his right hand cannot be identified with certainty, but it appears to be conical and may be the point of a spear. The object in his left hand, although abraded, is almost certainly a wine cup, as can be seen more clearly in two similar reliefs in the Mathura museum (Joshi 1966, figs. 40, 69). The slightly smaller, female companion seems to support in her lap what remains of a child; the damaged object held in her right hand probably represents a lotus.

Both stylistically and iconographically this relief is closely related to the earlier of the two Mathura museum sculptures. There, too, only a couple is represented and the female holds a child in her lap. While the identity of the male figure as Kubera is certain, the identification of the female as Hariti (Joshi 1966) may be questioned. As lord of the yakshas, Kubera is described in early texts as corpulent and fond of alcohol; the lance is also a prescribed weapon (Pal 1977). In a Buddhist context Hariti generally is also associated with Kubera (cf. S44), while in Hindu texts Kubera's companion is either Sri-Lakshmi or Riddhi, none of whom is ever shown with a child. Thus, if the goddess here does represent Hariti, then we must conclude that such Mathura reliefs were used in a Buddhist rather than Hindu context. In any event, such Mathura reliefs are clearly the counterparts of Gandharan steles with a tutelary couple as illustrated in entry S44.

S65 Relief with Three Goddesses
Uttar Pradesh, Mathura; second century
Mottled red sandstone; 6 ¾ in (17.1 cm)
Gift of Mr. and Mrs. Ramesh Kapoor;
M.85.212.3

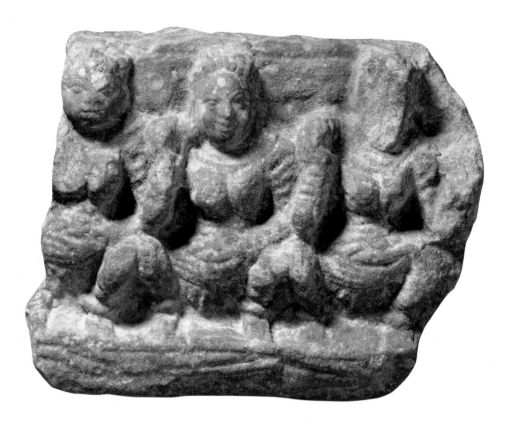

This broken relief may have contained more than three figures as is evident from part of the broken right arm of a fourth figure on the right. The three figures that are now partially preserved are female, and each sits identically on her haunches. Raised to shoulder level the right arm of each displays the gesture of reassurance, the left arm seems to rest on the left thigh. Thus, basically each goddess is almost identical to that seen in another contemporary relief representing Kubera and his spouse (S64). While two of the heads are clearly human, the third broken head may have been that of an animal such as a goat (cf. S66). Animal-headed goddesses were portrayed in other such Kushan-period reliefs.

Triads of goddesses are not unknown in Kushan Mathura, goddesses are also depicted in groups of five or six. The fourth figure in this relief may well have been a male serving as a common spouse. Because they do not have any specific attributes they are difficult to identify. A group of six, however, could represent the six Krittikas or Pleiades, who suckled the infant Kumara after his birth, or they could be identified as six mother goddesses, who later came to be regarded as part of the Saptamatrika group.

S66 A Fertility Couple
Uttar Pradesh, Mathura; second century
Mottled red sandstone; 10 ¾ in (27.3 cm)
Gift of Mr. and Mrs. Ramesh Kapoor;
M.85.212.1

Although fragmentary, this relief is of
considerable iconographic significance. The
animal-headed male figure on the right raises his
right arm in the gesture of reassurance.
Although the head looks like that of a horse,
very likely it is of a goat. His left arm with
closed fist is placed against his waist. A baby lies
in a shallow basket, which may be hanging from
the man's wrist. On his right stands a female
holding what appears to be a flywhisk in her
right hand. Her left hand may be clutching a
tassel or bag. Between the two is a small boy.

Almost certainly the animal-
headed god is Naigamesha, who appears in early
literature of the Jains as a yaksha who protects
children and in Hindu literature is a companion
of Kumara. He also came to be identified with
Kumara. In any event, according to Jain
tradition, Naigamesha was responsible for
transferring the embryo of Mahavira from one
woman to another. Whether in fact the infant
held in the basket represents this embryo is an
intriguing question. Who exactly is his female
companion is also not clear. In another relief of
the period (B. N. Sharma 1979, pl. 24)
Naigamesha is seated on a throne and one of the
three females in attendance is fanning him with a
flywhisk. Interestingly, there, too, a child stands
between the throne and the flywhisk-bearing
lady and a second woman holds an infant in a
shallow basket. Whether a second female
flanked Naigamesha on his left cannot be
determined.

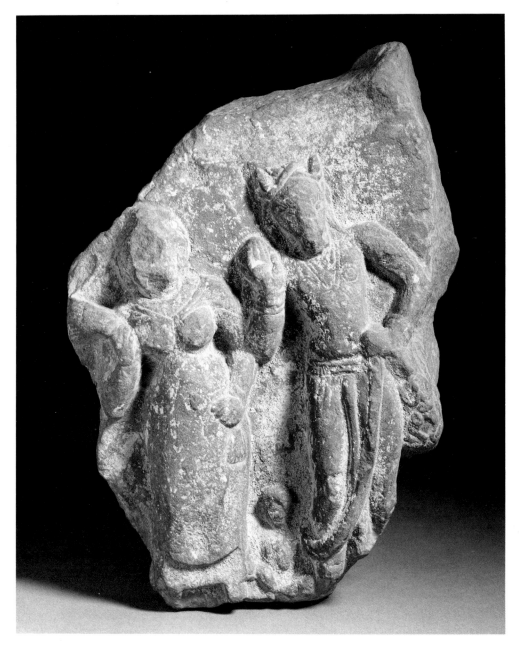

S67 *The God Kumara*
Uttar Pradesh, Mathura; second century
Mottled red sandstone; 5 ½ in (14.0 cm)
Gift of Mr. and Mrs. Herbert Kurit;
M.85.213.1

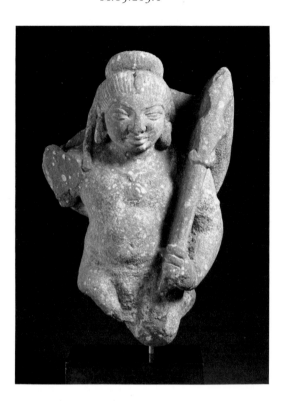

This fragmentary sculpture, probably used in a domestic shrine, is an extremely rare representation of the god Skanda, or Kumara. Although there is ample evidence of the flourishing cult of this deity in Kushan Mathura, in no other images of the period has he been portrayed so clearly as a child. He is usually depicted in Kushan Mathura and on coins (see C12c) as an adolescent. In this example we are left in no doubt that the god is a child who is yet to reach adolescence. His extreme youth is indicated by his plump figure and boyish features and hairstyle. His hair is gathered in a bun at the top of the head with two plaits falling over the shoulders. His ornaments include large, doughnut-shaped earrings and a locket, which rests against his chest. The lower garment does not cover his sexual organs. Although a child, he nevertheless stands like an adult, holding the spear with his left hand. The right hand was very likely raised to the shoulder and displayed the gesture of reassurance as in the more complete and much larger image of the god dated in the year 11 (Rosenfield 1967, fig. 49). A plain circular nimbus, parts of which remain at the back, clearly announces the child's divine nature.

S68 *A Mother Goddess*
Uttar Pradesh; second century
Red terra-cotta; 14 ½ in (36.8 cm)
Gift of Mr. and Mrs. Lionel Bell; M.81.269.2
Literature: Larson et al. 1980, p. 43, no. 5.

Straight and rigid, the goddess sits on a hollow, cylindrical stool. The right leg is broken, the head has been recently reattached. The hands are placed symmetrically on the knees. The object held in the right hand is missing, a shallow cup is held in the left hand (cf. S74). The modeling is perfunctory, the hands and feet coarsely rendered. The navel is prominent, and the pointed breasts are placed rather high on the torso. The goddess wears an apronlike skirt and necklace but no bracelets. Her elongated ears are curiously shaped, and her facial features are crudely delineated. The back, except for the hair, is even more summarily treated.

During the Kushan period this posture with legs extended was commonly assigned to a variety of female deities, loosely identified as Mother Goddesses. Some carry children, some are benign figures, others display their awesome nature by their strictly frontal posture and severe facial expression. Similar figures have been excavated from the Kushan-period tank at Sringaverapur near Allahabad (Thapar 1981, pl. xxixa–b). Smaller figures carrying children or shallow cups are attached to Kushan-period votive tanks found at Ahichchhatra, Kausambi, and other sites in Uttar Pradesh (Kala 1950, pl. liii, nos. 2–4; V. S. Agrawala 1947–48, pl. xxxix). Some Kausambi figures, characterized by hollow, cylindrical bodies, molded heads, and appliquéd limbs and ornaments, as in this sculpture, have been excavated from a layer datable to about 200 (G. R. Sharma 1960, pp. 78–79, pl. 47).

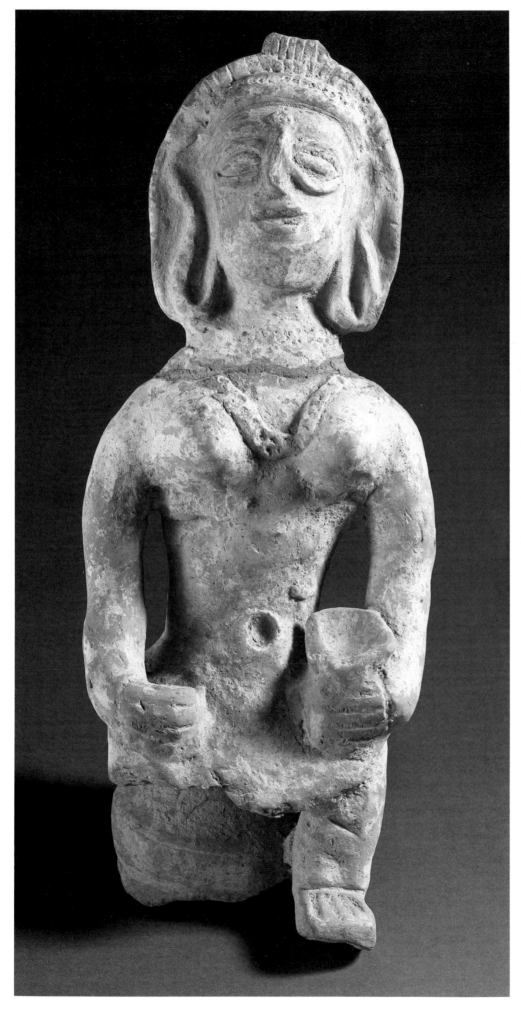

191

S69 The Lion Avatar of Vishnu (?)
Uttar Pradesh, Kausambi; second century
Buff terra-cotta; 3 ⅝ in (9.2 cm)
Indian Art Special Purposes Fund; M.82.18.1

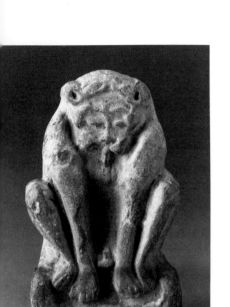

A lion is seated frontally on his haunches on a troughlike base with his hind legs bent at the knees and front legs fully extended. His tongue hangs out, and his phallus is erect. The back is plain without any modeling.

 An almost identical piece, probably from the same mold, was found in the ancient city of Kausambi (Kala 1950, p. 74, pl. LV; Kala 1980, fig. 204). In Kala 1980 the piece is mounted as a toy cart with the axle passing through the hole of the barrel-shaped base as in the toy ram in the collection (S26). It is possible that this example, too, was once attached to a cylindrical base and served as a toy or mobile votive object.

 An interesting feature of the animal is his erect phallus, which suggests that the lion probably is divine rather than mortal and may represent Narasimha, the man-lion avatar of Vishnu (see S129). From the Gupta period this incarnation of Vishnu generally is represented as a composite figure with an anthropomorphic body supporting the head of a lion. Some years ago, however, at least one representation was discovered in Andhra Pradesh in which the god is shown as a lion seated in the same posture as the figure here discussed but with two human arms added to the shoulders (Waheed Khan 1964). The sword and wheel carried in the animal's paws, together with the context of the representation, identifies the figure as Narasimha. Of particular interest is the representation in the Andhra figure of the ithyphallic nature of the divine animal as in this plaque. An erect phallus is not incompatible with Narasimha, whose association with yoga is well known (Gopinatha Rao [1914–16] 1968, 1: pp. 149–50, pl. 1). An earlier tradition of representing Narasimha theriomorphically clearly is demonstrated by a Kushan-period stone sculpture recovered from Bhita and now in the Lucknow museum (Srinivasan 1979, p. 41, fig. 6). In this sculpture, too, the theriomorphic Narasimha is seated exactly as he is in the Los Angeles terra-cotta plaque.

 Thus, there is a possibility that the lion in these Kausambi terra-cotta plaques serves both a secular and religious purpose. An ithyphallic lion would otherwise be difficult to explain if it were simply a child's toy. Kala dates the other Kausambi piece to the first century.

S70 Female Figure
Uttar Pradesh, Mathura; c. 200
Mottled red sandstone; 28 ½ in (72.4 cm)
From the Nasli and Alice Heeramaneck Collection
Museum Associates Purchase; M.78.9.16
Literature: Rosenfield et al. 1966, pp. 31–32; Beach 1967, p. 163; Meister 1968, p. 108; Trabold 1975, cover and pp. 12–13; Heeramaneck 1979, no. 26; Czuma 1985, p. 103.

The sculpture may once have served as a railing pillar or upright. If it did, then the upper section must have been similar to the other fragmentary pillar in the collection (S55). The back slab, however, is thinner and is not recessed to accommodate a crossbar as are others. It is possible that it was an end piece, and, hence, the groove would have been on the right. The width of the sculpture is unusual for a railing pillar, most of which are narrower. Whatever her exact architectural function, there is no doubt that, like other such figures, which represent the hallmarks of Kushan-period art at Mathura, she symbolizes the abundance of nature. As with several other well-preserved examples recovered from Bhuteswar or Mathura (Bachofer 1929, pls. 92–93), she may have stood on a grotesque dwarf and, hence, may be identified as a yakshi.

 Stylistically, however, she is quite different from the Bhuteswar yakshis, which are generally dated around 100. Rather, she shares qualities with the yakshi from Fyzabad now in the Bharat Kala Bhavan, Varanasi (Anand Krishna 1971, fig. 118), and several other similar female figures from Mathura generally dated to the second–third century. Similar also is a piece in a private collection in New York dated to the second–third century (Lerner 1984, pp. 8–9), while another, offering perhaps the closest comparison with the museum's figure and recovered from Jaisingapore near Mathura, has been assigned a circa third-century date (*In the Image of Man*, p. 112, no. 66). Indeed, both these figures are strikingly alike in their elegant proportions, posture with emphatic thrust of the right hip, clear and smooth contour, and svelte modeling. Thus, a circa 200 date for this yakshi seems eminently possible, and, while Rosenfield's suggestion (see Literature) for a late-fourth-century date is unacceptable, he is correct when he comments that this charming female figure "reaches a higher level of refinement than any of the dozens of known Kushan-period

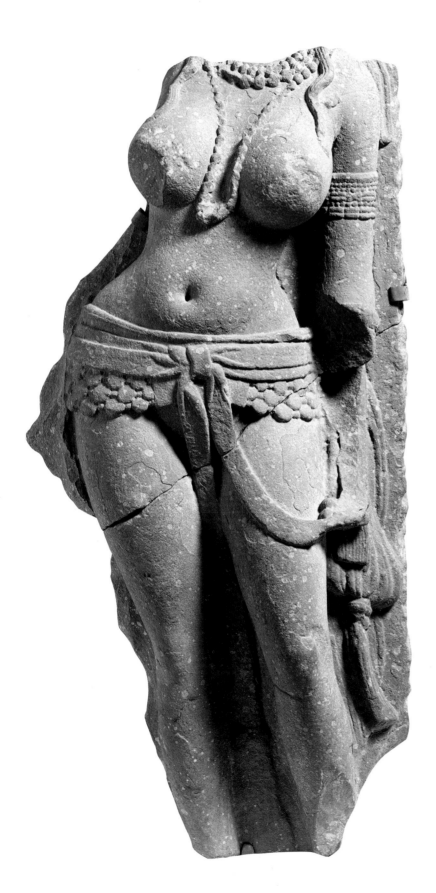

figures of the type" and that it may have been created by a "sculptor uniquely gifted for his time."

Indeed, several features make this figure unusual, if not unique. Usually, in such Kushan-period female figures the mons veneris is conspicuously displayed, but here the sculptor has decorously and deftly used the ends of the realistically rendered tape or belt to cover her nudity. She holds one of the two ends of the belt with her left hand, two fingers are still attached to the thigh. The articulately carved strings and tassels hanging along her left thigh are unusual. Another uncommon element is the almost invisible, diaphanous upper garment containing her voluptuous breasts. The faint outline of the hem is etched across the top of her breasts and is attached by a clasp to the other portion draping her left shoulder. Few female figures of the Kushan period are known to wear such an upper garment, which is reminiscent of the extremely light and gossamer cottons for which India was famous in the West as early as the Roman times. Finally, her proportions are somewhat more naturalistic than those of earlier Kushan figures (see S54), and the breasts and hips are not quite as full. These variations indicate that the sculptor responsible for this somewhat enigmatic figure was indeed inventive.

S71 *Female Figure*
Uttar Pradesh, Kausambi (?); c. 200
Red terra-cotta; 6 ⅜ in (16.2 in)
From the Nasli and Alice Heeramaneck
Collection
Museum Associates Purchase; M.72.1.2
Literature: Rosenfield et al. 1966, p. 10; Czuma
1985, p. 125.

Although rendered in a different medium, this terra-cotta figure stylistically is very similar to S70. She stands with arms akimbo, the weight of her body resting on her right hip and the left leg rather sharply bent at the knee. Her diaphanous garment is held in place by a chain girdle. A long, wide scarflike cloth hangs from the chains. Her ornaments consist of bangles and a necklace with an arrow-shaped pendant.

 The exact provenance of this figure, probably intended for a domestic shrine, is not known. She presumably was viewed only from the front since the back is not modeled. Closest parallels for this figure may be found among the terra-cottas from Kausambi, where in at least two examples is encountered a similarly distinctive treatment of the cloth hanging between the legs (see Kala 1950, pls. XXI, XXVb, XXVII–XXVIII for similar modeling and proportions). Thus, Kausambi remains a possible source for this figure, although Czuma (see Literature) has recently suggested a Mathura provenance. Similar figures were also found from Ahichchhatra, which makes it certain that the piece is from Uttar Pradesh.

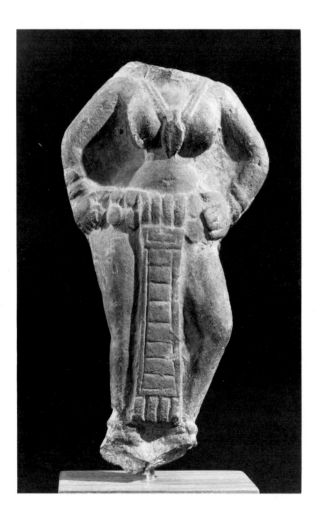

S72 *The Goddess Durga Destroying the Buffalo Demon*

Uttar Pradesh, Mathura; c. 200
Mottled red sandstone; 9 ½ in (24.1 cm)
Gift of Dr. and Mrs. Pratapaditya Pal;
M.84.153.1
Literature: Czuma 1985, pp. 135–36.

Standing in *déhanchement* with her right hip prominently thrust out, the goddess effortlessly strangles a buffalo with her two principal arms. In her other hands she holds a sword and unrecognizable object on the left and two disks above her head. She usually carries, along with a sword, a shield, which may be represented by the effaced object held in one of her left hands. The disks, no doubt, represent the sun and moon, the one on her left consists of a crescent and circle.

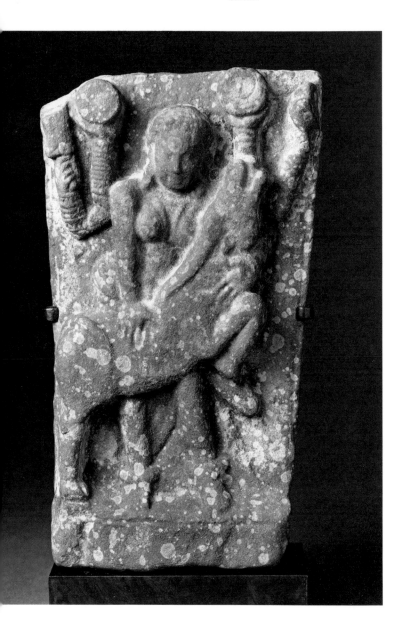

The goddess is Durga, and the buffalo is the demon Mahishasura, who assumes the form of the animal during his battle with the goddess. The theme, therefore, is usually known as Mahishasuramardini (destroyer of the buffalo demon). This representation is typical of Kushan-period reliefs of the subject, and, as all are small, it seems certain that they were used in domestic shrines. The Mathura sculptors of the Kushan period clearly were responsible for creating this image type.

The artists used the well-known yakshi type to represent the goddess. In fact, in form and style the goddess is very similar to the yakshi in the collection (S70). As with most Kushan-period female figures, the legs taper to rather narrow ankles, which are adorned with large doughnut-shaped anklets. Her ornaments, square shoulders, and rather clumsily jointed arms are also characteristic of Kushan-period sculpture.

The manner in which the goddess destroys the animal without using any of her weapons is unique to Kushan-period reliefs. The buffalo looks almost like a calf, in conformity with the hieratic scale that demands a relatively larger size for the goddess. Although the animal lunges at the goddess, she is totally unruffled and holds him as one would fondle a calf. Yet the intent undoubtedly was to show the goddess killing the demon with her bare hands. The ease with which she accomplishes her task is effectively expressed by contrasting her equanimity and equipoise with the diagonal and forceful depiction of the animal with his raised forelegs, taut body, and open mouth with tongue hanging out.

In textual descriptions of the theme, all of which belong to a later period, the goddess decapitates the buffalo with her sword and then drives her trident into the demon who emerges from the buffalo's neck. Thus, the Kushan-period artistic configuration obviously followed an earlier textual tradition, now lost. In this relief the goddess does not even carry a trident. Instead, two attributes are introduced by the unknown sculptor, the sun and moon, clearly representing the cosmic nature of the goddess. These two symbols were especially significant for the dynastic cult of the Kushan emperors. The mode of killing the demon with her bare hands is in keeping with the literal meaning of the word *mardana* (crushing) in the epithet Mahishasuramardini.

S73 *The Androgynous Form of Siva and Parvati*
Uttar Pradesh, Mathura; second–third century
Mottled red sandstone; 12 ⅛ in (30.8 cm)
Gift of Mr. and Mrs. Herbert Kurit;
M.85.213.2
Literature: Pal 1985b.

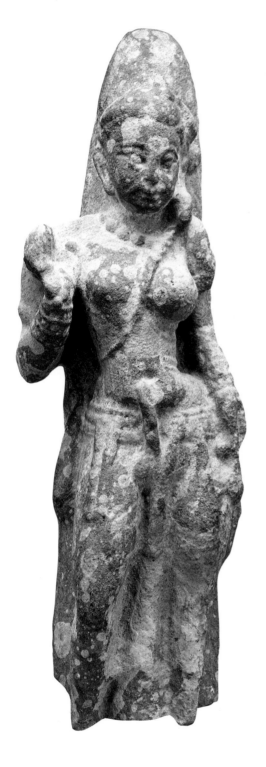

The image type in which Siva and Parvati (or Uma) are represented in a combined androgynous form is known as Ardhanarisvara (lord who is half-woman). The image was created during the Kushan period to express the nonplurality of the godhead. Although similar to the Greek concept of the hermaphrodite, the Indian androgynous form was composed in a different manner. Usually, as in this image, the deity is represented as half-male and half-female, the two halves clearly distinguished along the vertical axis. Thus, the right half always portrays Siva and the left half, Parvati.

In this small, but rare representation (only three other Kushan-period representations are known [see Literature and Czuma 1985]), the androgynous figure stands against a tapering shaftlike Sivalinga that is partially flat at the back. The slim figure is generally contained within the contours of the linga, except for the right arm and shoulder and left hip. The two halves are articulately differentiated along the vertical axis, the right half being male and the left, female. Beginning at the top, the typical *coque de chevelure* hairstyle of Kushan-period females at Mathura is seen only on the left side of the head, which is considerably narrower than the right side. The eyes are shaped differently, and the right ear is without any ornament, while a moustache is added above the mouth on the right. The left side displays a prominently carved breast, ample hips, and fleshy waist as befitting a woman. The erect penis with one testicle is depicted only on the right half and is tilted away from the female half in a manner that appears to have been characteristic of Kushan-period Ardhanarisvaras from Mathura. The left thigh of Parvati swells out much more emphatically than does Siva's, but his shoulder is much broader. Common to both are the string of pearls around the neck and sacred cord descending diagonally from the left shoulder. Both wear bangles, but Parvati has more of them. The design of their armlets is different. Siva's right hand is raised to the shoulders in the gesture of reassurance and holds the rosary; Parvati's arm hangs along her body and holds a flower.

But for the flat linga at the back, the figure is sculpted almost in the round. The slim, elegant proportions and svelte plasticity clearly indicate a date closer to third-century figures (S70–71) rather than to those of the first century (S54). Sensuous though the figure is, Parvati's voluptuousness is not brazenly displayed. The form in general is less concerned with swelling volumes as in early-Kushan-period sculpture. The expressive contours instead reflect a linear fluency anticipating the Gupta sculptural style.

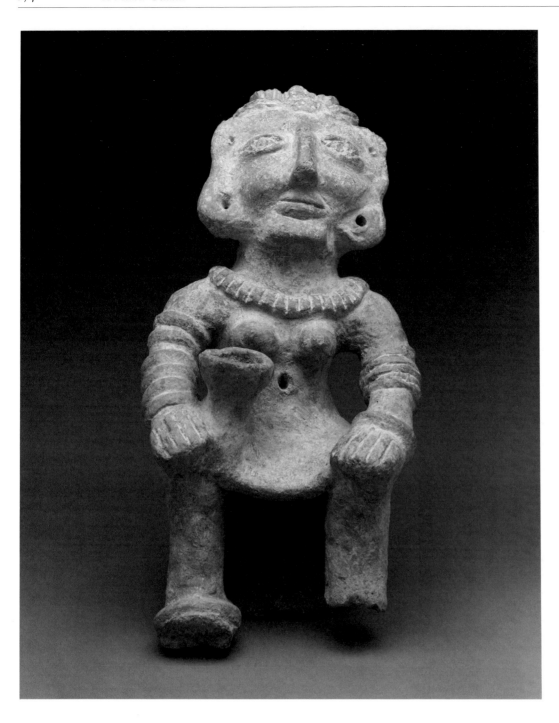

S74 A Mother Goddess
Uttar Pradesh; second–third century
Buff terra-cotta; 12 ¾ in (32.4 cm)
Gift of Marilyn Walter Grounds; M.83.221.5

Like entry S68, this is a similarly attired, seated goddess. Here, however, she holds a cup with her right hand and rests her left hand on her knee. Also, her right arm is completely covered with a row of bangles and her left arm is more sparsely ornamented. The proportions of the two figures considerably differ. Here the goddess has a rather stunted body but longer legs. The breasts and nipples are proportionately placed, but the navel is much too high. The outline of the ears follows the same general shape, but here the lobes are circular and pierced. The most distinctive feature of the figure is the very individualistic face with high cheekbones, recessed mouth and chin, and broad shape. The hair is pulled back into a wide bouffant adorned at the forehead with a pendant or clasp. The figure is strangely reminiscent of pre-Columbian sculptures. Nevertheless, despite their differences, the two goddesses in style and iconography are related and very likely belong to the same region.

S75 *The Boar Avatar of Vishnu*
Uttar Pradesh, Mathura; third century
Mottled red sandstone; 22 ½ in (57.1 cm)
From the Nasli and Alice Heeramaneck
Collection
Museum Associates Purchase; M.72.53.8
Literature: Pal 1974b, fig. 93; Pal 1985b;
Czuma 1985, pp. 132–33.

A subject of multiple symbolism, the myth of Earth's rescue from the primordial waters by Vishnu in the form of a boar has both cosmogonic and moral implications and is known in many different versions (Gonda 1969). In the most popular, the demon Hiranyaksha had dragged Earth, personified as a woman, to the bottom of the ocean; in another version Earth,

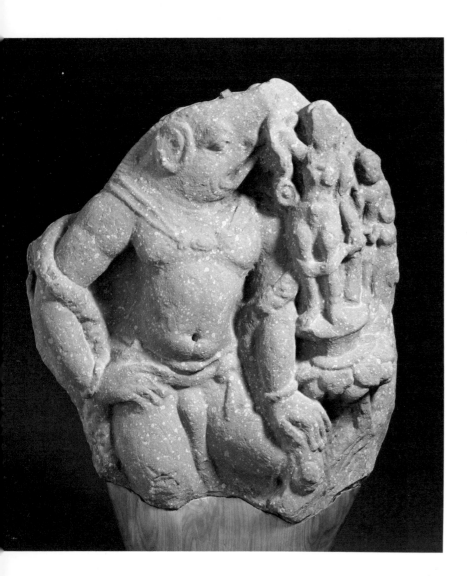

overburdened with evil, had sunk to the bottom of the sea. Although an ancient myth, the story did not capture the imagination of artists until the Gupta period, when several monumental representations of the theme were carved. This sculpture and a small relief in the Mathura museum (R. C. Sharma 1976, fig. 44) provide evidence that the subject was earlier represented by Mathura artists. The relief in the Mathura museum is inscribed and is possibly older than this example, but because the head of the figure is missing and the inscription does not mention Varaha the boar, a certain identification cannot be made. Thus, this may well be the earliest unquestionable representation of the boar avatar of Vishnu in the history of Indian art.

The sculpture shows Varaha as a human with a boar's head. The head sits solidly on a powerfully modeled body. The sculptor has attempted to indicate the muscles of the chest, stomach, and right arm. As is usual with Kushan-period male figures, the genitalia are prominently shown under the garment, which is held in place by a knotted cloth belt. Across his shoulders Varaha wears a scarf with clasp and thick garland of flowers, known as a *vanamala*, a typical attribute of Vishnu. The resolute posture of the god, with arms placed on the thighs, imparts a sense of stability as well as superhuman energy. His colossal size is further emphasized by the three diminutive figures near his left shoulder. Earth, personified as a goddess, stands on a lotus. She holds another lotus with her right hand and part of her scarf with her left hand. She is obviously being lifted from the waters by her right elbow, which is supported by Varaha's snout. Varaha holds a lotus bud with his left hand, thereby emphasizing the casualness of his effortless deed. The couple watching the divine rescue are probably two humans and are even smaller in the hierarchic scale.

Originally, the sculpture probably was about thirty inches high, perhaps even taller if it had been encircled by a nimbus, and may have been enshrined in its own temple. Although the proportions are somewhat different, the modeling, with its emphasis on musculature, is reminiscent of the Ardhanarisvara (S73). The capelike treatment of the scarf draping the boar's shoulders is also seen in a Vishnu image for which a fourth-century date has been suggested (Joshi 1966, fig. 72). While the facial features and plastic qualities of the Vishnu strongly reflect the Gupta style, this Varaha well expresses the Kushan-period aesthetic.

S76 *The God Siva*
Uttar Pradesh, Mathura or Ahichchhatra (?);
third century
Buff sandstone; 27 in (68.6 cm)
Museum purchase with acquisitions fund;
M.69.15.1
Literature: Dohanian 1961, no. 18; Glynn
1972, fig. 5; Harle 1974, p. 19, fig. 54; Pal
1974b, pp. 6, 45; Trabold 1975, pp. 14–15,
fig. 7; Pal 1979, p. 220.

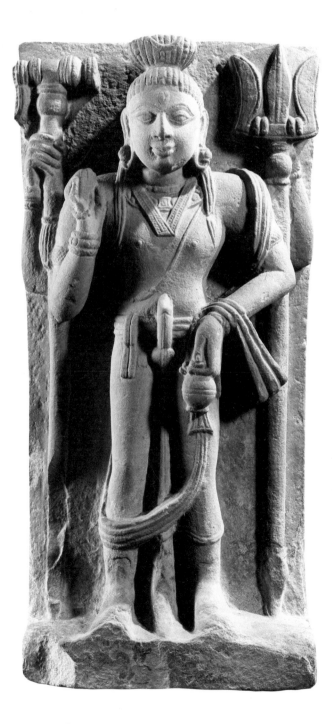

Wearing a dhoti and folded shawl, Siva stands erect with his feet placed evenly on either side of the pleats of his garment. Around his waist is tied a sash, its ends overhanging his right thigh. He wears various ornaments, and his hair is tied in an ascetic's chignon adorned with a string of pearls and crescent. Across his torso is the sacred cord. The third eye on his forehead and erect penis are prominently indicated. The principal right hand displays the gesture of reassurance and holds the rosary, the corresponding left hand carries the waterpot. The upper left hand grasps the trident, while the other right hand holds a malletlike object. This attribute cannot be firmly identified and may represent an unusual form of an ascetic's staff (*daṇḍa*).

While the identification of the figure with Siva is without doubt, its provenance and date are questionable. The figure is more closely related to Kushan-period sculptures of Mathura than to Gupta representations. In its stance, proportions, long, columnar legs, garments, and modeling, the figure is remarkably similar to an Ahichchhatra Maitreya of the late-first–early-second century (Pal 1979, figs. 6–7). Several details, such as the delineation of the shawl, two necklaces, shape of the left hand, and manner in which the waterpot is held are similar in the two sculptures and to another second-century Maitreya from Mathura (Bachofer 1929, 2: pl. 88). While the manner in which the upper left hand grasps the trident is characteristic of Kushan-period figures, the form of the trident itself with its long, narrow stem and pointed bottom is frequently encountered in Gupta sculptures. The unusual shape of the prongs is not known from Kushan-period tridents but is similar to that seen in a Mathura pillar dated to 380 (Williams 1982, fig. 16). Also, compared with the two second-century sculptures cited above, this figure seems somewhat dry and archaic, as appropriate for a sculpture attempting to copy an earlier style. Thus, a third-century date seems consistent with the evidence. As to the provenance, the sculpture could have originated at either Mathura or Ahichchhatra.

S77 Male Head
Uttar Pradesh, Kausambi (?); third century
Reddish brown terra-cotta; 6 ¼ in (15.9 cm)
Gift of Eleanor Abraham; M.82.219.2

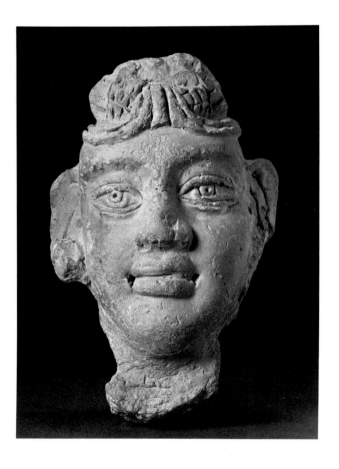

Although larger than the group of heads discussed in entry S78a–f, this head, too, is probably from Kausambi. Like others recovered from the site, it may have been inserted into a separately made body by means of tenon. The nose of the oval face is well shaped, and the mouth has deeply cut corners. The lips are slightly parted, and at least a perfunctory attempt was made to render the teeth, again a reflection of the strong sense of naturalism that motivated some artists of Kausambi. The wide-open eyes with their prominently grooved pupils are especially arresting and make this a portraitlike head. The turban with central crest was commonly seen in Kushan- and Gupta-period sculpture.

S78a–f Six Human Heads
Uttar Pradesh, Kausambi; third century
Reddish brown terra-cotta; *a*, 2 ⅜ in (6.0 cm);
b, 3 ½ in (8.9 cm); *c*, 2 ⅝ in (6.7 cm); *d*, 2 ⅞ in
(7.3 cm); *e*, 2 ½ in (6.3 cm); *f*, 3 ⁹⁄₁₆ in (9.0 cm)
Purchased with funds from Christian Humann;
M.72.47.3–8

These six human heads are said to have come from the ancient city of Kausambi, where excavations have yielded a large harvest of similar detached heads. The heads are handmade and modeled in the round. The necks often form tenons, which were probably inserted into cylindrical bodies. The tenons may also have permitted the heads to swing from side to side, and thus they may have been items of decoration and amusement. Most examples excavated between 1957 and 1959 were recovered from the

Kushan-Gupta levels (G. R. Sharma 1960, pp. 74–79). Those in the Allahabad museum are extremely similar in style and type to the museum's specimens and have been dated generally to the Kushan period (Kala 1950, pp. 67–68).

Of the six terra-cottas, two certainly represent heads of boys (*c–d*) and one, a female (*a*). The remaining three (*b, e–f*) cannot be definitely identified sexually, although *e* may portray a female. The heads, like others from the site, are characterized by particularized faces and a wide variety of hairstyles and headgears. Both Kala and Sharma have remarked on the preponderance of foreign ethnic features among these strange heads. Certainly both *a* and *c* reflect in their naturalistic modeling strong Hellenistic physiognomies. The charming, shaven-headed boy wearing a skullcap (*d*) probably also represents a foreign type, perhaps a

Central Asian, whereas the curious helmetlike headgear worn by *e* is strongly reminiscent of a Parthian crown. Thus, although the exact function of these terra-cotta heads with their strikingly varied countenances cannot be determined, they appear to be characteristic of Kausambi during the Kushan and early Gupta periods. The high degree of individualization and sensitive modeling clearly betray the artist's familiarity with Hellenistic models and keen sense of observation. A similar perspicacity and sophistication were also displayed by the terra-cotta sculptors of Patna during the much earlier Maurya period.

S78a

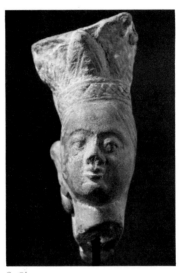

S78b

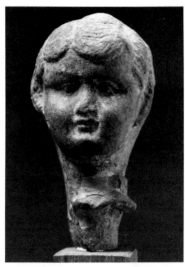

S78c

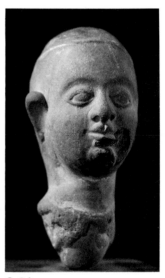

S78d

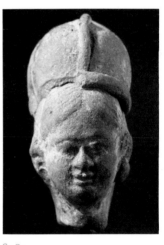

S78e

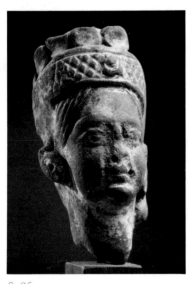

S78f

S79 A Buddha
Uttar Pradesh, Mathura; c. 300
Mottled red sandstone; 19 in (48.2 cm)
Gift of Mr. and Mrs. Michael Phillips;
M.84.227.1

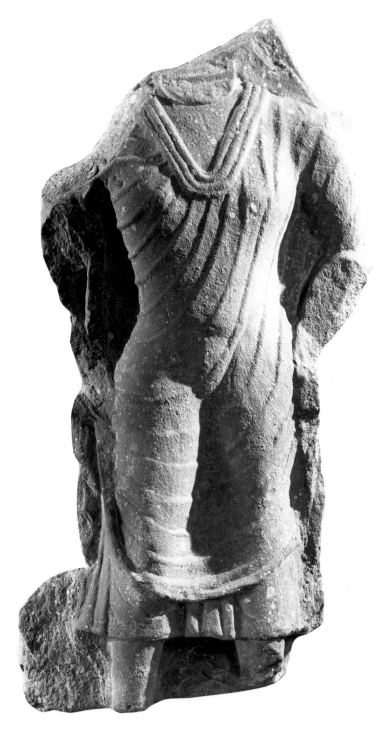

The gently swaying figure stands with his legs widely spread apart. The volume of his garments is clearly indicated by the hemline falling above the ankle and multiple pleats. A shawl fully covers the body. Below the neck part of the shawl forms a pronounced V-shaped collar. The right arm probably was raised to shoulder level with the hand displaying the gesture of reassurance as in entry S58. The left hand probably held the end of the shawl near the hip. A nimbus almost certainly once was attached to the head.

The practice of representing the volume of the upper garment by parallel folds probably was borrowed by Mathura sculptors from Gandhara. Early-Kushan-period Mathura Buddhas are draped in thin, transparent garments, the volume indicated by shallow incisions around the left shoulder and more substantial folds encircling the left upper arm (see S58). In Gandhara, however, the garment, which covered the entire body, customarily was represented by bold, ridgelike folds. Because of this dense, heavy garment, it is believed that Gandharan artists were naturalistically portraying the Buddha with a wool shawl. When Mathura sculptors attempted to imitate this particular feature, the shawl became a formal design.

In the Mathura museum are several figures stylistically similar to this Buddha (R. C. Sharma 1984, figs. 122–24), for which a late-Kushan-period date has been suggested. The figure certainly is much earlier than other fifth-century Gupta Buddhas. Typically, in these later, stylized figures riblike folds form a symmetrical design and the collarlike folds around the neck are semicircular. Here the garment does not quite form the trough typical of Gupta-period Buddhas and seems to drape the body somewhat more naturalistically. Moreover, the pronounced V-shaped collar more closely relates the figure to late-Kushan-period Buddhas than to Gupta Buddha images. Noteworthy also are the remnants of such early features as the prominent breasts and genitalia and placement of the left hand against the hip. The form, however, is not as volumetric as in Kushan-period Buddhas, and greater emphasis is placed on a more linear definition of the contour. The proportions, too, with rather extended legs and slim body, anticipate the typical Buddha of the fifth century. These considerations suggest a date around 300 for this damaged, but important Buddha image. The date may also be substantiated by comparison with another figure, which can be dated with some certainty in the second half of the fourth century (R. C. Sharma 1984, fig. 134).

S80 Male Head
Uttar Pradesh or Bihar; c. 300
Buff terra-cotta; 10 ½ in (26.6 cm)
Gift of Mr. and Mrs. Ramesh Kapoor; M.79.186

This head once must have belonged to an almost life-size figure. Whether the head is divine or human is difficult to determine. The disproportionately large ears with elongated earlobes would indicate a god rather than a human. The unusual hairstyle, however, consisting of a shaven head, except for a wide tuft that is brought forward on the forehead, may signify a particular ethnic type. The tuft of hair may, in fact, represent a piece of cloth. Seen in profile, the nose is sharp and prominent, and the thick lips protrude considerably. Its pronounced bow shape is so unnaturally extended that it is not clear whether part of the projection is meant to represent a moustache. The exact provenance of the head is not known, but it is likely to have originated in Uttar Pradesh or Bihar.

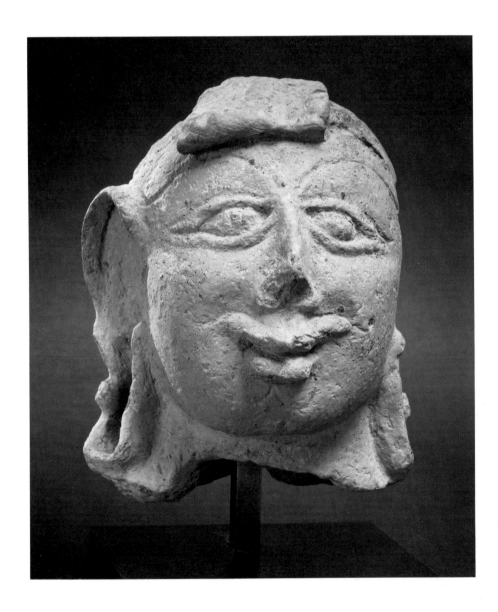

S81 The Buddha Sakyamuni Sheltered by
Muchalinda
Andhra Pradesh, Nagarjunakonda; third century
White limestone; 16 ½ in (41.9 cm)
Gift of the Michael J. Connell Foundation;
M.71.54
Literature: Pope 1942, pp. 32, 50; Pal 1976,
pp. 30–31; Newman 1984, p. 22, fig. 9.

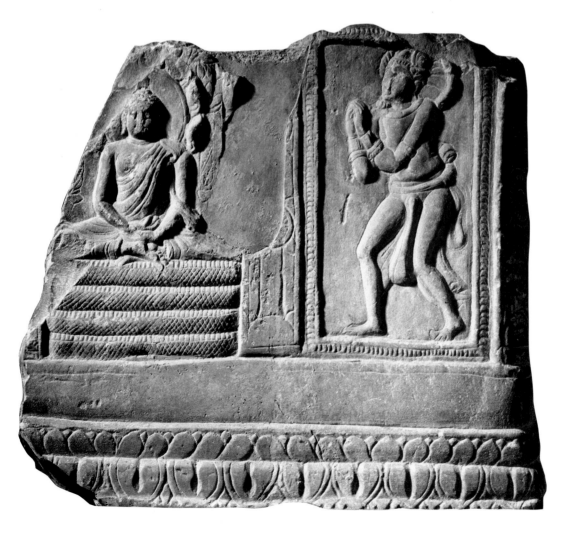

Carved in rather shallow relief, this sculpture depicts a triptychlike shrine with one panel broken off. Along the bottom is a molded border decorated with the lotus motif. A photograph published in 1942 (see Literature) shows the diagonal break in the center continuing to the bottom. Thus, parts of the serpent's coil below the Buddha, adjoining pillar, and lotus at the bottom were restored sometime between 1942 and 1971, when the museum acquired the relief.

The center of the shrine is occupied by the Buddha meditating upon a seat formed by the scaly coils of a serpent, whose polycephalic hood encloses a plain nimbus behind the Buddha's head. Two lightly etched slender columns, the tops of which are lost in the foliage above, indicate that the seat was also a throne placed below a tree. The Buddha wears the typical monk's robes. His arms are free from the upper garment, and his hands rest on his lap in the meditation gesture (*dhyanamudra*). His hair is indicated by small curls. On his left, framed like a picture, the serpent-king approaches the master with hands joined in the gesture of adoration. Dressed as a prince, the figure is distinguished by a serpent's head attached at the shoulder. The broken panel on the other side also may have portrayed another such figure.

The scene represents the occasion when the Buddha, after his enlightenment at Bodhgaya, sat meditating below a *muchalinda* tree. A violent storm broke out, and the serpent-king Muchalinda appeared and protected the master for seven days by spreading his hood above the Buddha's head. There are several representations of the theme at Amaravati and Nagarjunakonda, a region in which serpent worship has been popular since ancient times.

The exact provenance of the relief, which was used to embellish a stupa, is not known. When first published it was attributed to the Amaravati region. Very likely, however, the piece is from Nagarjunakonda, for the figure of the Buddha is remarkably similar to others recovered there (cf. Mitra 1971, pl. 126). The feet and hands of the Buddha are somewhat coarsely rendered. The manner in which part of the garment is folded back over the shoulder like an epaulet is rather unusual. Most Buddhist monuments at Nagarjunakonda were built during the rule of the Ikshvaku dynasty during the third and fourth centuries.

S82 *Scenes from the Life of the Buddha*
Andhra Pradesh, Gummadidurru (?);
third century
White limestone; 15 ½ in (39.4 cm)
Gift of the Ahmanson Foundation; M.72.50.1
Literature: Pal 1976, pp. 30, 32–34; Pal et al. 1984, p. 89; Pal 1985a, p. 68, fig. 5.

The lower portion of this fragment depicts one of the most significant miracles from the early life of the Buddha, when he was still the young Siddhartha. Known as the miracle of the Jambu (wood-apple) tree, there are two primary versions of it in Buddhist literature.

In one version (see Sivarama-murti 1956, pp. 249–50, for both versions), the child Siddhartha went with his father to see a plowing festival. He was left under a Jambu tree along with his nurse. Taking advantage of her distraction, the child sat under the tree and began to meditate. Miraculously, the shadow of the Jambu tree alone did not move. All present, including his father, were impressed and venerated the child. In the second version Siddhartha is a young man and the event takes place after he had seen the three miserable sights—a sick man, an old man, and a dead body—that changed his life. It appears that the young Siddhartha having watched the peasants struggle sat below a Jambu tree to escape the sun's heat. The story then continues like the other version.

The subject appears to have been fairly popular in the early art of the region, and the sculptor here has combined both versions. The Buddha is shown as a young man dressed as a prince, rather than as a child, although his nurse is still included. She must be the lady on his left with her head covered. The other adoring figure is, no doubt, his father. A nimbus encircles the young Buddha's head. His right hand forms the preaching gesture (*vyakhyanamudra*), although turned toward his body. His left hand is placed in his lap in the meditation gesture (dhyanamudra). This particular combination of gestures is not encountered in other Buddhist figures. Two divine (?) attendants holding flowers or flywhisks are added to the columns on either side of the central composition, thereby suggesting a shrine rather than solely a narrative panel.

Separated above by a shallow railing or trellis is a depiction of Siddhartha's departure from his mansion after he had decided

to renounce the world. This scene, too, is framed by columns and carved in very shallow relief. Curiously, however, Siddhartha himself is not represented, and a riderless horse is accompanied by several attendants, one of whom carries a parasol. As narrated in the texts, the horse's hoofs were upheld by yakshas to muffle the noise as the animal cantered through the city streets, while the citizens slept in the middle of the night. The placement of this scene immediately above the miracle of the Jambu tree, or stationary shadow, appears not to have been by chance. Siddhartha obviously had a premonition of his impending renouncement as he sat under the tree and may have seen his future departure in a vision. The representation of the horse without a rider, although Siddhartha is

represented below, is not uncommon in the early sculptural tradition of this region. Even after the image of the Buddha was introduced in the second century, Andhra artists continued to omit his representation from narrative scenes.

This and the following three reliefs (S83–85) were acquired together and very likely are from the same site. All four, like the depictions of the miracle of Muchalinda (S81), once served as architectural embellishments for stupas. These four fragments may have come out of Gummadidurru in the Krishna district, where excavations have revealed the lower portion of a stupa "with its drum veneered by a splendid array of sculptured slabs" (Mitra 1971, p. 212). A damaged inscription at the site indicates that the decoration of the drum was completed in the third century. The reliefs are similar to other third-century sculptures discovered in Amaravati and Nagarjunakonda, which are better documented and discussed than those from Gummadidurru.

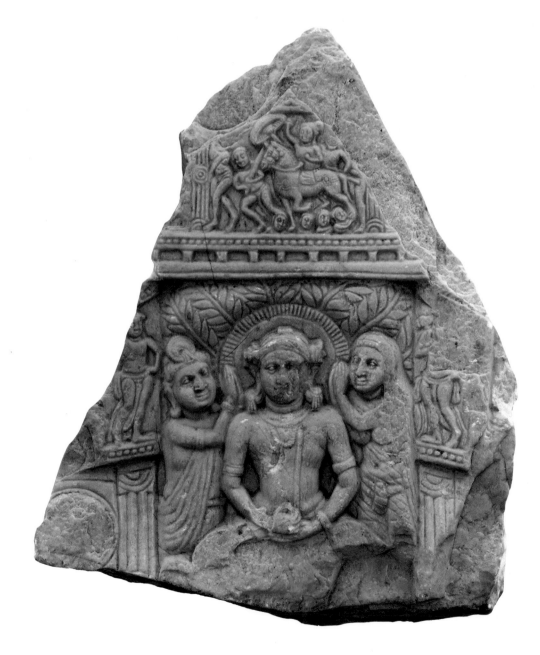

Andhra Pradesh, Gummadidurru (?);
third century
White limestone; 14 ¼ in (36.2 cm)
Gift of the Ahmanson Foundation; M.72.50.3
Literature: Pal 1976, pp. 33–34.

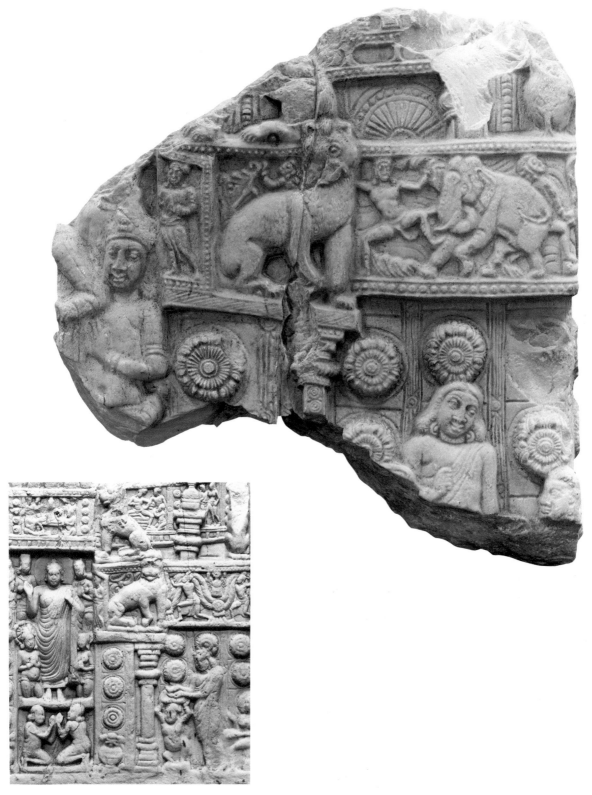

Detail of drum slab, Amaravati, third
century, limestone. British Museum;
1880,7–9,79.

This fragmentary relief probably once showed the Buddha on the left. This is evident from the still visible bent left arm clothed in a garment with a design of squares. Such a patchwork robe of rags was recommended in the early Buddhist church for all monks, but only rarely is the Buddha seen wearing one. Behind the left arm is a turbaned attendant, another stands in adoration in a panel in the upper tier of the shrine. Beside this panel is a heraldic lion with his head turned toward the Buddha, and behind the animal is the bust of a female. Another lion was represented above. On the right of the lion is a small rectangular panel showing two men struggling with an elephant. This is, perhaps, the elephant Nalagiri, who finally broke loose and attacked the master in the streets of Rajagriha. Ultimately, however, he was tamed by the Buddha. The recessed space below this panel is divided into several squares, some of which are filled with projecting lotuses. Along the bottom two young men, the bust of one and head of another still remaining, appear to be engaged in conversation.

Although damaged, it is possible to reconstruct the original position of this piece by comparing it with a drum slab of a complete stupa from Amaravati, now in the British Museum (see illustration). The Los Angeles fragment would have once formed the upper right-hand portion at about the shoulder level of the enshrined Buddha in the Amaravati slab. Thus, the broken-off Buddha figure in the museum's fragment would also have stood in a similar fashion, as evident by the bent position of his left arm. Of particular interest is the design of the Buddha's robe and spirited representation of the scene with the elephant instead of the garland bearers depicted in the Amaravati slab.

S84 Relief with Vajrapani
Andhra Pradesh, Gummadidurru (?);
third century
White limestone; 17 in (43.1 cm)
Los Angeles County Funds; 72.2
Literature: Pal 1976, p. 34.

What this piece would have looked like when complete can be determined by comparing it with a better-preserved relief now in the Cincinnati Art Museum (see illustration). The museum's fragment obviously shows the middle portion of the left-hand side of a scene depicting the worship of the fiery pillar, the empty seat symbolizing the presence of the Buddha. Parts of the flaming pillar still remain attached to this fragment. The two figures are Vajrapani, holding the thunderbolt (vajra) against his chest, and another divine companion. Above, a man or god rides a lion. A second lion and rider were above him, while a similar pair must have been placed on the other side.

Mitra has suggested that the Cincinnati relief is from Gummadidurru (1971, p. 212). If it is, then the Los Angeles fragment must also be from that site, for stylistically they are remarkably similar. Noteworthy, however, are the differences in design of Vajrapani's turban. Also, the throne must have been placed lower in the museum's piece, for it does not obscure the prominently delineated genitals of Vajrapani as it does in the Cincinnati relief. Vajrapani's figure, with its pronounced roll of flesh in the midregion, exemplifies the plastic qualities of the male body in early Andhra sculpture.

Like the early Mathura triads with Vajrapani (see S58), the scene here clearly is transcendentalized by the addition of the fiery pillar symbolizing the cosmic pillar and *mysterium tremendum*. Moreover, the four riders with lions may represent the four directions. The reluctance to depict the Buddha in such scenes clearly shows that in this region the symbol retained its potency for a much longer time than it did in other schools of early Buddhist art, such as Mathura and Gandhara.

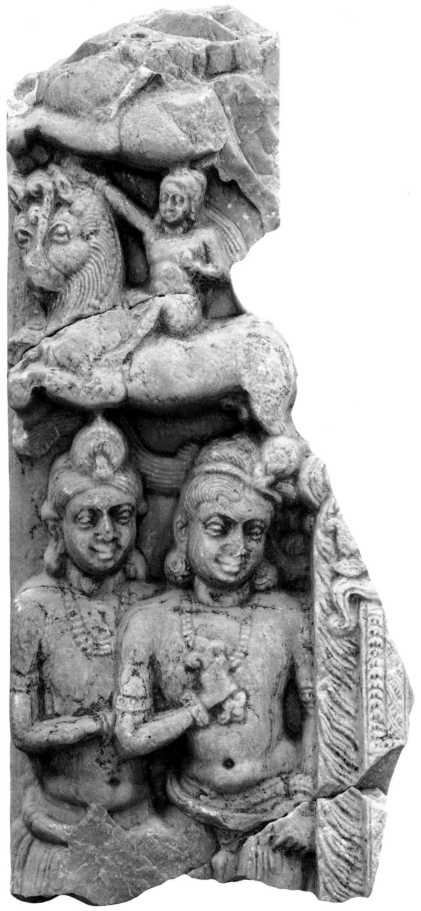

Relief, Amaravati, second–third century, limestone. Cincinnati Art Museum, given anonymously; 1952.187.

S85 *Fragment of a Rail Coping*
Andhra Pradesh, Gummadidurru (?);
third century
White limestone; 8 ⅛ in (21.3 cm)
Gift of the Ahmanson Foundation; M.72.50.2
Literature: Pal 1976, p. 33.

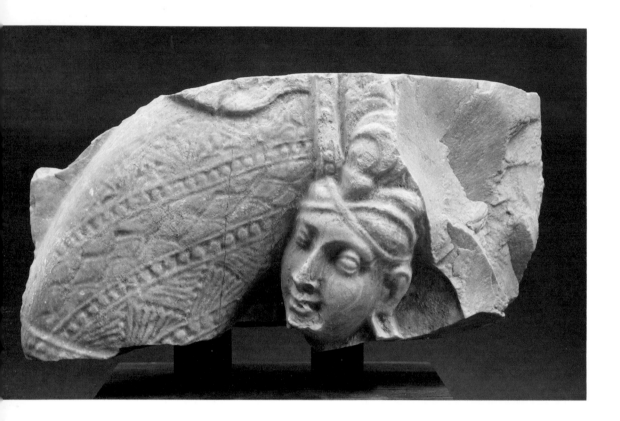

This fragment is part of a rail coping that originally would have looked something like that from Mathura (S53a–b). The typical rail coping surrounding the stupas in the Andhra country, however, was considerably larger and more elaborately carved. Usually, a wide panel below the rounded top contains much carving (Barrett 1954, pls. XL–XLI), the most prominent motif being a meandering, heavy garland carried on the shoulders by lively yakshas, who are often seen running and are either elegantly proportioned figures, as is the head still attached to this fragment, or playful dwarfs. The surface of the garland is adorned with floral designs and beads. The head of the yaksha is turbaned, and the features of his beautifully proportioned face are sensitively and articulately rendered.

Age of the Guptas

(fourth–seventh centuries)

Introduction

With a new beauty of definition it {Gupta art} establishes the classical phase of Indian art, at once serene and energetic, spiritual and voluptuous. The formulae of Indian taste are now definitely crystallized and universally accepted; iconographic types, and compositions, still variable in the Kuṣaṇa period, are now standardised in forms whose influence extended beyond the Ganges valley, and of which the influence was felt, not only throughout India and Ceylon, but far beyond the confines of India proper, surviving to the present day {Coomaraswamy (1927) 1985, pp. 71–72}.

Coomaraswamy's summation of the art of the Gupta age cannot be improved. The period was one of high intellectual and cultural achievement and, artistically, one of the most creative. The ideal forms created by the unknown artists of the Gupta period served as paradigms of beauty for successive generations in India and the various countries of Asia where Indian religions and cultural ideas were transplanted. Whether or not the age of the Guptas was more spiritual than any other comparable period of Indian history, it certainly was a time of sophisticated urbanity, witnessing a remarkable efflorescence of literature and drama, a continued vigorous commerce, especially with Southeast Asia, and cosmopolitan attitudes and refined aesthetic tastes. New ideas introduced by the influx of foreigners during the previous Kushan age were absorbed and molded, and probably for the first time in the subcontinent's history a kind of pan-Indian spirit prevailed across the country inspired by cultural rather than political ideas. Both religious and artistic ideas seem to have easily crossed political borders within the country and traveled across vast oceans and deserts to inspire cultures in distant lands. The art of this remarkable period in Indian history is represented in the collection by a richly varied group of sculptures in stone, stucco, terra-cotta, and metal as well as by gold coins.

Despite the disintegration of the Kushan Empire, artistic activity continued unabated in ancient Gandhara. Stucco, however, seems to have replaced gray schist as the principal sculptural medium during the fourth and fifth centuries. Although stucco, which was an invention of the late-Hellenistic period in Alexandria, appeared as early as the first century at Taxila, it became popular across a wide area of Gandhara only during the Gupta period. Because of the fall of the imperial Kushans and disruption of commerce, the monasteries in Gandhara very likely found stucco to be cheaper than stone. Since stucco was colorfully painted or

gilded, the monuments must have looked just as attractive as they did during the Kushan age. In his accounts of his travels through the region during the first decade of the fifth century, the Chinese pilgrim Fa-hsien (Faxian) recorded the flourishing condition of the monasteries and waxed eloquent about the stupas and devotion of the populace. The stupa of Kanishka was not only still intact, but as the monk observed, "Of all the topes and temples which [the travelers] saw in their journeyings, there was not one comparable to this in solemn beauty and majestic grandeur" (Legge 1965, p. 34). By the time another famous Chinese pilgrim, Hsüan-tsang (Xuanzang), arrived in the region in the first quarter of the seventh century, not only was this stupa in ruins, but most of the monasteries in the region were destroyed largely due to the invasions of the Huns during the previous century.

The museum's collection of stucco sculptures from ancient Gandhara is quite extensive, although their exact provenance is not known. Several sites in the region produced stucco sculptures, the best known being Hadda in present-day Jalalabad district in Afghanistan. The exquisitely painted and poignantly sensitive head of a bodhisattva, generally attributed to Hadda (S91), remains one of the finest such heads recovered from the region. It also epitomizes the distinct Hadda style noted for its "moving, spiritualized realism" (Rowland 1966, p. 72). Because of the fragility of the material, much surviving stucco sculpture from Gandhara consists of heads. The collection not only possesses a number of heads of bodhisattvas and the Buddha but also probably of devotees both male and female. Even more interesting is a seated, headless figure (S90). Apart from its rarity, it provides a good idea of the abstracted modeling characteristic of stucco sculpture. The naturalism that was a direct legacy of Hellenism in Kushan-period sculpture is now eschewed for a simpler and at times impressionistic formal statement. There is less concern with garment folds and details of jewelry. In contrast, the sculptors were more interested in registering inner feeling and spiritual ecstasy, not through dramatic distortions but by a subtle and serene expressiveness. Part of this change in aesthetic intent may have been dictated by the greater malleability of the material itself, but largely it was no doubt the result of influences from Gupta India.

The essential features of Gupta aesthetics can be succinctly summed up as follows. Gupta artists did not deviate fundamentally from the styles that they had inherited. Rather, they combined the plasticity of Sanchi and Mathura with the linear elegance of Amaravati to create a new form that is vibrant, suave, full, but buoyant, spiritually moving, although not devoid of sensuous appeal. Preferring neither the Hellenistic naturalism of Gandhara, the expansive volume and earthiness favored by Mathura artists of the Kushan period, nor the brazenly luxuriant elegance of Amaravati, the sculptors of the Gupta age achieved an ideal balance between the spiritual and the sensual. The dynamic vitality and heroic energy of the earlier schools is replaced by a more restrained animation, supple grace, and clarity of expression. Precisely because of its sustained elegance and depth of feelings, expressed with utmost simplicity, the Gupta aesthetic continues to elicit universal admiration.

These characteristics become clear by comparing a Kushan Buddha head (S60) with one created by Gupta sculptors (S119), both from Mathura. Indeed, Mathura continued to flourish as an important center for sculpture during the age of the Guptas, although other regions, too, became highly creative.

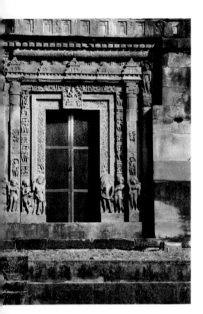

Entrance to Gupta temple, Deogarh, sixth century. Photograph courtesy Mrs. J. LeRoy Davidson.

Mathura sculptures of the period are not only varied iconographically, but they also display a remarkable stylistic diversity. At least two Buddha images from Mathura (S115, S118) demonstrate vividly a stylistic intercourse with the other important school of sculpture that developed during this period at Sarnath. This interaction is also reflected by the splendid golden bronze Buddha in the collection (S131). While these two schools with their distinct styles predominate in the collection, there are several other significant sculptures from Uttar Pradesh, both in stone and terra-cotta.

Most existing iconographic and aesthetic manuals appear to have been systematized during the Gupta period, although much material was probably borrowed from earlier literature. Many such texts were incorporated into the Hindu puranas and Buddhist canonical literature and were widely diffused not only across the subcontinent but to other Asian countries as well. Such systematization was largely responsible in providing a more unified theoretical basis for the carving of images in different parts of the country, and hence one notices a greater degree of stylistic coherence, in general, and iconographic consistency, in particular, within each religious tradition. Iconic forms of the divinities of all three religious systems became more rigidly determined and codified during the Gupta period, and there developed a stronger proclivity toward representing cosmic forms with multiple limbs. Some iconographic concepts, at an incipient state in the Kushan period, were expanded and elaborated further during the age of the Guptas. Thus, Gupta artists gave shape to many different forms of the principal Hindu deities and represented them in new guises. To mention only a few examples, the concept of the avatars of Vishnu, the Krishna legends, the two major epics, the various myths related to Siva, and the diverse aspects of the Goddess added enormously to the artistic repertoire. In Buddhist art, too, images of the Buddha were not only made more uniform, but the gestures and postures were elaborated and stabilized. The important theory of the bodhisattva, although introduced in the Kushan period, became popular during the Gupta period and contributed significantly in creating new iconographic forms. The age also witnessed a similar expansion of the pantheon of the Jains. Artists of the Gupta period further adhered to more uniformly codified canons of proportions than had their forebears. All this systematization no doubt somewhat restricted the artist's freedom of expression, as far as religious art is concerned, but the enormous expansion of the repertoire easily satisfied his creative impulse.

Although a uniform aesthetic underlies much of Gupta sculpture, regional differences are distinct and easily perceptible. Thus, although the stucco sculptures of Gandhara were influenced by the aesthetics of the Gupta period, nevertheless they are rendered in a style strikingly different from contemporary works rendered in Uttar Pradesh. Or again, a Buddha head (S119) created in fifth-century Mathura is notably different from one carved at about the same time in Sarnath (S126) and another made from terra-cotta at Devni Mori in Gujarat (S137). Notwithstanding such stylistic variations, sculptures created between the fourth and seventh centuries across northern India and the Deccan share certain essential qualities that may be regarded as the hallmarks of Gupta sculpture. These include a harmonious balance between form and movement, compact, but elegantly modeled plastic mass, and a predilection for simple surface patterns and adornments. The primary concern of Gupta sculptors was with the human form, whether in the guise of a divinity or mortal; animals and nature were included in images and reliefs largely as symbols or ornaments. Their representations, however, even when formalized or stylized, are no less lively and elegant than the human forms. While

most sculptures of the period are from Uttar or Madhya Pradesh, which constituted the heartland of the Gupta Empire, two unusual sculptures are from Rajasthan (S138–39). Carved from blue-gray schist, these sculptures, probably of Mother Goddesses, represent a localized version of the Gupta aesthetic. With their elegance and spontaneity these sculptures exhibit a remarkable naturalism and subliminal grace. Both the plastic volumes and sparse surface embellishments of these graceful figures reflect a refined simplicity. Although the hips are expansive and the breasts voluptuous, the outline of the figures is fluently defined with utmost economy. Especially appealing are the radiant faces with their delicate features and expressive freshness.

While these fifth-century Rajasthani sculptures reflect vestigial influences from Gandhara, the impact of the classicizing Gandharan schools was much more pronounced on the art of neighboring Kashmir. Although the Harwan tile of the third–fourth century (S98) presents a uniquely expressive and enigmatic style, perhaps derived more directly from earlier Parthian traditions than anything else in the region, by and large most Kashmiri sculptures of the fifth to seventh centuries bear a close affinity with Gandharan art. Very little art from the Kushan period or even from the Gupta age has survived in the Kashmir Valley. If the objects attributed to Kashmir in this catalogue are indeed from that region, then the group forms one of the most impressive assemblages of early Kashmiri art. Many of the early monasteries were already in ruins by the time of Hsüan-tsang's visit to the valley in the seventh century, but Kashmir had already become famous as a place for Buddhist learning by the year 400, when the famous Buddhist translator Kumarajiva was brought there by his mother from the distant Central Asian kingdom of Kucha for his higher education. Despite Hsüan-tsang's rather dismal picture, it was from Kashmir that Tibetans adopted Buddhism during the seventh century. Although secluded by mountains, Kashmir appears to have been a cosmopolitan and hospitable valley during the period and was occupied by both the Kushans and the Huns. Other Central Asians, too, found patronage at the Kashmiri court or came to trade as did the Tibetans. Monks from Kashmir were already traveling to China. It is not surprising therefore that, like Gandhara, Kashmir should have developed an eclectic tradition, combining elements from Gandhara, Central Asia, and northern India.

S86 *Roundel with a Male Bust*
Afghanistan (?); early fourth century
Silver; diameter 2 ¼ in (5.4 cm)
Indian Art Special Purposes Fund; M.82.159.1

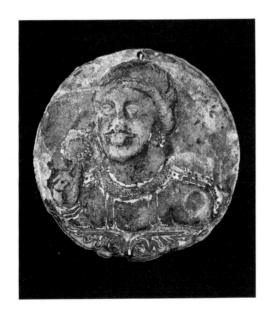

This relief representation of a male bust surrounded by stylized foliage or wings is said to have been found in Afghanistan. The figure wears a coat with decorated round collar and what look like epaulets. His left ear is adorned with a simple earring, his right hand holds a nosegay. The handsome face with well-articulated features and moustache is shown in three-quarter profile. His softly luxuriant hair appears to be rolled above the forehead. While no band can be recognized, a hole in the middle of the rolled hair may have held a precious stone. With its distinguished, noble bearing and particularized features, the bust probably belonged to a prince, perhaps of Iranian or Parthian origin.

Stylistically and icono-graphically, the object relates to a small group of Sasanian silver bowls with medallions enclosing similar busts (Harper 1978, pp. 31–32). This piece originally could indeed have functioned as a medallion for a bowl. The solitary, female figure in the Tehran bowl is shown smelling a flower very similar in shape to that held by this nobleman. In Sasanian medallions the busts generally are portrayed in strict profile, whereas here the head is shown in three-quarter profile. The design of this figure's jacket, with round collar and two dotted bands, is very similar to those worn by princes in Hatra (Rosenfield 1967, pls. 136–39; Colledge 1977, fig. 23). The Hatra sculptures are of the second century, while the comparable Sasanian material is dated to the late third–early fourth century. Thus, an early-fourth-century date for this piece is not incompatible with the evidence.

S87 *The God Kumara*
Pakistan, Swat Valley (?); fourth century
Gray schist; 5 in (12.7 cm)
Gift of Mr. and Mrs. Ramesh Kapoor;
M.85.212.2

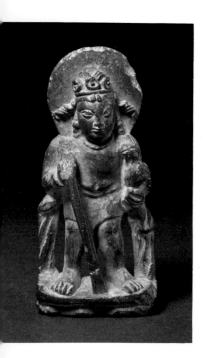

This small statuette, probably from the Swat Valley in Pakistan, represents the child-god Skanda, or Kumara. With his feet placed well apart on a narrow base, the god stands firmly and holds a now-broken spear and rooster. He is clad in a loincloth and adorned with necklace, earrings, and tiara. The two columnar appendages on either side of him probably are intended to be the ends of his sash, which, however, has not been delineated over the loincloth. Curly ribbons fly out on either side from the tiara, and the head is surrounded by a plain, circular nimbus.

At least two other similar, but earlier statuettes of Kumara from Gandhara are known (Pal 1977, pl. XI, fig. 15; Marshall [1951] 1975, 3: pl. 65h), and very likely each is a copy of the same original. Since all three examples are rather small and portable, they may have been modeled after an important ancient Gandharan cult image for pilgrims to carry away with them after a visit to the shrine. Only minor differences distinguish the three figures. Noteworthy is the fact that the Swat sculptor responsible for the museum's example appears to have misunderstood the function and form of the heavy sash, which is rendered more naturalistically in both other examples. The child-god is given rather heavy proportions with thick, muscular legs in all three sculptures, but the modeling of the Swat example is not as refined as in the other two. The eyes of this figure are rendered more obliquely, and the details are executed somewhat carelessly.

This figure represents the second type of Kumara image that was popular in Gandhara. In the other type (see S41) the youthful god is portrayed as a fully armed and attired general. In this image type the deity's childishness is emphasized by giving him rather plump and stocky proportions (cf. S67). Also, he stands like a defiant peasant-boy rather than an elegant general as in the earlier representation.

S88 *Head of the Emaciated Buddha*
Afghanistan or Pakistan; fourth century
Stucco; 5 ½ in (14.0 cm)
Gift of Mr. and Mrs. Herbert Kurit;
M.85.213.3

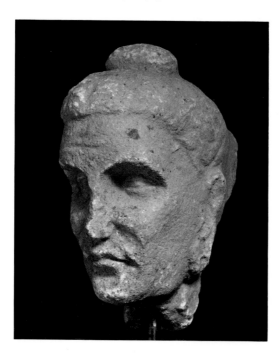

This well-modeled stucco head once belonged to an image of the emaciated Buddha, a subject that enjoyed great popularity in ancient Gandhara. Before his final enlightenment at Bodhygaya, Sakyamuni went through several stages of meditation during one of which he denied himself food for a great length of time. He became so emaciated as a result that only skin and bones were left on his body. This extreme self-mortification, however, did not bring him satisfaction, and later he was to preach against all such severe ascetic practices.

The subject inspired the artists of Gandhara to create a large number of stone sculptures of various sizes. The emaciated Buddha strangely was not a popular theme elsewhere in India. Its appeal for Gandharan sculptors may be attributed to their penchant for the strongly naturalistic, Hellenistic aesthetic tradition. Representations of the theme in stucco are quite rare. This fine example, with its subtle delineation of the gaunt face and lean cheeks, sunken eyes, and furrowed brow, is a more restrained expression than is usually encountered in stone examples.

S89 Head of the Buddha
Afghanistan or Pakistan; fourth century
Stucco; 27 ½ in (69.3 cm)
The Leo Meyer Collection; 50.25
Literature: Pope 1942, pp. 29, 43; Trubner
1950b, pp. 14–15, no. 13.

With its cranial bump intact, this head would
have measured well more than thirty inches tall,
and the figure itself, whether seated or standing,
would have been monumental. Gigantic Buddha
images, especially in stucco, have been
discovered from various sites in Gandhara and
Afghanistan. They inspired the making of the
colossal Buddhas that are such a striking feature
of the early Buddhist cave temples in China.
This head probably is from Afghanistan, perhaps
from Hadda in the Jalalabad district, where
Buddhists were especially active from the reign
of Kanishka and where some Buddha figures
were almost sixty-six feet high (Hallade 1968,
pp. 138–39).

The well-proportioned head is
finely modeled. The sensuous lips and half-shut
eyes anticipate the introspective expression
considered to be characteristic of Gupta Buddhas
(S137). The Gandharan artist preferred to
provide the master with a head covered with
wavy hair, which is rendered with particular
sensitivity in this example. Hair also would have
covered the cranial bump. Originally, the head
probably was painted as in S91–92. The hole at
the bottom of the neck indicates that the head
and body were made separately and joined
together.

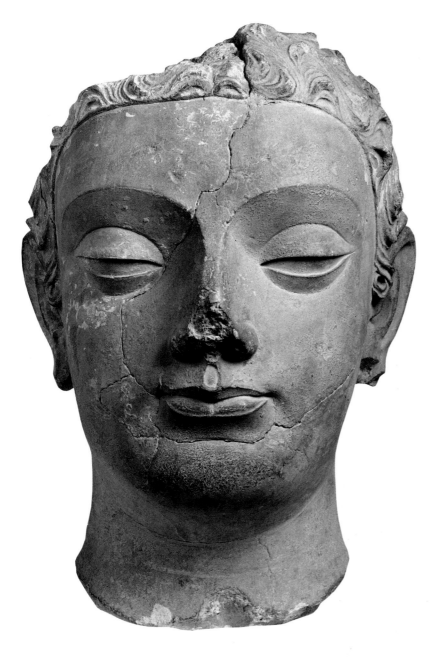

S90 Male Figure, Probably Bodhisattva Maitreya
Afghanistan or Pakistan; fourth–fifth century
Stucco with traces of color; 17 ½ in (44.4 cm)
Gift of Ravi Kumar in memory of his mother,
Prakashvati Jain; M.85.288

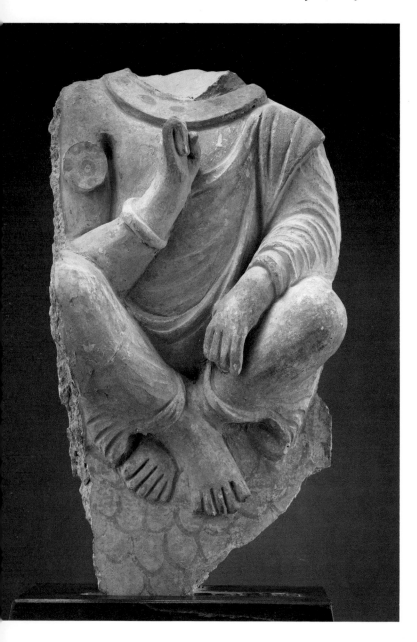

If preserved, the head of this figure may have
looked somewhat like those of the bodhisattvas
in the collection (S91, S94–95). Very likely, the
figure represents a bodhisattva perhaps engaged
in conversation. The posture, with legs crossed
at the ankles, is similar to that of one of the
ascetics in the Nara-Narayan panel (S122) and is
frequently seen in Gandhara for meditative
figures as well as for the teaching Maitreya
(Rosenfield 1967, figs. 99a, 100). The posture
was also given to Maitreya figures in
contemporary and later Chinese Buddhist art

 The figure wears a dhoti, and
his right arm and shoulder are left free of the
shawl, the volume of which is indicated by
prominent folds on the left arm and by shallower
bands across the body. These bands appear to
have been painted in red as was the plain torque
around the neck and rather large ornament
around the right upper arm. The only other
adornments are the heavy, plain bangles on both
arms. The figure is seated on a lotus, which was
also painted all around his feet. The left hand
rests casually over the left leg, the right hand
with closed fist is raised to the chest. This
unusual gesture is very likely symbolic of the act
of teaching or conversation.

 The exact provenance of this
sculpture is not known. Comparable sculptures
from Hadda are primarily in the Kabul Museum
(Rowland 1966, figs. 59, 70–71) and Musée
Guimet, Paris (Hallade 1968, pls. 108–9, 112).
Similar figures with heads intact are in the
Arthur M. Sackler Museum, Harvard Univer-
sity, where it is attributed to Hadda, and Muse-
um of Fine Arts, Boston (Watt 1982, p. 162,
no. 152). Such sculptures were also excavated by
Marshall at Taxila ([1951] 1975, 3: pl. 150b),
although there the lotus petals are modeled and
not painted as in the museum's sculpture.
Therefore, Hadda, rather than Taxila, seems a
more likely source for this elegant figure.

S91 Head of a Bodhisattva *Color plate, p. 57*

S91 Head of a Bodhisattva
Afghanistan, Hadda; fourth–fifth century
Stucco with color; 10 ¾ in (27.3 cm)
From the Nasli and Alice Heeramaneck
Collection
Museum Associates Purchase; M.80.6.4
Literature: Dohanian 1961, no. 9; Rosenfield et
al. 1966, pp. 17, 36–37; Trubner 1968, p. 7,
fig. 5; Los Angeles County Museum of Art
1975, pp. 20, 147; Heeramaneck 1979, no. 14;
Czuma 1985, p. 222.

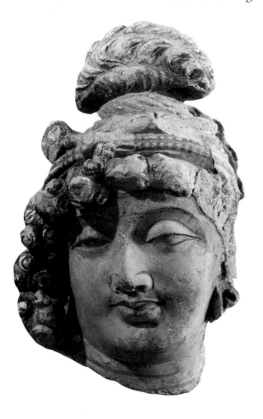

This elegantly serene head with much of its original paint intact belonged to a bodhisattva figure. Luxuriant rings of curly hair held by a band cascade down the right side of the face, thereby emphasizing the tilt of the head and direction of the gaze. The rest of the hair is pulled back and gathered into a fan-shaped topknot secured by a twisted cord. The auspicious *urna* is placed slightly off center. Earth-red pigment highlights the lines on the neck, lips, winged lion-shaped ear ornament on the right, eyes, hairline, and cloth band above. The moustache, pupils, and eyebrows are painted black. The hair was very likely tinted blue-black or indigo.

Two outstanding qualities of a bodhisattva are his compassion and sympathy for human frailties and imperfections. These qualities are poignantly conveyed by the pensive gaze and gentle expression of this remarkably sensitive stucco head. Although many similar bodhisattva heads have been recovered from Taxila in Pakistan and Hadda in Afghanistan, few achieve the tender expressiveness and subtle pathos of this example.

While it is extremely difficult to be certain of the provenance of such heads, very likely this example is from Hadda. In none of the Taxila heads has the original pigment been as well preserved. At least two heads with almost identical faces, although different hairstyles, were found in Hadda (Barthoux 1930, 3: pls. 50d, 79d). This particular hairstyle with curly rings was popular in Gandhara and Afghanistan.

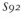 S92 *Head of the Buddha*

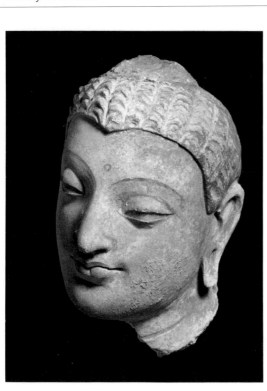

S92 *Head of the Buddha*
Afghanistan, Hadda; fourth–fifth century
Stucco with traces of color; 9 ¾ in (24.8 cm)
Given anonymously; M.55.1

Like the visage of the bodhisattva (S91), the countenance of this Buddha is characterized by a gentle, pensive expression. The pupils are painted black, and traces of black pigment remain on the eyebrows and hair. Red has been used in the *urna*, hairline, eyes, ears, chin, and neck. The manner of delineating the *urna* with a red circle appears to have been characteristic of several Hadda figures (Barthoux 1930, pls. 5, 12b, 50d, 51d). The scalelike hairstyle is similar to that of a Buddha head from Taxila (Marshall [1951] 1975, 3: pl. 158, no. 53). Thus, although it is extremely difficult to be certain of the provenance of this head, very likely it is from Hadda.

Afghanistan or Pakistan; fourth–fifth century
Stucco; 9 ½ in (24.2 cm) each
Gift of Marilyn Walter Grounds; M.82.225.6–7

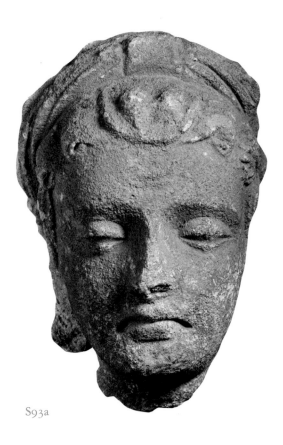

S93a

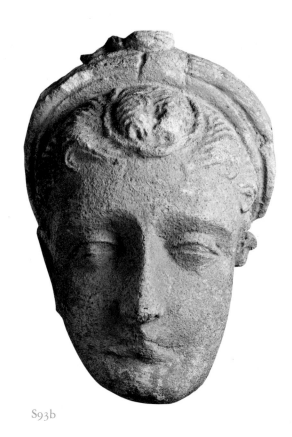

S93b

Despite their identical size and similar expressions of grief, the two heads represent different females. Their mournful demeanor is expressed not only by their eyes but also by their furrowed brows and tightly closed lips. Although the heads are similarly proportioned, the shapes of the faces are different. While the face of *a* is symmetrical, the two halves of *b* are different. The lips of *b* are more compressed, the upper lip being almost nonexistent. The eyes are differently shaped, more idealized in *a* with a wider lid, whereas in *b* the lower portion is broader, resulting in slit eyes. The rather similar hairstyles are held in place by a substantial band.

The sculptors of stucco figures, whether in Gandhara or Afghanistan, generally eschewed the narrative intent of the stone sculptors of the Kushan period. Representations of females are rather rare. If, indeed, these faces are of grieving women, then in the Buddhist context they would have formed the retinue of the Buddha in the scene of his death. In the few surviving death scenes made in stucco, women are not present. In earlier reliefs in stone, however, among the mourners are two tree goddesses (*Arts of Buddha Sakyamuni* [Nara: Nara National Museum, n.d.], no. 49). If, however, the expression on their faces is not to be interpreted as one of sadness, then they may represent pensive worshipers or donors.

Whatever their exact identification, it is clear from their expressive features that the two heads are strongly Hellenized. Such sensitively modeled heads have been recovered from sites in Gandhara and Hadda. Some heads from Hadda are remarkably Hellenized, and many show a similarly furrowed brow (Barthoux 1930, pls. 60c, 62a, 63d, 93h). An almost identical hairstyle also may be seen in a female head from Taxila (Marshall [1951] 1975, 3: pl. 161g). Thus, the provenance of these two heads cannot be certain.

S94 *Head of a Bodhisattva*
Afghanistan, Hadda; fourth–fifth century
Stucco with traces of color; 8 ½ in (21.6 cm)
Gift of Marilyn Walter Grounds; M.84.220.4

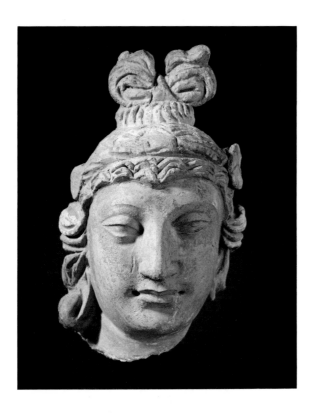

Tilted to the left, this classicized head is distinguished by a prominent nose and pensive gaze, a frequent characteristic of stucco heads from Gandhara and Afghanistan. Although its exact provenance is not known, very likely the head is from Hadda. Red paint still adheres to the neck, ears, lips, nose, eyes, hairline, and fillet. The irises are painted gray-black. The hair, parted in the middle, which must have also once been gray-black, cascades down in waves on either side of the face and is pulled back over the ears, one of which still retains its ring. The fillet is twisted and adorned with three circular, painted disks, one of which is broken. Part of the hair is gathered in a topknot surmounted by a bow. The rough, unfinished state of the back indicates that the head and figure were attached to a wall.

S95 *Head of a Bodhisattva*
Afghanistan or Pakistan; fourth–fifth century
Stucco with traces of color; 8 in (20.3 cm)
Gift of Marilyn Walter Grounds; M.84.220.3

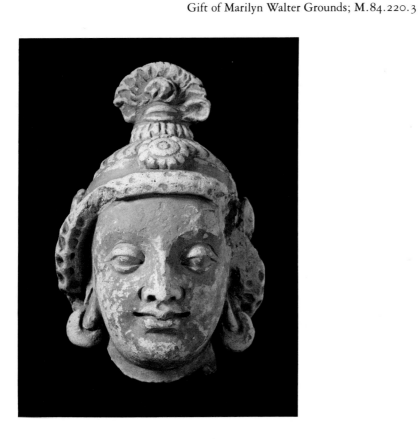

As with other bodhisattva heads (S94), the back is unfinished, suggesting that the head was meant to be viewed only from the front. The facial features are quite different in other examples. The nose of this head is not as strongly defined, and the nostrils are larger. The eyes are more roundly shaped, and the chin is more prominent. Both earrings are well preserved, but part of the face on the left is damaged. The hair is arranged around the forehead like a canopy or molding with a honeycomb design and is held in place by a shallow fillet decorated with three rosettes. The rest of the hair is gathered in a topknot surmounted by a fan-shaped crest. Traces of red still adhere to the ears, hairline, and rosettes. The pupils are painted black.

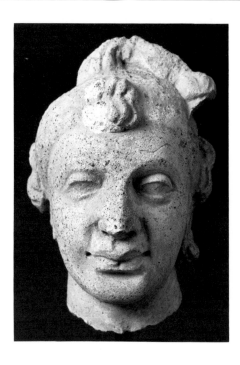

S96 *Male Head*
Pakistan; fourth–fifth century
Stucco; 6 ⅛ in (15.1 cm)
Gift of Anthony A. Manheim; M.81.205

Despite its idealization, the face has an individual expression and very likely was a portrait of a lay worshiper or donor. An earring hangs from the left ear, the right ear is broken. Distinctive are the shaven head and tuft of hair attached to the middle of the forehead like a pendant and longer tuft rising from the middle of the head and curving to the right. This particular hairstyle was popular among some Scythians, and a similar head of a shaven boy was recovered from the Dharmarajika stupa in Taxila (Marshall [1951] 1975, 3: pl. 160h; cf. also M. Bussagli, *Painting of Central Asia* [Geneva: Skira, 1963], p. 86, for a painted representation in the well-known reliquary from Kucha of a naked, winged musician with the same hairstyle).

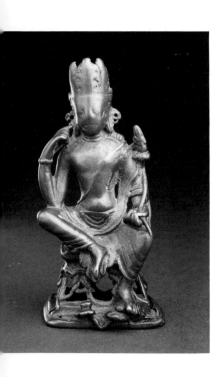

S97 *A Contemplating Bodhisattva*
Pakistan or Kashmir; fifth century
Copper alloy; 4 ¼ in (10.8 cm)
Indian Art Special Purposes Fund; M.85.9

Crowned, but sparsely ornamented, a bodhisattva is seated in a relaxed posture on a wicker seat. One of the two lotuses in front of the base supports his left foot; the right leg is raised and placed obliquely at the edge of the seat. The figure wears a dhoti; a light shawl drapes the abdomen, crosses the left shoulder, and loops back over the left arm. In addition, a sacred cord encircles the body diagonally also from the left shoulder. The face and crown are much effaced; very likely three triangular lobes formed the crown. The ears have elongated lobes. Rather curious are the holes on the bits projecting from behind the ears; additional ornaments may have been attached to them. The left arm holds a lotus stem on which rests an effaced, unrecognizable object. The right elbow is placed on the thigh, and the hand is raised to the shoulder with the index finger pointing to the chin. Repairs may be seen at the front and back. A lug at the back and hole on the top of the seat indicate that a nimbus was once used to set off the head. The back of the figure is summarily modeled, the wicker seat, however, is rendered in the round.

This figural representation of the bodhisattva Avalokitesvara, the compassionate one, was popular in Gandhara and Kashmir, although the type was also known in the art of Kushan Mathura (Lerner 1984, pp. 30–35). The position of the right hand is usually taken to symbolize contemplation, an appropriate gesture for Avalokitesvara, whose primary task is to save suffering humanity. In the art of eastern Asia, however, such contemplative figures are frequently identified with Maitreya and occasionally with Siddhartha. The position or gesture of the right arm, however, is not described specifically in any iconographic text.

Various considerations lead to the conclusion that this bronze was created in fifth-century Gandhara. The figure is certainly earlier than several other examples from Kashmir and Swat generally dated to the seventh century (Pal 1975b, pp. 134–35; von Schroeder 1981, pp. 84–85). The treatment of the dhoti and way the shawl is draped around the arm are seen frequently in Gandharan bodhisattva figures. The somewhat awkward manner in which the left hand holds the lotus stalk is also characteristic of Gandhara (Lyons and Ingholt 1957, figs. 415, 417), whereas in later versions the stem is grasped more naturalistically. Another detail that points to Gandhara is the realistic representation of the wicker seat, which is encountered quite often in Gandharan sculpture (Pal 1975b, pp. 234–35), while in later bronzes only the wicker design is repeated around the seat, which is placed on a lotus. The wicker seat is used quite frequently in Gupta coins of the fourth century (C27b, C29b). More importantly, the knots are tied in exact imitation of knots occurring on a Gandharan relief that is unlikely to have been carved after the third or fourth century (Lyons and Ingholt 1957, fig. 463). Despite such strong similarities with Gandharan sculpture, a Kashmiri provenance for this bronze cannot be ruled out altogether.

Kashmir

S98 Tile with Figures
Kashmir, Harwan; third–fourth century
Red terra-cotta; 20 ¾ in (52.7 cm)
Given in memory of Christian Humann by
Robert Hatfield Elsworth; M.82.152
Literature: Fisher 1982, p. 33.

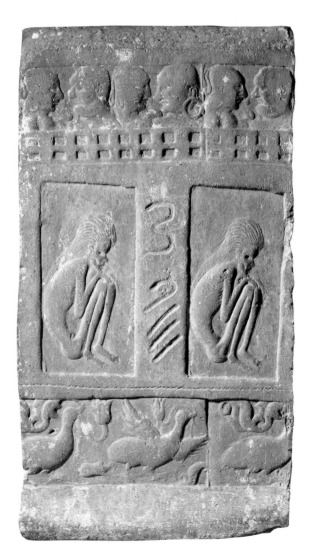

This is one of many identically stamped tiles that once decorated the low sidewall of a courtyard in a monument near the village of Harwan, not far from Srinagar, the capital of Kashmir. While the site generally is considered to be Buddhist, in a recent article (see Literature), it has been proposed that Harwan may have been occupied before the Buddhists by members of another religious sect known as the Ajivikas. There is some merit in this suggestion for the strange iconography of the tiles is difficult to explain in a Buddhist context.

The museum's tile, like most others of this type, is divided into three sections. At the bottom above a simple molding is a row of geese, one with its wings outspread, each carrying water lilies in its bill. Above the frieze in two recessed rectangular panels are identical images of naked ascetics seated on their haunches. Three numerals—three, seven, and eight—are written in Kharoshthi script in the raised divider between the two panels. Above, behind a balustrade like that in the Kushan upright from Mathura (S55), are six confronting men, who appear to be engaged in conversation with one another. The pair on the left is identical to the two on the right, and the same stamp obviously was used. All have shaved heads, except for those who face to the right. At the back of each head is a lock of hair. The second and sixth figures have substantial beards, while the first, fourth, and fifth figures wear large, plain earrings. The four figures have distinctly different faces and features.

Curved like a bow, the body of the seated ascetic is emaciated and extremely gaunt with thin, spindly limbs. His cheeks are sunken, his eyesockets are cavities, and his long hair and beard are unkempt. The posture is curious, reminiscent of the fetal position. The importance given to this strange ascetic is hardly

in keeping with Buddhist practice. More likely, he may be the only example of an Ajivika ascetic to have survived in Indian art. The geese at the bottom obviously were added to emphasize the principle of asceticism. A cosmic emblem, the bird is also a metaphor for the ideal ascetic, who usually is addressed as the *paramahaṁsa* (great gander). The bird can swim on the surface of the water without being attached to it, he can also soar through space and wander freely like a homeless ascetic.

Just as intriguing as the ascetic are the heads above him, which generally are assumed to represent foreigners. Some Central Asian peoples shaved their heads, leaving only a tress at the back and a tuft at the forehead. Frequently, however, shaven brahmins kept a similar tress of hair on their heads in the facetious belief that they could be pulled into heaven by the lock. In general, though, the physiognomy of the paired heads indicates a distinctly different ethnic type than that depicted in contemporary Gandharan art. While the style of these curious figures from Harwan is highly localized, their attribution to the third–fourth century is evident from the paleography of the numerals and scientific examination of one of the tiles (see Literature).

S99 *A Bodhisattva*
Kashmir; c. 400
Copper alloy; 10 ½ in (26.7 cm)
From the Nasli and Alice Heeramaneck Collection
Museum Associates Purchase; M.69.15.2
Literature: Dohanian 1961, no. 10; Huntington 1970, pp. 93–95, fig. 3; Glynn 1972, fig. 4; Pal 1973, fig. 10; Pal 1975b, p. 32, fig. 38; G. Bhattacharya 1980, p. 106, pl. VI/7; von Schroeder 1981, pp. 77–79, fig. 3g; Klimberg-Salter 1982, p. 96; Czuma 1985, p. 213–14.

This much-published bronze remains one of the most intriguing figures in the museum's collection. While most scholars agree that the figure represents the bodhisattva Maitreya, Huntington (see Literature) identifies him with Avalokitesvara. Dates suggested for the bronze range between the second and sixth century, while its attribution varies from Gandhara to Kashmir to Swat.

Clad in a dhoti, the figure stands on a lotus base and holds an ascetic's waterpot in his left hand. The fingers of the right hand are broken, the palm is turned toward the body. Although he wears a long necklace with a floral pendant, bracelets, and ear ornaments, his ascetic nature is emphasized by his hairstyle and antelope skin flung across his left shoulder. In addition, he wears the sacred cord.

Primarily because of the antelope skin, Huntington has identified the figure as Avalokitesvara. Otherwise the bodhisattva displays the basic characteristics of Maitreya: the ascetic's hairstyle and waterpot. The antelope skin is rarely worn by Maitreya in any period but became a fairly common feature of Avalokitesvara after the seventh century. Also, only from about the fifth century was Avalokitesvara represented as an ascetic rather than the princely figure encountered in the Kushan period. The antelope skin, a typical emblem of an ascetic, is, generally after the fifth century, also an attribute of the Hindu god Brahma. Certainly in the art of Gandhara, where Brahma is frequently represented, he is seldom given the antelope skin. The waterpot and gesture of the right hand, regarded as the gesture of salutation (*namaskāramudrā*) by Huntington, is common to Maitreya and Brahma in Gandharan art.

Thus, while an exact identification of this figure is not possible, very likely he represents the bodhisattva Maitreya. In any event, the figure probably served as an acolyte and once flanked a larger Buddha image, as is seen frequently in Gandharan steles of the Kushan period.

The closest stylistic parallels for this figure are to be found in Gandhara rather than Kashmir or Swat. Of these three regions, Swat is the least likely. Certainly, the shape and features of the face differ from Kashmir and Swat bronzes but relate closely to a late-fourth- or early-fifth-century bronze Buddha probably made in Gandhara (Pal 1975b, p. 193, no. 72). The treatment of the dhoti is remarkably similar to that worn by a standing bodhisattva on the left

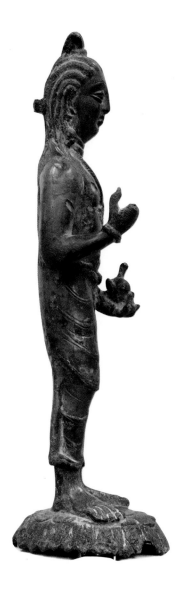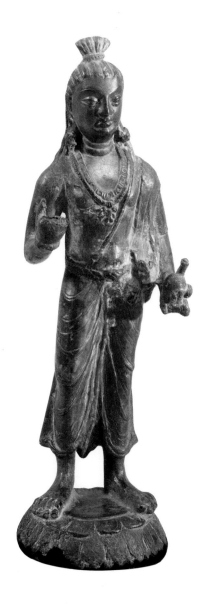

of the Buddha in a stele now in Karachi (Huntington 1970, fig. 2). The peculiar gesture of the right hand is also encountered in Gandharan bodhisattvas of the Kushan period and survived in Kashmiri-style seventh–eighth-century bronzes, whose provenance remains uncertain. In these later bronzes the fingers are generally much more elongated, while the fingers of the left hand in this example are naturalistically proportioned. Also in this example the waterpot is held in a distinctive manner. In all Gandharan and Kashmiri figures the waterpot is invariably suspended from the hand, but here it is placed on the palm (cf. S100). Another feature found more frequently in Gandharan sculptures of the Kushan period, rather than in later bronzes from either Swat or Kashmir, is the manner of representing the lotus with both rows of petals pointing downward (Huntington 1970, fig. 3). Thus, the cumulative evidence points to a date closer to the Kushan period. A late-fourth- or early-fifth-century date seems also to be supported by a

comparison with the Siva from Uttar Pradesh (S76); note the similar hairstyles, facial features, ear ornaments, and rather simplified modeling of the body, unlike the more naturalistic treatment characteristic of Kushan-period Gandharan bodhisattvas. The eyes, however, are more open and do not reflect the contemplative and pensive expression typical of Gupta or Gandharan figures of the fourth–fifth century.

Despite the similarities with Gandharan sculptures, this fascinating bronze is here attributed to Kashmir because of its strong technical affiliation to later Kashmiri bronzes.

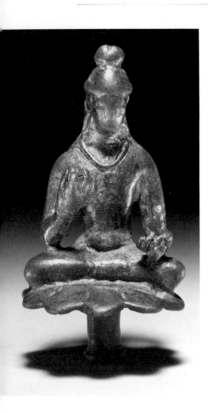

S100 The Bodhisattva Maitreya
Kashmir; fifth century
Copper alloy; 2 ½ in (6.3 cm)
Gift of Neil Kreitman; M.85.73.2

Both in style and iconography this seated
bodhisattva is similar to the better-known
standing figure in the collection (S99). He is
seated on a rather summarily delineated lotus
with a long hollow stem, which must have been
inserted into a tenon. Thus, the figure may have
been part of an altarpiece flanking a Buddha or
an embellishment to a stupa. The form of the
dhoti and facial features can no longer be
recognized, but the necklace with pendant and
plain bangles are of the same type as seen in the
standing figure. Similar also is the manner in
which the waterpot is held in the left hand. The
waterpot has a spout and is therefore of the
variety known in Sanskrit as a *kuṇḍikā*,
commonly used by brahmins and ascetics. The
right hand is turned toward the body with the
fingers bent so that the index finger and thumb
are touching one another. The hair is arranged in

a topknot. No animal skin, however, is flung
over the left shoulder as with the other Maitreya.

Although the facial features and
hair are no longer recognizable, this tiny figure
undoubtedly was made sometime during the
fifth century in the same region in which the
standing figure originated. The iconographic
similarities are rather striking, and both bronzes
reveal the same technique of using a hollow stem
below the lotus. The modeling of the form,
however, seems somewhat smoother and more
abstract in this seated figure.

S101 Fragment of a Plate with a Couple
Kashmir (?); fifth century
Terra-cotta; largest diameter 4 ⅜ in (11.1 cm)
Gift of Dr. and Mrs. Pratapaditya Pal; M.84.226

This pottery fragment probably belonged to a plate or shallow bowl. At the center is a beaded medallion enclosing an intimate composition of a couple in dalliance seated naturalistically. The male figure holds in his right hand a flower (?) and turns toward his female companion, who embraces his neck with her left arm.

It is not known precisely where this fragment was found, but other similar fragments in a private collection are said to be from Kashmir. The facial outlines of both figures, even in their abraded condition, relate to Kashmiri-style figures. Such couples in dalliance were a popular motif in the art of the Gupta period. The models for such terra-cotta plates probably date to those found in Gandhara and are considered to be Hellenistic "emblemeta figurines" (Dani 1965–66, p. 47, pl. XXXI). On the base of each example is a medallion enclosing a single bust in rather high relief. In the museum's fragment the design is stamped, a familiar technique in Kashmir as early as the third century, as is evident from the Harwan tiles (see S98). Pottery stamped with figural designs has also been found in fairly large quantities in Tapa Sardar, Afghanistan (Antonini 1977).

S102 *Personified Wheel*
Kashmir; sixth century or earlier
Copper alloy; 2 ¾ in (7.0 cm)
Gift of Neil Kreitman; M.82.95.1

This tiny, but animated figure represents Chakrapurusha, the personified wheel held as an attribute by the Hindu god Vishnu (S117). Depicted as a dwarf wearing a short dhoti, Chakrapurusha stands on a small circular base, which would have been attached to a larger pedestal with an image of Vishnu. The tilt of the figure's head indicates that he was looking at Vishnu. He wears a torque, bracelets, prominent armlets with crests, and disproportionately large earrings. He appears to be smiling. His face is dominated by large eyes with deep sockets that were once filled with silver; his nose is effaced. His hair is rolled above the forehead and gathered into a lotiform bunch at the top. His arms are folded across the chest with the fingers clasped. The wheel behind his head is rendered in an unusual fashion. The wide rim is grooved, but the spokes are bent to the right, perhaps to indicate movement.

With his overhanging belly, stocky legs, and realistic dhoti, the Chakrapurusha is reminiscent of two other examples that cannot be dated later than 600 (Pal 1975b, pp. 65, 78). The execution of this figure, however, is not quite as sophisticated. The toes on the right foot are crudely rendered; those on the left foot appear to have been rubbed away. Two features of the charming figure are not encountered in any other image. The whirligig treatment of the wheel is unique and appears to be the earliest Indian representation of a type of nimbus with similarly curved rays encountered in later eighth–ninth-century Buddhist paintings in Central Asia. An earlier example occurs as a stamped design on a pottery shard found in Tapa Sardar, Afghanistan (Antonini 1977, fig. 10). The other unusual element is the manner in which the arms are disposed. This appears to be a more tentative version of the crossed-arm position, usually symbolizing humility (*vinayahasta*), assumed by various attendant figures in Gupta sculpture. One of the earliest such figures is a representation of another Chakrapurusha in a fifth-century Mathura Vishnu image (Begley 1973, fig. 5). In the two earliest Gandharan or Kashmiri Chakrapurushas now known this particular gesture is not encountered. This further indicates that the sculptor of this bronze was following an earlier iconographic tradition, perhaps of the fifth century, which proved not to be popular with later Kashmiri artists. Another possible early feature is the design of the large, open earrings, popular with Gupta- and Kushan-period artists. Thus, a sixth-century date for this bronze seems certain, but the figure may well have been made somewhat earlier.

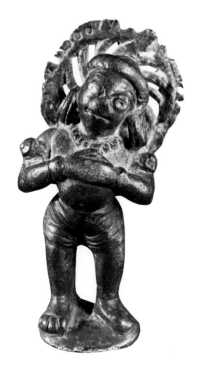

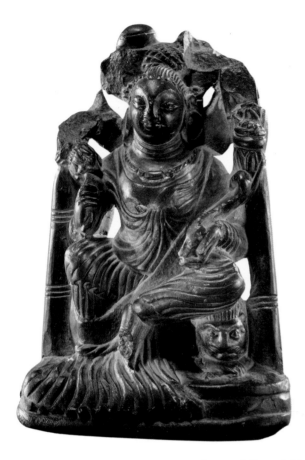
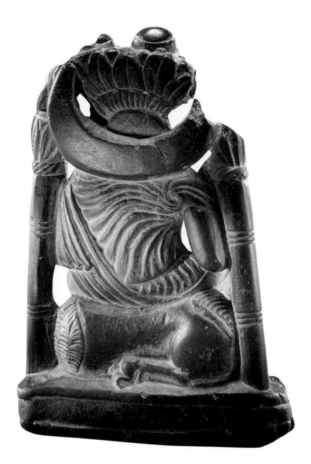

S103 A Syncretic Goddess
Kashmir; sixth century
Black schist; 5 ½ in (14.0 cm)
From the Nasli and Alice Heeramaneck
Collection
Museum Associates Purchase; M.72.53.6
Literature: Pal 1977, figs. 11–12.

This small image, probably intended for a domestic shrine, is a fascinating example of the kind of religious syncretism that prevailed in the northwestern regions of the subcontinent until the sixth century. A goddess wearing a chiton sits on a couchant lion between two columns terminating in lotiform capitals. Her right hand grasps a lotus, and her left hand holds a cornucopia, which is a strange composite of animal head, pot, and lotus. Two elephants, now broken off, once stood on either side of the goddess and poured water over her head. Behind her a crescent is attached to her shoulders, and a part of the nimbus is carved as a lotus.

The lotus in her right hand and animals above, now missing, indicate that she represents Gajalakshmi. She wears, however, a chiton, a legacy, as is the cornucopia, from the earlier Romanized art of Gandhara. In Kushan-period coins the cornucopia is the chief emblem of a goddess identified as Ardoxsho, who is conceptually no different from the Greek Tyche

or Roman Fortuna. Thus, the identification of the Indian Sri-Lakshmi with Ardoxsho, Tyche, and Fortuna is appropriate. The lion in the Indian context, and certainly by the sixth century, had become closely identified with the goddess Durga, who had borrowed it probably during the Kushan period from the West Asiatic goddess Nana, whose cult appears to have been popular in the Kushan Empire. Similarly, the crescent moon also is an attribute of Nana (Mukherjee 1969, pp. 11–12). In Gupta coins the goddess Sri-Lakshmi is shown similarly seated on a couchant lion (C25). Thus, this slightly damaged sculpture graphically demonstrates the fusion into a single icon of various concepts from Hellenistic, Iranian, and Indian religions.

Although its provenance is uncertain, very likely the sculpture was made in Kashmir. An almost stylistically identical figure of a goddess wearing a chiton with similar swirls was recovered from the town of Vijbror, which was known in ancient times as Vijayakshetra or Vijayesvara (Kak 1923, p. 59). Kak (p. 64) also illustrates a small Gajalakshmi relief of the type discussed here. Although its original location is not known, the piece is dated by Kak to the sixth century. The lion in the museum's relief is seated with its forelegs crossed as is a lion in a fragmentary sculpture from Pandrethan, also an old city like Vijbror in Kashmir (Kak 1923, p. 39).

S104 Male Head
Kashmir, Ushkur; sixth–seventh century
Terra-cotta; 5 ⅜ in (13.6 cm)
Purchased with Harry and Yvonne Lenart Funds;
M.85.193.1

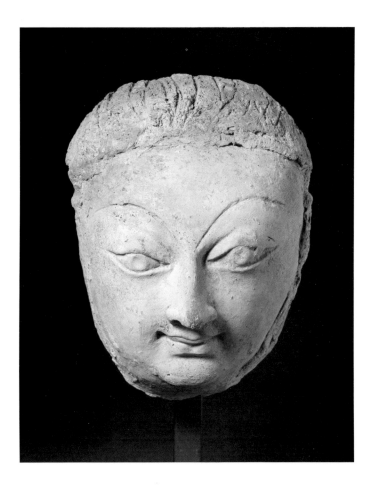

Ushkur is the name of a village near Baramula,
thirty-four miles west of Srinagar. Baramula,
where the river Jhelum flows out of the Vale of
Kashmir, is at an important western pass
connecting Kashmir with Panjab. The area is
rich in archaeological remains and monuments,
Ushkur being considered to have been a Kushan
foundation. The village is identified with
Huvishkapura, a settlement established by the
Kushan king Huvishka (see C12a–c). Akhnur
and Ushkur remain as the two most important
sites in Kashmir for terra-cotta sculptures. Both
have yielded a considerable, although
fragmentary, amount of Buddhist sculptures.
Most scholars agree that the brick stupas and
sculptures from these two sites date to the
sixth–seventh century.

Although an exact
identification of this head is not possible, it may
have represented a bodhisattva or devotee. A
cursory comparison with similar heads from
Gandhara (S89, S92) clearly points to the fact
that Ushkur artists were heavily dependent upon
their Gandharan colleagues. Nevertheless,
differences are perceptible in the shape of the face
and features. The cheekbones are more fleshy and
swelling, anticipating the facial type that
became more characteristic of eighth-century
Kashmiri sculpture. The lips are somewhat more
compressed, and the chin forms a more distinct
loop. The eyes have a stronger upward slant,
especially the right, and the eyebrows rise more
sweepingly from the bridge of the nose. The hair
is rendered by sketchy, furrowed lines,
apparently a characteristic of Ushkur figures.
This head appears to have been made from a
mold, and the clay representing the top of the
head and hair was separately attached. The back
of the head was filled in with additional lumps of
clay roughly applied.

S105 The Goddess Durga Killing the Buffalo
Demon
Kashmir; seventh century
Dark gray schist; 5 ¾ in (14.6 cm)
Christian Humann Memorial Fund; M.84.180

The goddess Durga stands majestically
triumphant over a buffalo on a rectangular
pedestal decorated with plain moldings in the
front and sides. She wears a chiton, which
spreads out like a long skirt at the back. Her
ornaments include a large garland, which loops
down to her thighs, two pearl necklaces, the
larger one with a pendant, and two different ear
ornaments. Her hair is pulled back and tied with
a ribbon that keeps in place the two ornamented
side bouffants. Two additional floral ornaments

project above her ears. What looks like a
damaged plain nimbus is, in fact, a crescent over
which hangs the two ends of the ribbon. With
her right foot clearly shown and adorned with a
plain anklet the goddess presses down on the
back of the crouching animal. Her left foot,
completely covered by drapery, presses down
upon the buffalo's nose. One of her two right
hands holds the buffalo's tail, the other thrusts
the trident into the animal's shoulders. Her left
hands carry a bell and waterpot. Except for the
broken bell-bearing arm, the small sculpture is
in good condition.

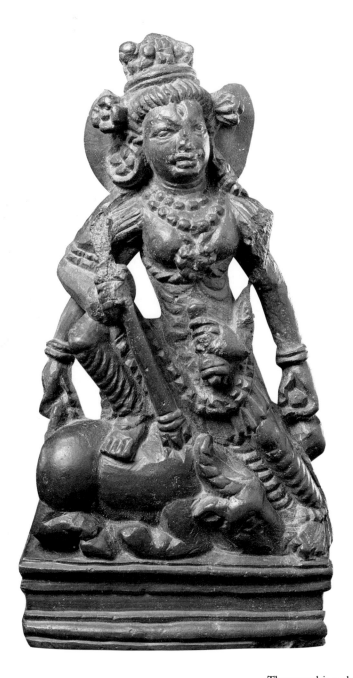

The crouching, helpless posture of the buffalo with all four legs bent and contrasting heroic attitude of the goddess are characteristic of several representations of the theme discovered in Afghanistan and is quite distinct from either Kushan- or Gupta-period reliefs. Unfortunately, all three Afghani reliefs are badly damaged, except for the buffalo (Kuwayama 1976, figs. 7–9; Taddei 1973). As in the Afghani fragment from Gardez, the goddess here also holds the tail of the buffalo with one of her right hands. A close relationship with sculptures from Afghanistan is demonstrated by the treatment of the ribbon in the back of the head, which is characteristic of at least three images, although none are of the goddess (Kuwayama 1976, figs. 15, 21–22). The design of the ribbon in this example differs considerably from that of the Afghani sculptures, while similar ribbons occur in the impressive Kumara figure found in Kashmir (Kak 1923, pp. 65–66). As Kak writes: "The streamers attached to the back of the head and flying sideways in many folds are strongly reminiscent of Sassanian influence." There are other reasons also to suggest a Kashmiri rather than Afghani origin for the museum's Durga. The dark gray schist is the same material used for the syncretic goddess in the collection (S103) and also for other Kashmiri sculptures (Kak 1923, p. 64; Klimberg-Salter 1982, p. 102, pl. 26). The representation of the crescent at the back is again similar to that seen in the statuette of the syncretic goddess.

A seventh-century date seems consistent with Afghani material generally dated to the seventh–eighth century and Kashmiri sculptures of the sixth–seventh century showing strong Gandharan influence. The goddess's chiton, moon at the back (relating her to Nana, or Artemis), absence of a lion, and human form of the demon are features indicating an early tradition.

S106 The God Ganesa
Kashmir; seventh century
Copper alloy; 3 ¼ in (8.3 cm)
Indian Art Special Purposes Fund; M.84.67

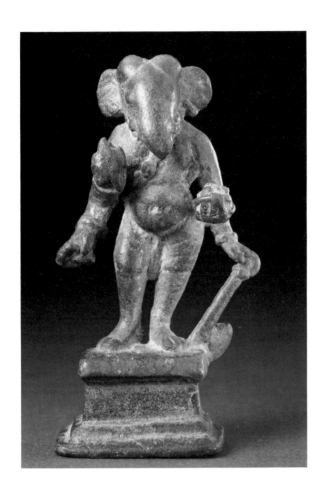
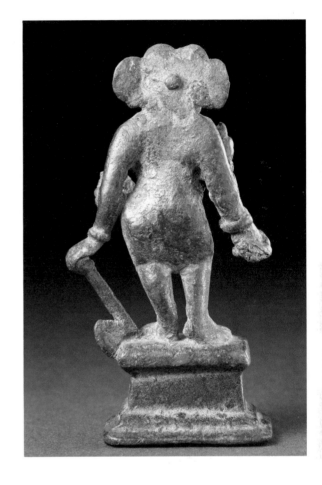

The Hindu god Ganesa, distinguished by his elephant head, stands gracefully on a rectangular pedestal. He wears a short dhoti and plain bracelets. A serpent, slung diagonally across his body, forms his sacred cord. He holds in his lower right hand a circular object, very likely a rosary; in his upper right his broken right tusk; in his lower left hand a battle-ax placed upside down on the pedestal; and in his upper left hand a bowl of sweets. The end of his trunk, with which he would have been busy nibbling the sweets, is broken off. The back is left rather plain.

Although small, the figure is well proportioned and sensitively modeled, especially the legs, rotund belly, and head. The heel of the right foot is slightly raised in a graceful and naturalistic posture. The bronze may be stylistically compared with the small Chakrapurusha (S102), although the workmanship here is more sophisticated. Other examples of similar images of Ganesa, which cannot be dated later than the seventh century, may be seen in Afghanistan (Kuwayama 1976, figs. 4–6). This Ganesa significantly does not wear a crown, unlike all other examples, whether from Afghanistan, Kashmir, or Chamba in Himachal Pradesh. A flattened lug at the back of the head indicates that the nimbus was separately attached. The rectangular base with simple moldings is very similar to those seen in a sixth-century bronze Vishnu in Berlin and fifth-century Buddha in Kansas City (Pal 1975b, p. 65).

Haryana

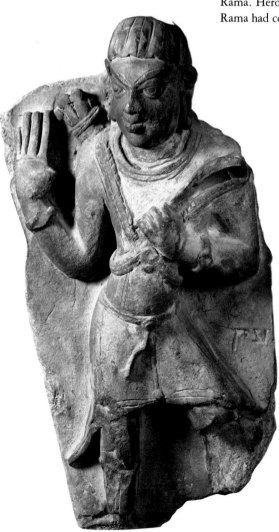

S107 *The God Rama*
Haryana, Nacharkherha (?); fifth century
Brown terra-cotta; 18 ½ in (47.0 cm)
Gift of Marilyn Walter Grounds; M.83.221.6

The Gupta-period Brahmi inscription near the figure's left thigh identifies him as the god Rama. Hero of the Sanskrit epic the *Ramayana*, Rama had come to be regarded by the Gupta period as a god and avatar of Vishnu. He has remained the ideal Hindu king, and Gupta emperors very likely modeled their popular archer-portrait coin types after the image of Rama.

As was quite common in the art of the Gupta period, Rama is dressed as a warrior in a tunic like that worn by Gupta monarchs (C28a–c) and possibly wearing pajamas. In addition, he wears across his chest a cross-belt (*channavira*), characteristic of a hero. His principal attributes are the bow, half of which remains attached to his left hand, and arrows, placed in a quiver behind his right shoulder. His raised right hand displays the gesture of reassurance; very likely he was addressing or confronting another person in the complete composition.

Themes from the *Ramayana* were quite popular for narrative reliefs decorating the walls of both brick and stone temples in a large area of north-central India during the Gupta period. Of all the brick temples in which terra-cotta reliefs were used, none, however, is inscribed. The only *Ramayana* panels with inscriptions were found some years ago at a site called Nacharkherha in Haryana. In one of these reliefs part of a couplet is written above the scene, and in another the name of a character is inscribed as an identifying label (Sri Yogananda 1970). Thus, the museum's panel with Rama very likely belonged to a Gupta-period brick temple that once stood at Nacharkherha. Rama stylistically is similar to the figure of his younger brother, Lakshmana (see Sri Yogananda 1970). Lakshmana strikes an identical posture and wears the same hairstyle. His face is also characterized by large, open eyes, obliquely sweeping eyebrows, and elongated ears. Rama's face is, however, more expressive, revealing a stronger personality.

S108 A Goddess
Uttar Pradesh; third–fourth century
Reddish brown terra-cotta; 10 ¾ in (27.3 cm)
Gift of Paul F. Walter; M.83.219.1

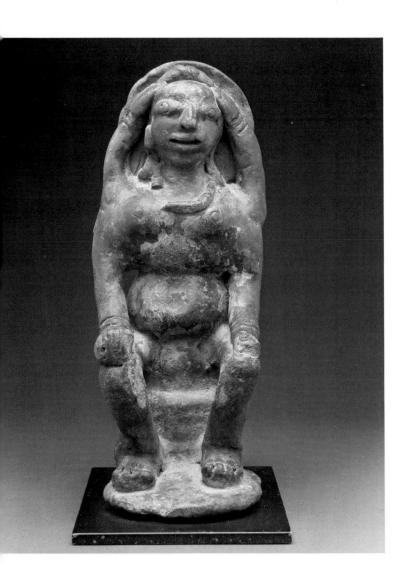

The basic iconography of this goddess is similar to those seen in an earlier sculpture (S68) with a few modifications. Here the goddess has four instead of two arms. The two principal hands are placed on the knees. Although the left hand is broken, neither hand appears to have held any attributes. With the two other hands she seems to be placing a garland on her head. This is an unusual feature, which, so far, has been encountered only in images of Durga killing the buffalo demon (Harle 1970). As Harle convincingly has shown, Durga in those images is engaged in placing on her head a garland given to her by Ocean, when the gods were equipping her for battle against the demon. In this particular figure, however, no element specifically identifies her with Durga, and, therefore, the act of garlanding oneself must have had a broader significance. The gesture may symbolize the goddess's victory over the demon and may have been suggested by Hellenistic iconography, where mortal victors are often presented with a wreath by Nike, the goddess of victory. Since Durga herself is a goddess of victory, it would not be too farfetched to identify this seated figure as a form of Durga, who is accepting the accolade of the gods after her spectacular victory.

The figure once again is characterized by the kind of unrefined modeling of earlier sculptures (S68, S74), although an attempt has been made to distinguish in outline and volume the upper part of the body from the stomach. The breasts are not quite as prominent, and the open, staring eyes protrude conspicuously. The slightly open mouth is quite large, but the ears, although perfunctorily rendered, are ornamented and more proportionate. The apronlike garment is missing, and the figure appears to be nude.

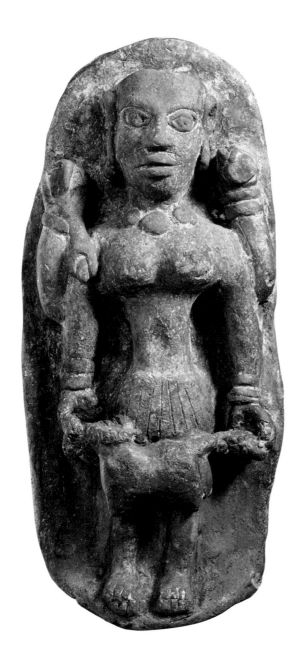

S109 *The Goddess Durga Killing the Buffalo Demon*
Uttar Pradesh; third–fourth century
Reddish brown terra-cotta with color;
9 ¾ in (24.7 cm)
Gift of Marilyn Walter Grounds; M.84.220.6

The goddess Durga rigidly stands on a shallow base formed by the gently curving bottom of the oval plaque. She wears a short skirt, indicated by incised lines, bangles, and a necklace of three pellets. Her elongated ears are not ornamented, and her head is not crowned. The upper right hand holds a short trident pointing downward, the weapon in the corresponding left hand is not recognizable. With her principal hands, she holds the buffalo stretched across her knees by the head and tail.

To my knowledge, in no other Indian representation of the theme is the goddess shown holding the animal in such a manner, as if she were about to give it a good spin and hurl the creature as far as possible. That she has not yet used her trident indicates that the animal is still alive. The short garment may, in fact, represent a skirt made of leaves usually worn by tribal figures. In literature Durga is frequently associated with tribes such as the Barbaras, Pulindas, and others. This may explain why she is not given a crown of any kind.

Stylistically, the figure is closely related to the seated goddess (S108), although the body here is much slimmer with larger breasts. The eyes do not protrude as much, but the shape and features of the face are remarkably similar. Traces of black paint still adhere to the feet, and it appears that the piece was daubed in vermilion powder until recent times.

S110 *Buddha Sakyamuni*

S110 *Buddha Sakyamuni*
Uttar Pradesh, Mathura; third–fourth century
Mottled red sandstone; 9 ¼ in (23.5 cm)
Gift of Mr. and Mrs. Michael Phillips;
M.82.165.4

The right hand of the Buddha is raised in the gesture of reassurance. The head is set off against a circular nimbus decorated with a lotus surrounded by a row of rosettes and scalloped edges. Because the top of the lower garment is shown hugging the hips, it may be assumed that the figure originally stood on a base. Usually in seated Buddhas, the folded legs would have covered the band, although it can be seen in the well-known seated Buddha from Katra in the Mathura museum (R. C. Sharma 1976, fig. 33).

The sculpture stylistically is unusual as it combines elements of Kushan and Gupta styles. The facial features and expression

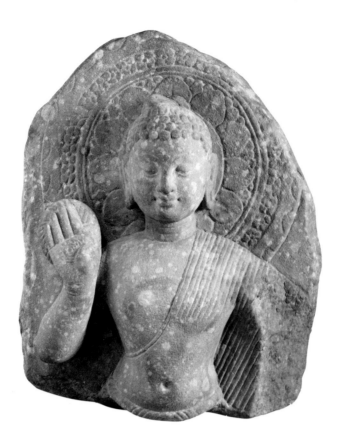

with half-shut eyes are characteristic of Gupta Buddha images, but the *urna*, right hand with stumpy fingers, hand rest, and absence of webbing between the fingers are elements of Kushan-period images. Likewise, the garment draped over the left shoulder is depicted in the Kushan rather than Gupta manner. The design of the nimbus is not as elaborate as that seen in fifth-century Buddha figures but is consistent with third–fourth-century steles. Perhaps the most striking feature of the figure is the rather boyish face, as if the sculptor wanted to represent a youthful Buddha. A similarly puffed and adolescent face may be seen in an inscribed Mathura image of Parsvanatha probably of the early fourth century (R. C. Sharma 1976, fig. 69). The halo in that sculpture is similarly designed. This may in fact be a representation of the infant Buddha, whose cult was popular in Buddhist countries outside India.

S I I I *Head of Siva*
Uttar Pradesh, Mathura; fourth century
Red terra-cotta; 4 in (10.2 cm)
From the Nasli and Alice Heeramaneck
Collection
Museum Associates Purchase; M.73.4.8
Literature: Rosenfield et al. 1966, p. 37, no. 23;
Pal 1981, p. 41.

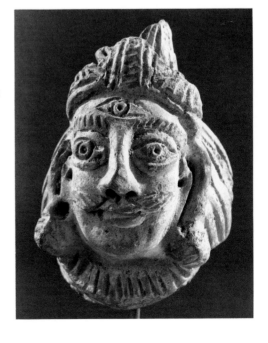

When first published, it was suggested that this head may have been part of a vessel or Siva image. An almost identical head forming part of a Sivalinga was found in Mathura and is now in the Allahabad museum (Ghosh 1961, p. 69, pl. LXXIXc). Indeed, but for the opposite tilt of the Allahabad head, the two heads are so similar that they could have been made from the same mold.

The head is distinguished by a moustache, bushy eyebrows, horizontally placed third eye on the forehead, partly broken turban, and torque that looks like an Elizabethan ruff. At first glance, one may be tempted to identify the head as belonging to an image of Indra, who is generally turbaned and given the horizontal third eye, while Siva's third eye is depicted vertically (see S76). Most Kushan-period Sivalingas have highly rubbed faces, but one or two examples clearly show the third eye horizontally delineated (Pal 1979, pp. 220–21, figs. 15, 17). The best-known representation of Siva with the horizontal third eye is the enigmatic, inscribed image from Kausambi (Williams 1982, fig. 31). It is not uncommon to see Siva wearing this type of turban in Kushan-period representations in keeping with his epithet *ushnishī* (turbaned one).

S112 *Male Head*
Uttar Pradesh; fourth century
Red terra-cotta; 6 ¾ in (17.2 cm)
Gift of Eleanor Abraham; M.82.219.1

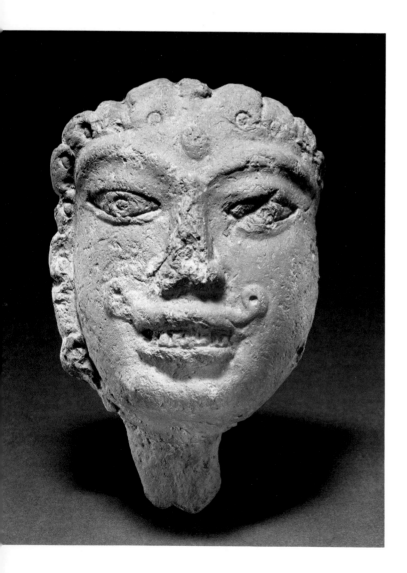

Covered with a red slip, the head is hollow at the back and may have been used as a mask. Both sides of the face originally were framed by flowing curls. The moustache is elegantly curled at either end, and the open mouth reveals a row of teeth. If the circle between the eyebrows is meant to be a third eye, then the figure may represent Siva himself or a Saivite deity. The display of teeth would then suggest a fearsome being; the teeth of a female head in the collection are exhibited in a similar manner (S113). The nose and neck are partly damaged.

Gupta-period figures generally have flowing, curly locks. This head with its well-modeled features reveals the kind of sophistication characteristic of Gupta-period terra-cotta temple figures (cf. S107, S122).

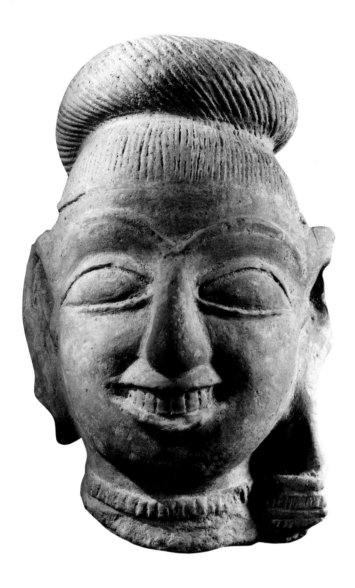

S113 *Female Head*
Uttar Pradesh (?); fourth century
Reddish brown terra-cotta; 9 in (22.9 cm)
Gift of Mr. and Mrs. Lionel Bell; M.81.269.1

This striking female head with carefully
arranged coiffure is modeled in the round. The
hair is coiled into an elegant doughnut-shaped
bun at the top of the head. Even more distinc-
tive, however, is the display of a well-formed
upper row of teeth and expressive grin. The large
eyes are without pupils, and the eyebrows are
prominent. An ear ornament hangs from the left
earlobe, the right having been broken. A
necklace encircles the neck only in the front.

While the exact provenance of
this head is not known, it very likely is from
Uttar Pradesh because of its general affinity with
a Gupta-period terra-cotta from Ahichchhatra
(V. S. Agrawala 1947–48). The figure cannot be
precisely identified. No Mother Goddess is
known to have such a grinning face, and the
hairstyle would also be unusual for a goddess,
although suitable for a yogini.

S114 *The Androgynous Form of Siva and Parvati*
Uttar Pradesh (?); fourth century
Buff sandstone; 14 ¼ in (36.1 cm)
Indian Art Special Purposes Fund; M.85.8

The Ardhanarisvara image type basically continues the form developed during the Kushan period by artists in Mathura (see S73). A novel

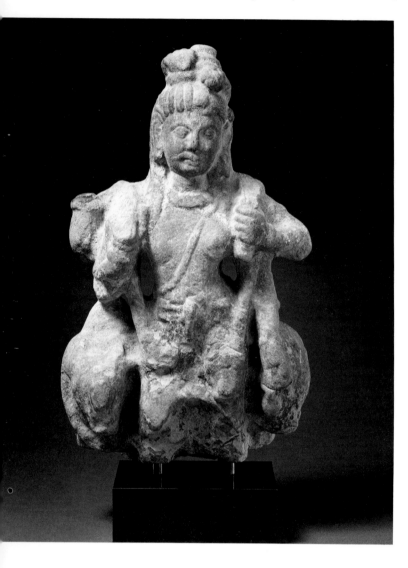

feature of this composition is the placement of the conjoint figure in front of Siva's bull rather than near a linga. Siva is distinguished by his matted hair, partially rendered third eye, moustache, and erect phallus. Parvati has an elaborate coiffure including what appears to be a garland and rosette, a prominent breast, and widely flaring hip. Altogether the composite deity has four arms, unlike the two in the earlier representation. The attribute in Siva's upper right hand is broken, the second hand probably held a rosary and formed the gesture of reassurance. Parvati holds a waterpot by her side; the object in the other hand may be a book. Siva's powerfully modeled bull with its burgeoning form stands behind the androgynous figure like a solid bulwark.

 The exact provenance of this interesting sculpture is not known, but it is said to have come from Pakistan. The image of Siva standing against his bull was popular in Kushan-period coins (see C13a–b, C16) and continued to be used frequently in the northwestern region of the subcontinent, including Kashmir. The buff sandstone, however, was not employed in Kashmir but was used commonly in Uttar Pradesh and parts of Madhya Pradesh. Apart from the stone, the smooth abstract modeling of the figure precludes a Kashmiri or Afghani origin. The plastic qualities of the figure clearly reflect a stylistic relationship with the Gupta sculptural tradition of the Ganges Valley, while the shape and features of the face as well as the matted hair of Siva are reminiscent of Mathura figures (S116). Unlike Gupta-period figures, however, the eyes are wide open rather than half-shut. Within the collection, the sculpture may be compared with the bronze bodhisattva (S99) and third-century Siva (S76). It is probably later than a Kausambi third-century Siva-Parvati (Williams 1982, fig. 31), but earlier than a Mathura fifth-century Siva-Parvati (Williams 1982, fig. 77).

S115 *Buddha Sakyamuni*

S115 *Buddha Sakyamuni*
Uttar Pradesh, Mathura; 350–400
Buff sandstone; 18 ¾ in (47.6 cm)
Gift of Mr. and Mrs. Harry Lenart; M.83.8

The headless Buddha is seated in the meditation posture on a lion throne. Part of his undergarment is spread fanlike in front of his seat. His left hand holds the gathered end of the upper garment that drapes his body. The garment is also indicated over the right arm and around the neck. The right hand with webbed fingers is raised in the gesture of reassurance. Very likely the figure represents the Buddha Sakyamuni.

 In the corners of the lower section of the throne are two lions, in the middle is a meditating Buddha flanked by two kneeling worshipers. The Buddha's head, although abraded, is intact and suggests what the missing head above must have looked like. The eyes seem almost fully closed, the earlobes are elongated, the hair consists of small curls, and the head is crowned with a bump. The two worshipers also have long ears and an ascetic's hairdo, although they probably are not monks. The Buddha's head is surrounded by a plain, circular halo.

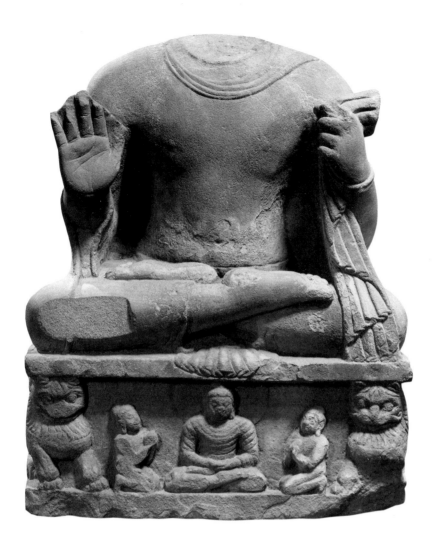

Notwithstanding the damages sustained by the sculpture, it is an important image for various reasons. Despite the fact that the sculpture is carved from buff sandstone, it was made in Mathura. Sculptures from Mathura generally were carved in mottled red sandstone, but buff sandstone began to be used at least from the second century (R. C. Sharma 1984, figs. 124, 126, 133–35, 138). Although the transparent garment without any parallel folds generally is characteristic of the Sarnath school, at least two Buddha images from Govindnagar have come to light that show the drapery without folds (R. C. Sharma 1984, figs. 135, 147). The museum also possesses a fourth such figure from Mathura (S118). The garment of the meditating Buddha on the pedestal is rendered with incised folds following the Mathura mode (S120). The Buddha stylistically is very close to a standing Buddha from Govindnagar dated to the fourth century (R. C. Sharma 1984, fig. 135; Williams 1982, fig. 19). The treatment of the garment end in the left hand is encountered in several Mathura Buddhas that generally may be placed in the third–fourth century (R. C. Sharma 1984, figs. 126, 133–34; Williams 1982, fig. 22).

To return to the identification of the Buddha on the pedestal, scenes of worship are more common in Kushan-period Buddha images than in those of the Gupta period. Also, the object of veneration generally is a symbol, such as the wheel or bodhi tree. In all instances in which a divine figure is represented, he invariably is a meditating bodhisattva appropriately turbaned and bejeweled and usually is identified as the future Buddha, Maitreya. The concept also was prevalent in Gandhara, but there, too, the meditating figure on the pedestal generally is a bodhisattva identified as either Siddhartha or Maitreya. Thus, the presence of a Buddha is rather unusual, although at least in another Buddha image, the figure from Mankuwar, Uttar Pradesh, dated 459, two meditating Buddhas are included in the pedestal (Harle 1974, fig. 55). While an exact identification of the second Buddha in the museum's sculpture is not possible, he very likely represents Maitreya, who is portrayed both as a Buddha and bodhisattva. If this attribution is correct, then this may be one of the earliest representations of Maitreya as a Buddha.

S116 Head of an Ascetic
Uttar Pradesh, Mathura (?); early fifth century
Reddish brown sandstone; 9 in (22.9 cm)
From the Nasli and Alice Heeramaneck
Collection
Museum Associates Purchase; M.78.9.17
Literature: Trubner 1950a, p. 290; Trubner,
1950b, p. 24, fig. 39; Zimmer [1950] 1960, pl.
106; Rosenfield et al. 1966, p. 36, no. 20;
Heeramaneck 1979, no. 29.

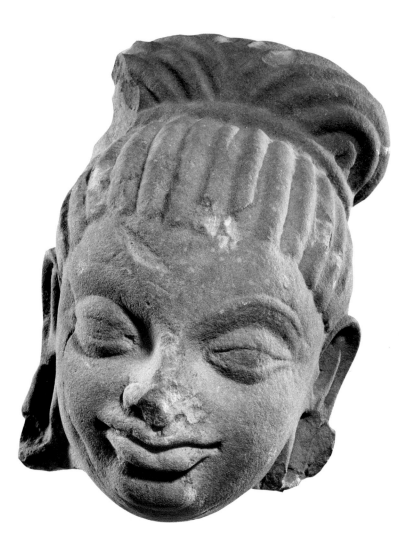

Although frequently published and much
admired, scholars disagree about the
provenance, age, and identity of this attractive
head. While it has been tentatively associated
with Mathura, the head is not carved from the
mottled red stone characteristic of sculptures
from that region. Reddish brown stone was used
in several parts of Uttar and Madhya Pradesh,
including Mathura. The range of dates
suggested for the sculpture falls between the
fourth and sixth century. Close comparisons,
however, can be made with at least three heads
from Mathura dated to the late fourth or early
fifth century (Harle 1974, figs. 50, 102; Pal
1978, p. 20).

While the facial features of the
sensitively modeled head are rather similar to the
three heads cited earlier, this particular face with
its smiling expression is more youthful. The lips
are much wider than in the other heads or near-
contemporary Buddha head in the collection
(S119). The hair is pulled back and tied in the
ascetic's hairstyle as in contemporary Siva
images, and the ears are elongated as appropriate
for a divine image. The absence of the third eye,
however, precludes an identification with Siva,
and hence the head may have belonged to a
divine ascetic.

S117 The God Vishnu as Vamana
Uttar or Madhya Pradesh; c. 400
Dark brown terra-cotta; 7 ¾ in (19.8 cm)
Christian Humann Memorial Fund; M.81.240

Clad in a dhoti, the erect figure holds the three characteristic attributes of Vishnu: the club, wheel, and conch (cf. S140). The empty lower right hand displays the gesture of charity (*varada*). Like the standard representation of Vishnu, the figure is adorned with bracelets and necklace. The elongated earlobes are not ornamented; instead two rosettes protrude from the middle of the ears. Unlike other Vishnu representations, no crown adorns this figure,

rather the head is covered with tiny circles forming a crowning topknot. The circles, no doubt, represent small curls as characteristic of Buddha and Jina heads. The topknot and elongated ears are also reminiscent of Buddha images.

Among Vishnu images, Vamana—an avatar of Vishnu and one of his twenty-four emanatory (*vyūha*) forms—wears short, curly hair. Vamana literally means "dwarf," and on one occasion, when the gods were threatened by the demon-king Bali, Vishnu incarnated himself as a dwarf brahmin and subdued Bali's ambition. Vamana generally is shown as a dwarf with two arms and long, loose hair as befitting a brahmin novice. In some regions, however, particularly in Madhya Pradesh, he is represented with Vishnu's attributes and a head fully covered by curly hair (K. S. Desai 1973, pp. 101–2, fig. 75). In such images, as also in this terra-cotta version, the figure is meant to represent Vamana as one of Vishnu's emanatory forms rather than as an incarnation. Such an identification would explain the attributes and the fact that he is not depicted as a dwarf.

In material and form this plaque stylistically is related to the terra-cotta Durga (S109). That most Vamana figures with curly hair have been found in Madhya Pradesh or Rajasthan suggests that this terra-cotta may belong to central India rather than Uttar Pradesh. The known examples in stone were made a good deal later than this terra-cotta plaque, which may be one of the earliest representations in Indian art of Vamana as an emanation. Why Vamana was given the closely cropped hairstyle generally associated with the Buddha or twenty-four Jinas is not known, but during the Gupta period this hairstyle is also found in images of the deified Saiva teacher Lakulisa.

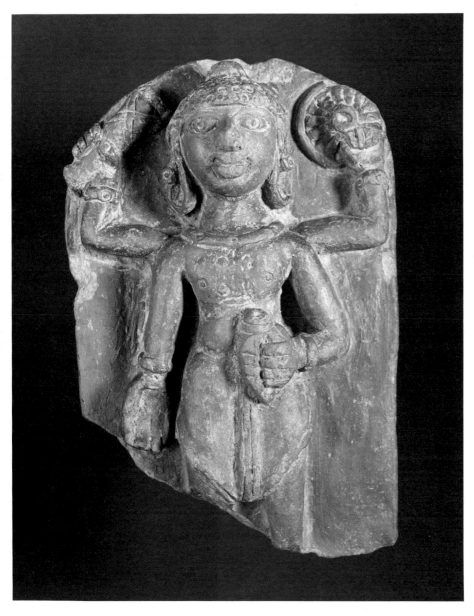

S118 Buddha Sakyamuni
Uttar Pradesh, Mathura; 400–425
Buff sandstone; 27 in (68.5 cm)
Purchased with funds provided by the Art
Museum Council; M.79.83

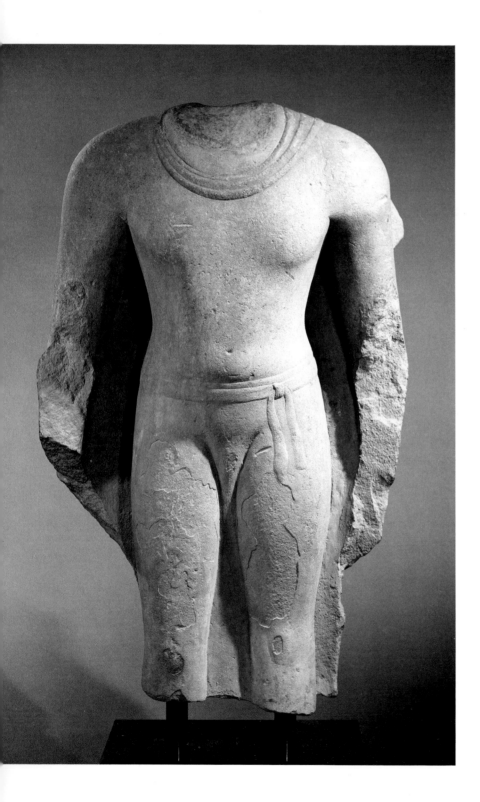

When complete, the Buddha would have stood
on a plain base in slight *déhanchement*. His right
hand would have been raised in the gesture of
reassurance, and his left would have grasped the
end of the garment as in a similar, although
seated, figure (S115). The head of the Buddha
would have been something like the slightly
later head of Sakyamuni (S119). Unlike that of
the more familiar Mathura Buddhas (see S120),
the upper garment is transparent and without
any folds as with the seated Buddha. The dhoti is
secured by neatly tied narrow bands with the
ends falling naturalistically on the left thigh. A
nimbus originally was attached to the head and
shoulders.

 Although it may have been
carved slightly later, the figure stylistically is
related to the seated headless Buddha (S115). It
may also be compared with several other
Mathura Buddhas recovered mostly from
Govindnagar (R. C. Sharma 1984, figs. 135,
142–47). One is dated 434–35. Another
comparable head belongs to a late-fourth-
century Buddha from Govindnagar in the
National Museum, New Delhi (R. C. Sharma
1984, fig. 135), although in terms of
proportion, modeling, and execution, the
museum's fragment seems to be somewhat more
sophisticated. The sculpture is, therefore,
attributed to the first quarter of the fifth
century.

S119 *Head of Buddha Sakyamuni*
Uttar Pradesh, Mathura; c. 450
Mottled red sandstone; 12 in (30.5 cm)
From the Nasli and Alice Heeramaneck
Collection
Museum Associates Purchase; M.82.6.3
Literature: Rosenfield et al. 1966, p. 35, no. 19;
Beach 1967, p. 163; Meister 1968, p. 108;
Trubner 1968, p. 8, fig. 6; Heeramaneck 1979,
no 30.

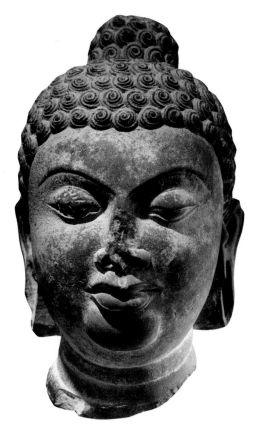

This finely carved head was created by sculptors
of the Mathura school during the fifth century.
Many complete Buddha images in this style are
known, one of which is dated in the year 435 (R.
C. Sharma 1984, figs. 142–43). Except for a few
details, the museum's head compares closely
with the head of the dated Buddha. The slightly
puffier face and strong curve of the chin, also
encountered in other Buddha images of the
period, may indicate a slightly later date for this
head.

Typical of Buddha images of
the period, the eyes are half-shut, suggesting
inner concentration and compassion. The lips are
full and sensuous, the underlip being especially
prominent. Among the superhuman signs,
noteworthy are the elongated earlobes,
substantial cranial bump, and articulately
rendered snail-shell curls that cover the head.
The hairstyle and cranial bump are now typical
characteristics of the Gupta Buddha as is the
absence of the *urna*.

S120 *Buddha Sakyamuni*
Uttar Pradesh, Mathura area; fifth century
Red sandstone; 10 ½ in (26.6 cm)
Gift of Maureen Zarember; M.85.19

This is a rare example of a portable stone image
of the Buddha in the Mathura style of the Gupta
period. Most known examples of Mathura
Buddha images are much larger and were
intended to be used in monasteries or large
shrines. Small sculptures such as this must have
been carved in large numbers for pilgrims to
carry away with them as sacred souvenirs and for
use in domestic shrines. Such sculptures may
well have served as models for artists in the
distant lands where Buddhism prevailed. A
smaller stone image from Sarnath surfaced as far
off as Thailand (Pal 1978b, p. 67). Thus, despite
its damaged condition, this diminutive relief is
of considerable historical significance.

Typical of Mathura Buddha
figures, the volume of the upper garment is
indicated by deeply grooved parallel lines, which
begin in a V shape at the neckline and widen as
they fall to the hem, imitating the concentric
rings formed when a stone is dropped into a pool
of water. The right hand would have displayed
the gesture of reassurance, the left hand would
have held the end of the drapery as in the late-
sixth-century bronze figure (S131). The missing
head would have been a miniature version of the
larger head of entry S119, while the large
nimbus may have been decorated with various
vegetal motifs characteristic of Mathura Buddha
images of the Gupta period (R. C. Sharma 1984,
figs. 139–41; fig. 148 illustrates a similarly
damaged figure closely comparable with the
museum's example).

S121 *Head of Bhairava*
Uttar Pradesh; fifth century
Reddish brown terra-cotta; 4 in (10.2 cm)
Gift of Mr. John L. and Mrs. Maria C. Bicocchi;
M.82.220

This finely modeled, expressive head once belonged to an image of Bhairava, the terrifying form of Siva. Siva's third eye is clearly marked on the forehead. The face also has a beard and moustache. The frightening expression is perceptively conveyed by the rolling eyes, protruding eyeballs, and open mouth. While the angry eyes are quite commonly represented, in few Bhairava images is the mouth depicted so widely open, as if the figure were about to swallow the universe. The gaping mouth may also indicate that Bhairava is laughing aloud to instill terror into the hearts of evildoers.

 When exactly images of Bhairava began to be fashioned is not known. One of the earliest complete representations possibly of the fifth century, was discovered at Ahichchhatra (V. S. Agrawala 1947–48, pl. LXIII). There, too, the belligerent god is shown with his mouth wide open as if he were howling.

S122 *The Sages Nara and Narayana*
Uttar Pradesh; fifth century
Red terra-cotta; 22 ½ in (57.2 cm)
Gift of Mr. and Mrs. Harry Lenart; M.69.38
Literature: Pal 1970–71, p. 77, fig. 3; Trabald
1975, p. 16, fig. 9; Srinivasan 1978–79, pl. IV,
fig. 21.

Separated by a tree and hourglass stand, two
ascetics engage in discourse. A faceless,
emaciated figure sits on a wicker stool and reads
a manuscript to his obese companion. The two
represent Nara and Narayana, anchorites, who
lived in a forest hermitage. Nara (literally,
"man") represents humanity and is identified
with the god Vishnu. He is also equated with
Arjuna, one of the heroes in the *Mahabharata*.
No clue individually identifies the saints, even
though two distinct figures are depicted: one
well fed, the other emaciated. Their hairstyles
are different, but both wear the antelope skin
across their left arms.

This impressive panel once
adorned a Gupta-period brick temple, the exact
location of which is not known. Similar panels
with Vaishnava themes decorated the fifth-
century brick temple at Bhitargaon (see
illustration). Panels primarily representing Saiva
subjects are said to have embellished a
fifth–sixth-century temple in Ahichchhatra.
Both sites are in Uttar Pradesh, and the close
stylistic relationship of the figures on those
panels with this example suggest that the
museum's panel must belong to the same region
and date. The Bhitargaon temple does indeed
have a panel depicting the Nara-Narayana
theme, which appears to have been quite popular
in north-central India during the Gupta period.

Gupta temple, Bhitargaon, Uttar
Pradesh, fifth century, brick.
Photograph courtesy Mrs. J. LeRoy
Davidson.

S123 The Planet Rahu (?)
Uttar Pradesh; fifth century
Reddish brown terra-cotta; 6 ½ in (16.5 cm)
Gift of Marilyn Walter Grounds; M.83.221.1

A demonic head with two hands projects from a
well-preserved, molded plaque, which probably
once embellished a brick temple. The head is
made terrifying with a beard, fangs, open
mouth, angry eyes, furrowed brows, and lined
forehead. The thick hair falls over the forehead
in clawlike strands and is held in place by a ring
or band. Two identical ornaments adorn the
pierced earlobes.

 The head may represent a
demon or more specifically Rahu, one of the nine
planets collectively worshiped to ward off evil.

Although regarded as a planet, Rahu really is a
demon, who causes the eclipse of the sun and
moon by literally seizing them and swallowing
them up. Hence, the emphasis placed here on
the two enlarged hands. If indeed this is Rahu,
then the plaque must have formed part of a set of
seven or eight representing the planets and could
have been used above a lintel within a shrine. By
the fifth century it had become common practice
to place images of seven or eight planets above
doorways of temples, and possibly palaces, to
keep evil influences at bay.

S124 *Plaque with Two Female Figures*
Uttar Pradesh; fifth century
Reddish brown terra-cotta; 8 ⅛ in (20.6 cm)
Indian Art Special Purposes Fund; M.74.40.2

Two ladies stand side by side as they appear to
shake hands. The left hand of the lady on the left
hangs limply along her side. The other figure
stands more gracefully with her head inclined to
the left and left hand placed on her stomach.
Each wears a differently patterned skirtlike lower
garment. One garment is decorated with
stamped and pricked circles and pinholes, while
the lower section of the other has a chevron
pattern. Rather curiously, a single shawl extends
across the lower breasts of both figures, as if to
emphasize their close relationship. Each woman
wears earrings and pellets with holes arranged as

necklaces. Bracelets are indicated with incised
lines on the forearms, and only the figure on the
right wears anklets. The hair of both seems to be
rolled back to reveal rather broad and high
foreheads. While their facial features are similar,
the figure on the left has a distinctly larger face.
The hands and feet are rendered crudely as in
several other terra-cotta figures (S108–9).

 The identity of the ladies or
provenance of the plaque is not certain. In all
probability they do not represent cult figures and
the plaque may have formed part of a narrative
relief. Despite the somewhat crude execution,
the intimate relationship of the figures is
expressively represented. There is a strong
possibility that the plaque is from Ahichchhatra
(cf. V. S. Agrawala 1947–48, pls. LXVII, XIX).

S125 *Buddha Sakyamuni's Sermon to Indra*
Uttar Pradesh, Sarnath; c. 450
Cream-colored sandstone; 18 ¼ in (46.4 cm)
Museum purchase with County funds; 69.3
Literature: Pal 1970–71, pp. 76–77; Pal
1974b, pp. 20, 48.

The principal figure in this stele represents
Buddha Sakyamuni seated in the yogic posture,
his hands engaged in the gesture symbolizing
teaching, specifically known as turning the
wheel of the law (*dharmachakrapravartanamudra*).
Above him only one of two flying celestials now
remains. In the frieze below are three figures and
an elephant. The elephant helps identify the
crowned figure as Indra, king of the gods. The
other two abraded figures probably represent
monks.

Notwithstanding its iconic character, the stele represents the occasion in Buddha Sakyamuni's life when Indra came down from the heavens to the Indrasala cave in Magadha (ancient Bihar) to hear a sermon on the true religion from the master. To date, this is the only representation of the subject from Sarnath. The story more frequently was depicted in the Buddhist narrative art of the Kushan-Satavahana period, and the only other known Gupta-period example occurs in the rock-cut reliefs at Kanheri near Bombay.

In contrast to the hieratic and rather detached representation of the Buddha, the scene below is delineated with considerable naturalism and animation. Especially compelling is the lively portrayal of the elephant, which reveals the artist's powers of observation and empathy for the animal. One is immediately reminded of the delightfully lifelike studies of cavorting elephants on the painted ceilings of the fifth-century Buddhist caves at Ajanta.

S126 *Head of the Buddha*
Uttar Pradesh, Sarnath; c. 475
Cream-colored sandstone; 10 in (25.4 cm)
From the Nasli and Alice Heeramaneck
Collection
Museum Associates Purchase; M.79.9.2
Literature: Rosenfield et al. 1966, pp. 36–37;
Pal 1978b, p. 69; Heeramaneck 1979, 31a–b.

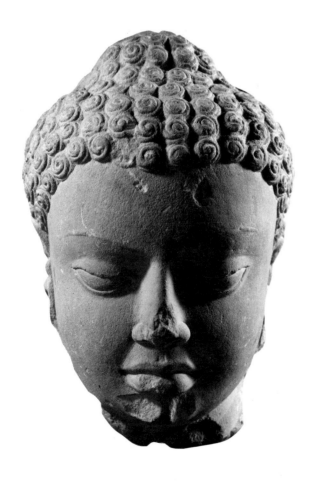

This finely carved head epitomizes the ideal Buddha image created at Sarnath during the second half of the fifth century. The outline of the oval face is defined with simple clarity, and the idealized features relate to one another in harmonious proportion. The modeling of the smooth surfaces is remarkably subtle, enhancing the sculpture's plastic qualities. Compared with the Mathura Buddha head of about the same period (S119), the Sarnath example is suaver and more linear but somewhat remote and detached in its expressiveness. There are also obvious differences in the proportions of the two faces and delineation of the hair. The bump on the Sarnath head is considerably less prominent, while the curls, although equally articulate, turn in the opposite direction. In this, the Sarnath artist seems to have deviated from the prescribed norm, for the hair of the Buddha is supposed to curl to the right (*dakshiṇāvarta*), as in this head.

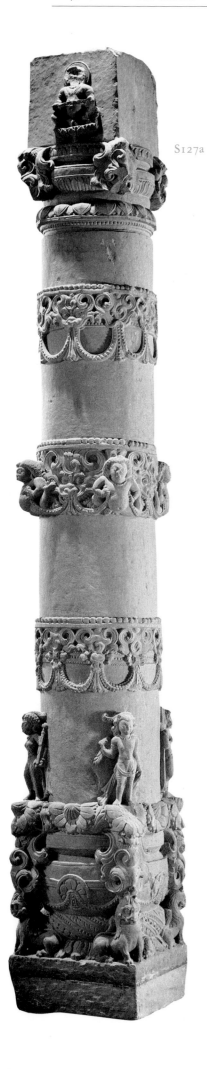

S127a

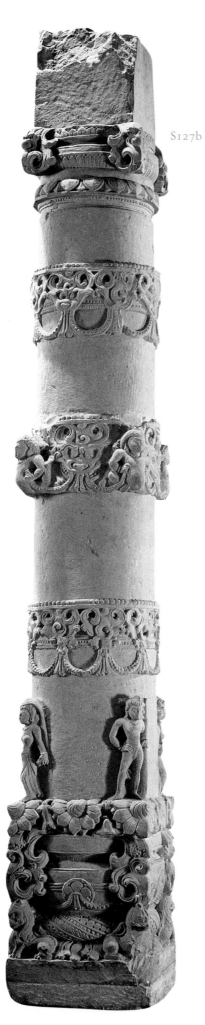

S127b

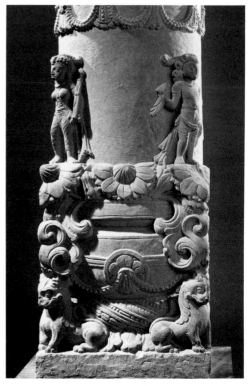

Detail, S127a

S127a–b Two Columns
Uttar Pradesh, Sarnath area; c. 500
Cream-colored sandstone;
57 ½ in (146.0 cm) each
From the Nasli and Alice Heeramaneck
Collection
Museum Associates Purchase; M.83.1.1.a–b
Literature: Rosenfield et al. 1966, p. 52; Pal
1978b, pp. 72–73; Heeramaneck 1979, no. 34.

Carved in the round, these two columns
probably supported the ceiling of either a hall or
portico of a Hindu temple. Similar columns still
stand in Sarnath (Williams 1982, fig. 234),
displaying the same crisp, but somewhat
indurate quality in the carving of the ornamental
motifs. Strongly modeled and deeply carved, the
exuberant vegetation is rich in chiaroscuro. The
size of the columns suggests the modest
proportions of Gupta-period temples.

 The base of each column is
carved into a pot overflowing with lotuses and
luxuriantly scrolling leaves. At the bottom
corners four lions carry the pot, while four
figures, two males and two females, stand on
half-lotuses at the top corners (see detail of *a*).

Detail, S127b

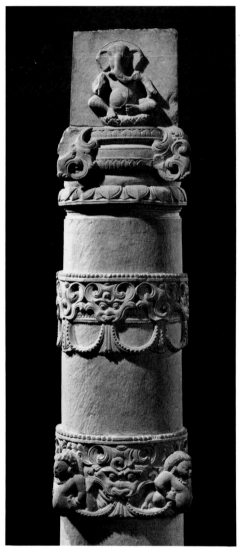

Detail, S127b

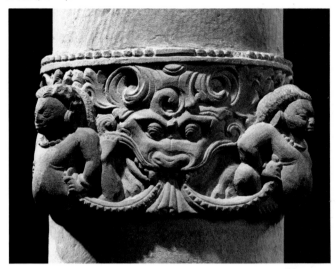

Some figures hold flowers or garlands; the two lance-bearing males may represent guardians. The gracefully proportioned figures assume various postures and are distinguished by elegant hairstyles characteristic of the Gupta period.

The shaft of each column is adorned with three bands rich with foliage, garlands, and rows of beads. Some of the foliage has been deftly carved into leonine faces of glory (*kirttimukha*), while the central band has four projecting celestial beings (*gandharva*) emerging from the surface with garlands (see detail of *b*). The capital consists of a shallow pot with foliage placed on a lotus, above which is a simple square section with an image of a god. One of the figures represents Ganesa seated on a lotus; the other may be Kubera. The potbellied Ganesa with his elephant head is seated in a relaxed posture (see detail of *b*). His right hand holds his broken tusk, his left hand probably held a bowl of sweets. The other figure in *a*, too, is obese and is seated with the feet touching at the toes. His head as well as the object he holds across his stomach are broken.

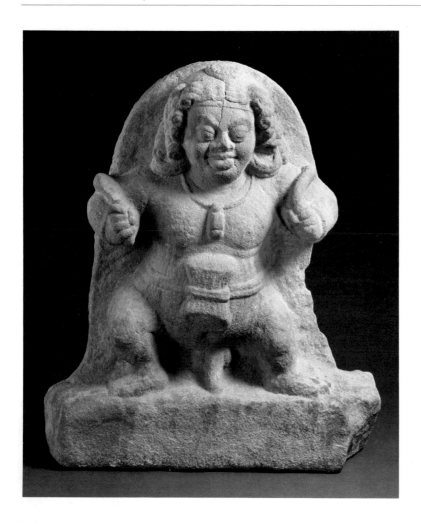

S128 A Dwarf Drummer
Uttar or Madhya Pradesh; c. 500
Reddish buff sandstone; 24 ¾ in (62.9 cm)
From the Nasli and Alice Heeramaneck
Collection
Museum Associates Purchase; M.69.13.10
Literature: Pal 1978b, p. 85, no. 34;
Heeramaneck 1979, no. 33; Kramrisch 1981, p. 84.

This boldly carved figure represents a *gana* (literally "multitude" or "people"), who form the impish dwarf attendants of Siva. Both in literature and the visual arts they are represented as plump and rambunctious figures, performing various duties for the god and entertaining him and his wife. This particularly jovial fellow is about to beat the small drum tied around his ample belly. Except for a charm around his neck and two large earrings, he is naked, displaying his rather substantial sexual organ. Bathed in a slightly mischievous smile, his face is framed by cascading sausage curls, characteristic of the Gupta period. The well-modeled, expressive face is distinguished by large eyes that seem to twinkle, thick lips and nose, and high cheekbones.

That it is a sculpture of the Gupta period is undoubted, but its exact provenance is not known. It may have come from the bordering region of today's Uttar and Madhya Pradesh.

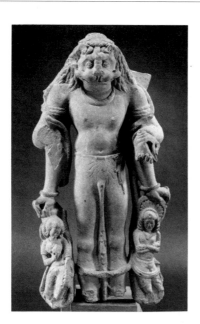

S129 The Man-Lion Avatar of Vishnu
Uttar Pradesh, Mathura area; midsixth century
Mottled red sandstone; 33 ¼ in (84.5 cm)
From the Nasli and Alice Heeramaneck
Collection
Purchased with funds provided by the Jane and Justin Dart Foundation; M.81.90.20
Literature: Harle 1974, p. 51, fig. 112; Pal 1978b, p. 102; Heeramaneck 1979, no. 39.

This impressive cult icon of Narasimha, the man-lion avatar of Vishnu, was used either as the principal side figure in a Vaishnava temple or the central focus of worship in a temple dedicated to this particular incarnation. Because of his heroic character and awesomeness, temples dedicated to Narasimha usually were built by royalty. In this avatar Vishnu descended to earth as half-man, half-lion to destroy the tyrannical demon-king Hiranyakasipu, who was a follower of Siva. Thus, the myth definitely reflects sectarian bias.

As with Narasimha images from the Gupta period onward, the god is basically human, except for his additional arms and lion head. Wearing a dhoti and adorned

with various ornaments and the *vanamala* garland, the god rigidly stands flanked by two of his personified attributes. All three originally would have stood on a rectangular base. Parts of a circular nimbus are still attached to his shoulders, and his head is crowned by a lotus that seems to grow out of his rich mane.

The broken right hand of Narasimha probably would have been extended and held a myrobalan as in a more complete and conventional image in the collection (S140); the corresponding left hand holds a conch. The two lower hands rest on the personified attributes, the club on the right and wheel on the left. Because the Sanskrit word for *club* (*gadā*) is feminine in gender, the attribute is personified as a female. She holds a flower of dalliance (*līlākamala*) with her right hand and one end of her scarf with her left hand. The personified wheel (see S102) is a male who stands with his arms crossed against his chest.

Narasimha is a powerfully modeled figure with broad shoulders, strong limbs, and somewhat disproportionately elongated thighs and legs. His grimacing lion face with rolling eyes, arched, scowling eyebrows, and prominent moustache is almost a caricature in its expressive exaggeration. The rigidity of the columnar stance is relieved by the graceful *déhanchement* of his two elegantly coiffed attributes.

S130 *A Jain Family Group*

S130 *A Jain Family Group*
Uttar Pradesh, Sarnath area; 550–600
Cream-colored sandstone; 20 in (50.8 cm)
Gift of Mr. and Mrs. Harry Lenart; M.77.49
Literature: Pal 1978a, p. 54.

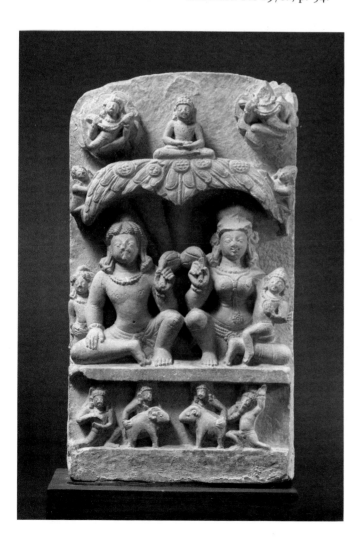

A couple is seated under the leafy canopy of a stylized fruit-bearing tree on top of which sits a meditating Jina. The male rests his right hand on his thigh and holds a flower in his left hand. The female holds an identical flower in her right hand and supports a child with her left hand. The child holds a ring in his left hand and places his right hand on his mother's left breast. A second child stands beside the male, while two more children seem to be climbing the leafy canopy. Four other boys are amusing themselves by instigating a rams' fight in the recessed panel below. At the upper corners of the stele are two cherubs flying in front of stylized clouds and bearing garlands.

The principal figures in such reliefs usually are identified as the parents of a Jina. Since there are twenty-four Jinas, however, it is difficult to determine which Jina is represented here. The little boy seated on his mother's lap has the same hairstyle and elongated earlobes as the meditating Jina, whereas all the other boys have hairstyles typical of mortals and also sport ear ornaments. The clue to a more exact identification is provided by the tree, which is identical to that above one of the four Jinas in the four-sided shrine (S134). A precise identification of the tree, however, is difficult to determine. These reliefs obviously are the Jain counterparts of Buddhist family groups, such as those representing Panchika and Hariti (S44). In fact, boys cavorting with rams are also found on Buddhist reliefs.

The sculpture is very likely from the Varanasi area and is closely related to the near-contemporary shrine (S134). It may also be compared with a midsixth-century Jain sculpture from Mathura (Williams 1982, fig. 230), where almost identical garland bearers fly amid clouds.

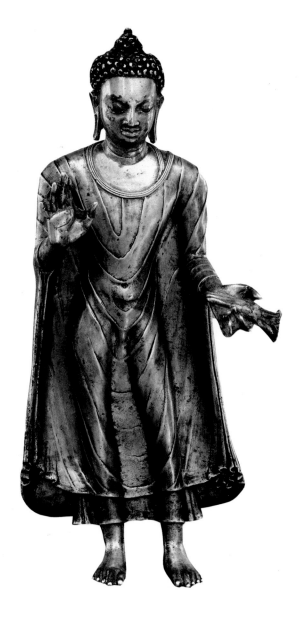

S131 *Buddha Sakyamuni*

Uttar Pradesh (?); late sixth century
Copper alloy with color; 15 ½ in (39.4 cm)
Gift of the Michael J. Connell Foundation;
M.70.17
Literature: Los Angeles County Museum of Art
1975, pp. 21, 147; Pal 1975a, p. 51; Pal
1978b, p. 110; von Schroeder 1981, pp.
216–17; Pal 1984, p. 201.

Originally, the figure would have stood on a
rectangular pedestal and a nimbus would have
been attached to the back of the head.
Otherwise, considering its age, the sculpture is
in good condition, except for the broken little
finger of the left hand. The bronze appears to
have been preserved in a Tibetan monastery,
from which it emerged in the late 1960s.

 The slim, elegant figure stands
with his weight placed on the right leg and hip
thrust out gently. The upper garment hugs the
length of the body and flares out considerably on
either side, almost like a toga. His right hand,
with prominently webbed fingers, displays the
gesture of reassurance, and his left hand gently
holds the end of his robe. The neck is marked
with three lines, and the earlobes are elongated.
The curly locks are covered by black paint, and a
small knob crowns the cranial bump.
Characteristic of Gupta-period Buddha images,
the *urna* is not delineated. Except for the outline
of the right arm, the back is treated as a plain,
flat surface, showing some flaws in casting and
ancient repairs.

 Although the exact provenance
of this elegant figure is not known, it relates to
Mathura and Sarnath Gupta-period stone
Buddhas. While the striations on the garment
occur only in Mathura Buddhas (S120), its
transparency and wide troughlike flaring are
more typical of Sarnath Buddhas. The oval face
and smooth, abstract modeling are reminiscent
of Sarnath rather than Mathura. Thus, this
bronze seems to combine stylistic traits of
Mathura and Sarnath and, hence, the attribution
to Uttar Pradesh.

S132 *The God Revanta and Companions*

S132 *The God Revanta and Companions*

Uttar Pradesh, Sarnath area;
early seventh century
Pale cream sandstone; 23 in (58.4 cm)
Gift of Mr. and Mrs. Harry Lenart; M.73.87.1
Literature: Pal 1974b, p. 18; B. N. Sharma
1975, frontispiece; Pal 1978a, p. 41.

Revanta is regarded as a son of the sun god,
Surya, and is worshiped as the patron deity of
horse traders. He generally is portrayed, as in
this relief, as a hunter returning from the hunt.

Dressed in the northern attire of boots, trousers,
and tunic, like Surya or the Kushan emperors
(C10a–c), Revanta faces front as he sits astride a
horse walking to the right. His hair, like that of
many of his companions, is shaped in the form of
a Phrygian cap. He holds the reins in his left
hand and a cup in his right hand. He presumably
is celebrating a successful hunt by drinking, for
one of his attendants behind the horse's head
holds a flask. Two more companions walk ahead
of the horse, the one above carrying a sword. Of

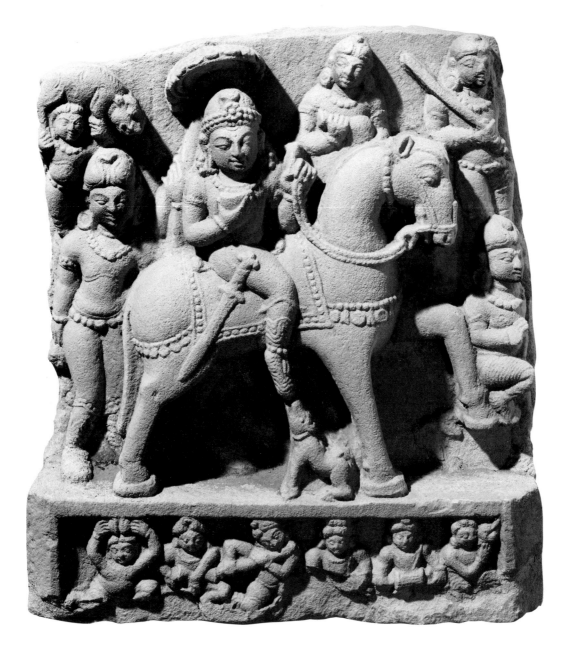

the two figures behind, one holds a parasol above Revanta's head, and the other carries an animal, perhaps a trophy of the hunt. Another realistic element is the hunting dog licking his master's booted foot. Along the bottom is a frieze of dancing musicians playing various instruments including cymbals, flute, two kinds of drums, and conch.

Not only is this one of the most elaborate representations of Revanta the hunter, it is also among the earliest known in Indian art. Indeed, nothing in this sculpture announces Revanta's divinity. He is not provided with a halo, and his parasol bearer is the same size as he. Why Revanta should have been portrayed as a hunter is a mystery, and it is possible that the concept of the hunter-god was influenced by Iranian royal and cosmic imagery. Sasanian silver plates displaying hunting monarchs must have been familiar in India during the Gupta age, and more than one feature of Revanta's iconography points to Iran. The relief provides a graphic representation of the hunt, a popular royal pastime in Gupta India.

Apart from its iconography, the relief is also interesting for its narrative composition. Although the figures are arranged on two levels without much foreshortening, the relative proportions of the various characters in the principal scene are more realistically rendered than is usual in such compositions. Figures of symbolic importance, such as Revanta, the parasol bearer, and the servants carrying the animal and wine flask, are shown frontally, even though they are meant to be moving to the right. Thus, while the artist complied with the formal requirements of a narrative composition, he did not ignore altogether the demands of accepted iconography. This is also evident in the placement of the musicians below. Although clearly separated from the scene above, they nevertheless are a remarkably lively group.

S133 *Siva's Family*
Uttar Pradesh (?); c. 600
Buff sandstone; 38 in (96.5 cm)
From the Nasli and Alice Heeramaneck
Collection

Museum Associates Purchase; M.72.53.2
Literature: *Los Angeles County Museum of Art
Bulletin* 19, no. 2 (1973): 50, fig. 44; *Archives of
Asian Art* 27 (1973–74): 99, fig. 22;
Heeramaneck 1979, no. 51; Kramrisch 1981,
pp. 58–59.

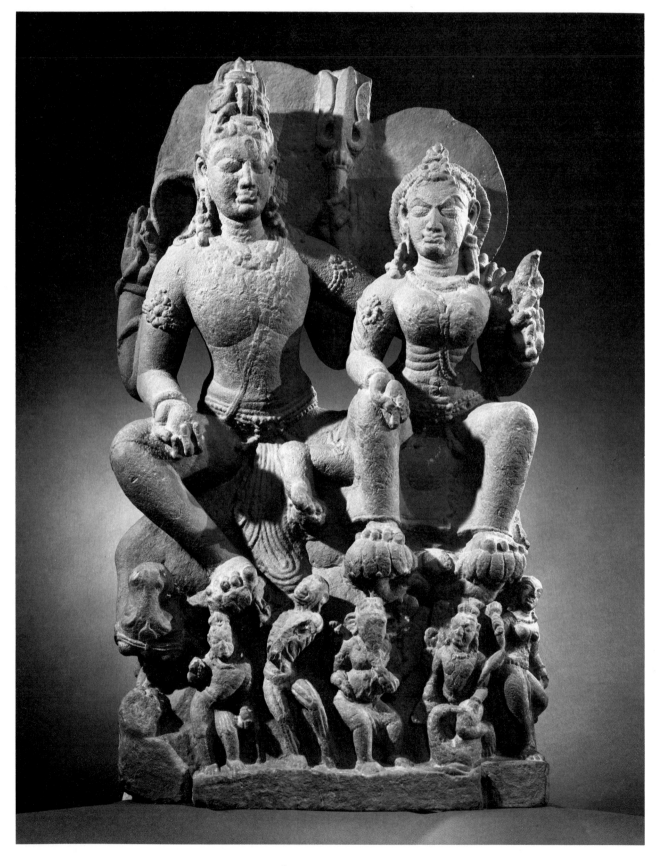

This image type in which Siva and Parvati are seated with or without other members of their family generally is referred to as Uma-Mahesvaramurti in Hindu iconographic texts. Uma is a synonym of Parvati and Mahesvara, of Siva. In this particular example the three-eyed Siva is seated on his bull in the posture of grace (*lalitasana*), while his spouse sits more formally on her lion, whose head is hidden from view behind the standing female on the right. The pendant leg of each is supported by a lotus. Both are elaborately ornamented. Siva's hair is arranged in a towering ascetic's chignon, Parvati's coiffure is elegantly arranged in a large bun encircling the back of her head. She wears two different kinds of ear ornaments, that in her left ear forming a long tube.

Siva holds a snake with his upper right hand and a trident with his corresponding left hand. His lower right hand grasps a fruit, probably the lemon symbolizing the universe, another arm is outstretched to embrace his wife's shoulder. In Uma's right hand she holds a piece of fruit and rests her arm on her right thigh, as does Siva. In her left hand she grasps a mirror. A plain circular nimbus surrounds each head.

Siva's bull turns his head up at an unnatural angle to gaze admiringly at his master, while Uma's lion is shown growling with his tongue hanging out. The lively tableau beneath them is formed by their two sons, Ganesa and Kumara, and two acolytes, including the skeletal Bhringi, who looks up at Siva as he dances. Ganesa and Kumara seem to interact with one another, and the whole ensemble is reminiscent of puranic descriptions of Siva's family life, when he and his spouse often watched the antics of their sons and beloved *ganas*.

The representation is unusual in the strong contrast between the hieratic quality of the pair above and animated scene below. Siva is sternly dignified and majestic, while Uma's facial expression and posture convey aloofness, if not disdain. During the Gupta period this posture generally was assigned to Mother Goddesses rather than to Uma. The unknown sculptor certainly did not represent Siva's spouse as a timid, acquiescent female, as she is generally shown in such compositions.

While Kramrisch (see Literature) is correct in commenting on the uniqueness of the image and dating it to the sixth–seventh century, her suggested provenance—Markandi in Maharashtra—is highly unlikely. Apart from the fact that the Markandi temples are five centuries later, it is very difficult to accept this work as a stylistic precursor. Moreover, the sculpture generally is not rendered in the style of the monuments of Maharashtra. On the contrary, the elongated faces are somewhat reminiscent of a terra-cotta Siva head found at Ahichchhatra (V. S. Agrawala 1947–48, pl. XLIV), while Uma may be compared with the similarly seated Mother Goddesses from Madhya Pradesh (Harle 1974, figs. 30–32). Parvati's coiffure with coiled bun at the back of the head is worn by female figures in the Gupta-period temple at Deogarh (Williams 1982, fig. 204), while the curious cylindrical ear ornament is more commonly found in figures from Bihar. Thus, Uttar Pradesh rather than Maharashtra is a more likely source for this intriguing sculpture.

S134 Shrine with Four Jinas
Uttar Pradesh; c. 600
Cream-colored sandstone; 23 in (58.2 cm)
Gift of Anna Bing Arnold; M.85.55
Literature: Pal 1985a, pp. 72–73, figs. 13, 15.

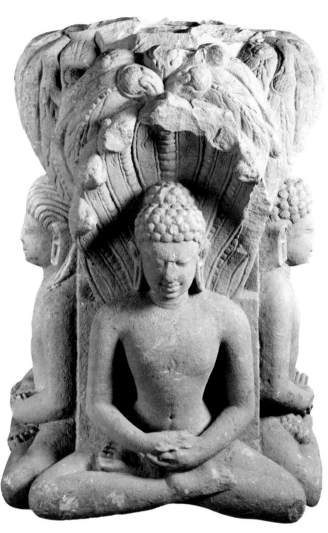

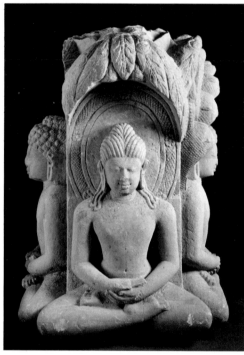

Side b

Side a

This image type with four Jinas individually portrayed on each side is known as Sarvatobhadra (auspicious on all sides) and was popular among the Jains. In this cosmic representation the four Jinas preside over the cardinal directions. These shrines may thus be regarded as the Jain counterparts of the four-faced Sivalingas or Buddhist votive stupas with four Buddhas presiding over the four directions. The shrine originally would have had a pedestal and crowning elements consisting of umbrellas or a tiered structure.

All four figures are identically portrayed except for the individual on side *b*, who has a different hairstyle. Completely nude, each Jina is seated in the meditating posture. Like the Buddha, each has extended ears and a cranial bump. The heads of three Jinas are covered with short, curly hair. One on side *b* has long hair pulled back with a few strands coming down the shoulders. Each Jina is protected by a single tree, which forms a leafy canopy above; on side *c* the canopy has been destroyed. The

head of the Jina on side *a* is surrounded by the seven hoods of a serpent. The other three Jinas have oval nimbuses, each with a border decorated with crosshatchings and small lotuses or rosettes.

The Jina with the seven-hooded serpent canopy is Parsvanatha, a historical figure, who lived during the ninth century B.C. He has remained one of the most popular of the Jinas, and his most distinctive attribute is the serpent, which plays a significant role in his hagiography. The Jina with the distinctive hairstyle is Rishabhanatha, also known as Adinatha, who is regarded as the earliest of the Jain patriarchs. His hairstyle is reminiscent of Siva's, while his animal emblem is the bull, which is Siva's mount as well. He alternatively is known as Vrishabhanatha, also an appropriate epithet of Siva.

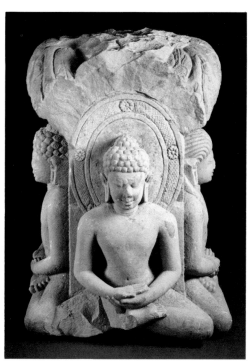

Side c

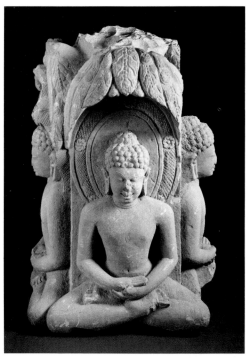

Side d

The two remaining Jinas are difficult to identify precisely, but most certainly one is Mahavira and the other Neminatha. Mahavira is the last of the twenty-four Jinas. Although the *Kalpasutra*, a Jain canonical text, mentions twenty-four Jinas, it discusses in detail the lives of only four: Rishabhanatha, Parsvanatha, Neminatha, and Mahavira. Each Jina is associated with a different type of tree and can, thereby, usually be identified. In this instance, however, it appears that the same tree is represented on each side, and the tree very likely is meant to represent the asoka, which came to be associated with Jain tree-shrines (*chaitya-vriksha*) from early times (U. P. Shah 1955, pp. 67–71).

The exact provenance of the sculpture is not known. The cream-colored stone from which it is carved was popular in the Varanasi area of Uttar Pradesh but was also used in various regions of Madhya Pradesh. Stylistic parallels may be seen in several Gupta-period sculptures from Sarnath and Mathura. Perhaps the closest example is a stele representing Rishabhanatha from Mathura for which a date in the second quarter of the sixth century has been suggested (Williams 1982, fig. 230).

Although the sculptor of the museum's impressive shrine is unknown, there can be little doubt that he was a master. He has eminently succeeded in infusing the figures with extraordinary spiritual force. His restrained, but sensitive modeling has resulted in images of vigorous plasticity and serene dignity.

S135 Female Bust
Bihar (?); fourth century
Reddish pink terra-cotta; 3 ⅜ in (8.6 cm)
From the Nasli and Alice Heeramaneck
Collection
Museum Associates Purchase; M.84.32.4
Literature: Rosenfield et al. 1966, p. 37.

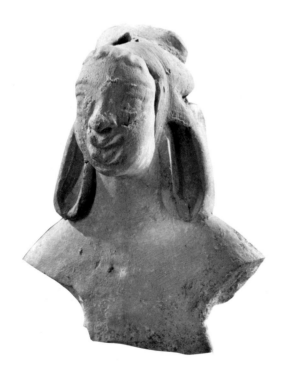

The terra-cotta bust is distinguished by its
strongly modeled countenance with unusually
distended earlobes. The sloping shoulders are
well proportioned, and the body probably was
very thin. The flat chest is unusual, without any
indication of breasts. Small pellets were perhaps
attached separately to the chest. Notable also are
the very thick and heavy lips. The hair is held by
a flat band pierced by a hole, and the eyes are
widely open.

The shape and treatment of the
lips relate this piece to another terra-cotta head
in the collection, which may be from Bihar
(S80). A Bihar provenance is also suggested by a
comparison with other terra-cotta figures found
in a site called Belwa (Shere 1961, fig. 3). Some
Belwa heads are characterized by thick lips and
highly distended, rectangular earlobes as in this
example.

S136 *Buddha Sakyamuni*
Bihar, Bodhgaya area (?); 400–600
Tan chloritic schist; 15 in (38.0 cm)
Gift of Michael Phillips; M.84.227.3

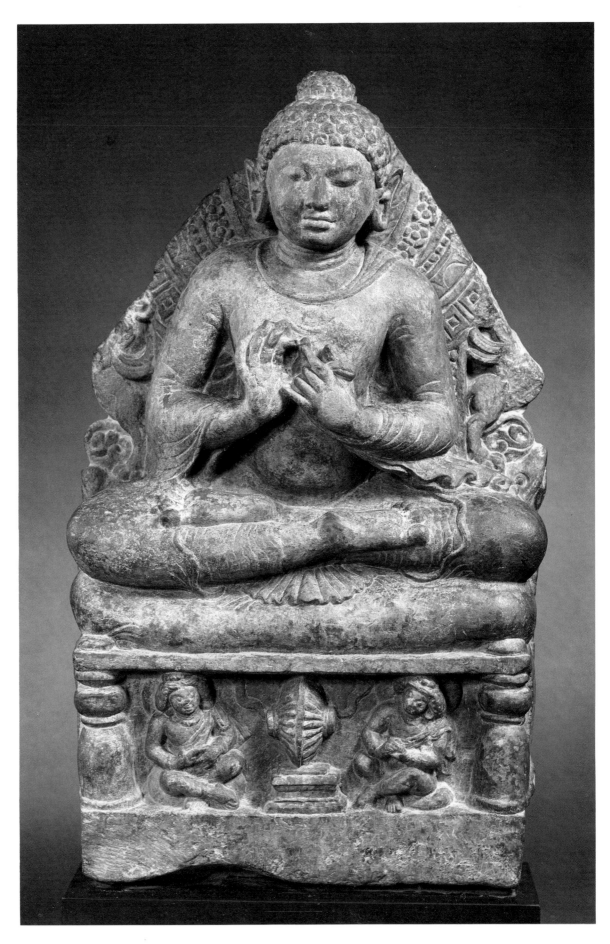

Buddha Sakyamuni is seated in the meditating posture on a cushion atop a throne supported by two legs with pot-shaped capitals. His hand gesture indicates that he is engaged in preaching the law, further symbolized by the wheel placed on a pedestal below the throne. The wheel is flanked by two listeners seated on cushions with their legs crossed at the ankles and hands joined in the adoration gesture. Circular nimbuses behind their heads indicate that they are divine figures; they are, however, not distinguished from each other. Originally, at either side of the throne back were makaras, only one of which remains, and winged lions, whose heads are broken. The damaged nimbus behind the Buddha is adorned with concentric circles of flames, lotuses, beads, scallops, and a motif consisting of a rectangle enclosing a square.

Both in iconography and composition, the stele is undoubtedly related to the well-known late-fifth-century preaching Buddha of Sarnath, with some interesting differences (Harle 1974, fig. 70). In that example the throne is also supported by similar legs, the wheel is flanked by figures, and the deer clearly indicate that the scene represents the master's first sermon in the deer park at Sarnath. In the museum's example the audience consists of a pair of gods. In addition, no streamers fly from the wheel as in the Sarnath stele. While winged lions and makaras are also present on the Sarnath image, their positions are reversed here, and their forms are much more perfunctorily delineated. The decorative motifs on the nimbus are quite different from the design of the Sarnath halo. Only the scallops are common to both.

Even more significant are the differences in the proportions, modeling, and facial features of the Buddhas. The Buddha in this image is squatter with a shorter neck and broader face. The ears are wider and not as elongated as in other Buddha heads (S119, S126), and the curls on the head are rendered somewhat sketchily. While the garment is severely plain in the Sarnath Buddha, the sculptor of the Bihar figure has attempted to indicate more naturalistically the folds and wrinkles of the robes. Unusual also is the treatment of the ends of the robe below the knee and the way the pleats of the gathered portion cascade below the left arm. These details have yet to be observed in any other Buddha image.

The most likely place of origin for this intriguing Buddha is Bihar, perhaps the Bodhgaya area. Several sculptures from that region have been carved from the same light brown chloritic schist. The proportions of the figures and the manner in which the lotus on the halo is rendered are similar to seventh-century sculptures from Shahabad district and Nalanda (Asher 1980, pls. 52–53, 57–59, 73–75). The rippling effect of the Buddha's undergarment can be paralleled in several of the Shahabad figures (Asher 1980, pl. 29), while more specifically the curious motif of the rectangle enclosing a square, which decorates the halo, is often encountered in later Buddha images from Bihar (Rosenfield et al. 1966, p. 41, fig. 29). Finally, in proportion and modeling, this Buddha is probably somewhat earlier than an inscribed Buddha Muchalinda image from Bodhgaya of the second half of the seventh century (Asher 1980, pp. 43–44, pl. 62).

These parallels notwithstanding, this relief possibly may have been carved earlier than the Sarnath image. The Buddha with widespread, folded legs is somewhat reminiscent of the Bodhgaya Buddha of the year 64 (Gupta era = A.D. 384) as well as the seated Jinas in the sculpture of Neminatha from Rajagriha in southern Bihar (Asher 1980, pls. 11, 15). Secondly, the scalloping in the halo is rarely, if ever, seen in sculptures of this region after the fifth century. This is a carryover, as is the winged lion, in Gupta art from Kushan-period images. A unique feature of this image are the flames issuing immediately from the back of the Buddha's head. The flame generally is not a common feature in the art of the Gupta period, and when it does occur the motif is added to the edge of the aureole. Thus, whether the sculpture is of the fifth or seventh century, the addition of the flame motif in the inner halo is most unusual. In Gandharan Buddha images flames emanate from the master's shoulders, while in sculptures from Amaravati in Andhra Pradesh flaming pillars symbolize the Buddha (see S84). As a matter of fact, the design of the flames here is not unlike that seen on the pillars. Such flames emerging from the neck surround the Buddha's head in an unusual gilt bronze of the ninth–tenth century from Nepal (Pal et al. 1984, p. 265, no. 136). In a rare Chinese sculpture of Maitreya, discovered in Shensi Province and dated 471, rather bold flames similar to those in this sculpture emanate from the figure's body in the innermost circle of the aureole (T. Akiyama and S. Matsubara, *Arts of China: Buddhist Cave Temples*, trans. A. C. Soper [Tokyo: Kodansha, 1969], fig. 147).

Gujarat

S137 *Head of the Buddha*
Gujarat, Devni Mori; 375–400
Buff terra-cotta; 8 in (20.3 cm)
Purchased with funds provided by Mr. and Mrs.
Paul E. Manheim and Rexford Stead; M.79.8

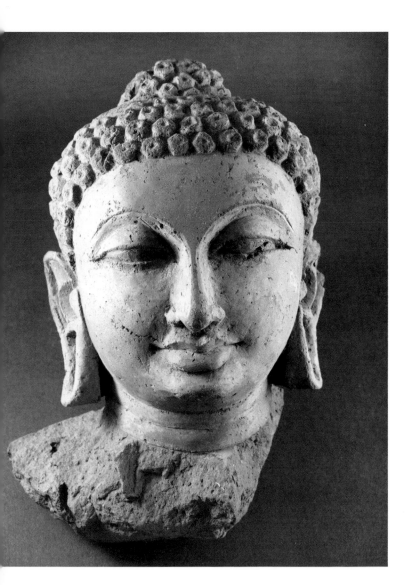

This Buddha head is from a stupa that was systematically excavated at a site called Devni Mori in northern Gujarat (Mehta and Chowdhary 1966). The stupa was decorated with a large number of terra-cotta Buddha images, all seated in meditation and of a remarkably uniform style. Only minor differences, such as in the shape of the face or hairstyle, distinguish the various Buddha figures. There is some disagreement among scholars about the date of the stupa and, hence, of the sculptures. While the excavators date the monument to about 375, others consider the sculptures to have been modeled between 400 and 415 (Williams 1982, pp. 58–60; Schastok 1985, pp. 27–32).

The Buddha head almost certainly was cast in a separate mold and then attached to the body. No evidence suggests that the images were painted as were other terra-cotta and stucco monuments of the period. The features of this almost circular face with half-shut eyes, well-proportioned nose, sweeping eyebrows, and elongated earlobes are articulately modeled. By contrast, the curls on the head, although substantial, are rendered less precisely as little circlets. The *ushnisha* at the top is present but not the *urna*. Although some Devni Mori Buddhas reflect influences from northwestern Gandhara, this particular head is related more to the later Buddhas of Uttar Pradesh (S119), especially in the degree of idealization. Controversy regarding its date aside, the sculptures of Devni Mori are of great significance for the art history of the region.

S138 A Mother and Child
Rajasthan, Tanesar-Mahadeva; 450–500
Foliated dark green schist; 30 in (76.2 cm)
From the Nasli and Alice Heeramaneck
Collection
Museum Associates Purchase; M.82.42.2
Literature: Pal 1971; Shah 1972; Harle 1974, p.
50, fig. 92; Pal 1978b, p. 88; Heeramaneck
1979, no. 41; Pal 1983, p. 306, fig. 8; Schastok
1985, pp. 82–85, pl. XXXIII, fig. 55;
Huntington and Huntington 1985, p. 231; Pal
1985a, p. 72, fig. 12.

This and the following sculpture once belonged
to a group of now-dispersed images that were
scattered under a tree near the village of Tanesar-
Mahadeva, about thirty miles from the city of
Udaipur in Rajasthan (see R. C. Agrawala
1961). Apart from a couple of male figures,
most sculptures in the group represent a divine
mother playing with a male child. Indeed, no
other school of Indian sculpture has left us such
expressive portrayals of the tender relationship
between an infant and his mother. As with this
representation, in most of these images only the
halo announces the divinity of the mother.
Whether the same goddess and divine child are
depicted in all such examples or whether they
represent different Mother Goddesses, known as
Matrika, is uncertain. In a recent publication
Schastok (see Literature) suggests that the group
represents the Matrika. The Mother Goddesses
usually are portrayed more hieratically, even
when accompanied by children. In this group of
sculptures, however, they strike remarkably
varied postures and the child is shown
performing different antics. If they represent a
particular mythical personality, then the goddess
must be identified as Parvati and the infant as
Skanda, or Kumara.

In this elegant example the
goddess demurely stands carrying the child near
her right shoulder. Her head is covered by her
upper garment, which is tied over her left
breast. In addition, above her forehead she wears
a floral tiara, which seems to be the immediate
target of her rambunctious son. He obviously is
trying to pluck one of the flowers, while the
indulgent mother gently restrains him even as
she lowers her head away from his grasp. In the
Indian context only a very individualistic
sculptor would have attempted to express so
fleeting a moment in the intimate relationship
between a mother and child with such candor
and perception. The naturalism and
psychological perceptiveness expressed in this
sculpture is clearly derived from Gandhara, but
the modeling is much more suave and the
expression softer.

The Tanesar sculptures with
their elegance and relaxed spontaneity exhibit a
remarkable naturalism and subliminal grace.
There is a refined simplicity about these figures
in their plastic volume and surface embellish-
ments. Although the hips are expansive and
breasts full, the outline of the figures is fluently
defined with utmost economy. Especially
appealing are the radiant faces with their
delicate, refined features.

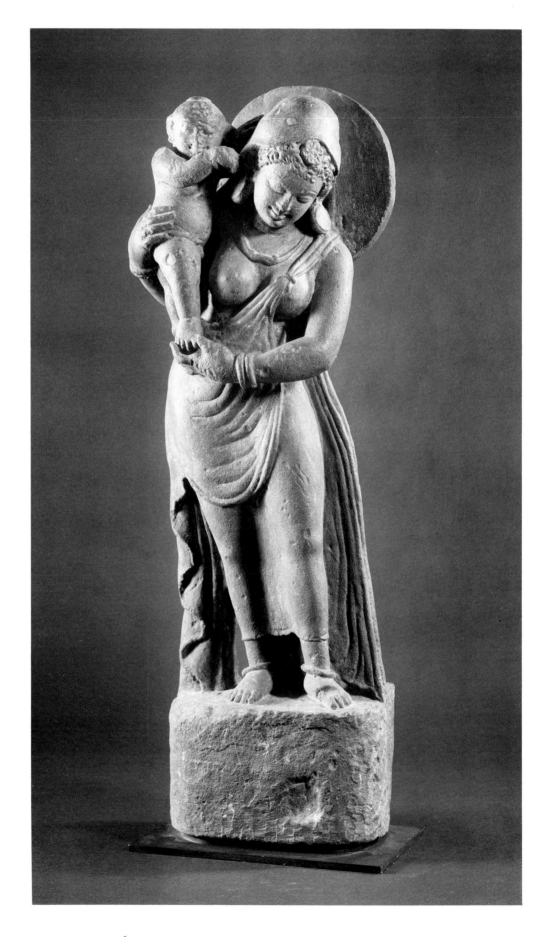

S139 A Tantric Goddess
Rajasthan, Tanesar-Mahadeva; 450–500
Foliated dark green schist; 30 in (76.2 cm)
From the Nasli and Alice Heeramaneck
Collection
Museum Associates Purchase; M.82.42.1
Literature: R. C. Agrawala 1961, fig. 16; Pal
1971; Shah 1972; Harle 1974, p. 50, fig. 93;
Heeramaneck 1979, no. 44.

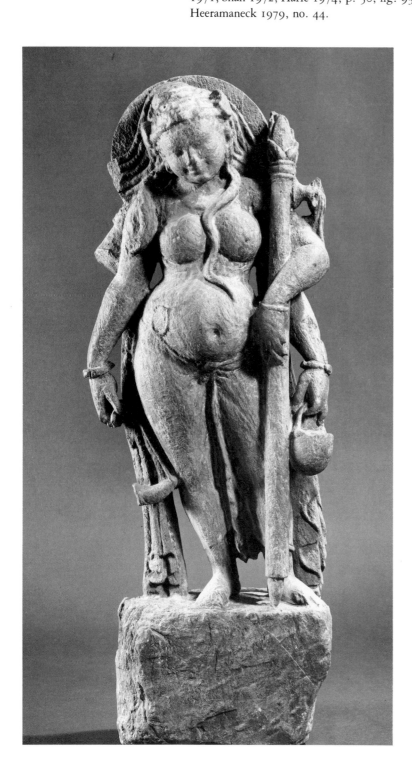

This is the only divine female figure from
Tanesar who is without a child and has four
arms. Her very large belly may suggest that she
is pregnant. In point of fact, however, the artist
was probably following the texts describing
some goddesses as potbellied (*ghaṭodarī*). Among
the regional goddesses included in the Gupta-
period text *Matsyapurana* is one called Ghatodari
(V. S. Agrawala 1963b, p. 258). But as no
description is given, an exact identification of
the goddess is difficult to determine.

She seems to hold in one right
hand a horn suspended by two strings. In
another hand she holds what looks like a spear
with a thick shaft and unusual head; with a third
hand she grasps a bucketlike ascetic's waterpot.
The tail of a snake slithers between her breasts.
She also seems to wear a sacred cord with a ring
attached to it. The bump on her head may be a
topknot or even an effaced skull; her hair flies
wildly around both sides of her head. Because of
the spear, I had earlier (see Literature) identified
her as the Mother Goddess Kaumari, the
personified energy of Kumara (see S142). Most
of the other attributes and traits, however, are
unusual for Kaumari. Although the figure's
obesity, flying hair, and snake characterize an
awesome deity, her face is serenely radiant.
Schastok (1985, p. 85) has recently suggested
that the goddess represents an angry and cosmic
form of Devi or Durga, such as Chamunda, who,
however, is generally portrayed as emaciated.

Whatever her exact
identification, she is an unusual manifestation of
the Great Goddess. She is one of the earliest
representations of a potbellied goddess and is a
prototype of such later Buddhist deities as
Ekajata and Parnasabari with their prominently
rotund bellies (B. Bhattacharyya 1958, p. 285,
fig. 173).

S140 The God Vishnu
Madhya Pradesh (?); early fifth century
Reddish brown sandstone; 6 ⅞ in (17.4 cm)
Gift of Dr. and Mrs. Pratapaditya Pal;
M.84.153.2

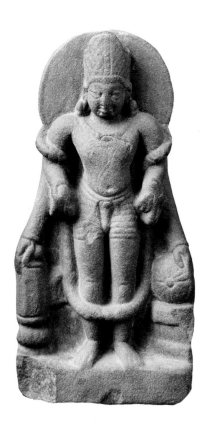

Although small and probably meant for a domestic altar, the relief is a typical example of Gupta-period Vishnu images that were popular in a large area of north-central India, including the modern states of Uttar and Madhya Pradesh. Stylistically, the sculpture is closely related to several well-known Vishnu images from Uttar Pradesh of the first half of the fifth century (Harle 1974, figs. 61–62), but the stone itself and the way in which the volume of the short dhoti is indicated by parallel horizontal lines seem to point to a Madhya Pradesh provenance (cf. S142).

The god stands firm and erect on a plain base, which is damaged at one corner. His adornments include a garland of wild flowers, plain bangles, necklace, ear ornaments, and tall crown decorated with diamond-shaped crosshatchings. A plain, circular nimbus offsets his head and shoulders. The placement of his arms is quite characteristic of Gupta-period Vishnu images, with two arms bent at the elbow and two arms fully outstretched with the hands resting on a club and a wheel placed on a pedestal. The conch is held vertically in the upper left hand, and the round object in one of the right hands is the myrobalan fruit.

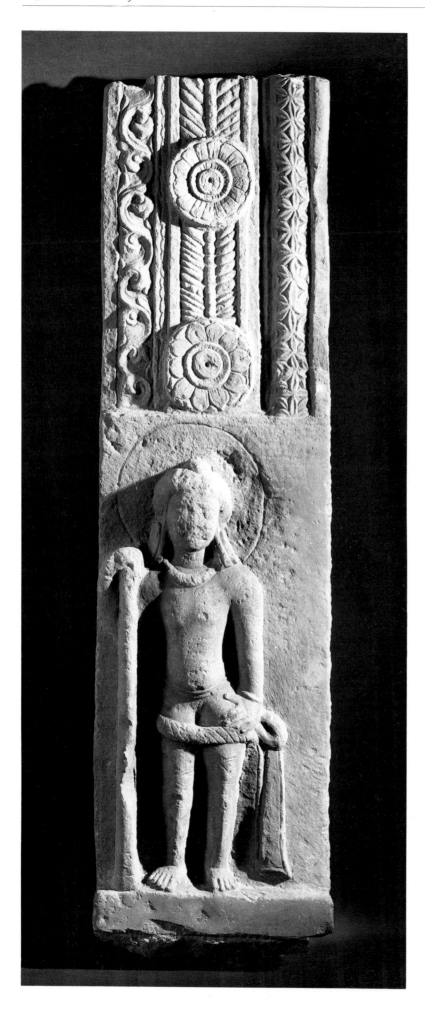

S141 *Doorjamb with Guardian*
Madhya Pradesh; late fifth century
Reddish brown sandstone; 42 in (106.6 in)
Gift of Neil Kreitman; M.77.153

This lower portion of a typical doorjamb of the Gupta period probably was placed at a temple entrance. Carved on the bottom half is a nimbated divine guardian, who stands with his left hip thrust out slightly. The broad-shouldered figure wears a dhoti and thick, heavy sash tied in a bow at the left hip on which he has placed his left hand. Other ornaments include bracelets, necklace, and large, open earrings. The right hand rests on top of a thick staff, as is usual in Kushan-period Vishnu images from Mathura. The face is damaged, and the hairstyle is quite typical of the Gupta period. The upper half of the jamb is decorated with various vegetal motifs in three vertical rows, the broad central panel additionally is adorned with two lotuses.

 In the vegetal patterns and figural style, the doorjamb may be compared with those of several Gupta-period temples from Madhya Pradesh such as the Parvati temple at Nachna and others at Pipariya and Marhia, all built probably between 475 and 550 (Williams 1982, figs. 151, 154–55, 174, 188). The guardian figure is especially similar to those adorning the doorjambs and pillars in the late-fifth-century Parvati temple at Nachna. The crisply articulate carving of the scrolling vine on the left row is comparable with similar motifs and carving on the two columns from Sarnath (S127). Notwithstanding regional differences, Gupta sculptors shared a common stock of such ornamental motifs.

Madhya Pradesh; seventh century
Reddish brown sandstone; 28 ½ in (72.4 cm)
Gift of Mr. and Mrs. Harry Lenart; M.77.4
Literature: Pal 1978a, p. 42.

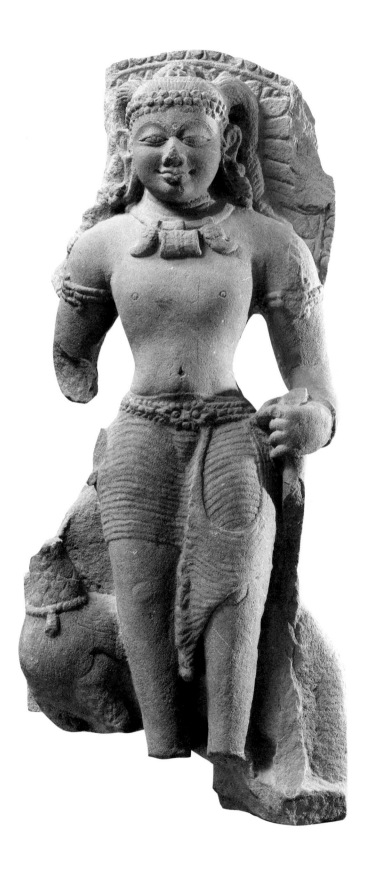

Known also as Karttikeya, or Skanda, Kumara
was an important Hindu deity in northern India
during the first few centuries of the Christian
era. The predominant deity of the militant tribe
known as the Yaudheyas, he appeared on
Kushan-period coins (C12c) and was especially
venerated by at least two Gupta emperors,
Kumaragupta and Skandagupta, both of whom
were named after him. It was probably during
the Kushan period that he was elevated to the
position of the divine general and became closely
associated with Agni, the fire god, and Siva.
Although his pedigree is disputed, in mythology
he generally is regarded as the son of Siva and
Parvati.

In this cult image Kumara is
represented frontally, holding the shaft of his
spear with his left hand. His right forearm is
broken, the hand may have displayed the gesture
of charity or been engaged in feeding his pet
peacock, who stands behind him and whose
upturned head is broken from the neck. As
customary, Kumara is represented as a youthful
figure, which is indicated by his three-braid
hairstyle and tiger-claw necklace. The hairstyle
was fashionable for small boys (see S23), and the
tiger claws were used as charms to repel evil
influences. Kumara's divinity is emphasized by
the scalloped lotus halo.

The practice of scalloping the
nimbus was characteristic of Mathura images of
the Kushan period and was also continued
during the Gupta period, although rarely later.
While the design of Gupta-period halos is
generally more elaborate, the combination of the
lotus and scallops, as in this example, is
reminiscent of the nimbuses behind the three
inscribed fifth-century Jina images found in
Durjanpur in Madhya Pradesh (Williams 1982,
figs. 12–14). The proportions and modeling of
this Kumara, however, are more graceful than
the somewhat stocky, weightier Jina figures.
Although Kumara is a war god, he is depicted
here as a friendly figure, his handsome
countenance with half-shut eyes bathed in a
pleasant smile. Also noteworthy is the stylish
elegance of the dhoti's fanlike fold across the
thigh. A similar garment occurs in a Vishnu
image from Aphsad in Bihar dated to the eighth
century (Asher 1980, pl. 195).

S143 Lion
Northern India; sixth century
Copper alloy; 3 ¼ in (8.3 cm)
Indian Art Special Purposes Fund; M.84.111

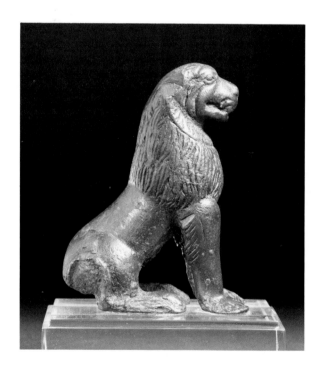

Neither the exact function nor the provenance of this heraldic lion can be determined, but very likely a sixth-century date can be upheld. It is stylistically comparable with several Gupta-period stone lions from Mathura and central India. The stylized, collarlike delineation of part of the mane is frequently seen in Gupta-period lions from Mathura (see S115; Williams 1982, figs. 59, 80), while the rest of the mane shows the same treatment as on the lions decorating the pilasters of the fifth-century temple at Tigawa in Madhya Pradesh (Williams 1982, fig. 130). In general, however, this powerfully modeled animal is characterized by a greater sense of naturalism than is apparent in Gupta-period stone lions from north-central India, and thus it is likely that the piece may have originated in the northwestern regions of the subcontinent. Whatever its exact provenance, it remains an unusual and rare example of a Gupta-period bronze animal sculpture.

S144 Cow and Calf
Northern India; late seventh century
Light pink sandstone; 20 ½ in (52.1 cm)
Gift of Mr. and Mrs. Harry Lenart; M.73.87.2
Literature: Pal 1974b, p. 31; Pal 1978a, p. 18;
Beach 1985, p. 10; P. Chandra 1985, p. 110.

This charming representation of a cow suckling her calf clearly demonstrates the sculptor's skill in delineating animals with affection and empathy. Indian artists have always been adept in portraying the elephant, cow, and bull. In this delightfully animated example the animals are sparingly, but tenderly modeled, the muscles and limbs articulated with subtle naturalism. The sensitive rendering of the cow's head with prominent dewlap, manner in which her tail is tucked between the legs, and crouching posture of the calf with its curled tail indicating its satisfaction clearly reflect the artist's powers of close observation and familiarity with the subject.

Removed from its original context, the relief cannot be identified with certainty. It may have belonged to a much larger composition depicting a scene from Krishna's life. The cowherder-god is often shown surrounded by his favorite animals. The relief may have originated in Uttar Pradesh, although the state of Rajasthan cannot be ruled out because of the pink tinge of the sandstone. Chandra (see Literature) has recently suggested that the sculpture is from Uttar Pradesh and has dated it to the early ninth century; Beach (see Literature), however, dates it to the sixth–seventh century.

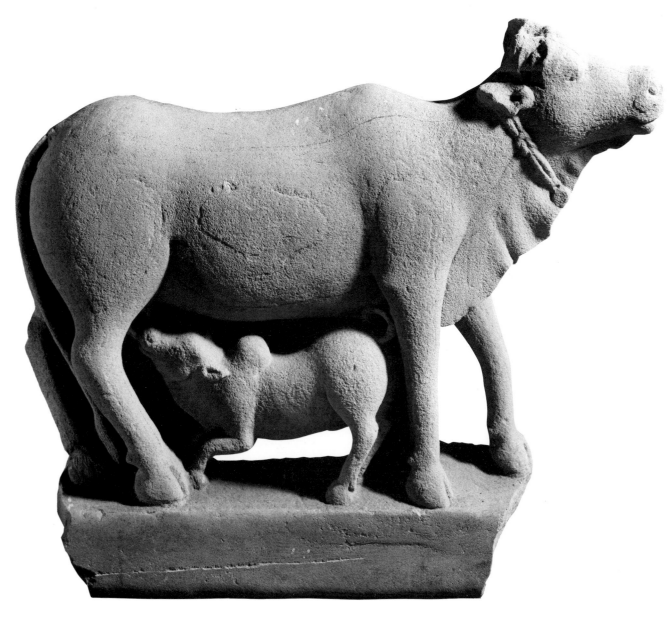

Chronology

B.C.

2500–1500 Indus Valley civilization flourishes; Mohenjo-Daro and Harappa are active centers.

2000–1000 Aryans arrive in several waves.

c. 1500–500 Vedic Period; *Vedas*, *Brāhmaṇas*, and *Upanishads* (collections of religious and philosophical writings) are formulated by an Aryan-dominated society.

563 Siddhartha Gautama, the Buddha, founder of Buddhism, is born; dies 483.

c. 526 Mahavira Jina, historical founder of Jainism, dies.

Late sixth century Persian king Darius the Great conquers parts of northwestern India.

c. 400 Grammarian Panini writes *Ashṭādhyāyī*, first scientific grammar of Sanskrit.

327 Macedonian king Alexander the Great reaches Indus.

321–187 Maurya dynasty reigns.

305 Maurya emperor Chandragupta defeats invading Seleucid army in Panjab.

302 Chandragupta receives Megasthenes as Greek ambassador.

c. 273–232 Maurya emperor Asoka reigns, patronizes Buddhism and encourages spread of religion to Afghanistan and Sri Lanka, erects columns inscribed with his laws.

256–255 Bactrian Greeks secede from Seleucids.

Second century B.C.–third century A.D. Amaravati school flourishes on eastern coast.

187–75 Sunga dynasty reigns in central India.

c. 160–140 Indo-Greek king Menander, sympathetic to Buddhism, reigns in northwestern India and Afghanistan.

First century B.C.–first century A.D. Sakas (Scythians) invade subcontinent.

57–58 Vikrama era begins, probably established by Saka king Azes I.

50 B.C.–A.D. 25 Stone gateways of the Great Stupa at Sanchi are constructed.

A.D.

First century Sanskrit poet Asvaghosha composes *Buddhacharita* (Life of the Buddha). Greek and Roman traders learn to navigate monsoon winds and thereby hasten sea vogage from Alexandria to western coast of subcontinent.

First–third centuries Kushan dynasty reigns in northwest, including Uttar Pradesh; Satavahana dynasty reigns in the Deccan.

c. 50 Apostle Thomas visits and dies in India (?).

78 Saka era begins, probably established by Kanishka the Great.

Second century Buddhist philosopher Nagarjuna is active.

c. 225 Sasanians assume control of Bactria, Gandhara, Sogdiana.

320, February 26 Gupta era begins. Dynasty ends c. 600.

c. 325–625 Two Vakataka dynasties reign successively in central India and the Deccan.

c. 395 Gupta emperor Chandragupta II defeats Sakas of western India; his empire is visited and described by Chinese pilgrim Fa-hsien (Faxian).

Fifth century Dramatist and lyric poet Kalidasa and mathematician and astronomer Āryabhaṭṭa are active.

c. 400 Hindu cave temple with colossal image of boar avatar is excavated and dedicated by Chandragupta II's ministers at Udaygiri hills near Bhopal.

400–425 Gunavarman of Kashmiri royal family goes to Sri Lanka and Java where he preaches Buddhism.

475–500 Buddhist caves at Ajanta are excavated and painted.

480–550 White Huns invade subcontinent.

c. 500–550 Chālukya dynasty reigns in the region of Badami in Bijapur district (Maharashtra).

500–600 Hindu cave temple at Elephanta, off coast of Bombay, is excavated.

507–87 Hindu astronomer Varahamihira, author of *Bṛihatsaṁhitā*, is active.

c. 510–532 Narasimhagupta Baladitya I reigns, patronizes great Buddhist monastic university of Nalanda in Bihar.

c. 525–50 Cosmas Indicopleustes, an Alexandrine Greek, visits India and writes about the country in his *Christian Topography*.

c. 550 Pallava dynasty begins reign in Tamil Nadu.

c. 575 Kingdom of Thaneswar (in Haryana) begins expanding in northwestern India and Uttar Pradesh.

588–89 Mahānāman, monk from Sri Lanka, builds temple at Bodhgaya.

606–47 Harshavardhan of Thaneswar reigns, his court poet Bāṇabhaṭṭa composes *Harshacharita* (Life of Harsha).

627 Karkota dynasty is founded by Durlabhavardhan in Kashmir.

630–43 Chinese pilgrim Hsüan-tsang (Xuanzang) visits India, spends eight years within the dominions of Harshavardhan.

643 Muslim Arabs execute naval raid at mouth of Indus, larger invasion occurs c. 660.

Bibliography

Agrawala, R. C. 1961. "Some More Unpublished Sculptures from Rajasthan." *Lalit Kalā* 10: 31–33.

————. 1970. *Human Figurines on Pottery Handles from India and Allied Problems*. Baroda: Department of Museums Gujarat State.

————, and M. Taddei. 1966. "An Interesting Relief from the Swat Valley." *East and West*, n.s. 16, no. 1–2: 82–88.

Agrawala, V. S. 1939. "Vasudhara." *Journal of the Indian Society of Oriental Art* 7: 13–17.

————. 1947–48. "The Terracottas of Ahichchhatra." *Ancient India. Bulletin of the Archaeological Survey of India* 4: 104–79.

————. [1953] 1963a. *India as Known to Panini*. 2d ed. Varanasi: Prithvi Prakashan.

————. 1963b. Matsya Purāṇa: *A Study*. Varanasi: All India Kashiraj Trust.

————. 1965. *Indian Art*. Varanasi: Prithivi Prakashan.

Allan, J. [1914] 1967a. *Catalogue of the Coins of Ancient India*. London: Trustees of the British Museum.

————. [1914] 1967b. *Catalogue of the Coins of the Gupta Dynasties and of Śaśāṅka, King of Gauḍa*. London: Trustees of the British Museum.

Allchin, R., and B. Allchin. 1982. *The Rise of Civilization in India and Pakistan*. Cambridge: Cambridge University Press.

Altekar, A. S. 1954. *Catalogue of the Gupta Gold Coins in the Bayana Hoard*. Bombay: Numismatic Society of India.

————. 1957. *The Coinage of the Gupta Empire and Its Imitations*. Varanasi: Numismatic Society of India.

Anand Krishna, ed. 1971. *Chhavi*. Varanasi: Bharat Kala Bhavan.

Antonini, C. S. 1977. "Pottery from Tapa Sardar." In *South Asian Archaeology*. Edited by M. Taddei. 2 vols. Naples: Istituto Universitario Orientale.

Art of India and Southeast Asia. 1964. Champaign: Krannert Art Museum, University of Illinois.

Asher, F. M. 1980. *The Art of Eastern India, 300–800*. Minneapolis: University of Minnesota Press.

Auboyer, J. 1981. "About an Indian Terracotta of the Guimet Museum, Paris." In *Chhavi*. Edited by Anand Krishna, 2: 158–60. Varanasi: Bharat Kala Bhavan.

Bachofer, L. 1929. *Early Indian Sculpture*. 2 vols. Paris: Pergasus Press.

Bajpayee (Das), K. 1980. *Early Inscriptions of Mathura*. Calcutta: Punthi Pustak.

Bandinelli, R. B. 1971. *Rome: The Late Empire*. Translated by P. Green. New York: Braziller.

Banerjea, J. N. 1956. *The Development of Hindu Iconography*. 2d ed. Calcutta: University of Calcutta.

Barrett, D. E. 1954. *Sculptures from Amaravati in the British Museum*. London: Trustees of the British Museum.

Barthoux, J. J. 1930. *Les Fouilles de Haḍḍa*. Paris: Editions d'art et d'histoire; G. van Oest.

Barua, B. 1979. *Barhut*. 3 pts. in 1 vol. New Delhi: Indological Book Corporation.

Basham, A. L., ed. 1968. *Papers on the Date of Kaniska*. Leiden: Brill.

Beach, M. C. 1967. "Collecting the Arts of India and Nepal: The Connoisseurship of Nasli and Alice Heeramaneck." *Connoisseur* 164 (March): 162–65.

————. 1985. *The Art of India and Pakistan*. Durham, N.C.: Duke University Institute of the Arts.

Begley, W. E. 1968. *Indian Buddhist Sculpture in American Collections*. Louisville, Ky.: J. B. Speed Art Museum.

————. 1973. *Viṣṇu's Flaming Wheel: The Iconography of the Sudarśana-Cakra*. New York: New York University Press for the College Art Association of America.

Bellenitsky, A. 1969. *Central Asia*. Translated by J. Hogarth. London: Barric and Rockliff, Cresset Press.

Bhattacharji, S. 1970. *The Indian Theogony: A Comparative Study of Indian Mythology from the Vedas to the Purāṇas*. Cambridge: Cambridge University Press.

Bhattacharya, B. C. 1974. *The Jaina Iconography*. 2d rev. ed. New Delhi: Motilal Banarasidass.

Bhattacharya, G. 1980. "Stupa as Maitreya's Emblem." In *The Stupa: Its Religious, Historical, and Architectural Significance*. Edited by A. L. Dallapiccola and S. Zingel-Ave Lallemant. Wiesbaden: Franz Steiner Verlag.

Bhattacharya, T. 1963. *The Canons of Indian Art; or, A Study of the Vāstuvidyā*. 2d ed. Calcutta: Firma K. L. Mukhopadhyay.

Bhattacharyya, B. 1958. *The Indian Buddhist Iconography*. 2d ed. rev. Calcutta: Firma K. L. Mukhopadhyay.

Biswas, S. S. 1981. *Terracotta Art of Bengal*. New Delhi: Agam Kala Prakasan.

Bivar, A.D.H. 1956. "The Kushano-Sassanian Coin Series." *Journal of the Numismatic Society* 18: 13–35.

Carter, M. L. 1982. "The Bacchants of Mathura: New Evidence of Dionysiac Yaksha Imagery from Kushan Mathura." *Bulletin of the Cleveland Museum of Art* 69, no. 8: 247–56.

————. 1985. "A Numismatic Reconstruction of Kushano-Sasanian History." *Journal of the American Numismatic Society* 30: 215–81.

Chandra, M. 1966. "Nidhiśṛṅga (Cornucopia): A Study in Symbolism." *Bulletin of the Prince of Wales Museum of Western India* 9: 1–33.

————. 1973a. *The World of Courtesans*. New Delhi: Vikas Publishing House.

————. 1973b. "Studies in the Cult of the Mother Goddess in Ancient India." *Bulletin of the Prince of Wales Museum of Western India* 12: 1–47.

————. 1977. *Trade and Trade Routes in Ancient India*. New Delhi: Abhinav Publications.

————, and P. L. Gupta. 1962–64. "Jewellery Moulds in Ancient India." *Bulletin of the Prince of Wales Museum of Western India* 8: 8–17.

Chandra, P. 1970. *Stone Sculpture in the Allahabad Museum: A Descriptive Catalogue*. Poona: American Institute of Indian Studies.

————. 1985. *The Sculpture of India, 3000 B.C.–1300 A.D.* Washington, D.C.: National Gallery of Art.

Chatterjee, A. K. 1970. *The Cult of Skanda-Kārttikeya in Ancient India*. Calcutta: Punthi Pustak.

Chattopadhay, B. 1979. *The Age of the Kushāns: A Numismatic Study*. 2d ed. Calcutta: Punthi Pustak.

Colledge, M.A.R. 1977. *Parthian Art*. Ithaca, N.Y.: Cornell University Press.

Coomaraswamy, A. K. 1923. *Catalogue of the Indian Collections in the Museum of Fine Arts, Boston*. 2 pts. Cambridge: Harvard University Press.

————. 1928. "Archaic Indian Terracottas." In *IPEK: Jahrbuch für Prähistorische Ethnographische Kunst*. Edited by H. Kühn. Leipzig: Kunkhardt & Bierman.

————. 1935. *Elements of Buddhist Iconography*. Cambridge: Harvard University Press.

————. [1927] 1985. *History of Indian and Indonesian Art*. Reprint. New York: Dover.

Cowell, E. B. [1894] 1968. *The Buddha-carita of Asvaghosha*. Sacred Books of the East, vol. 49, pt. 1. New Delhi: Motilal Banarasidass.

Craven, R. C. 1976. *A Concise History of Indian Art*. New York: Praeger.

Cunningham, A. 1879. *The Stupa of Bharhut: A Buddhist Monument*. London: Wm. H. Allen.

Czuma, S. J. 1970. "A Gupta-Style Bronze Buddha." *Bulletin of the Cleveland Museum of Art* 57 (February): 55–67.

————. 1979. "Mathura Sculpture in the Cleveland Museum Collection." *Bulletin of the Cleveland Museum of Art* 64 (March): 83–112.

————. 1985. *Kushan Sculpture: Images from Early India*. Cleveland: Cleveland Museum of Art.

Dani, A. H. 1965–66. "Shaikhan Dheri Excavation." *Ancient Pakistan* 2: 12–214.

Daniélou, A. 1964. *Hindu Polytheism*. New York: Pantheon.

Darmesteter, J., tr. 1969. *The Zend-Avesta*. Sacred Books of the East, vols. 4, 23. New Delhi: Motilal Banarsidass.

Davidson, J. L. 1968. *Art of the Indian Subcontinent from Los Angeles Collections*. Los Angeles: Art Galleries, University of California, Los Angeles.

Desai, D. 1975. *Erotic Sculpture of India: A Socio-Cultural Study*. New Delhi: Tata McGraw-Hill Publishing Co.

Desai, K. S. 1973. *Iconography of Viṣṇu*. New Delhi: Abhinav Publications.

Dhavalikar, M. K. 1971. *Mathura Art in the Baroda Museum*. Baroda: Department of Museums, Gujarat State.

Dobbins, K. W. 1971. *The Stupa and Vihara of Kanishka I*. Calcutta: Asiatic Society.

Dohanian, D. K. 1961. *The Art of India*. Rochester, N.Y.: University of Rochester.

Faccenna, D. 1962. *Sculptures from the Sacred Area of Butkara I*. Pt. 2. Rome: Istituto Poligrafico dello Stato.

———. 1964. *Sculptures from the Sacred Area of Butkara I*. Pt. 3. Rome: Istituto Poligrafico dello Stato.

———, and G. Gullini. 1962. *Reports on the Campaigns 1956–1958 in Swat {Pakistan}*. Rome: Istituto Poligrafico dello Stato.

Fairservis, Jr., W. A. 1971. *The Roots of Ancient India*. New York: Macmillan.

Fisher, R. E. 1982. "The Enigma of Harwan." *Art International* 25, nos. 9–10: 33–45.

Fleet, J. F. 1970. *Inscriptions of the Early Gupta Kings and Their Successors*. 3d ed. Corpus Inscriptionum Indicarum, 3. Varanasi: Indological Book House.

Gardner, P. [1886] 1971. *The Coins of the Greek and Scythic Kings of Bactria and India in the British Museum*. Reprint. New Delhi: Sagar Publications.

Ghosh, A., ed. 1958. *Indian Archaeology, 1957–58: A Review*. New Delhi: Department of Archaeology, Government of India.

———, ed. 1960. *Indian Archaeology, 1959–60: A Review*. New Delhi: Department of Archaeology, Government of India.

———, ed. 1961. *Indian Archaeology, 1960–61: A Review*. New Delhi: Department of Archaeology, Government of India.

———, ed. 1964. *Indian Archaeology, 1961–62: A Review*. New Delhi: Department of Archaeology, Government of India.

———, ed. 1973. *Indian Archaeology, 1965–66: A Review*. New Delhi: Department of Archaeology, Government of India.

Glynn, C. 1972. *Aspects of Indo-Asian Art from the Los Angeles County Museum of Art*. Redlands, Calif.: Tom and Ann Peppers Art Gallery.

Göbl, R. 1967. *Dokumente zur Geschichte der Iranischen Hunnen in Baktrien und Indien*. 3 vols. Wiesbaden: Otto Harrassowitz.

———. 1976. *A Catalogue of Coins from Butkara I*. Rome: Istituto Italiano per il Medio ed Estremo Oriente.

———. 1984. *System und Chronologie der Münzprägung des Kušānreiches*. Vienna: Verlag der Österreichischen Akademie der Wissenschaften.

Goddard, A. 1965. *The Art of Iran*. Translated by M. Heron. New York: Praeger.

Gonda. 1969. *Aspects of Early Visnuism*. 2d ed. New Delhi: Motilal Banarsidass.

———. 1970. *Viṣṇuism and Sivaism: A Comparison*. London: Athlone Press.

Gopinatha Rao, T. A. [1914–16] 1968. *Elements of Hindu Iconography*. 2d ed. Reprint. 2 vols., 4 pts. New York: Paragon Book Reprint Corp.

Gorakshakar, S. V., ed. 1979. *Animals in Indian Art*. Bombay: Prince of Wales Museum of Western India.

Grönbold, G. n.d. *Die Mythologie des Indischen Buddhismus*. Stuttgart: Ernst Klett Verlag.

Gupta, P. L., ed. 1965. *Patna Museum Catalogue of Antiquities: Stone Sculptures, Metal Images, Terracottas, and Minor Antiquities*. Patna: Patna Museum.

———, and S. Srivastava. 1981. *Gupta Gold Coins*. Varanasi: Bharat Kala Bhavan.

Gupta, S. P. 1980. *The Roots of Indian Art*. New Delhi: R. B. Publishing Corporation.

Hallade, M. 1968. *Gandharan Art of North India and the Graeco-Buddhist Tradition in India, Persia, and Central Asia*. Translated by Diana Imber. New York: Abrams.

Harle, J. C. 1970. "On a Disputed Element in the Iconography of Early Mahiṣāsuramardinī Images." *Ars Orientalis* 8: 147–54.

———. 1971–72. "On the Mahisāsuramardinī Images of the Udaygiri Hill (Vidiśā) Caves." *Journal of the Indian Society of Oriental Art*, n.s. 4, pt. 1: 44–48.

———. 1974. *Gupta Sculpture: Indian Sculpture of the Fourth to the Sixth Centuries A.D.* Oxford: Clarendon Press.

Harper, P. O. 1974. "Sasanian Medallion Bowls with Human Busts." In *Near Eastern Numismatics, Iconography, Epigraphy, and History: Studies in Honor of George C. Miles.* Edited by D. K. Kouymjian. Beirut: American University of Beirut.

———. 1978. *The Royal Hunter: Art of the Sasanian Empire.* New York: Asia Society.

Hartel, H. 1976. "Some Results of the Excavations at Sonkh." In *German Scholars on India*, 2: 69–99. Bombay: Nachiketa Publications.

———. 1977. "Eine Mathura-Inschrift der vor-Kusana-zeit." In *Beiträge zur Indienforschung.* Berlin: Museum für Indische Kunst.

Heeramaneck, A. 1979. *Masterpieces of Indian Sculpture from the Former Collections of Nasli M. Heeramaneck.* New York: Privately printed.

Herzfeld, E. 1930. *Kushano-Sasanian Coins.* Calcutta: Government of India.

Huntington, J. C. 1970. "Avalokiteśvara and the Namaskāramudrā in Gandhāra." *Studies in Indo-Asian Art and Culture*, 1: 91–99.

Huntington, S., and J. C. Huntington. 1985. *The Art of Ancient India.* New York: Weatherhill.

Ingalls, D.H.H. 1965. *An Anthology of Sanskrit Court Poetry.* Cambridge: Harvard University Press.

In the Image of Man: The Indian Perception of the Universe through Two Thousand Years of Painting and Sculpture. London: Arts Council of Great Britain, 1982.

Irwin, J. 1973–76. "'Asokan' Pillars: A Reassessment of the Evidence." *Burlington Magazine* 115 (November 1973): 706–30; 116 (December 1974): 712–27; 117 (October 1975): 631–43; 118 (November 1976): 734–53.

Joshi, N. P. 1966. *Mathura Sculptures.* Mathura: Museum of Archaeology.

———. 1979. *Iconography of Balarama.* New Delhi: Abhinav Publications.

Kak, R. C. 1923. *Handbook of the Archaeological and Numismatic Sections of the Sri Pratap Singh Museum, Srinagar.* Calcutta: Thacker, Spink & Co.

Kala, S. C. 1950. *Terracotta Figurines from Kausambi.* Allahabad: Municipal Museum.

———. 1980. *Terracottas in the Allahabad Museum.* New Delhi: Abhivnav Publications.

Khandalavala, K. 1984. "The Five Dated Gandhara School Sculptures and Their Stylistic Implications." In *Indian Epigraphy.* Edited by F. M. Asher and G. S. Gai, pp. 62–71. New Delhi: Oxford and IBH Publishing.

Khosla, S. 1982. *Gupta Civilization.* New Delhi: Intellectual Publishing House.

Klimburg-Salter, D. E. 1982. *The Silk Route and the Diamond Path.* Los Angeles: Art Council, University of California, Los Angeles.

Kosambi, D. D. 1965. *Ancient India.* New York: Pantheon.

Kramrisch, S. 1981. *Manifestations of Shiva.* Philadelphia: Philadelphia Museum of Art.

Krishna Murthy, K. 1977. *Nāgārjunakoṇḍā: A Cultural Study.* New Delhi: Concept Publishing.

Kuwayama, S. 1976. "The Turki Sahis and Relevant Brahmanical Sculpture in Afghanistan." *East and West* 26, nos. 3–4: 375–408.

Lahiri, A. N. 1965. *Corpus of Indo-Greek Coins.* Calcutta: Poddar Publications.

Larousse Encyclopedia of Mythology. London: Batchworth Press, 1959.

Larson, G. J., et al. 1980. *In Her Image: The Great Goddess in Indian Asia and the Madonna in Christian Cultures.* Santa Barbara: University Art Museum.

Lee, S. E. 1942. *Buddhist Art.* Detroit: Detroit Institute of Arts.

Legge, J., tr. 1965. *A Record of Buddhistic Kingdoms.* New York: Paragon Book Reprint Corp.

Lerner, M. 1976. "Treasures of South Asian Sculpture [in the Norton Simon Museum of Art]." *Connoisseur* 193 (November): 196–203.

———. 1984. *The Flame and the Lotus.* New York: Metropolitan Museum of Art.

Liebert, G. 1976. *Iconographic Dictionary of the Indian Religions.* Leiden: Brill.

van Lohuizen-de Leeuw, J. E. 1949. *The "Scythian" Period.* Leiden: Brill.

———. 1981. "New Evidence with Regard to the Origin of the Buddha Image." In *South Asian Archaeology, 1979.* Edited by H. Hartel. Berlin: Dietrich Reimer Verlag.

Los Angeles County Museum of Art. 1975. *A Decade of Collecting, 1965–1975.*

Lyons, I., and H. Ingholt. 1957. *Gandharan Art in Pakistan.* New York: Pantheon.

Majumdar, R. C. 1960. *The Classical Accounts of India.* Calcutta: Firma K. L. Mukhopadhyay

———, ed. 1968. *The Age of Imperial Unity*. 4th ed. Bombay: Bharatiya Vidya Bhavan.

———, ed. 1970. *The Classical Age*. 3d ed. Bombay: Bharatiya Vidya Bhavan.

Marshall, J. [1951] 1975. *Taxila*. 3 vols. New Delhi: Motilal Banarasidass.

Matheson, S. A. 1976. *Persia: An Archaeological Guide*. 2d ed. London: Faber and Faber.

Mehta, R. N., and S. N. Chowdhary. 1966. *Excavation at Devnimori*. Baroda: M. S. University of Baroda.

Meister, M. 1968. "The Arts of India and Nepal." *Oriental Art* 14, no. 2: 107–13.

Miller, B. S., ed. 1983. *Exploring India's Sacred Art: Selected Writings of Stella Kramrisch*. Philadelphia: University of Pennsylvania Press.

Mirashi, V. V. 1981. *The History and Inscriptions of the Satavahanas and the Western Kshatrapas*. Bombay: Maharashtra State Board for Literature and Culture.

Mitchiner, M. 1978. *Ancient and Classical World 600 B.C.–A.D. 650*. London: Hawkins Publications.

Mitra, D. 1971. *Buddhist Monuments*. Calcutta: Sahitya Samsad.

Mitterwallner, G. von. 1976. "The Kusana Type of the Goddess Mahisasuramardini as Compared to the Gupta and Medieval Types." In *German Scholars on India*, 2: 196–213. Bombay: Nachiketa Publications.

Montgomery, G., and A. Lippe. 1962. *The Art of India: Stone Sculpture*. New York: Asia Society.

Morris, R. 1982. "The Early Sculptures from Sarnath." *Indologica Taurinersia* 10: 155–68.

———. 1983. "Some Observations on Recent Soviet Excavations in Soviet Central Asia and the Problem of Gandhara Art." *Journal of the American Oriental Society* 103, no. 3: 557–67.

Mukherjee, B. N. 1967. *The Kushana Geneology I*. Calcutta: Sanskrit College.

———. 1969. *Nanā on Lion: A Study in Kushāṇa Numismatic Art*. Calcutta: Asiatic Society.

———. 1981. *Mathura and Its Society*. Calcutta: Firma KLM.

———. 1982. *Kushana Silver Coinage*. Calcutta: Indian Museum.

———. 1983. *A Plea for the Study of Art in Coinage*. Varanasi: Numismatic Society of India.

———. 1985. *Art in Gupta and Post-Gupta Coinages of Northern India*. Lucknow: State Museum Lucknow.

Mukhopadhyay, S. K. 1972. "Terracottas from Bhīṭā." *Artibus Asiae* 34, no. 1: 71–94.

Nagaraja Rao, M. S., ed. 1981. *Madhu: Recent Researches in Indian Archaeology and Art History*. Atlantic Highlands, N.J.: Humanities Press.

Narain, A. K. 1980. *The Indo-Greeks*. New Delhi: Oxford University Press.

———, ed. 1985. *Studies in Buddhist Art of South Asia*. New Delhi: Kanaka Publishers.

Newman, R. 1984. *The Stone Sculpture of India*. Cambridge: Center for Conservation and Technical Studies, Harvard University Art Museums.

Otsuka, R. Y., and M. C. Lanius. 1975. *South Asian Sculpture: The Harold P. and Jane F. Ullman Collection*. Denver: Denver Art Museum.

Pal, P. 1970–71. "Notes on Two Sculptures of the Gupta Period." *Archives of Asian Art* 21: 76–79.

———. 1971. "Some Rajasthani Sculptures of the Gupta Period." *Allen Memorial Art Museum Bulletin* 28, no. 2: 104–18.

———. 1973. "Bronzes of Kashmir: Their Sources and Influences." *Journal of the Royal Society of Arts* 121 (October): 726–49.

———. 1974a. *The Arts of Nepal*, pt. 1. Leiden: Brill.

———. 1974b. *The Sacred and Secular in Indian Art*. Santa Barbara: Department of Religious Studies, University of California, Santa Barbara.

———. 1975a. "The Asian Collection in the Los Angeles County Museum of Art." *Arts of Asia* 5 (May–June): 47–57.

———. 1975b. *Bronzes of Kashmir*. Graz: Akademische Druck.

———. 1976. "South Indian Sculptures in the Museum." *Los Angeles County Museum of Art Bulletin* 22: 30–57.

———. 1977. "Dhanada-Kubera of the *Vishṇudharmottara Purāṇa* and Some Images from North-West India." *Lalit Kalā* 18: 13–25.

———. 1978a. *The Divine Presence: Asian Sculptures from the Collection of Mr. and Mrs. Harry Lenart*. Los Angeles: Los Angeles County Museum of Art.

———. 1978b. *The Ideal Image: The Gupta Sculptural Tradition and Its Influence*. New York: Asia Society.

———. 1979. "A Kushan Indra and Some Related Sculptures." *Oriental Art* 25, no. 2 (Summer): 212–26.

———. 1981. "An Addorsed Saiva Image from Kashmir and Its Cultural Significance." *Art International* 24 (January–February): 6–60.

———. 1983. "The Divine Image and Poetic Imagery in Gupta India." In *The Art Institute Centennial Lectures. Museum Studies* 10: 297–309. Chicago: Contemporary Books, Inc.

———. 1985a. "Indian Sculpture." *Arts of Asia* 15 (November–December): 68–79.

———. 1985b. "Some Mathura Sculptures of the Kushan Period." *Annali Dell' Istituto Universitario Orientale* 45: 629–40.

———, et al. 1984. *Light of Asia: Buddha Sakyamuni in Asian Art.* Los Angeles: Los Angeles County Museum of Art.

Pargiter, F. E., trans. 1969. *The Mārkaṇḍeya Purāṇa.* New Delhi: Indological Book House.

Paul, P. G. 1981. "Some Terracotta Plaques from the Swat-Indus Region: A Little-Known Phase of the Post-Gandhara Art of Pakistan." In *South Asian Archaeology, 1979.* Edited by H. Hartel. Berlin: Dietrich Reimer Verlag.

Paulson, J. 1977. *From River Banks and Sacred Places: Ancient Indian Terracottas.* Boston: Museum of Fine Arts.

Piggott, S. 1950. *Prehistoric India.* Harmondsworth: Penguin.

Pope, J. 1942. *The Sculpture of Greater India.* New York: C. T. Loo.

Rosenfield, J. M. 1967. *The Dynastic Arts of the Kushans.* Los Angeles and Berkeley: University of California Press.

———, et al. 1966. *The Arts of India and Nepal: The Nasli and Alice Heeramaneck Collection.* Boston: Museum of Fine Arts.

Rowland, B., Jr. 1966. *Ancient Art from Afghanistan: Treasures of the Kabul Museum.* New York: Asia Society.

———. 1977. *The Art and Architecture of India: Buddhist, Hindu, Jain.* 7th ed. Harmondsworth: Penguin.

Roy, U. N. 1979. *Śālabhañjikā.* Allahabad: Lokbharti Publications.

Sarianidi, V. 1985. *The Golden Hoard of Bactria.* New York: Abrams.

Sarma, I. K. 1973. "A Coin Mould-piece from Nagarjuna-konda Excavations." *Journal of the Economic and Social History of the Orient* 16: 89–106.

———. 1980. *Coinage of the Satavahana Empire.* New Delhi: Agan Kala Prakashan.

Schastok, S. L. 1985. *The Śamlājī Sculptures and Sixth-Century Art in Western India.* Leiden: Brill.

Schroeder, U. von. 1981. *Indo-Tibetan Bronzes.* Hong Kong: Visual Dharma Publications Ltd.

Shah, P. 1961. *Viṣṇudharmottara-Purāṇa: Third Khaṇḍa,* 2 pts. Baroda: Oriental Institute.

Shah, U. P. 1955. *Studies in Jaina Art.* Varanasi: Jaina Cultural Research Society.

———. 1972. "Western Indian Sculpture and the So-Called Gupta Influence." In *Aspects of Indian Art: Papers Presented in a Symposium at the Los Angeles County Museum of Art, October, 1970.* Edited by P. Pal, pp. 44–48. Leiden: Brill.

Sharan, M. K. 1972. *Tribal Coins: A Study.* New Delhi: Abhinav Publications.

Sharma, B. N. 1975. *Iconography of Revanta.* New Delhi: Abhinav Publications.

———. 1979. *Jain Pratimāyen.* New Delhi: Indological Book Corporation.

Sharma, G. R. 1960. *The Excavations at Kausambi.* Allahabad: Institute of Archaeology, Allahabad University.

Sharma, R. C. 1976. *Mathura Museum and Art.* 2d ed., rev. Mathura: Government Museum.

———. 1984. *Buddhist Art of Mathura.* New Delhi: Agam Kala Prakashan.

Shepherd, D. G. 1980. "The Iconography of Anahita." *Berytus Archaeological Studies* 28: 47–73.

Shere, S. A. 1961. *Terra-cotta Figurines in Patna Museum.* Patna: Patna Museum.

Sircar, D. C. 1968. *Studies in Indian Coins.* New Delhi: Motilal Banarasidass.

———. 1977. *Early Indian Numismatic and Epigraphical Studies.* Calcutta: Indian Museum.

Sivaramamurti, C. 1956. *Amaravati Sculptures in the Madras Museum.* Madras: Government Museum.

———. 1970. *Sanskrit Literature and Art: Mirrors of Indian Culture.* New Delhi: Lakshmi Book Store.

———. 1978. *Chitrasūtra of the Vishnudharmottara.* New Delhi: Kanak Publications.

———. 1979. *Sources of History Illuminated by Literature.* New Delhi: Kanak Publications.

Soper, A. C. 1951. "The Roman Style in Gandhara." *American Journal of Archaeology* 55, no. 4: 301–19.

Srinivasan, D. 1978–79. "God as Brahmanical Ascetic: A Colossal Kusana Icon of the Mathura School." *Journal of the Indian Society of Oriental Art* 10: 1–16.

———. 1979. "Early Vaishnava Imagery: Caturvyuha and Variant Forms." *Archives of Asian Art* 32: 39–54.

Srivastava, A. K. 1969. *Indo-Greek Coins in the State Museum, Lucknow.* Lucknow: State Museum.

———. 1972. *Catalogue of Saka-Pahlava Coins of North India.* Lucknow: State Museum.

Staviski, B. 1979. *Mittelasien Kunst der Kuschan.* Leipzig: E. A. Seemann.

Taddei, M. 1970. *India.* Translated by J. Hogarth. Geneva: Nagel.

———. 1973. "The Mahisamardini Image from Tapa Sardar, Ghazni." *South Asian Archaeology.* Edited by N. Hammond. Park Ridge, N.J.: Noyes Press, pp. 203–13.

Thapar, B. K., ed. 1981. *Indian Archaeology: A Review.* New Delhi: Archaeological Survey of India.

Trabold, J. L. 1975. *The Art of India.* Northridge: Fine Arts Gallery, California State University, Northridge.

Trubner, H. 1950a. "A Group of Indian Sculpture from Mathura." *Art Quarterly.*

———, ed. 1950b. *The Art of Greater India.* Los Angeles: Los Angeles County Museum of Art.

———. 1968. "The Arts of India and Nepal." *Rotunda: The Bulletin of the Royal Ontario Museum* 1, no. 1: 2–14.

Vats, M. S. 1940. *Excavations at Harappā.* 2 vols. New Delhi: Manager of Publications, Government of India.

Waheed Khan, M. A. 1964. *An Early Sculpture of Narasimha.* Andhra Pradesh Government Archaeological Series No. 16. Hyderabad: Government of Andhra Pradesh.

Watt, J.C.Y., et al. 1982. *Asiatic Art in the Museum of Fine Arts, Boston.* Boston: Museum of Fine Arts.

Wheeler, M. 1962. *Chārsada.* London: Oxford University Press.

Williams, J. G. 1982. *The Art of Gupta India: Empire and Province.* Princeton: Princeton University Press.

Yogananda, Sri. 1970. "*Vālmīkī ke* Śloka *se ankit istikāfalak*" [Terra-cotta panels carved with Valmiki's verses]. *Bulletin of Museums and Archaeology in Uttar Pradesh* 5–6: 5–6.

Zaheer, M. 1981. *The Temple of Bhitargaon.* New Delhi: Agam Kala Prakasan.

Zimmer, H. [1955] 1960. *The Art of Indian Asia.* 2d ed. Edited by J. Campbell. 2 vols. Princeton: Princeton University Press.

———. [1946] 1963. *Myths and Symbols in Indian Art and Civilization.* Edited by J. Campbell. Princeton: Princeton University Press.

———. 1984. *Artistic Form and Yoga in the Sacred Images of India.* Translated by G. Chapple and J. B. Lawson. Princeton: Princeton University Press.

Index

Supervisors and Trustees